GORDON
PARKS

GORDON

PARKS

PAUL ROTH
AMANDA MADDOX

WITH CONTRIBUTIONS BY SÉRGIO BURGI,
BEATRIZ JAGUARIBE, PETER W. KUNHARDT, JR.,
FLÁVIO PINHEIRO, TIMOTHY POTTS,
MARIA ALICE REZENDE DE CARVALHO,
AMANDA SMITH, AND NATALIE SPAGNOL

STEIDL
THE GORDON PARKS FOUNDATION

RYERSON IMAGE CENTRE
THE J. PAUL GETTY MUSEUM
INSTITUTO MOREIRA SALLES

THE

FLÁVIO

STORY

170
2c8 on
25

LIFE MAGAZINE

LIFE PHOTO BY		TAKE NO.	DATE	SET NO.
GORDON PARKS		2	3/XX 30/61	~~62170~~
Property of Life Magazine Reproduction Forbidden without Express Consent				62170-A

STORY & LOCATION		REPORTER	DEPT.	NO. OF PRINTS
Latin American essay Favela			memo	

BLACK & WHITE FILM				COLOR FILM		
35 mm	120	PACK	CUT	35 mm	120	CUT
8	5			3-E		

Rio de Janeiro, slum conditions
in Brazil. Da'Silva family

X HOUSING - BRAZIL - SLUMS - RIO
X BRAZIL - P+C
X BRAZIL - CITIES - RIO
FLAVIO DA SILVA
CX FOODS - COOKERY

(prepares family meal)
JOSÉ M. DA SILVA (FAMILY)

Used ABC
LIFE 50th Anniv.
television special

ELI

S
1996.2005

Contents

Foreword

In the years since the death of renowned photographer, filmmaker, author, and composer Gordon Parks (1912–2006), numerous museum exhibitions and publications have revisited key documentary assignments he photographed for *Life* magazine. These projects have yielded essential new scholarship on Parks and collectively provide a reexamination of his photojournalism, bringing his profound talent as a visual storyteller to the fore. This book and the exhibitions that accompany it add to the ongoing exploration of Parks' diverse career by untangling one of the most important, complicated, enduring, and deeply personal assignments he ever undertook for *Life*.

In 1961, at the height of the Cold War, *Life* asked Parks to contribute to a series of feature articles addressing the United States' relationship with Latin America. His picture story, published under the headline "Freedom's Fearful Foe: Poverty," focused on Flávio da Silva, a resourceful, hardworking twelve-year-old boy afflicted with asthma who lived with his family in a Rio de Janeiro favela. The story prompted an unprecedented response from readers, who sent unsolicited funds to *Life*, along with letters offering to help the child, his family, and their community. The magazine's editors immediately sent Parks back to Brazil, where he helped relocate the family to a home in a working-class neighborhood, and transported Flávio to Denver, Colorado, to receive advanced medical care at an asthma hospital for children. Parks himself was featured prominently in the magazine's dramatic account of "rescue," published five weeks after the original story had introduced Flávio to *Life*'s readers.

The cultural impact of Parks' photographic essay was profound, resonating long after it first appeared in the magazine. Flávio's treatment and education in the United States continued for two years, during which he lived apart from his parents and siblings. Brazilian media outlets reacted against what they considered patronizing reportage from a U.S. media giant; the most influential Brazilian picture magazine, *O Cruzeiro*, countered *Life*'s coverage by sending photographer Henri Ballot to New York to highlight poverty in America. A second report by Ballot alleged that Parks' documentation of life in the favela had been fabricated. Meanwhile, *Life* dedicated a portion of its readers' donations to underwrite improvements to the favela where the da Silvas had lived. The publisher's office quietly administered funds earmarked for Flávio, the da Silva family, and the favela throughout the 1960s.

For Parks the story was a defining moment in his career as a photographer. He returned to Rio de Janeiro in 1976 to visit Flávio, by now an adult, and wrote a remarkable book describing their unusual encounter. Photographer and subject corresponded occasionally through the years, and in 1999, Parks again visited Flávio—this time in conjunction with a documentary film about his own life and work. Today, Flávio and some of his siblings still live on the property purchased for the family by *Life* readers' donations in 1961.

Three institutions—the Ryerson Image Centre, the J. Paul Getty Museum, and the Instituto Moreira Salles—have collaborated on this project, with assistance from the Gordon Parks Foundation. Featuring unique material by Henri Ballot from the Instituto Moreira Salles collection, and important works by Parks recently acquired by the J. Paul Getty Museum with the support of the Getty Museum Photographs Council, this book and the related exhibitions also bring together significant works held by the Gordon Parks Foundation and the International Center of Photography. Additional images by other photographers, including *Life* freelancers Carl Iwasaki and Paulo Muniz, and Flávio's surrogate father in Denver, José Gonçalves, help visualize aspects of the story that Parks did not capture. Texts by Natalie

Spagnol, curatorial assistant at the Ryerson Image Centre, introduce each of the plate sections, guiding readers through the stages of the project's development.

Several essays in the book unpack and update this complex history. Paul Roth, director of the Ryerson Image Centre, recounts the creation and reception of Parks' original photo essay during a period of historic change, placing these events in the context of U.S. political attitudes to Latin America. Professors Beatriz Jaguaribe and Maria Alice Rezende de Carvalho examine the cultural, political, and historical context of favelas in Brazil in relation to Parks' reportage for *Life*. Sérgio Burgi, photography coordinator and curator at the Instituto Moreira Salles, tells of the notable backlash against Parks' coverage in *Life* by *O Cruzeiro* and photographer Henri Ballot. Amanda Maddox, associate curator in the Department of Photographs at the J. Paul Getty Museum, investigates the many formats in which Parks told the story of Flávio between the 1960s and 1990s, and what these versions of the story reveal. Finally, a recent interview with Flávio da Silva introduces the present-day outlook of Parks' most famous subject.

Throughout his storied career at *Life*, Parks contributed numerous photographic essays that spoke to large and diverse audiences, while also conveying aspects of his own experience with indigence, racial discrimination, religion, political and criminal justice, and loss. Commissioned at this moment to document the geopolitical implications of poverty in Brazil, Parks chose to disregard his editors' directives and personalize the subject by focusing on the destitution of a single boy and his family. From their first encounter, Flávio da Silva reminded the photographer of his own childhood struggles. Parks' empathetic perspective, which complicated *Life*'s political agenda, elicited an overwhelming and unusual degree of identification from the magazine's predominantly middle-class readers, who felt (as many admitted) that Flávio's misfortune could just as easily have befallen them. The extraordinary nature of this story—its profound emotional impact, the political repercussions it provoked, and its remarkable ability to transcend and outlast the moment of its telling—underscores Parks' rare ability to portray the lives of others with unusual intimacy and directness.

Peter W. Kunhardt, Jr.
Executive Director
The Gordon Parks Foundation
Pleasantville, New York, United States

Flávio Pinheiro
Executive Superintendent
Instituto Moreira Salles
Rio de Janeiro and São Paulo, Brazil

Timothy Potts
Director
The J. Paul Getty Museum
Los Angeles, California, United States

Paul Roth
Director
Ryerson Image Centre
Toronto, Ontario, Canada

In March 1961, President John F. Kennedy proposed the Alliance for Progress, a foreign aid program designed to improve economic cooperation between the United States and Latin America. Less than three months later, *Life* magazine launched a five-part series titled "Crisis in Latin America." It was published biweekly, with the explicit aims of supporting formation and funding of the Alliance and warning against the spread of communism in the region. For the second article in the series, *Life* sent Gordon Parks to Rio de Janeiro with a specific assignment: to photograph the life and work of an impoverished father of eight to ten children and learn of his political leanings. Once in Brazil, however, Parks sidestepped these terms, focusing instead on twelve-year-old Flávio da Silva, who lived in the hillside favela of Catacumba with his seven brothers and sisters, and his parents, José and Nair. Parks' photographs show Flávio cooking, cleaning, scavenging for supplies, and minding his siblings while his parents work outside the home, despite his suffering from bronchial asthma and malnutrition. Later, in his book *Flavio*, the photographer recalled the da Silva home as being in a constant state of chaos and wondered "how, in such a weak condition, [Flávio] could face this each day—the fighting, the whimpering, and the filth." Parks felt an emotional connection to the boy and his suffering, and urged *Life*'s editors to publish an extensive photographic essay that effectively conveyed the tragedy of the da Silvas' poverty. Managing editor Edward K. Thompson initially steered the story in a different direction, including only a sample of Parks' reportage among photographs by others in an early layout. However, *Life* reconsidered, and published the Flávio story, "Freedom's Fearful Foe: Poverty," across twelve pages in its June 16, 1961, issue.

1961

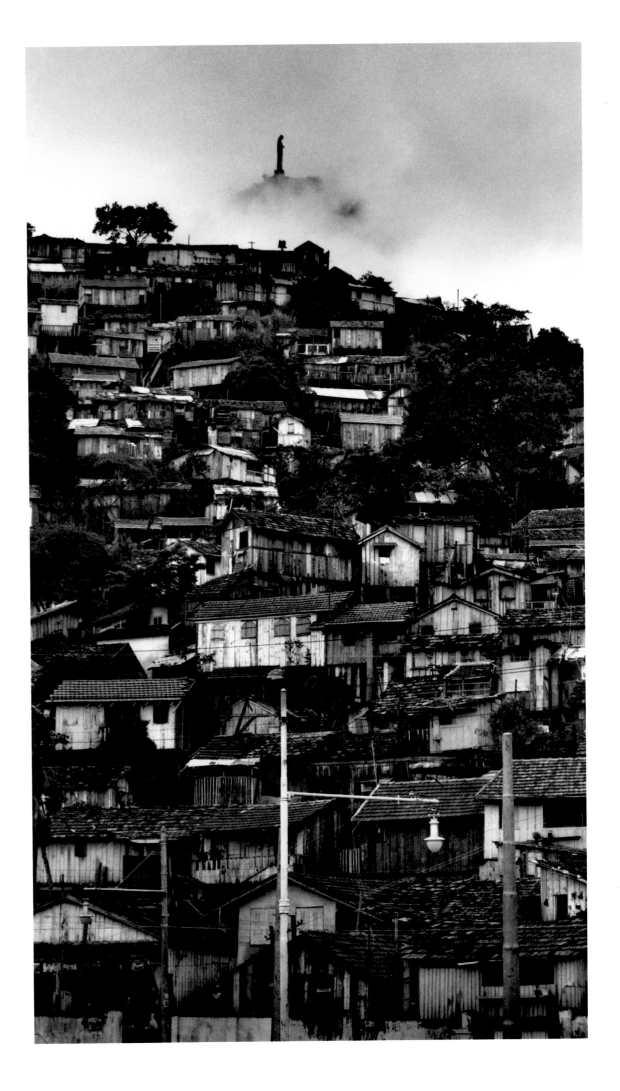

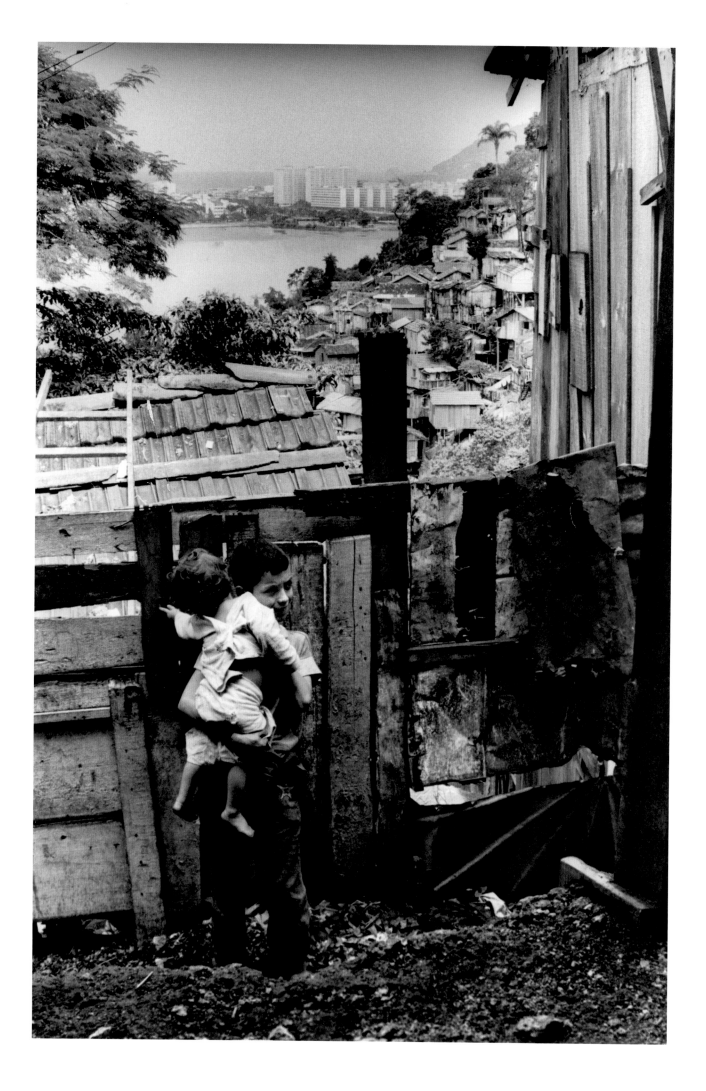

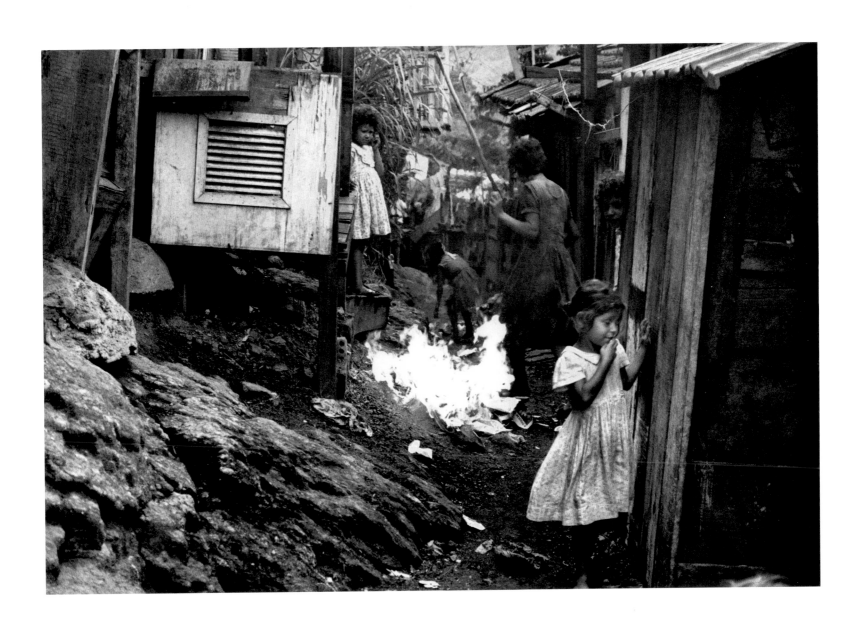

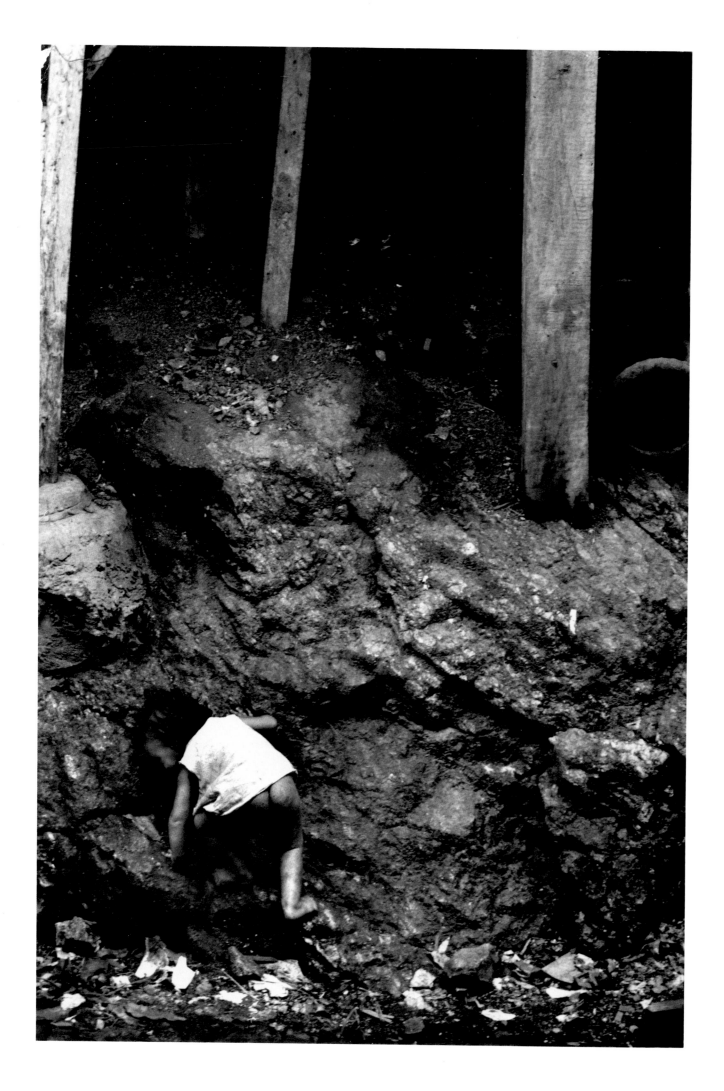

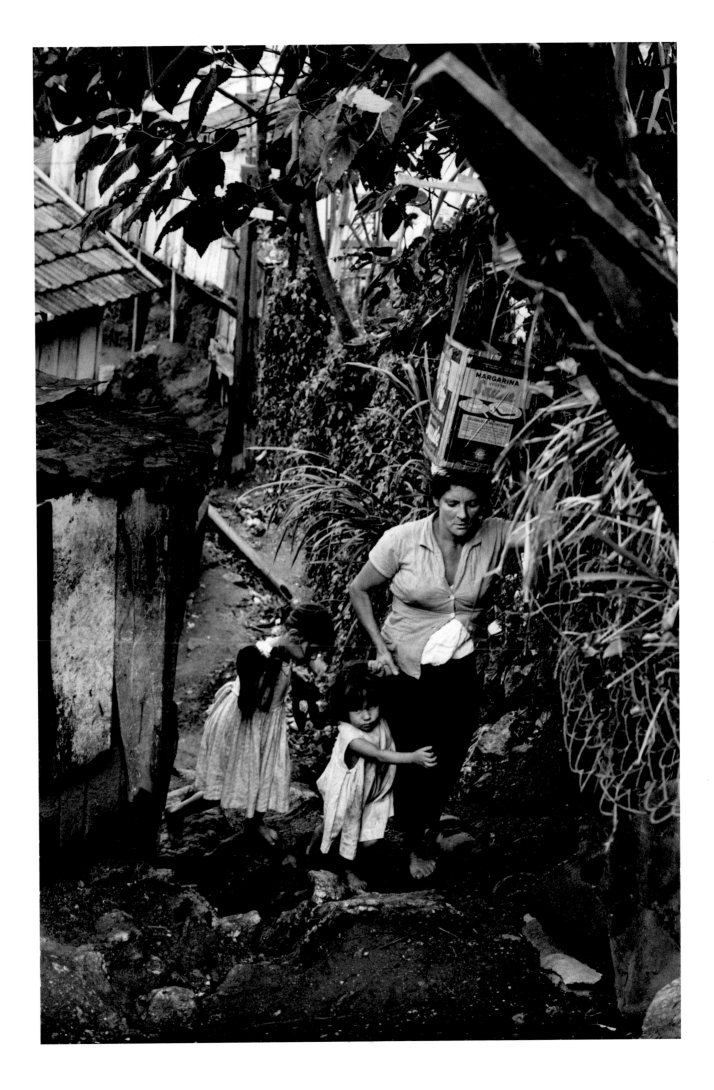

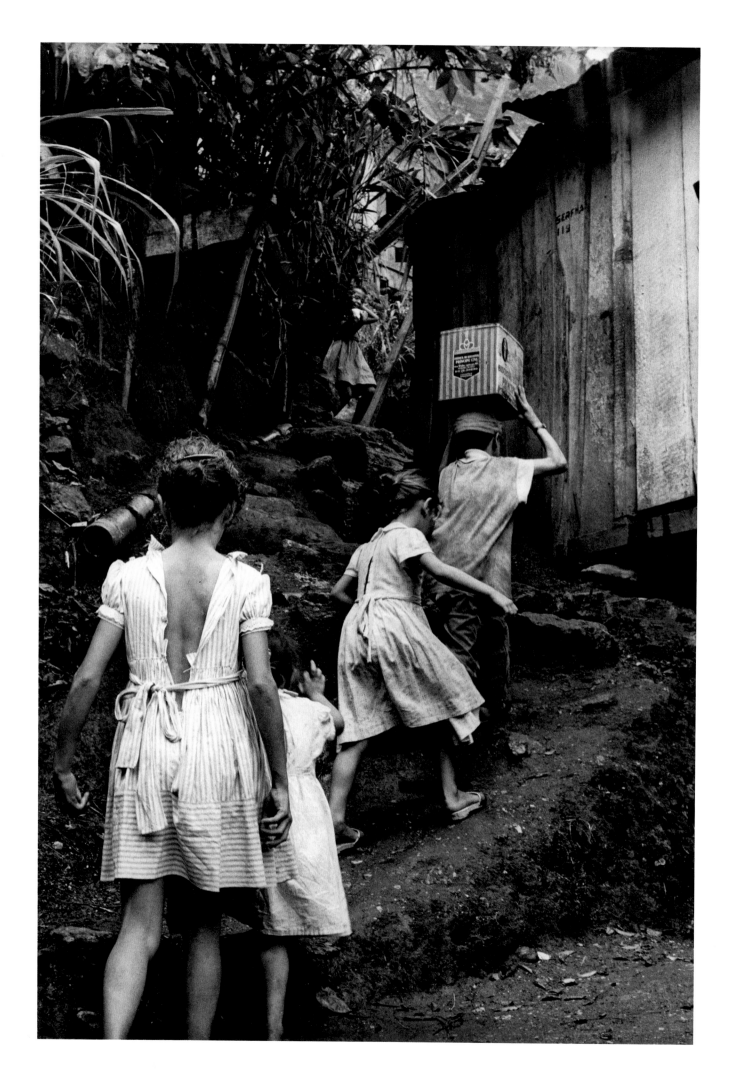

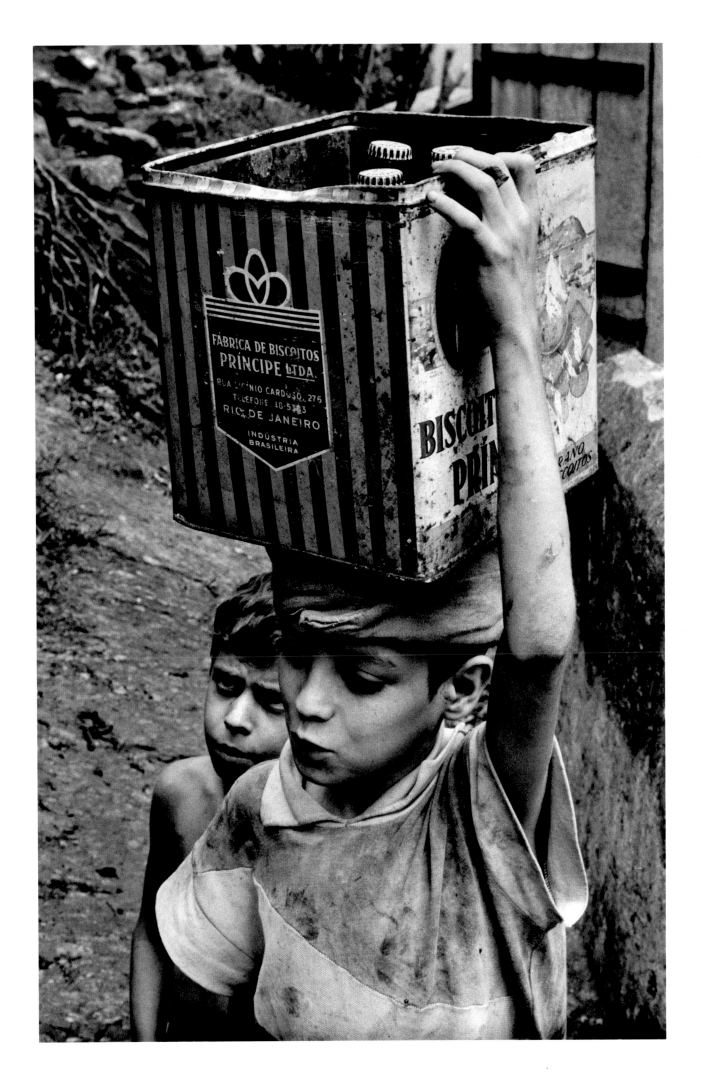

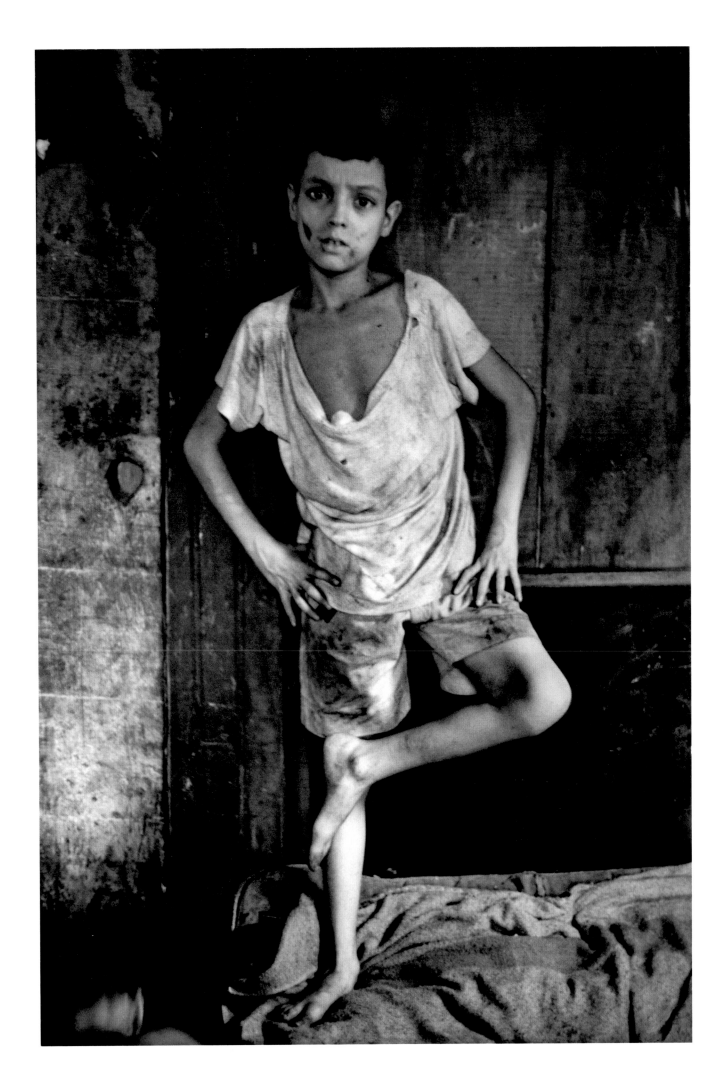

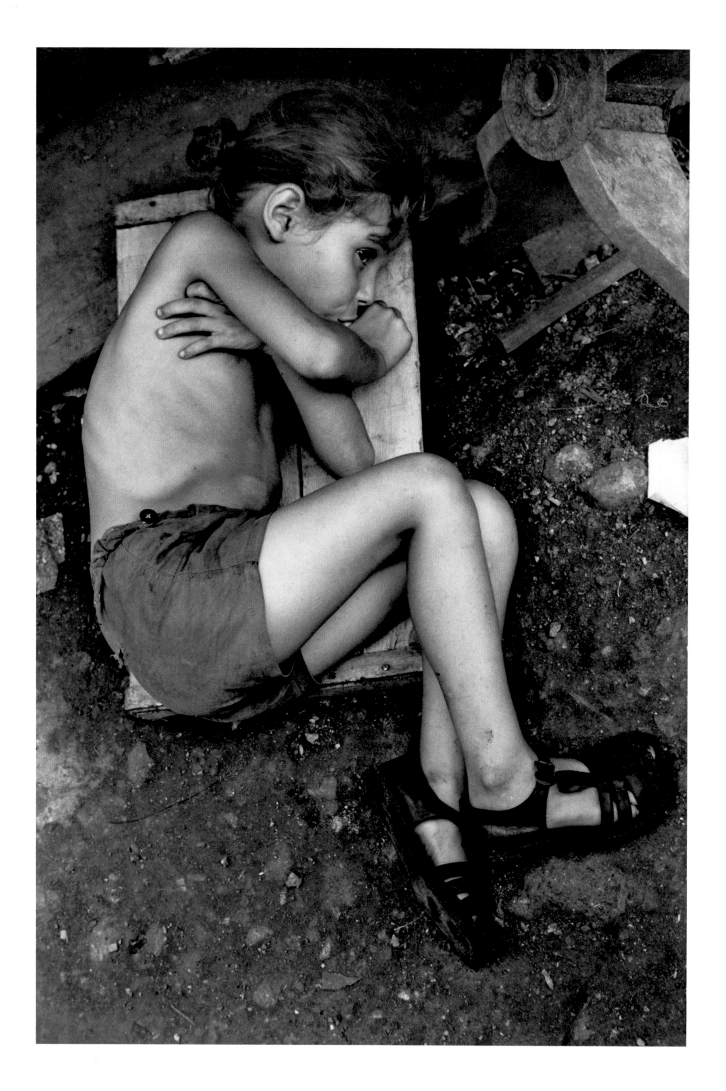

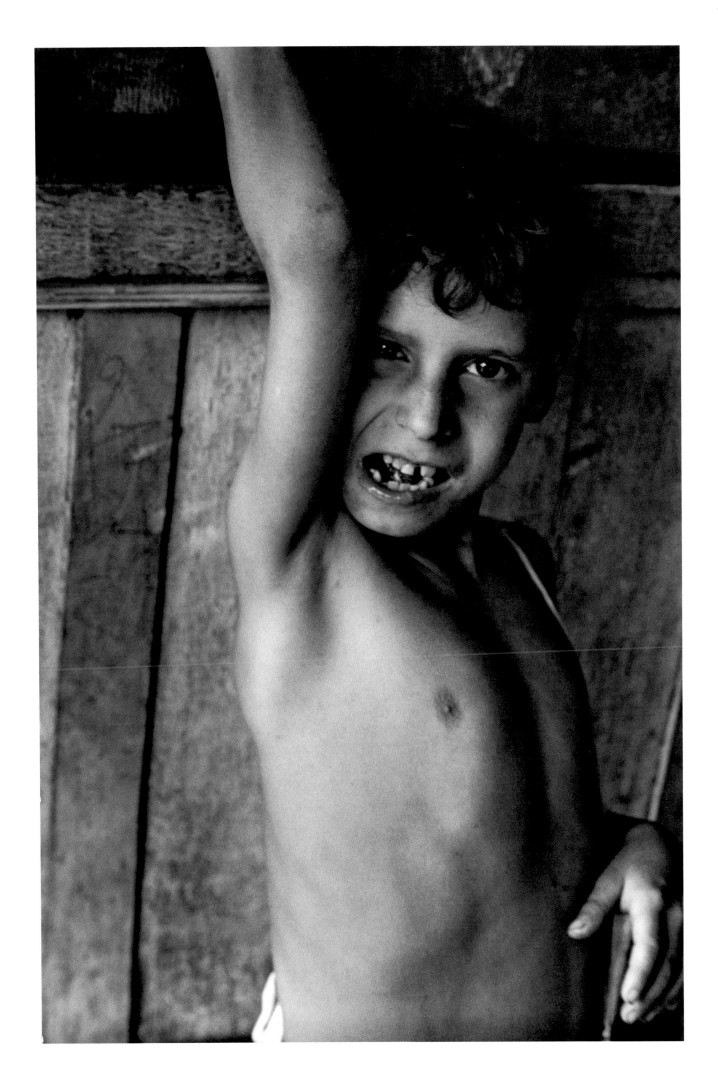

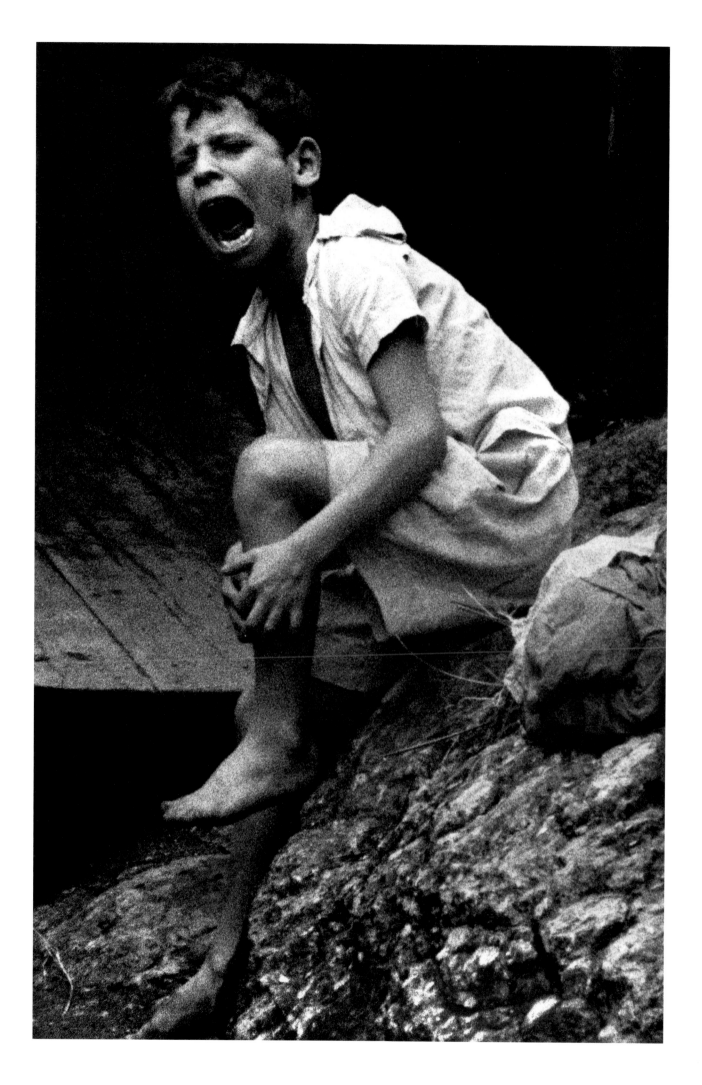

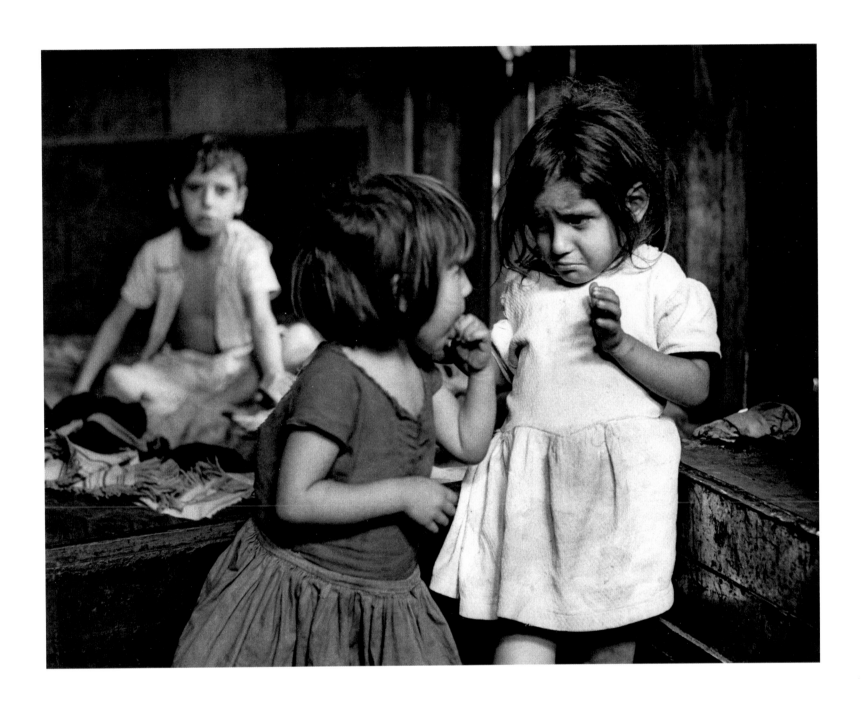

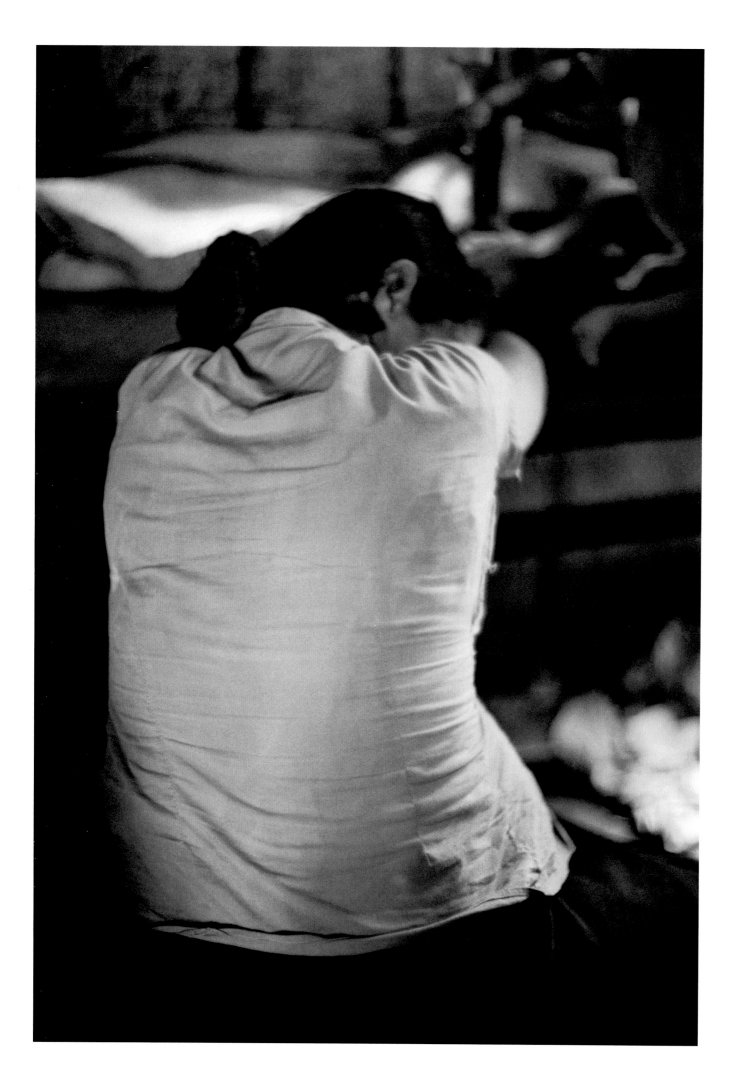

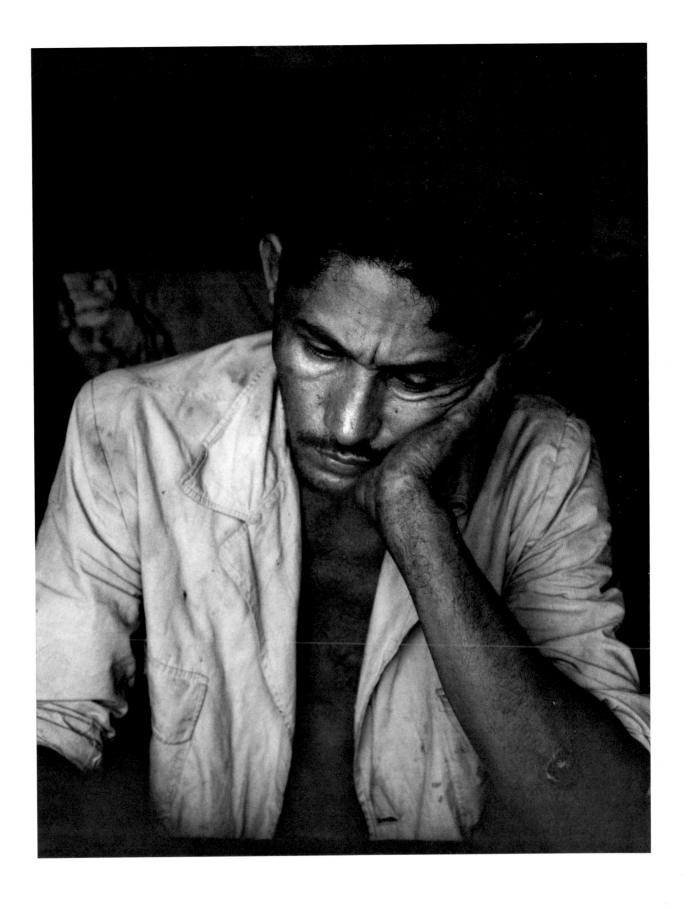

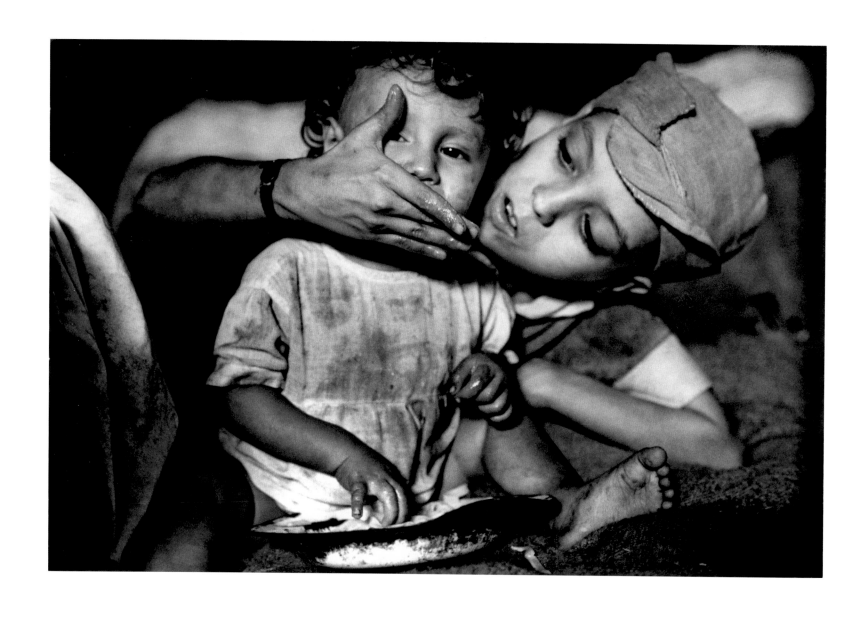

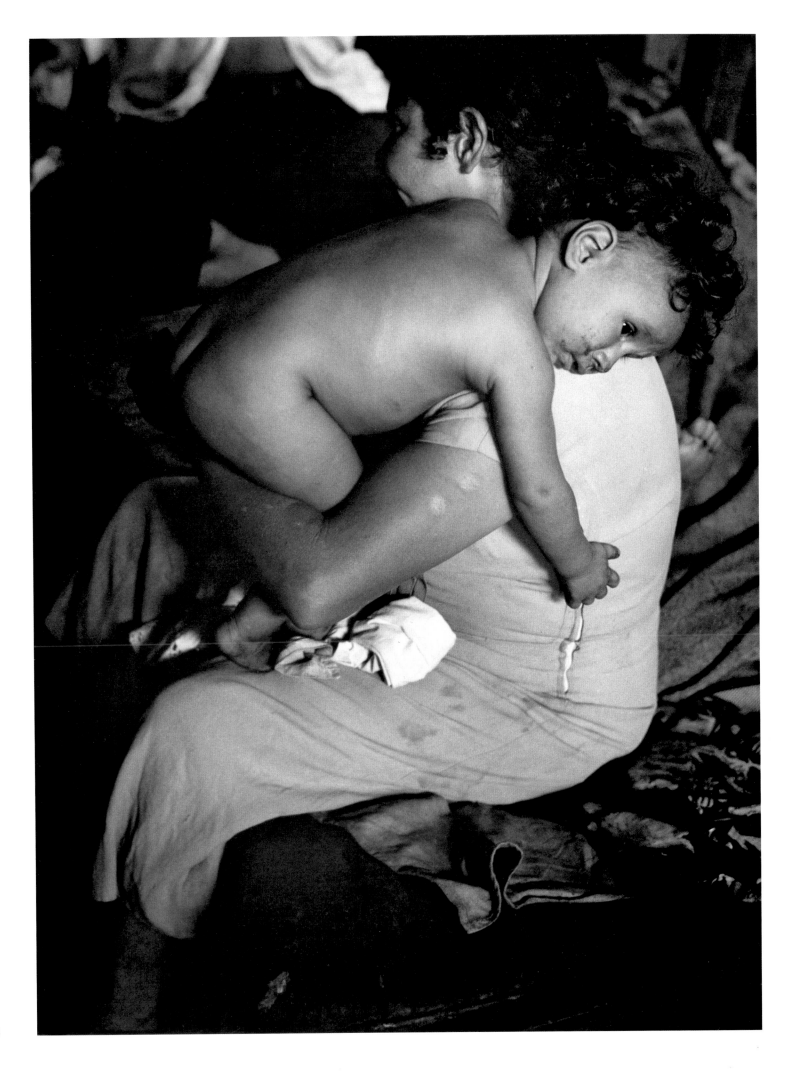

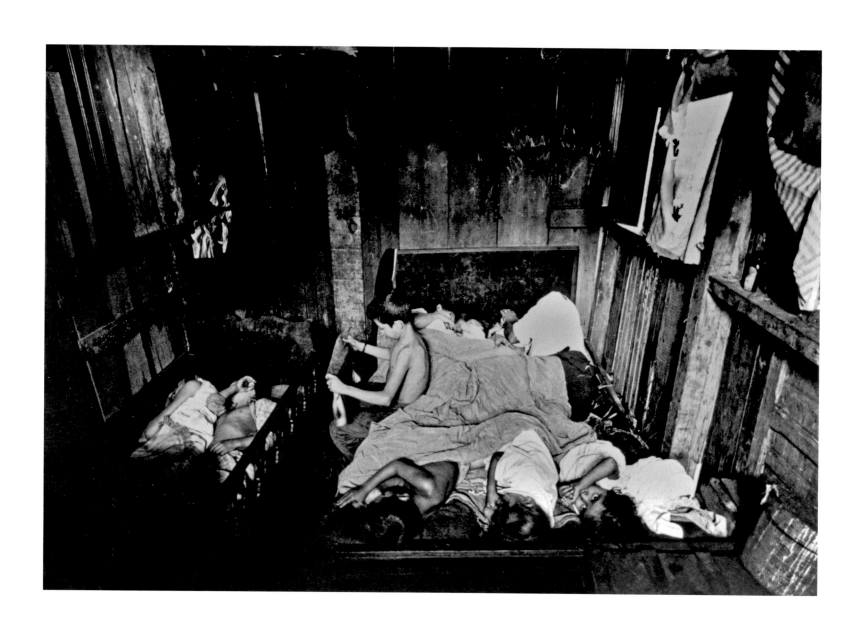

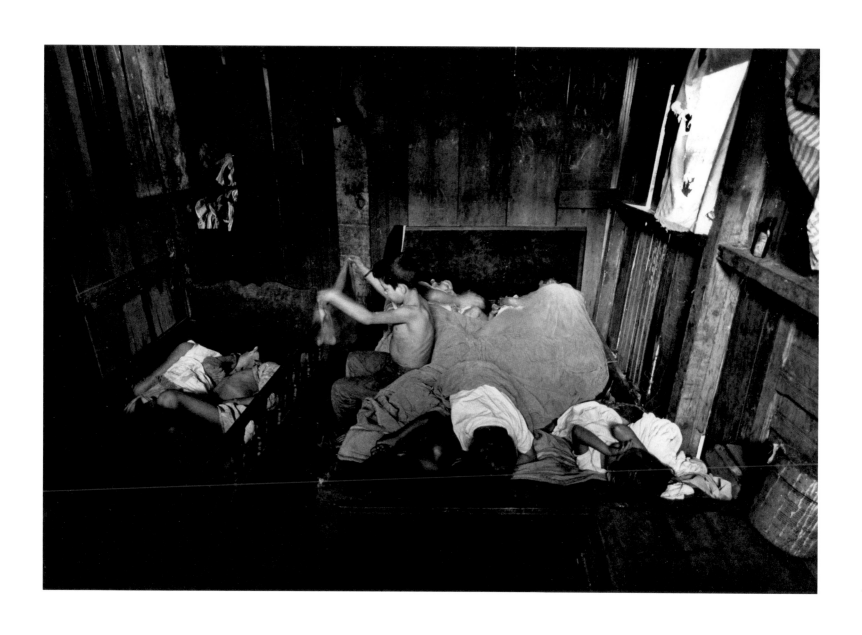

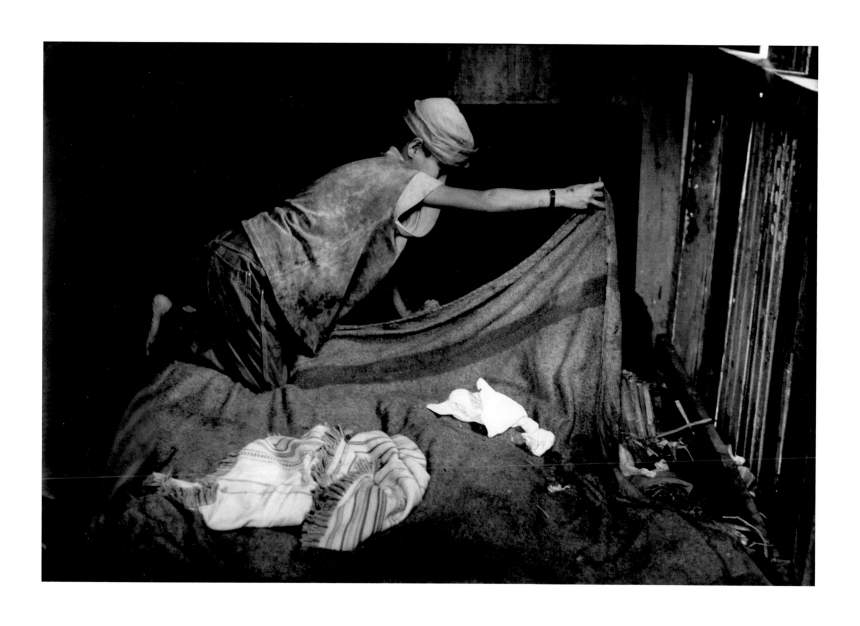

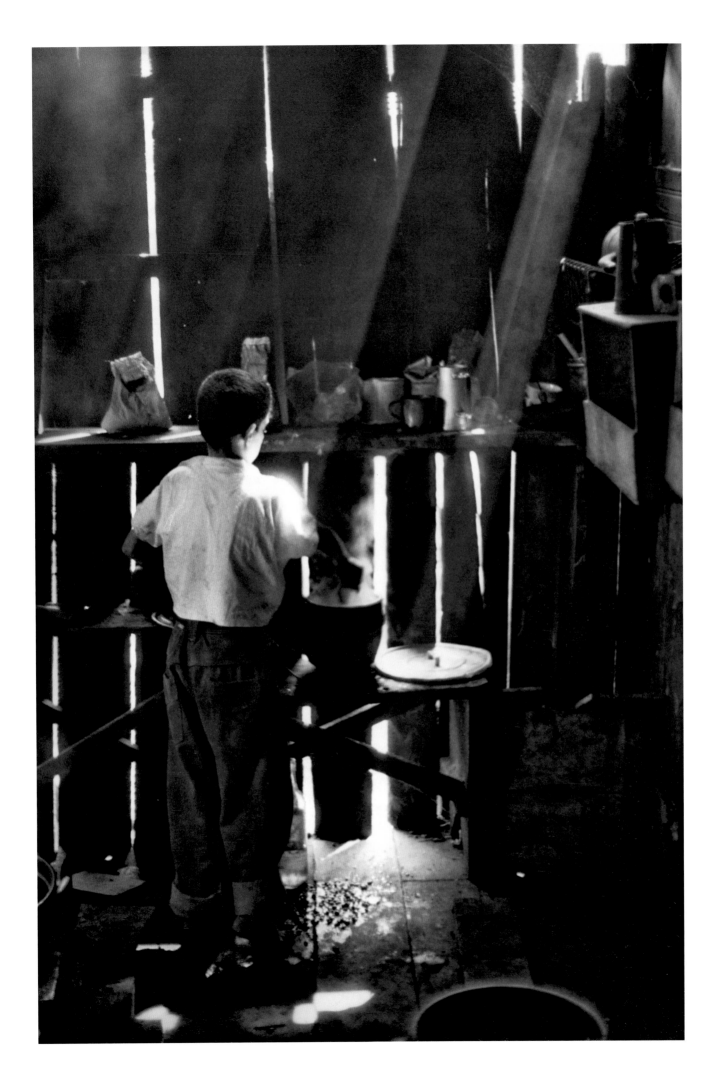

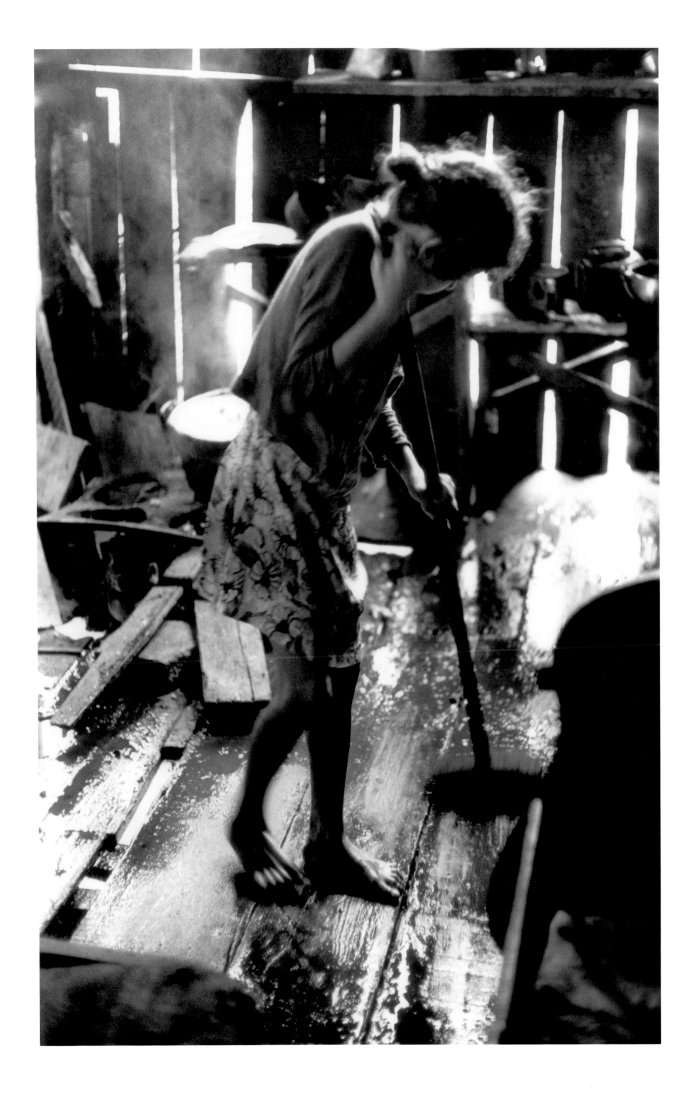

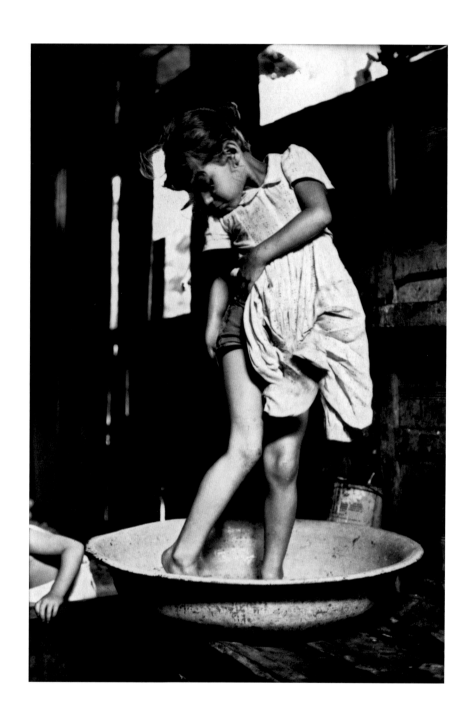

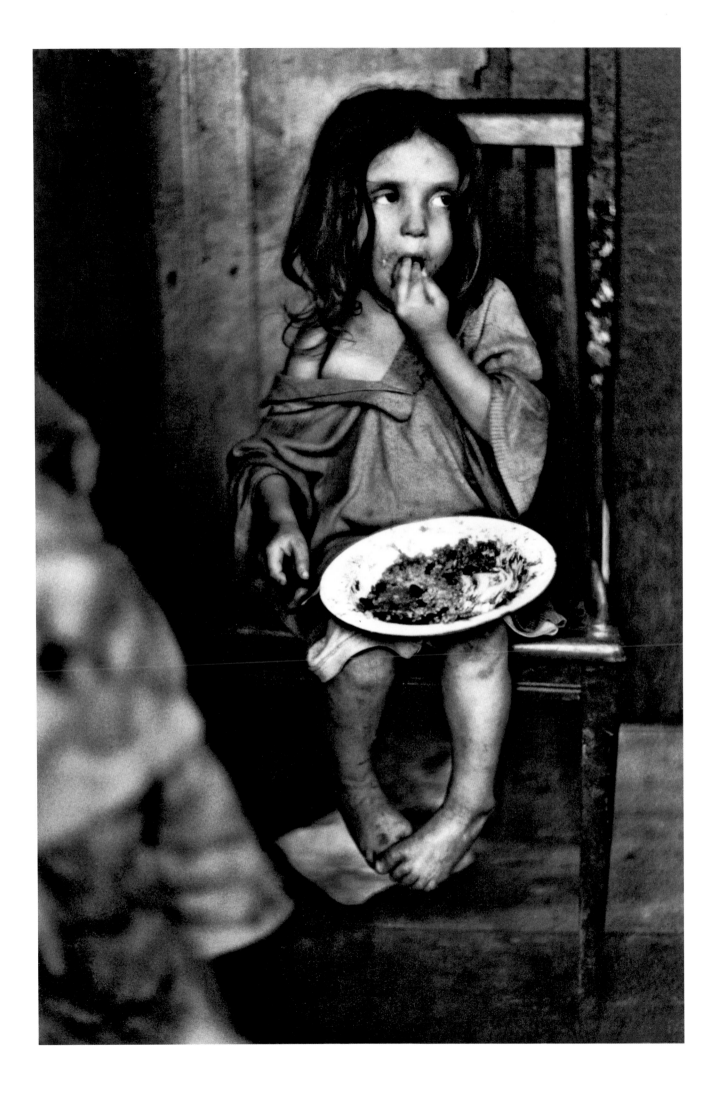

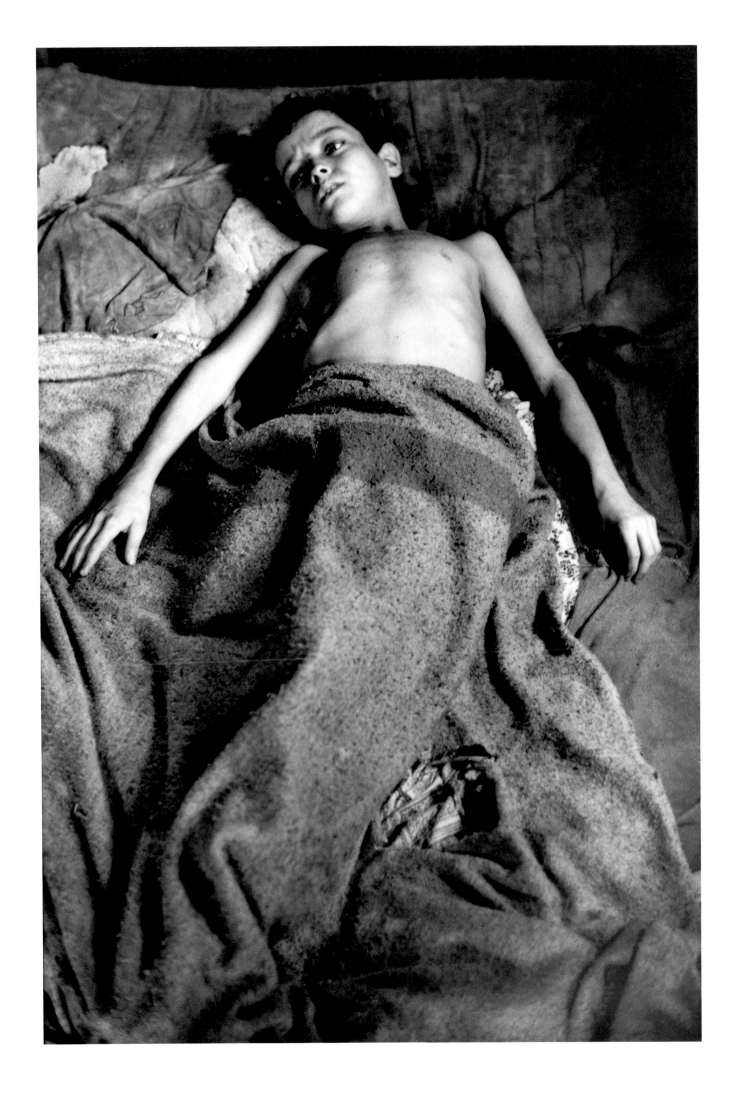

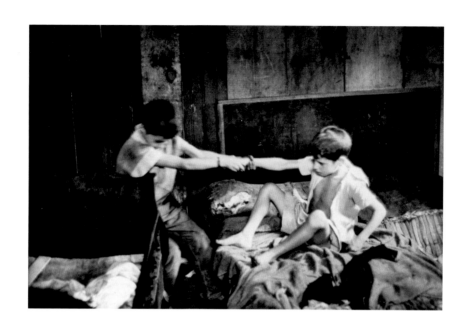

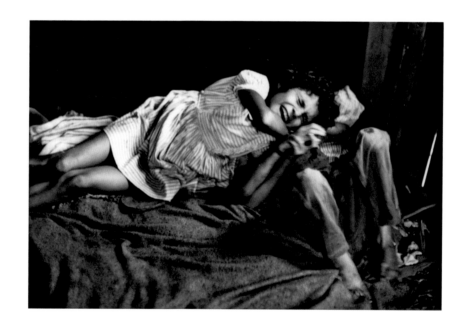

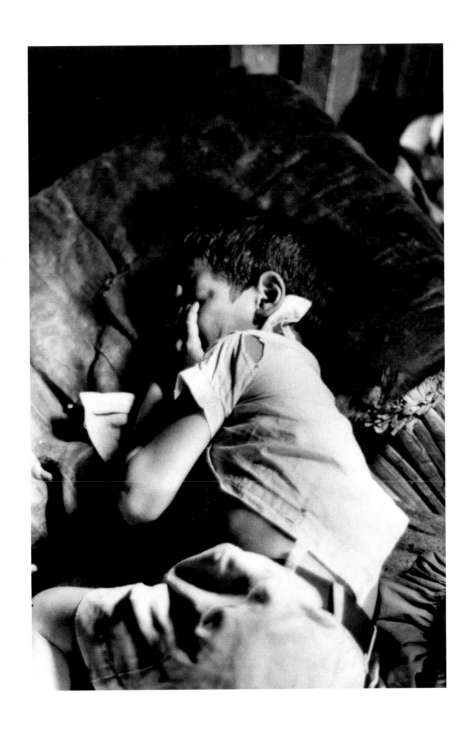

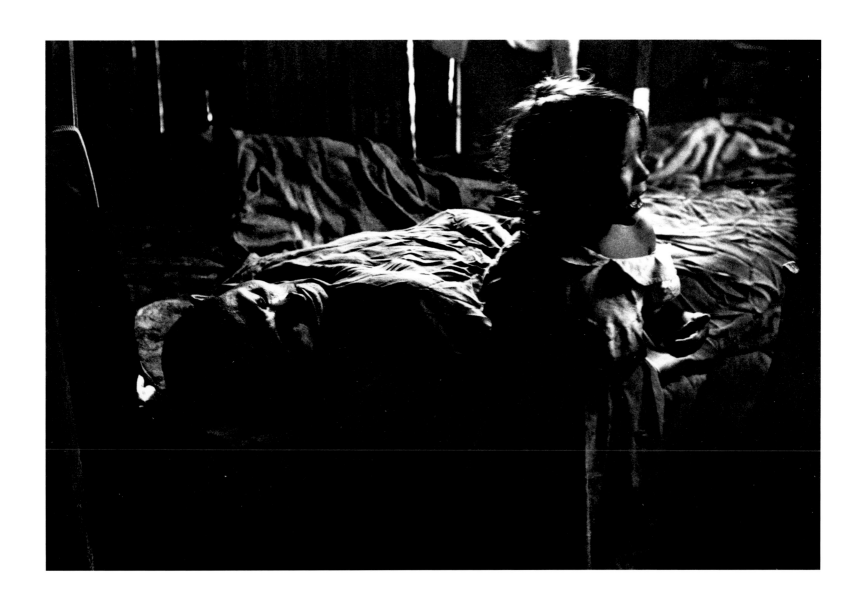

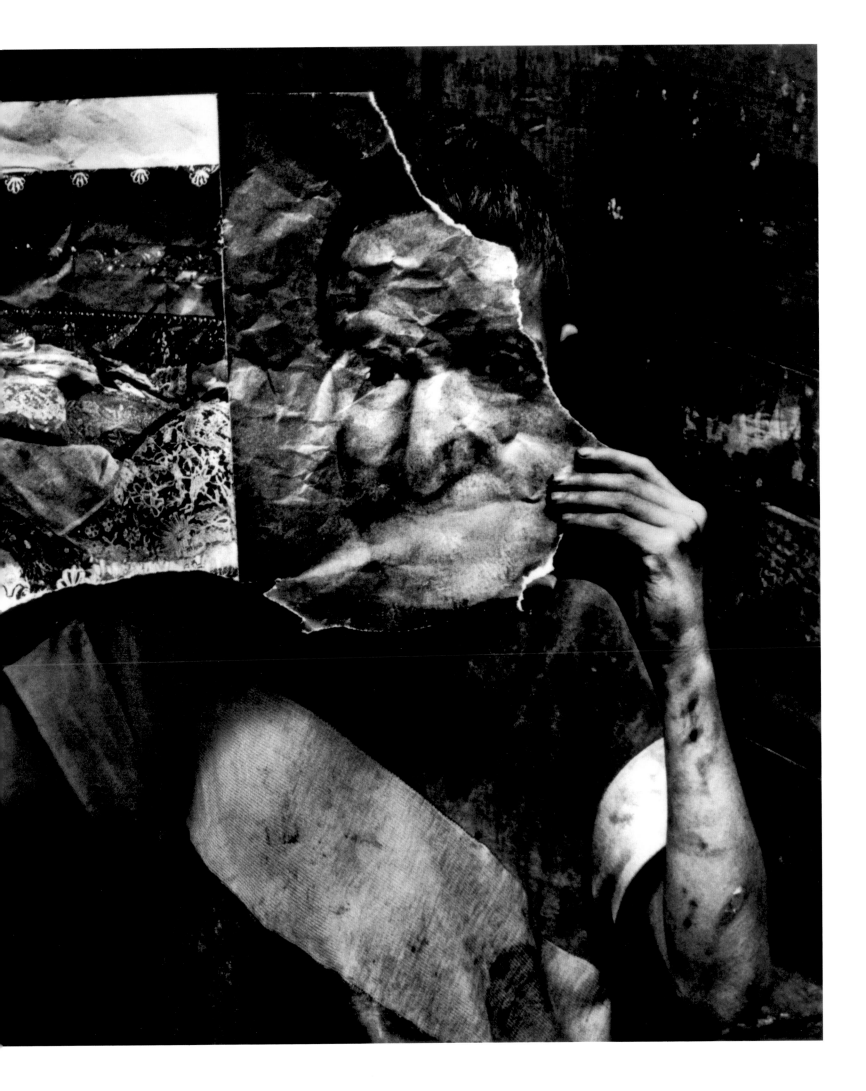

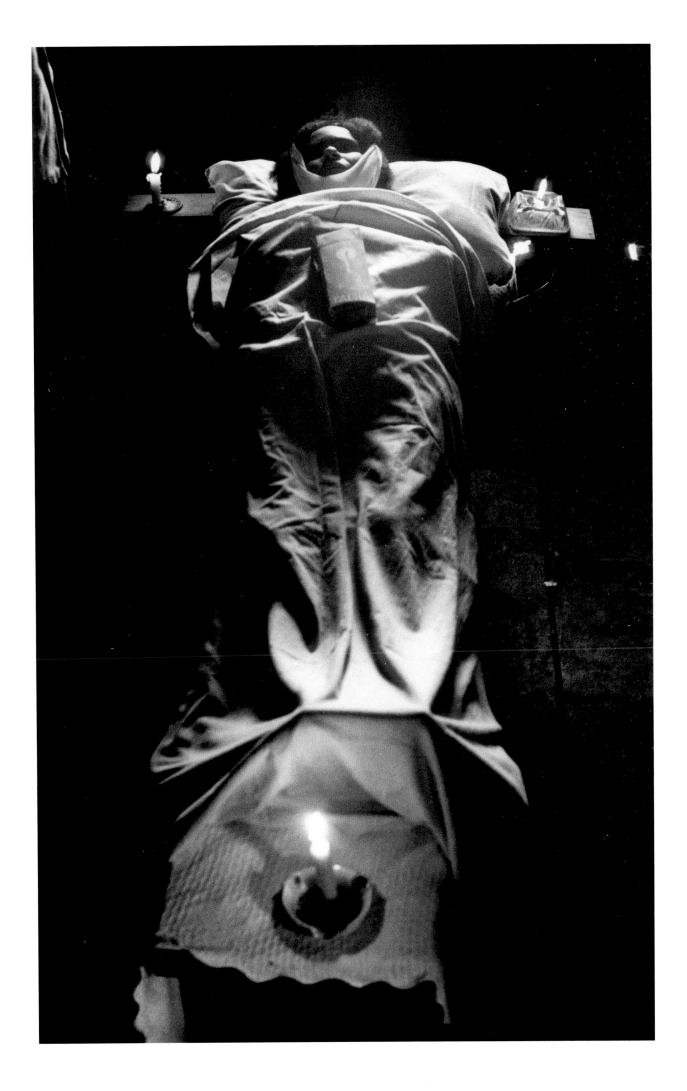

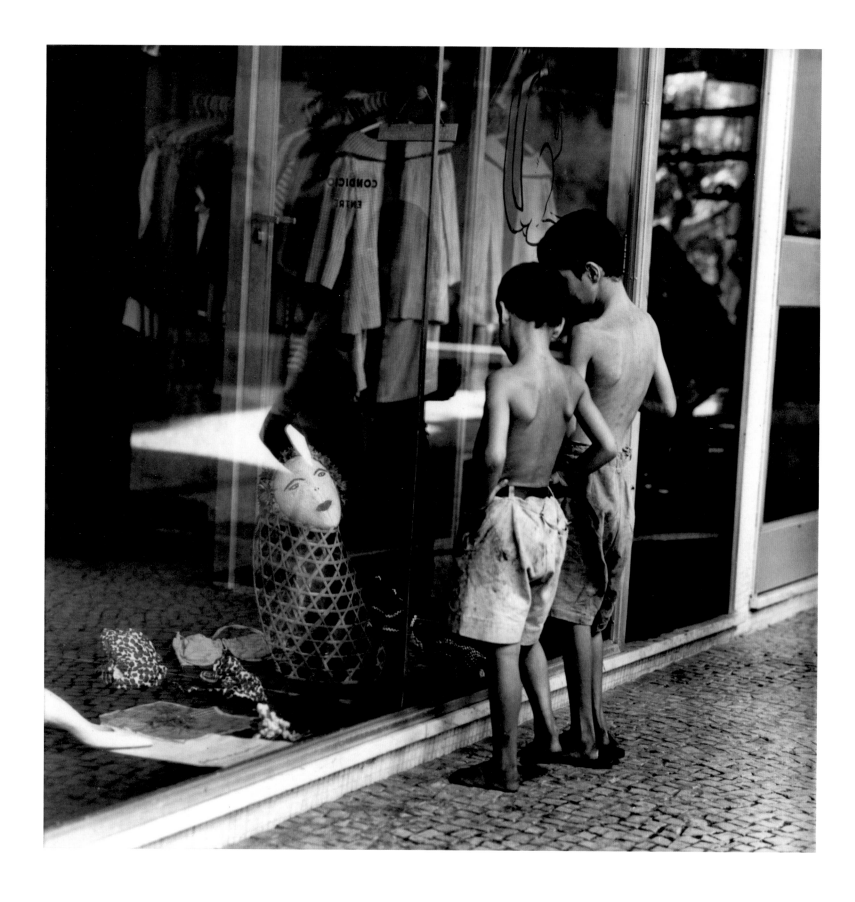

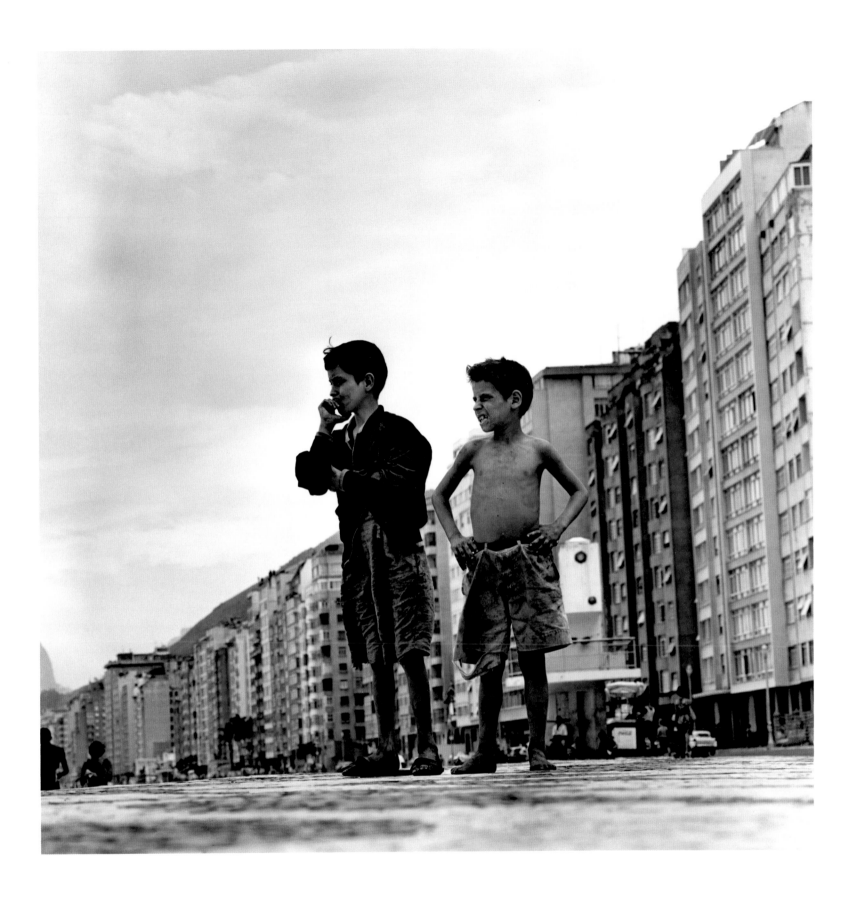

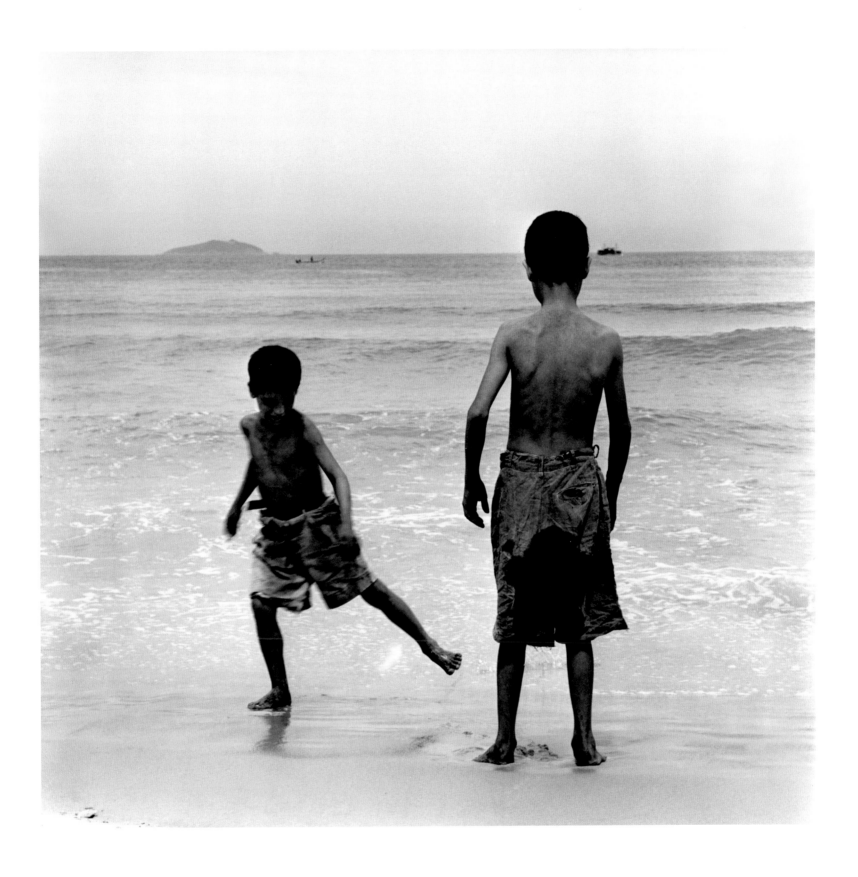

The June 16, 1961, publication of Gordon Parks' photo essay "Freedom's Fearful Foe: Poverty" prompted an overwhelming response from readers of *Life*. After receiving hundreds of letters and unsolicited donations to help the da Silvas, the magazine's editors featured thirty emblematic excerpts in a special report published on July 7, "A Great Urge to Help Flavio." Donated funds, *Life* informed, would be "used to move the Da Silvas into modest quarters, set up Flavio's father in a regular job and bring Flavio himself to a hospital for treatment." An understated appeal encouraged further contributions: ultimately, *Life* would receive nearly $30,000. *Life* sent Parks back to Brazil to spearhead this "rescue" mission alongside José Gallo, an office manager in Time Inc.'s Rio de Janeiro bureau who had worked as reporter and interpreter on the original story. Together they relocated the da Silva family from the favela into a new home purchased thanks to reader funds, complete with furniture, new clothing, and toys. With his parents' permission, Parks and Gallo accompanied Flávio to the United States for what would be a two-year course of medical treatment at the Children's Asthma Research Institute and Hospital (CARIH) in Denver. *Life* documented this remarkable succession of events for a follow-up article in the magazine's July 21 issue, "The Compassion of Americans Brings a New Life for Flavio." While his transition proved difficult, Flávio learned quickly in school, catching up to his age group and adapting his behavior to U.S. cultural mores. On weekends, a local Portuguese-speaking family, the Gonçalveses, hosted Flávio in their home, where he continued to learn English and experience American daily life, holidays, and customs. Over time, he had little contact with his family in Brazil and grew used to his new circumstances. He was desperate to remain in the United States, and pleaded with Parks and the Gonçalves family to adopt him. In July 1963, two years after leaving Brazil, Flávio returned to Rio de Janeiro, where he reunited briefly with his family before leaving again to attend boarding school in São Paulo.

This section includes photographs by Parks, *Life* freelancers Paulo Muniz and Carl Iwasaki, and Flávio's surrogate father, José Gonçalves.

1961–1963

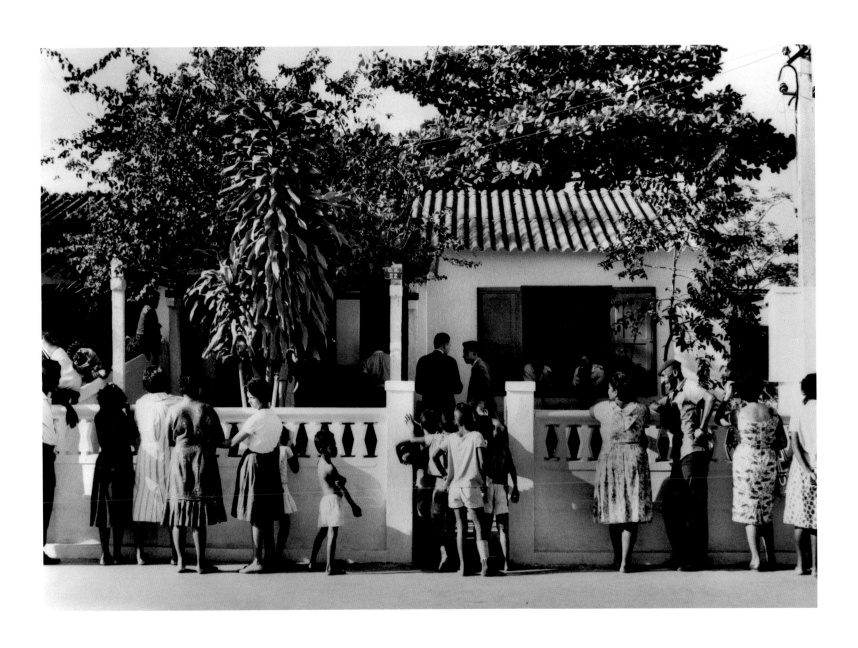

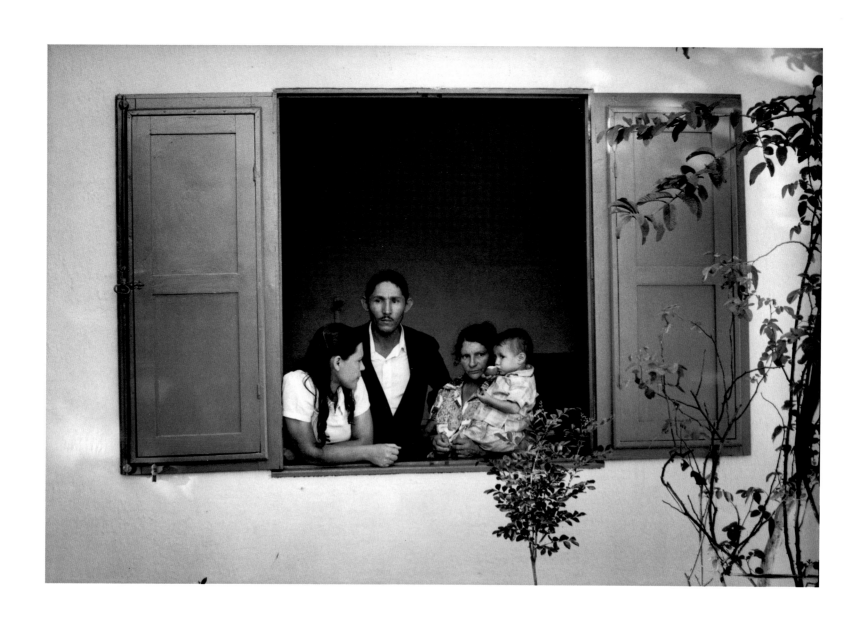

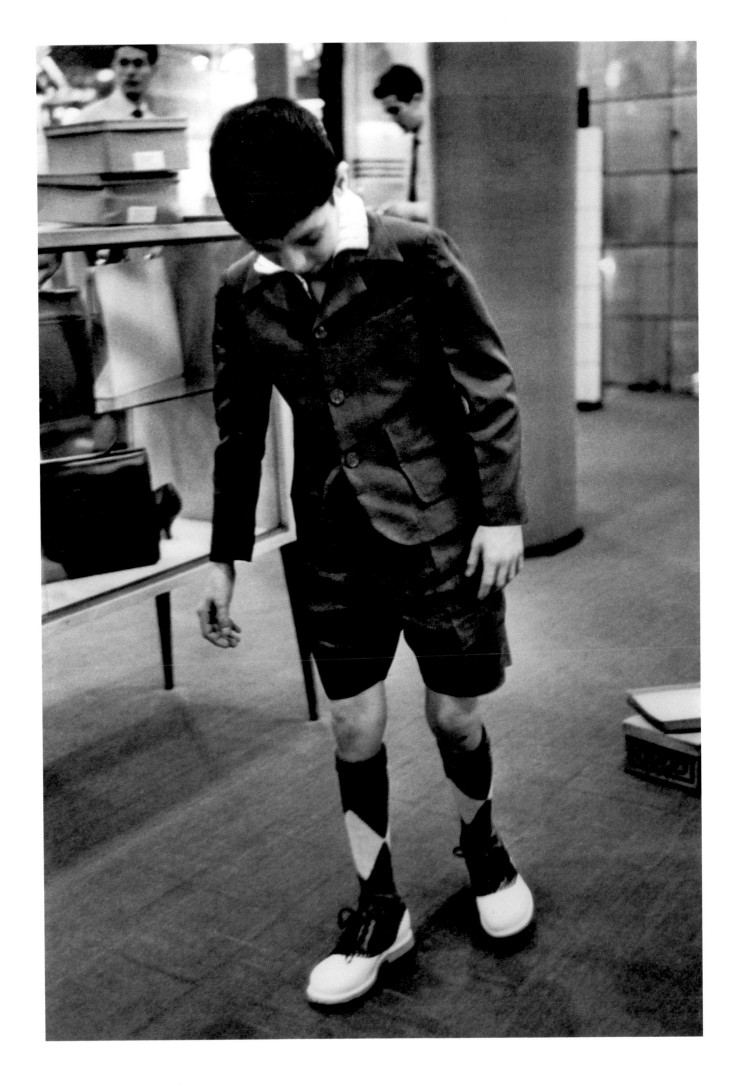

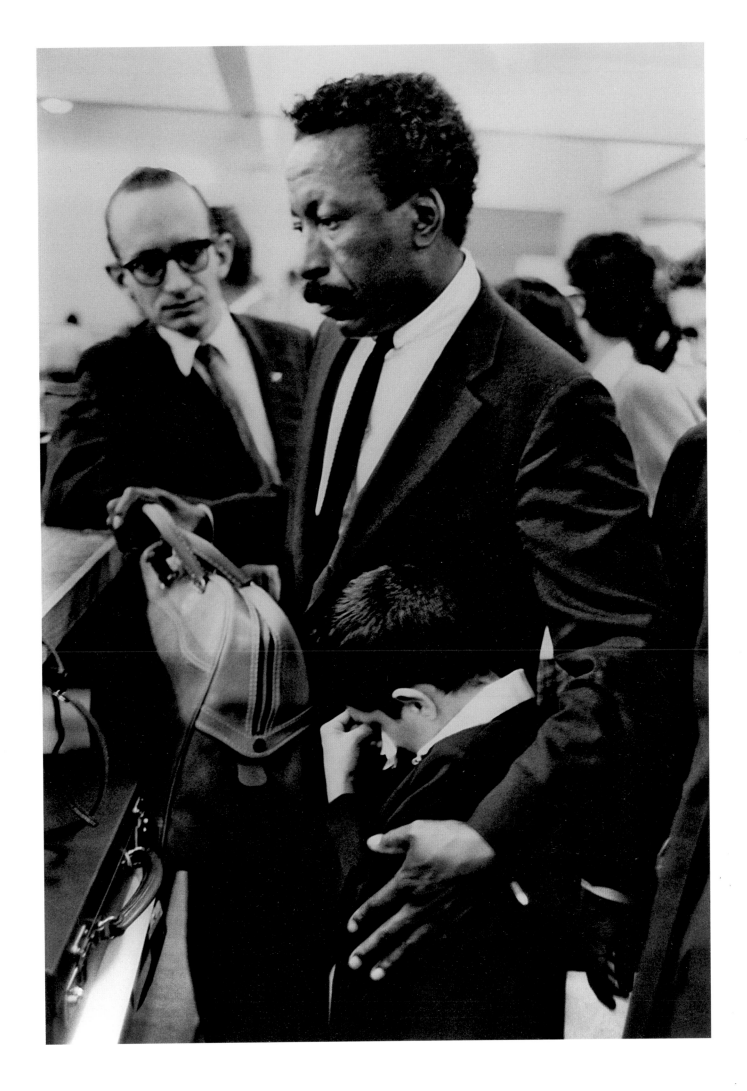

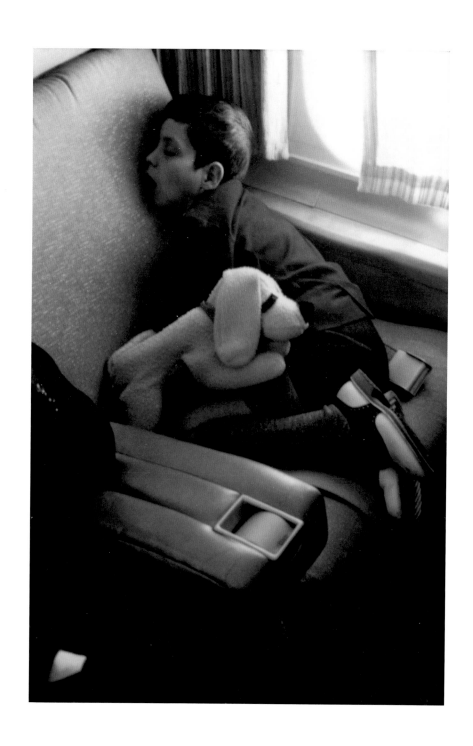

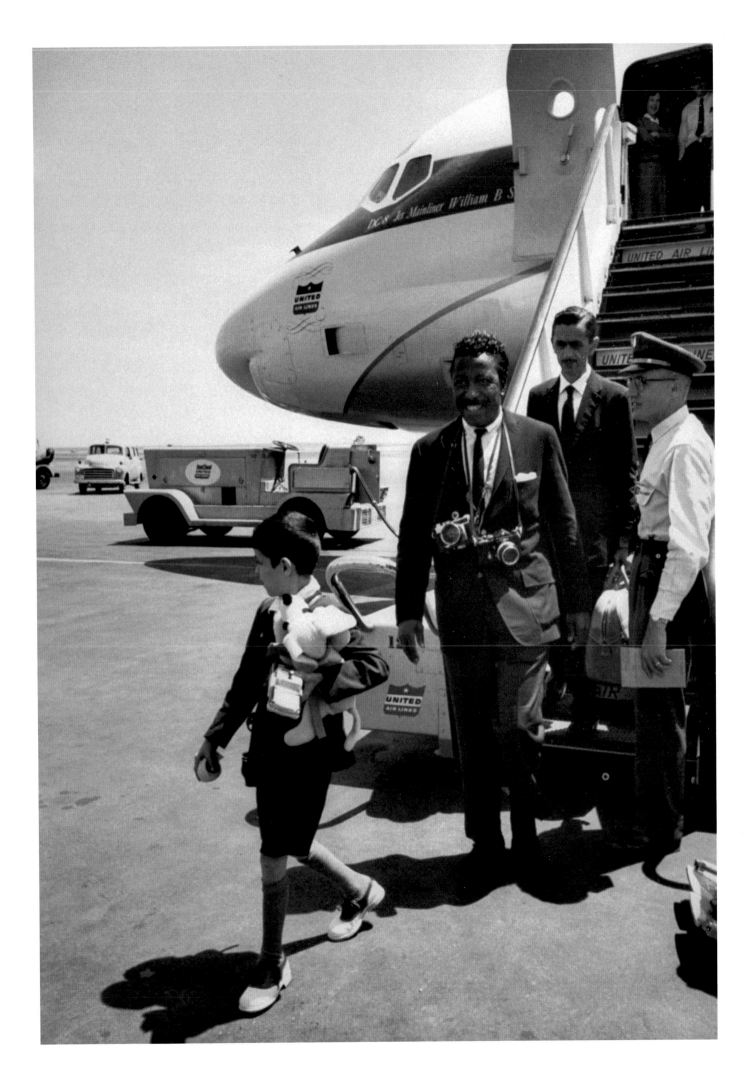

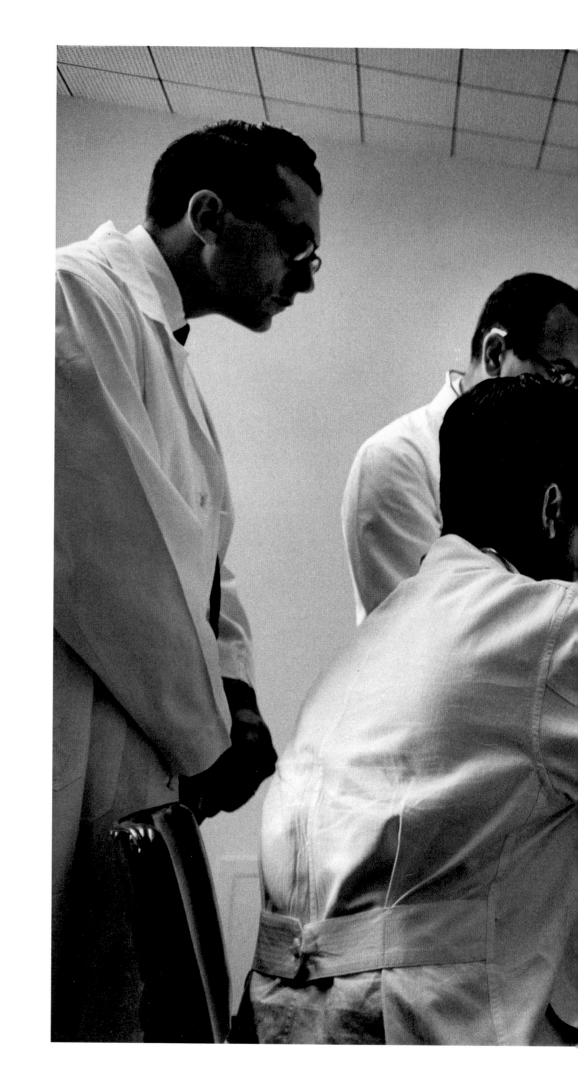

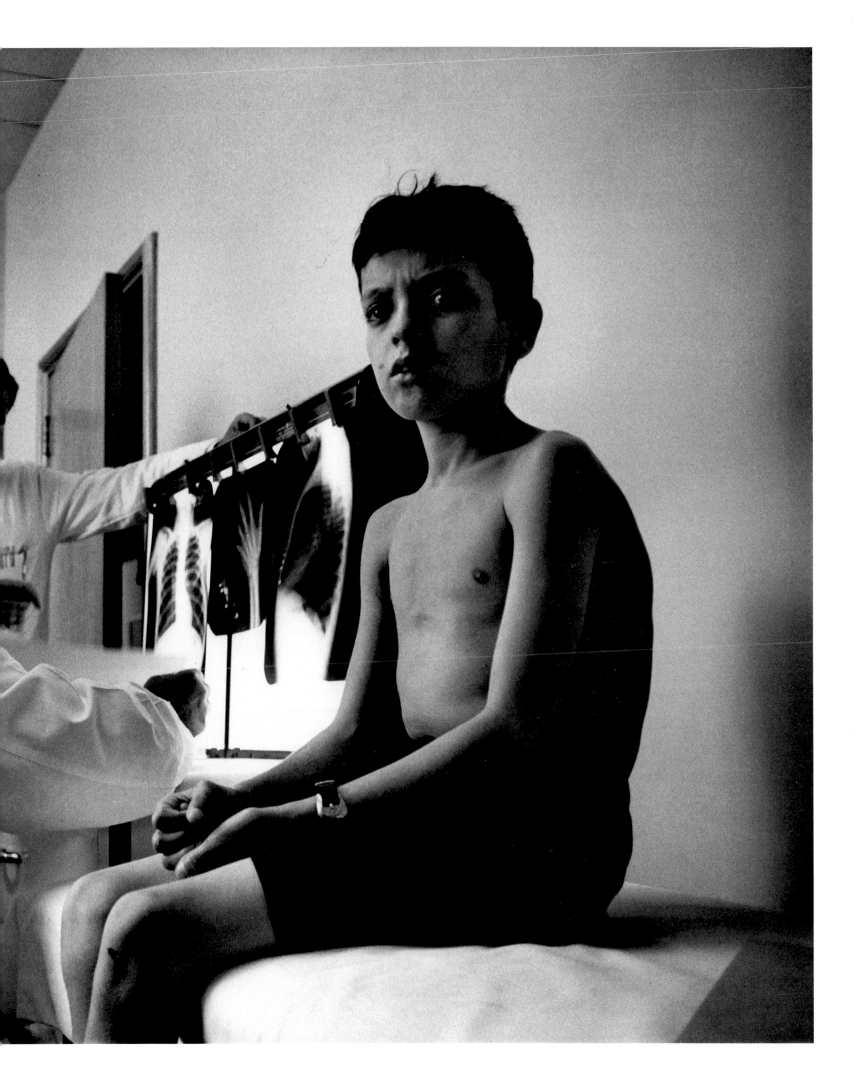

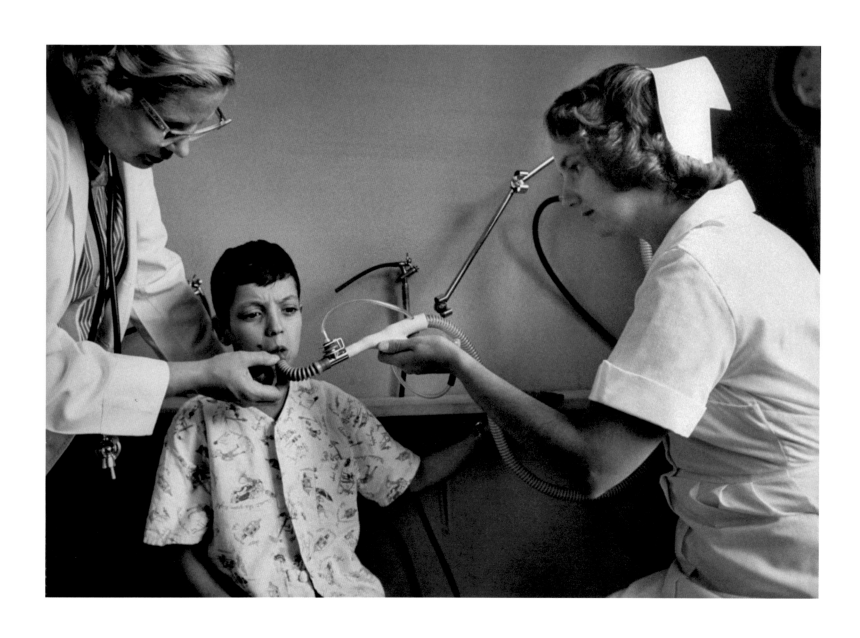

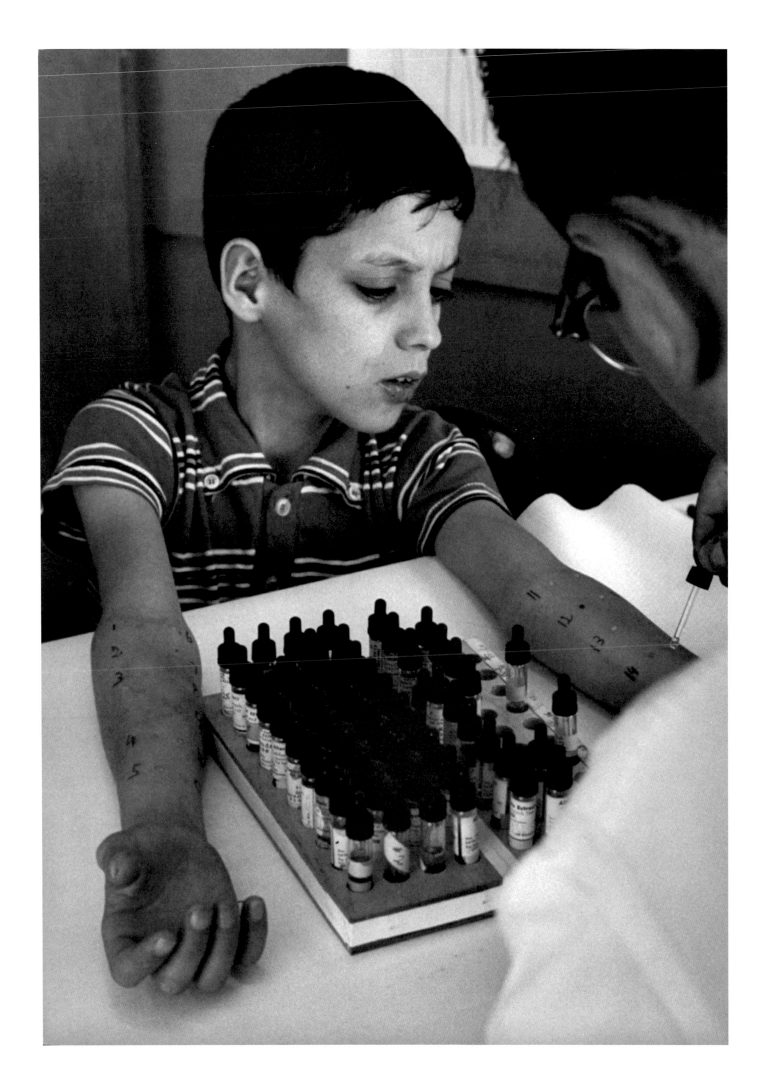

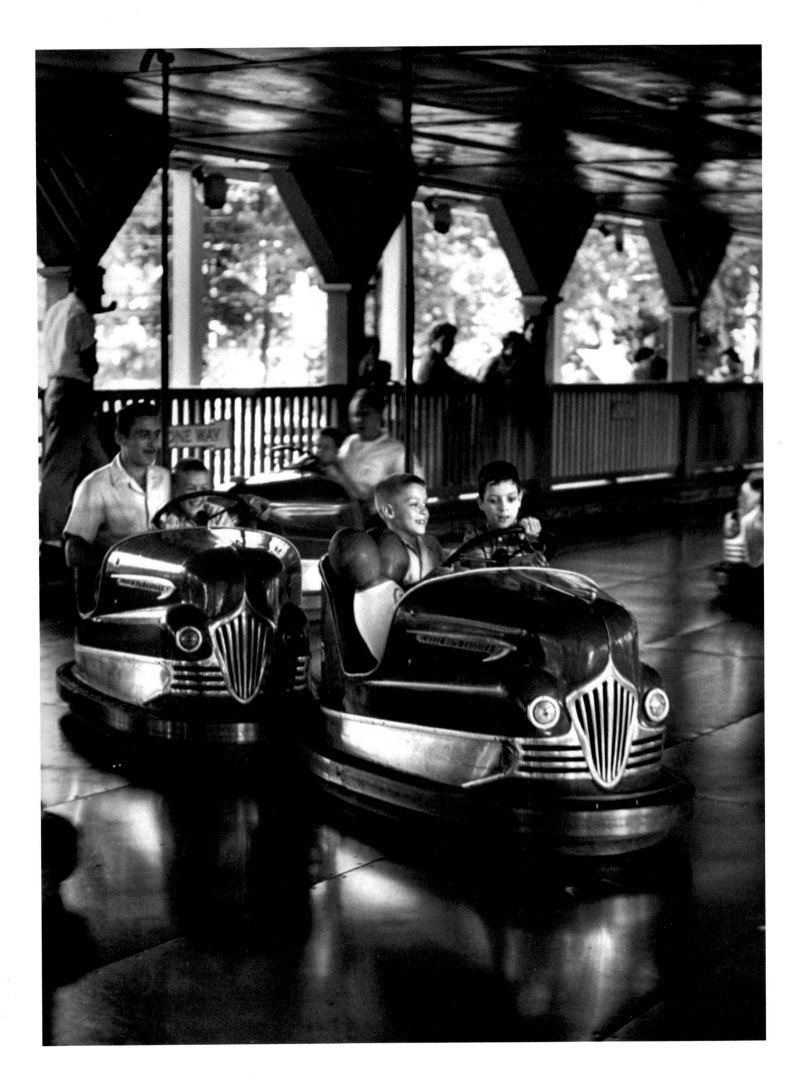

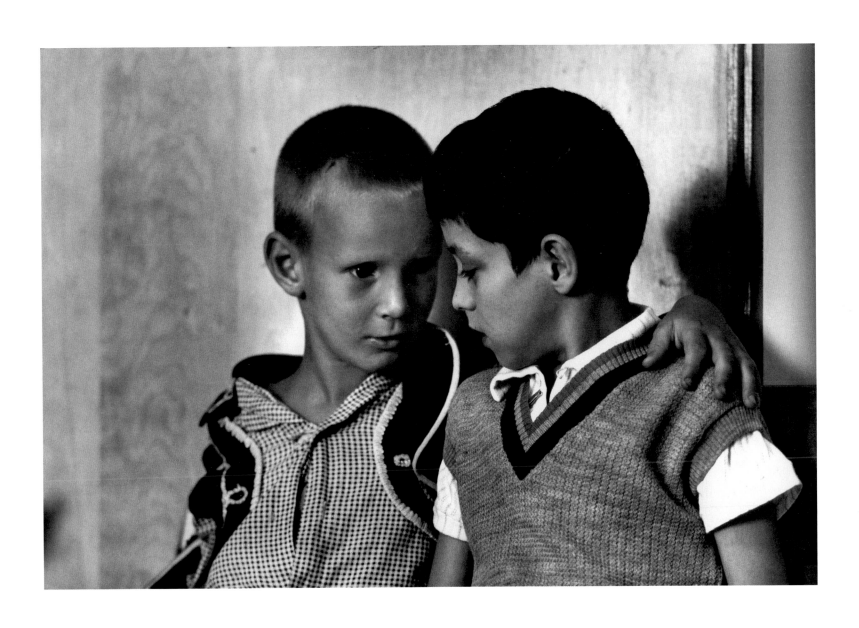

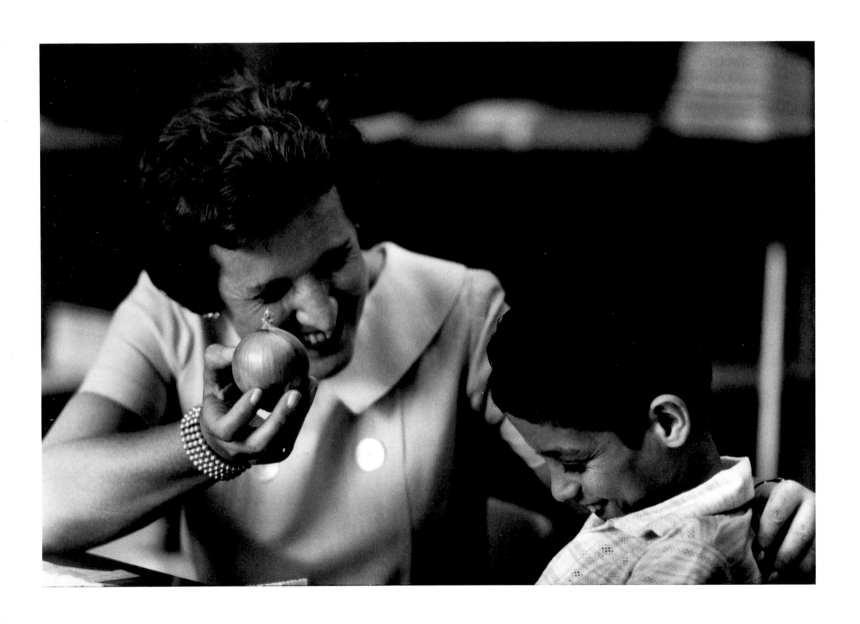

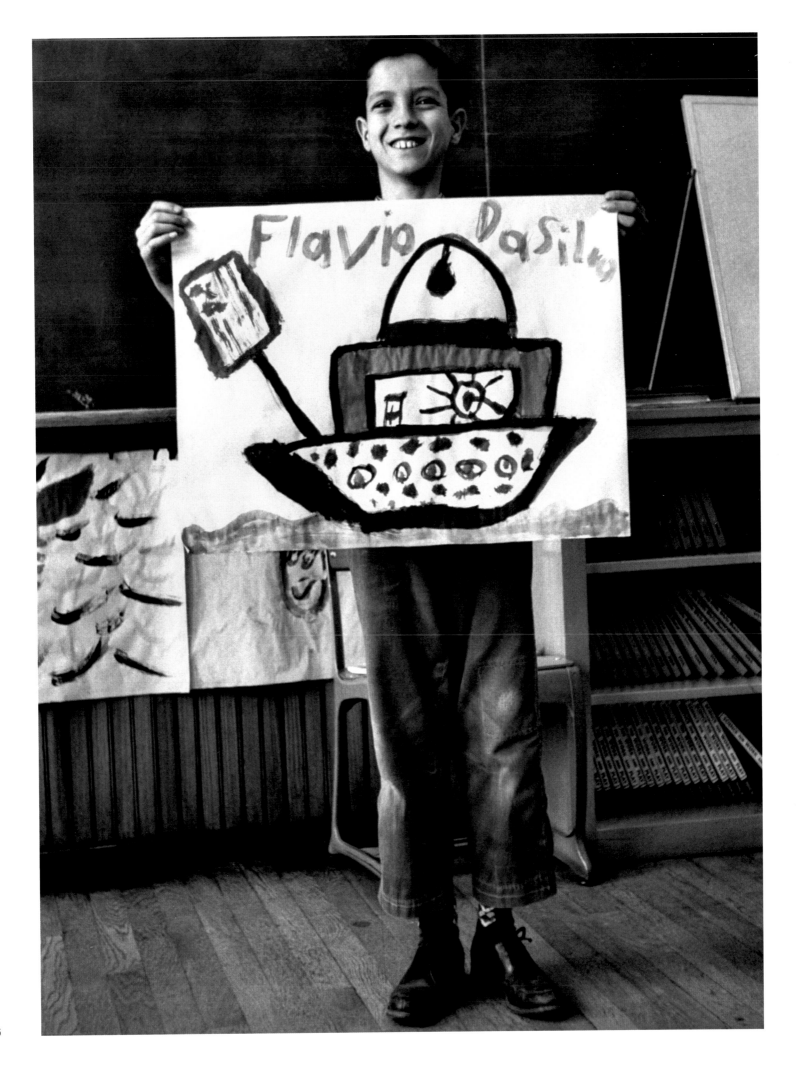

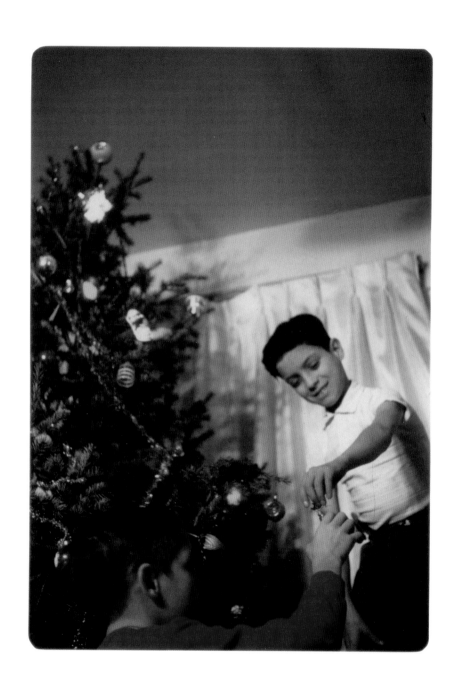

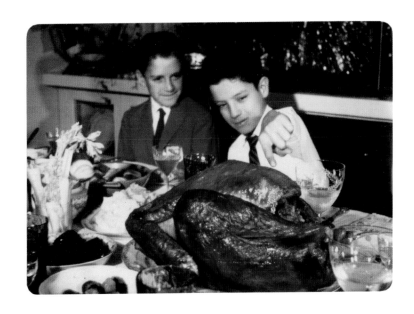

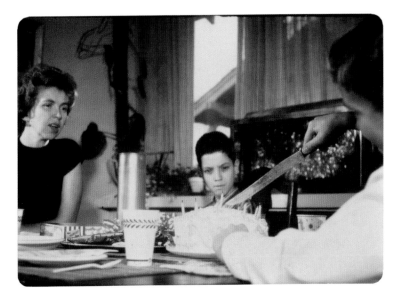

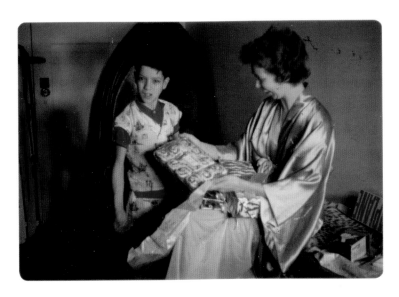

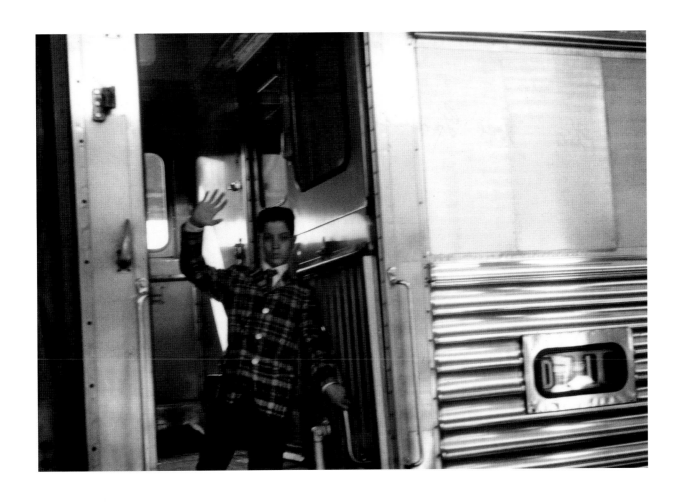

Saving Flávio:
A Photographic Essay
in Context

Paul Roth

This is a dream, and I shall end by awakening.
—Flávio da Silva, July 5, 1961[1]

On June 2, 1961, *Life* magazine premiered a new series titled "Crisis in Latin America." The cover, featuring a menacing portrait of Fidel Castro, trumpeted "Beginning This Week: The Crisis In Our Hemisphere, Part I: Exclusive photo report shows how Castro and the Communists are working to seize Latin America." Inside, the magazine's art director designed the series title around an isolated graphic of the Cuban leader's eyes; below, an introduction read:

> The messianic eyes of Fidel Castro, hypnotic and hungry for power, summon up a new and nightmarish danger for the U.S. His threats to take over Latin America were at first laughable; already he has made deep inroads and his momentum is increasing. But Castro is only one face of the troubles of Latin America. The others are more difficult to see. To show them, LIFE this week starts a special five-part series on the Latin American crisis which must be met if freedom and order in our hemisphere are to survive.[2]

Incendiary and hyperbolic as this text was, at the time it was likely regarded as justified by many *Life* readers. Only six weeks earlier, a military invasion of Cuban exiles at the Bay of Pigs, supported by the CIA, was launched and immediately defeated by Castro's Cuban Revolutionary Armed Forces. The aftermath brought unprecedented tension to the relationship between the United States and its near-neighbor, and amplified U.S. coverage of events in Central and South America. Just as this issue of *Life* reached subscribers' households, news agencies reported that Generalissimo Rafael Trujillo of the Dominican Republic had been assassinated, and violent reprisals had ensued. A few days later, as readers awaited their next issue of *Life*, U.S. Ambassador to the United Nations Adlai E. Stevenson arrived in Caracas, Venezuela, to begin a three-week outreach tour of South American countries, a government initiative to increase influence in the region.

The United States' highest-circulation weekly magazine chose to begin the series on Latin America in an unusually prominent issue, selected by the editors to commemorate the twenty-fifth anniversary of the magazine's founding in November 1936. Without ambiguity, *Life* presented the series as a response to the hemispheric expansion of the Cold War between capitalism and communism, and between the United States and the Soviet Union. On the first page, an editorial titled "The Aim of LIFE" appeared under the byline of the magazine's publisher, C. D. Jackson, who had been an advisor and speechwriter to former President Dwight Eisenhower. He wrote that "it is apparent to the editors of LIFE that the national goals of our country can be stated in these two propositions: 1) Win the Cold War. 2) Create a better America. Can a magazine presume to say that it will help win the Cold War, help create a better America? It cannot presume otherwise."[3]

Yet another editorial, positioned at the center of the magazine, provided context for the series on Latin America. The uncredited author of this political sermon, titled "We Must Win the Cold War," presented his thesis as a challenge to the new president, John F. Kennedy:

> Ever since the bitter week of Cuba, the American people have been quoting back at President Kennedy his own words. Not in derision and certainly not in disapproval. He is simply being told that he must suit his actions to his words. "We shall pay any price, bear any burden, meet any hardship, support any friend, oppose any foe to assure the survival and success of liberty." The words of the President of the United States do not have the force of dogma in our democratic society. Yet when the President's solemn words are widely consented to, then they do commit him and they commit the country.[4]

To the editors of *Life*, the new series was a matter of utmost national urgency.[5] Published every other issue for nine weeks during Kennedy's first six months in office, "Crisis in Latin America" unambiguously promoted U.S. economic interventionism in the region. Readers would certainly not have been surprised by such political editorializing, much in character for the magazine whose founder, Time Inc.'s legendary editor in chief, Henry R. Luce, once told a correspondent that "Communism is the most monstrous cancer which ever attacked humanity, and we shall do our best, however feeble, to combat it at all times and all places."[6] But *Life*'s subscribers and newsstand buyers might have been surprised to know that "Crisis in Latin America" was not published merely in reaction to current events. Rather, *Life* editors planned and timed these articles to present the case for—and thus promote—President Kennedy's efforts to launch, and secure legislation and funding for, a new foreign aid, development, and trade initiative for South America. Introduced by the president at a White House ceremony, this program boldly promised to modernize Latin America and aid its poorest citizens:

> Throughout Latin America—a continent rich in resources and in the spiritual and cultural achievements of its people—millions of men and women suffer the daily degradations of hunger and poverty. They lack decent shelter or protection from disease. Their children are deprived of the education or the jobs which are the gateway to a better life. If we are to meet a problem so staggering in its dimensions, our approach must itself be equally bold. ... Therefore I have called on all the people of the hemisphere to join in a new Alliance for Progress—*Alianza para Progreso*—a vast cooperative effort, unparalleled in magnitude and nobility of purpose, to satisfy the basic needs of the [South and Central] American people for homes, work and land, health and schools—*techo, trabajo y tierra, salud y escuela*.[7]

From the first installment, *Life*'s editors emphasized the importance of U.S. efforts to combat poverty throughout Latin America, as a means of gaining the upper hand in the war against communism. A cautionary tale, headlined "A Fidel Front Among Impoverished Peasants," introduced U.S. readers to Francisco Julião, leader of the Pernambuco Agricultural and Livestock Society, a

union of agrarian workers in northeastern Brazil. The well-intentioned reformer had fallen prey to Castroism, *Life* ominously suggested, emerging as a revolutionary who "naturally found his way into the waiting arms of the Communists."[8] It was critical, the editors suggested, to offer an alternative to his choice.

But it would be a different story about poverty in Brazil, to be published two weeks later, that ultimately had the most lasting and significant impact among the separate installments of "Crisis in Latin America." While staff photographer Dmitri Kessel produced the majority of pictures chosen to illustrate the series, *Life* commissioned Gordon Parks to make the photographs for Part II. After flying to Rio de Janeiro in mid-March, Parks searched for an emblematic story about poverty, one he hoped would be an eye-opener for the magazine's readers. He succeeded beyond his editors' expectations—indeed, beyond their wildest hopes and imagination.

. . .

As the 1960s dawned, Gordon Parks made the difficult decision to leave his coveted position as staff photographer at *Life* magazine.[9] Having begun his relationship with the magazine as a little-known freelancer in 1948, Parks was hired a year later, integrating its prestigious international roster of photographers.[10] During his eleven years on the masthead, Parks had achieved considerable fame as a documentary photographer, and as a pioneering black American. As scholar Erika Doss later noted, "*Life* was where Parks wanted to work. '*Life* was *the* magazine as far as photographers were concerned,' he recalled in 1995. 'It was the goal of thousands to work there. *Life* had an edge on every other magazine—it was slicker, it was better known throughout the world.'"[11]

By the time he departed the staff, Parks had achieved a symbiosis with the magazine and its readers, especially when his subjects were difficult ones. Some of his more groundbreaking photo essays had resonated strongly with *Life*'s middle-class audience, most notably a 1948 profile of Harlem gang leader Red Jackson; a 1956 exploration of the effects of racial segregation among one extended family in the American South; and a 1957 picture story on crime in the United States. But Parks was a versatile cameraman, producing portraits, fashion photographs, even dramatic stills from Broadway theatrical productions: whatever he was assigned to illustrate *Life* stories. For two busy years he had served a coveted posting to the magazine's Paris bureau, where he photographed subjects throughout Europe. But by 1957, his assignments had dropped off considerably. From a high of thirty-nine in 1951, and an average since 1950 of twenty-eight assignments per year, Parks recorded just forty-two assignments over the last three years of the decade. In 1960, the year he switched to being a "Contributing Photographer," he covered just eight stories for *Life*.[12]

The reasons for his departure from the staff are unclear; in his memoirs Parks tended to obscure the fact that he had changed his relationship with the magazine ten years before posting his final story for the weekly in

1970. One surviving letter from a friend and colleague suggests that Parks may have been seeking greater creative freedom: "I gather you are off 'Life' now, and expanding frighteningly in other fields."[13] And indeed, during this period Parks made many changes in his life. A 1961 divorce finalized a long separation from his first wife, Sally. He began writing a novel based on his own childhood, *The Learning Tree*, which would be published in 1963. Having scored and performed several classical compositions during the 1950s, Parks continued his engagement with music as the new decade began. Now free to photograph for other magazines, he undertook several fashion assignments in 1960–1961 for *Vogue* and *Glamour*. And finally, *Life*'s editors and publishers continued to consider him one of the family, as did Parks himself. It seems likely he retained some kind of "favored nation" contractual status with Time Inc. magazines, and was still available for freelance assignment.

. . .

Life, too, was in the midst of significant transition in the early months of 1961. For more than two years, the publisher's office of Time Inc. experienced considerable anxiety about the pictorial weekly, which had been a financial juggernaut and "the great revenue driver of the company for two decades."[14] While circulation was at an all-time high, nearing 7 million copies in subscriptions and newsstand sales, advertisers were beginning to move their business to television, where they could find lower prices and larger audiences. In 1959, *Life* had registered a significant net deficit, the first time this had occurred since the magazine's earliest years. While the balance sheet moved up and down from year to year afterward, the loss was the beginning of a downward trend, and Time Inc. knew it.[15] Exceedingly expensive to produce, the magazine could ill afford any drop in advertising revenue.[16] Compounding the financial pressure, in 1960 the company completed an expensive, multiyear endeavor to build sleek new offices for its magazines on Sixth Avenue in New York City.[17] By 1961, despite *Life*'s still-robust reputation and continuing strong sales, the office hallways ran with rumors that the magazine might soon fold.[18]

Edward K. Thompson (fig. 1), who joined *Life* as an assistant picture editor the year after its 1936 launch, first appeared on the masthead as the magazine's managing editor in the same August 1949 issue where Parks was first listed as staff photographer. By all accounts, Thompson ran *Life* smoothly and effectively throughout the 1950s, during its era of greatest financial and cultural success. Despite this, by the beginning of the 1960s he was at war with the magazine's financial executives, who blamed the editorial division, rather than advertising, for the magazine's slump.

Henry Luce, who regularly wrote his top editors with suggested improvements or editorial direction, prodded Thompson that the magazine "should of course address itself to important issues . . . such things as the face of poverty—but . . . there was 'no reason why *Life* should be a weekly headache and pain in the neck.'" The magazine's publisher, Andrew Heiskell, also agitated for

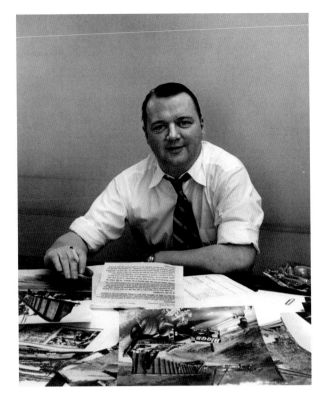

change, observing "that we were sometimes *too earnest*," that "more and more of the news events of the world could never happen to the reader," and pointedly asking, "Are we telling the story of Man in terms that appeal to him?"[19] While he seemed to many unaffected by the pressure—"Watching him fend off the 'business side' was a lesson in editorial freedom," said one assistant editor[20]—Thompson was in a dangerous position. His fractious, ongoing conflict with *Life*'s publisher became particularly hazardous when Heiskell was elevated to chairman of the board for all of Time Inc. in 1960.[21]

Among the significant changes suggested to bring the magazine out of its slump, Thompson was ordered to undertake a sweeping redesign to *Life*'s familiar template. Overseen by assistant managing editor George Hunt, working with head layout artist Bernard Quint, the shift (unveiled in the same twenty-fifth-anniversary issue that launched the "Crisis in Latin America" series) introduced several changes to graphic design. The most obvious was the elimination of the familiar red band along the bottom of the cover, which had adorned every issue since the first. Replacement of familiar typefaces and more spacious layout of photographs completed the "bold and striking new look," staff writer Loudon Wainwright remembered. "Hunt, with his own strong artistic sensibilities, had long felt that *Life* was too cluttered, too chopped up with small pictures, too simpleminded in its straightforward sequential logic of presenting pictures."[22] The redesign was also conceptual: new and renamed sections (such as "Special Report," "Life Guide," and "Better Living") were introduced, and the magazine's presentation of information was reordered. An editor's note added:

> Our new arrangement of space gives more room for . . . our classic departments. One is the Photographic Essay which this week starts our series on the Crisis in Latin America. . . . The changed look helps us to share more

and more with you the things which we and you feel to be provocative, entertaining—and important.[23]

Although Thompson was still managing editor when the issue hit the stands, the redesign constituted an unsubtle challenge to his leadership—and to that of longtime art director Henry Tudor. Hunt, Thompson's deputy, had served in many capacities at *Life* and, before that, at Luce's financial magazine, *Fortune*. Luce had approached Hunt a year earlier, behind Thompson's back, and requested his thoughts on changes that might improve the magazine:

> Included in . . . seventeen pages of notes on "a new prospectus" were proposals that the magazine needed restructuring of its basic departments and a strong reaffirmation of the importance of the photograph and photography in the depiction of human events. . . . Hunt said with characteristically ringing emphasis: "Every gain the competition makes seems like a step backward for us—which is not so. . . . It is the time when leadership must suffer and when, in a place where the sensitivities and the individuality of the human being are held dear, it must take the step forward of stripping down for the fight."[24]

The redesign gave Hunt the opportunity to test out many of his recommendations, to demonstrate their efficacy—and to raise his profile within the company. He had not been shy with Luce about his ambition to replace Thompson at the top of editorial; and so, as the Latin American series began, the longtime managing editor known as "EKT" was in very real jeopardy.

. . .

Assistant editor Timothy Foote (fig. 2) had first proposed the Latin America series early in 1961. Though the component subjects had been approved and assigned in February, Parks later recalled that *Life*'s editorial leadership had ordered a particular approach to photographing poverty, one that both he and Foote vehemently objected to. At first, they were charged with capturing one emblematic photograph from each of seven separate countries, which together would convey the story of poverty across the region. Parks, with Foote's support, argued against the idea, reasoning that "such an approach was far too impersonal. We preferred to confine the story to one situation, hoping that *Life*'s readers could more easily relate to it."[25] Parks suggested Brazil as a good place to find such a story: "During a trip to Rio de Janeiro several years before, I had seen poverty at its worst in the infamous favelas ringing the city." Foote agreed, and later, at a "heated" lunch meeting, Parks recalled, the writer "made a last ditch fight to get the editorial board to agree to my shooting the assignment in the Rio favelas. The voting was unanimously against him, and he left the luncheon angered and disappointed."[26]

Foote, a tough and seasoned field reporter who had been hit by gunfire while covering the 1956 Hungarian uprising, joined *Life*'s editorial staff in 1958.[27] Parks regarded him as a trusted ally and close friend. His colleague Loudon Wainwright later remembered Foote as

very bright and somewhat acidulous with a didactic turn of mind. . . . From very early in his career, he expressed with a certain clarity—and often a persuasiveness—his feelings about what was wrong with and what needed doing about *Life*. The fact that he was right a considerable part of the time did not necessarily endear him to the recipients of his urgent messages, but he was respected for his skills and conscientiousness.[28]

Undeterred, Foote and Parks continued their campaign to shift the story's focus. While Thompson seemed inured to their arguments, Foote told Parks that he considered Hunt a potential supporter, that he would focus his entreaties on the rising assistant managing editor. After several days, the effort paid off:

> I was handed an amendment to my assignment. Reading it I realized that George Hunt had helped and that Tim and I had won—but there were still certain stipulations. The story would be confined to Rio's favelas, but the Rio news bureau would look for a special type of poor family. I was to select one of my choice; then zero in on the father, show how he supported his family, explore his everyday life, his religion, his politics or social life. Obviously, the story would be a kind of summary, in terms of one individual father, of all the stories in the series. I still wasn't happy. Nor was Tim.[29]

Despite their dismay, Foote encouraged Parks to accept the partial victory, and improvise from there. "Rio de Janeiro is a long, long way from Rockefeller Plaza," Parks would later remember him saying. "Who knows, you might just misinterpret your instructions."[30]

. . .

President John F. Kennedy had prioritized U.S. relations with its "sister republics south of the border" from the outset of his administration, suggesting a new approach to Latin America in his soon-to-be famous Inaugural Address. Speaking more generally, Kennedy proposed a stance of "soft power" and economic aid to what was then called the "Third World": "To those people in the huts and villages of half the globe struggling to break the bonds of mass misery," he declared, "we pledge our best efforts to help them help themselves, for whatever period is required—not because the communists may be doing it, not because we seek their votes, but because it is right."[31]

Expanding on a recent U.S. initiative to improve deteriorating relationships with several Latin American countries, launched during President Eisenhower's last year in office, Kennedy hoped that a package of economic development funds and direct foreign aid would begin to repair tattered lines of communication, advance U.S. hemispheric hegemony, and inhibit the spread of state communism in the region. The President's Task Force for Latin America, convened to develop policy for his nascent Alliance for Progress, recommended "a sustained effort for development and social progress, combining vigorous measures of self-help with the provision of complementary outside resources."[32] Progress would be challenging, the Task Force warned: the Alliance would

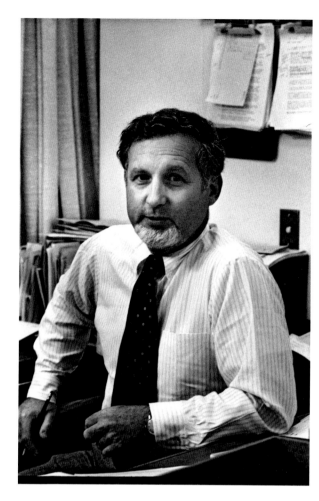

FIG. 2 Timothy Foote, senior editor at *Time* and former *Life* correspondent, at his desk in the Time-Life Building, New York City, 1970. Martha Holmes/The LIFE Images Collection

confront "an ancient heritage of poverty, widespread illiteracy, and grave social, economic, and geographical imbalances." Given this, the administration prioritized public outreach, in order to line up nations willing to commit themselves to the U.S.-led effort. The United States Information Agency aggressively—and sometimes covertly—promoted the Alliance by disseminating propaganda throughout Latin America by radio, television, documentary film, planted news reports, and even comic books, produced in the hundreds of thousands.[33]

Doing its part, *Life* showed immediate support for the president when he announced the Alliance for Progress with much fanfare in a March 13 speech, broadcast throughout Latin America in English as well as Spanish, Portuguese, and French. "First," Kennedy declared, "I propose that the American Republics begin on a vast new Ten Year Plan for the Americas, a plan to transform the 1960s into a historic decade of democratic progress." The effort would require a sweeping commitment from participating nations, he cautioned:

> Let me stress that only the most determined efforts of the American nations themselves can bring success to this effort. They, and they alone, can mobilize their resources, enlist the energies of their people, and modify their social patterns so that all, and not just a privileged few, share in the fruits of growth. If this effort is made, then outside assistance will give vital impetus to progress; without it, no amount of help will advance the welfare of the people.[34]

A *Life* editorial, published only ten days later, heralded Kennedy's initial request to Congress for $500 million

in urgent assistance, and, once incentives had been met, "U.S. technical aid for teachers and scientists, freer trade, more measures to stabilize commodities prices, emergency food relief, arms limitation and development loans." While *Life*'s editorialist adopted a condescending tone, stating his hope that Kennedy will "have more success than Eisenhower could in getting the Latins to accept his emphasis on self-help," the magazine firmly committed its support for the president's ambition to uplift and transform the economic and social fabric of the continent, with a program "comparable to the Marshall Plan."[35]

While Henry Luce aligned *Life* and his other magazines with his own conservative views, and charged them to consistently promote positions and candidates in line with Republican Party politics, his publications had followed the 1960 U.S. presidential campaign with unusual evenhandedness. Though *Life* ultimately endorsed Vice President Richard Nixon, the Republican candidate, its extensive coverage flattered then Senator Kennedy, and Luce expressed enthusiastic support when JFK won the election, both to the president-elect and to his father, Joseph, with whom he was well acquainted. On January 20, 1961, Luce attended Kennedy's swearing-in ceremony, where he heard the Inaugural Address from his seat in the president's box.[36] In truth, the media baron had long cultivated a relationship with the powerful Massachusetts family: in 1940, with shrewdness approaching prescience, Luce wrote the introduction to the young Kennedy's first book, *Why England Slept*, at the request of his father. After JFK was elected, Luce readily agreed to update his earlier text when a second edition was published in 1961.[37]

For his part, President Kennedy nurtured Luce carefully, in hopes of shaping coverage of his actions in the Time Inc. magazines (fig. 3). He routinely invited Luce to the White House. He regularly wrote letters communicating his reactions, positive and negative, to articles in *Life* and *Time*, and Luce responded.[38] Among other blandishments during his first months in office, the president agreed to record comments for a nationally televised celebration of *Life*'s twenty-fifth anniversary on March 2.[39] Scarcely mentioning the milestone, Kennedy used the opportunity to lobby, urging the media giant to use its reach in support of his agenda:

> The United States is playing an increasingly significant role in the world today as the chief defender of freedom in a time of freedom's maximum danger. The entire democratic system . . . depends in a very real sense on information and communication—for our judgment is no better than our information. The great organizations of communication, therefore, in this country, have an obligation and a responsibility unequaled in our national life, and basic to our national future.[40]

While stated as a challenge, the President's words could not have aligned better with the views of Time Inc.'s editor in chief. Luce was perhaps the definitive media exponent of U.S. exceptionalism in international affairs, coining the expression "The American Century" in a famous *Life* editorial of the same name. Published in 1941 to address the still-unsettled role of the United States in World War II, this sprawling doctrine advocated a view of national responsibility that Luce would explore and refine in the pages of his magazines for the rest of his life:

FIG. 3 Time Inc.'s John Jessup, Henry Luce, and Otto Fuerbringer with presidential candidate Senator John Kennedy and others at the Time-Life Building, August 5, 1960. Margaret Norton/Time & Life Pictures

We have some things in this country which are infinitely precious and especially American—a love of freedom, a feeling for the equality of opportunity, a tradition of self-reliance and independence and also of co-operation. . . . It now becomes our time to be the powerhouse from which the[se] ideals spread throughout the world and do their mysterious work of lifting the life of mankind from the level of the beasts.[41]

More recently, Luce had worked to formulate a generational adaptation of his viewpoint, to address the period of the Cold War. In 1960, he commissioned a host of thinkers—including public intellectuals, a corporate titan, a political historian, and a religious leader—to address this topic in a group of essays called "The National Purpose."[42] Published throughout the spring and summer in *Life* and *Time*, the series expanded to include responses from both Kennedy and Nixon during the presidential campaign. While the different perspectives varied widely, most of the writers expressed the view that the United States was engaged in a battle for the soul of civilization. Political columnist Walter Lippmann, for example, contended that "we are confronted with a rival power which denies the theory and the practice of our society, and has forced upon us a competition for the leadership of the world."[43]

Luce felt strongly that Kennedy's election portended an acceptance by the citizenry of his long-held belief in American interventionist policy. Just eight days after Kennedy delivered his Inaugural Address, the editor in chief appeared at New York's University Club and expounded on the president's call for urgent positive action overseas. His speech, titled "Needed: A General Theory for U.S. Action in World Affairs," declared: "Our general theory now contains two propositions 1) The world requires order 2) America with her devotion to 'liberty' and 'right' must make the greatest contribution to the establishment of world order." On February 1, Luce delivered a copy of this speech to his magazine's top editors.[44]

. . .

Gordon Parks arrived in Rio de Janeiro on March 20, a Monday evening, loaded down with photography equipment and sweating in his wool sports jacket and overcoat. He was greeted by José Gallo, longtime business manager at the local bureau of Time Inc.[45] Assigned by bureau chief George de Carvalho to work as a reporter on the poverty story, Gallo was responsible for guiding and assisting Parks as he made his way around the city and into the favelas; serving as an interpreter, since Parks didn't speak Portuguese; and collecting information for the captions and text, to be written later by Tim Foote and his writers back in New York.[46]

Parks was surprised by a reporter from the Rio newspaper *Tribuna da Imprensa*, who was awaiting his flight in hopes of securing an interview with the famous photographer. Days earlier, Time Inc. had promoted Parks' pending visit to the local daily, apparently offering an exclusive. On March 15, in an article headlined "Only Black Photographer for *Life* Magazine Coming to Photograph the Favelas," *Tribuna da Imprensa* trumpeted the U.S. magazine's search for "an indigent family" to include in its upcoming series on Latin American countries. Once they had been found, the story revealed, Parks would report on various aspects of the family's experience, "such as religion, their customs, their anguish, the opinion they have of the current government and of communism, [and] happy moments in their lives . . ."[47]

Parks told the reporter that he expected to spend three weeks in one of the local favelas, and that he might cover other stories as well. He wanted, the writer noted, to really "'see' and understand the favela from a different angle, 'from the inside,' as if he himself were a *favelado*."[48] Parks credited São Paulo writer Carolina Maria de Jesus' recently published *Quarto de despejo: Diário de uma favelada* as an inspiration for the type of story he hoped to illustrate.[49] Covered throughout the world, de Jesus' controversial 1960 book was the only contemporaneous account of life in the Brazilian favelas available for Parks and Foote to consult.

The next day, Parks and Gallo began the search for their subject. Although Parks would later write that his selection was a spontaneous one, the two worked from a list of ten families, vetted earlier by Time Inc. staffers who interviewed numerous candidates in four different slum communities.[50] The first favela they visited had the foreboding name Catacumba—meaning Catacomb. At the time of Parks' visit, there were more than two hundred favelas in Rio, with an aggregate population of at least 700,000.[51] Catacumba occupied a steep hill rising above the southeastern quadrant of the Lagoa Rodrigo de Freitas (Rodrigo de Freitas Lagoon; fig. 4), quite near the wealthy and touristed southern Rio beach communities of Ipanema and Copacabana. Beginning in the 1940s, rural migrants to Rio expanded the small community of makeshift homes up and down the knoll called "Chácara das Catacumbas."[52] A vast second wave of settlers, forced from Brazil's Northeast by poverty and persistent drought, arrived by the early 1950s. By 1960, after this and other such migrations from the rural hinterlands, explosive growth had transformed the urban centers of Brazil.[53] Catacumba's population expanded apace, and by 1961 the favela housed as many as 20,000 people, sprawled across the hillside in eight distinct neighborhoods.[54]

By the early 1960s, a reverse form of social stratification had taken hold: the poorest inhabitants lived in shacks high up the hillside, and the better-built homes were down the hill, nearest the Avenida Epitácio Pessoa and closest to services, the water supply, and transportation.[55] So it was that on a brutally hot day, up the path in "a tangled maze of shacks," Parks and Gallo visited the first family on their list of ten. Parks later remembered that it was the eldest son, an elfin twelve-year-old, who first held his attention. Watching as the boy ascended Catacumba's steep dirt hill, balancing a forty-pound tin of water on his head, Parks was transformed by the sight:

> He was horribly thin, naked but for his ragged pants. His
> legs looked like sticks covered with skin and screwed into

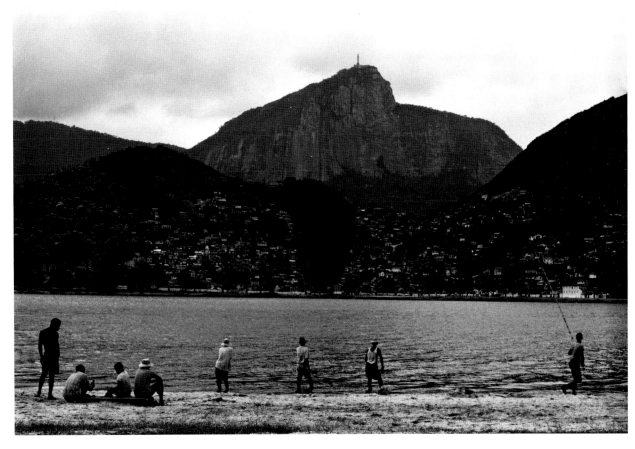

two dirty feet. He stopped for breath, coughing, his chest heaving as the water slopped over his shoulders and distended belly. I had seen many like him that morning on the way up, all with the same sullen stare of hunger and hopelessness. Death was all over him, in his sunken eyes and cheeks, in his jaundiced coloring and aged walk. He might have passed forgotten, just another starving child, half-alive, suffering his way up a narrowing path. But suddenly, with the jerky movement of a mechanical toy, his head twisted sideways to us and he smiled. Caught in a moment of awkward pity, we found ourselves unable to smile back. Then suddenly he turned and went on up the hill.[56]

Parks and Gallo had found their subject: a boy named Flávio.[57]

. . .

Days after the inauguration of President Kennedy, Brazil's new president, Jânio Quadros, took office in the country's new capital of Brasília. The former governor of São Paulo had been elected with a convincing plurality against two opponents. He inherited an economy in crisis: his predecessor as president, Juscelino Kubitschek, had aggressively accelerated economic development and infrastructure spending, and the country was running a significant budget deficit as 1961 began. For ordinary Brazilians, the cost of living had spiked by 40 percent over the previous year. Both the United States and the International Monetary Fund had ceased lending money to Brazil.[58] Quadros took power with the promise of stabilizing the economy and reforming government; he had also pledged an independent exercise of foreign policy,

hoping "to open new options for the country, to give it greater international maneuverability and at the same time greater moral purpose in the world."[59] From the perspective of the U.S. government, this declaration of "independence" raised fears of Brazilian disloyalty.

Quadros' action on economic matters was swift: the same day President Kennedy announced his plans for the Alliance for Progress, the Brazilian president imposed an aggressive austerity program mostly to the liking of U.S. government observers—cutting public spending, eliminating subsidies for essential imports like petroleum, and devaluing the currency.[60] These moves had immediate impact, inspiring outrage among many. The Brazilian public was forced to absorb skyrocketing prices for such staples as flour and gasoline; and the American oil companies Standard Oil, Texaco, and Atlantic Refining were angered when Brazil nationalized their windfall profits from the new increase, which they considered "illegal confiscation."[61]

At the same time, Quadros' position on relations with Cuba "was viewed . . . as posing a threat to the cordiality of relations with the Kennedy government."[62] Interaction between the United States and Brazil had been notably anxious since former president Getúlio Vargas blasted "decades of domination and plunder by international economic and financial groups" in an extraordinary suicide note written before he took his own life in 1954.[63] Early in March 1961, Quadros rejected an offer from Adolf Berle, a special envoy sent by Kennedy, to provide $300 million in foreign aid in exchange for cooperation with U.S. opposition to Cuba.[64] Quadros considered this a barely concealed bribe, and an insult to Brazilian autonomy. Their tense exchange leaked to

the media, provoking controversy in both the United States and Latin America.[65] Later, however, in his annual address to the nation, Quadros pledged to commit Brazil not only to "broadening ties with all countries in the world, 'including the Socialist (Communist bloc) countries,'" but also, he said, to "relations of sincere collaboration with the United States in defense of the democratic and social progress of the Americas."[66] This gesture calmed matters somewhat in the days before Parks' arrival in Rio de Janeiro.

Castro's takeover in Cuba dramatically raised the stakes for the United States in its expectations about South America's largest country. Increasingly, the Kennedy administration's primary concern in all Brazilian matters was to prevent the spread of communism, which it viewed as an urgent and existential danger, particularly in the country's large northeastern region. As Arthur Schlesinger, a special assistant to President Kennedy for Latin American affairs, later explained:

> Here was half of the western hemisphere, which, if it turned against the United States, would mock our leadership before the world and create a hard and lasting threat to our national security; but which, if we could work effectively with its people, might provide the world a model in the processes of democratic development. If the United States were not ready to offer an affirmative program for democratic modernization, new Castros would undoubtedly rise across the continent.[67]

. . .

The first stop on Parks' list was a dilapidated home in the upper reaches of Catacumba. There the two reporters found a single, tiny room, with a roof of corrugated metal; one bed, a crib, and two wooden boxes as furniture; walls made of gaping wood planks and flattened cans; and a rotting floor. Only children were at home, no parents. The eldest son, Flávio, who greeted the two men at the door, was clearly in charge. While he projected calm, authority, and a certain charm, Parks noticed straightaway that the boy's siblings seemed riven by frustration and inner turmoil—expressed as violence, directed at one another. They included the eldest sister, eleven-year-old Maria da Penha; Mário, eight; Luzia, six; Isabel, four; Abia, three; and the youngest, Zacarias, seventeen months.[68] Parks' first impression, he remembered later, was of destitution beyond anything he had ever experienced.

At day's end, the visitors from *Life* met the children's parents when they returned from working at the bottom of the hill. Mother Nair Germano was a washerwoman, thirty-five years old and pregnant with her ninth child; and her husband, José Manuel da Silva, forty-two, was proprietor of a wooden kiosk that sold detergent and kerosene. With them was another son, João Batista, age five, who had spent the day with his father. After the family ate, Gallo explained their presence, and the assignment, and tried, with difficulty, to negotiate access so Parks could photograph the family. Eventually José da Silva agreed: "'you can photograph us,' he said, 'but you must show us in a good light.'"[69]

Parks and Gallo began their work on the story that very day, March 21, taking pictures, interviewing, and gathering relevant information (fig. 5).[70] They visited the da Silvas frequently in the weeks after, and Parks extensively photographed the children, who functioned with a level of autonomy and impunity unlike anything he had ever seen. Left most days by their parents, who spent the day at the bottom of the hillside, the children moved freely about the favela, untethered to home, playing in dirt and garbage. As Parks and Gallo observed them, their behavior seemed impulsive in the extreme. They yelled at and fought constantly and had frequent run-ins with other children in the community. Stunned by the

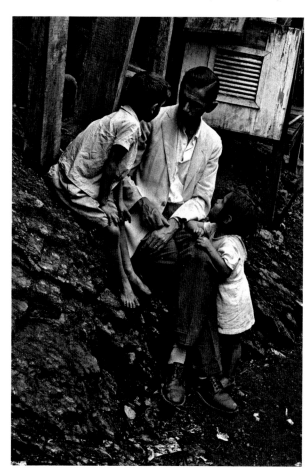

FIG. 5 Gordon Parks, Untitled (José Gallo with Two da Silva Children), Rio de Janeiro, Brazil, 1961. The Gordon Parks Foundation

level of psychic and physical violence in the household, Parks wondered about its future impacts on the growing children, as well as others growing up in such an environment. The da Silva children also appeared to be in perpetual danger from stray dogs and spiders, the raw sewage running nearby, and the ramshackle construction of the shacks. Parks tried to capture these impressions in the photographs he made in and around the da Silvas' home (pp. 12–45).

As the oldest child, Flávio was often left in charge by Nair and José (actually his stepfather), and he assumed a remarkable degree of responsibility for managing the household and monitoring his brothers and sisters.[71] Essentially a surrogate parent, he delegated chores to the others and supervised their work, but carried out most tasks himself: making coffee and food, fetching water, feeding and bathing the infant Zacarias, cleaning the floors, and securing wood to fuel the family's

makeshift stove (fig. 6). Touchingly, amid all the chaos, Flávio tried to educate his siblings to act with responsibility. He policed their combative behavior, taking on the role of peacemaker and mediator in their ongoing battles. In Parks' later description of him, Flávio appears to be more of a responsible adult than either of his parents, who seem perpetually fatigued and depressed (Nair) or embittered and alienated (José).

Over time, Parks was increasingly fascinated, even obsessed, by this unusual boy. In his photographs, he tried to capture Flávio's maturity, his diligence and sense of order, his devotion to his family, skill at diplomacy, and remarkable selflessness. With growing concern, Parks and Gallo sensed that Flávio was deeply afraid of his stepfather, and they speculated that José resented and perhaps even beat him. More alarming, as the days passed they witnessed Flávio struggle with crippling and recurrent bouts of asthma, coughing so severely that his neck veins bulged as he gasped desperately for breath. Observing that the parents felt powerless to address his poor health, and that his siblings took his condition for granted, the two reporters decided to intervene and took Flávio to a small health clinic that served the favela. It was the first time he had ever been to a doctor for his asthma (fig. 7). There the reporters learned the boy was wasting away because of these respiratory problems and malnutrition: he might last two more years at most, the doctor opined.

. . .

On March 24, the Brazilian newspaper *Jornal do Brasil* published a feature about Parks and his work in Rio thus far (fig. 8).[72] Essentially a personality profile, the article extensively quoted the forty-eight-year-old star photographer on the purpose of his assignment, but also reported on his family, career, wide range of creative endeavors, and the tools he brought with him to photograph the favelas. Impressed by the achievements and success of her African American subject, this journalist—like the one who handled Parks' arrival for *Tribuna da Imprensa*—highlighted the fact that he was the only black photographer then contributing to *Life*. Three photographs showed Parks in his hotel room, speaking earnestly; two of the images allowed a wider view, including the array of photographic equipment he had brought to cover his story.

Misleadingly, Parks suggested to his interviewer that he had only just begun his explorations, that he had searched Catacumba and the nearby community of Sacopã for a family to photograph, with additional favelas still to visit. At first, he said, he was taking no photographic equipment, wanting to understand the shantytowns before beginning his reportage. Recounting past assignments in Latin America, Parks compared poverty in Puerto Rico, and among indigenous peoples in Peru and Bolivia, with what he was now seeing in Rio: "Never in my travels have I seen anything as terrible as the favelas." Despite the suffering of the people, though, he admitted to being impressed with "the solidarity of the *favelados* and the vitality of the women."

His intention, Parks informed the reporter, was to make a truthful representation of poverty in Brazil. "I'll be taking pictures only in black-and-white," he stated; color photography would obscure the brutal reality:

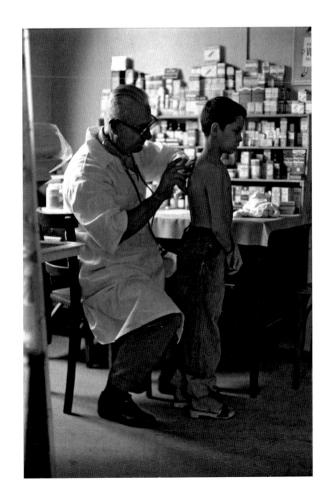

Fotógrafo americano trouxe 7 máquinas para fazer reportagem em prèto e branco nas favelas do Rio

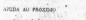

ARTES VISUAIS

VIDA LITERÁRIA

NOTAS E COMENTÁRIOS

REGISTRO SOCIAL

MÚSICA

Música na Áustria

NOTAS RELIGIOSAS

SÃO GABRIEL ARCANJO

98

"The world must see the tragedy of poverty as it is, and feel all its drama." Sooner or later, "everyone must face the problems of humanity. My way of facing these issues is through photography. It is important because it can show, without needing words, everything that is wrong and can be improved."

In response to questioning, Parks openly discussed the political context surrounding his subject. He expressed hopeful support for the new U.S. president, and described Kennedy as "young, progressive and not set in his ways." Nevertheless, Parks said, the United States lacked credibility to solve problems in Latin America and first needed to "clean up its own yard," namely in resolving the lingering issue of racial segregation. The reporter noted Parks' firm belief that societies should work hard to improve the condition of their least fortunate populations—"regardless of whom the aid comes from, provided it comes from the heart, and not in exchange for political favors."

"I would like," he said, "for my photographs to draw peoples' attention to the problems they show, thus helping to solve them."

. . .

As the assignment continued over the next several weeks, Parks nurtured a feeling that his story would be an extraordinary one. Far from merely fulfilling his assignment, the photographer had found—in the distressed psychology of the da Silva family, and in the struggle and suffering of Flávio—a remarkable microcosmic portrayal of poverty and its destructive effects. Two weeks after Parks' arrival in Rio, local bureau chief George de Carvalho reported to Foote and his colleagues in New York his and Parks' clear sense that the story might well have great impact when published in the pages of *Life*.[73] Three "takes" of Parks' film (numbering more than thirty-five rolls) had been processed and contact printed by Rio freelance photographer Paulo Muniz, and captions prepared, to be sent by plane ("packeted") to New York City.[74] Relaying Parks' progress to date, and discussing the photography still to come, de Carvalho expressed his excitement in the clipped language, unorthodox word compounds, and frequent typos characteristic of telex communication:

GORDON NOW STARTING TO WRITEUP HIS OWN HUMAN DAYBYDAY IMPRESSIONS WHICH SHOULD BE FINE BONUS: HES GOING THROUGH FANTASTIC PERSONAL EXPERIENCE (WRITTENUP AT LENGTH IN LOCAL PRESS). INTERVIEWING GORDON ON HOURSLONG TAPE TO GET IT DOWN FOR HIM, YOU AND BUREAU RESEARCH—WHICH WILL INCLUDE FAMILY LIFE HISTORY, STORY OF ITS FAVELA PLUS FULLEST FRAMEWORK ON BRAZILS FAVELAS AND LATAMS URBAN BINONVILLES TO EMPHASIZE THIS IS THE EXISTENCE OF NOT JUST ONE FAMILY BUT OF MILLIONS IN THIS HEMISPHERE.[75]

Thus far, de Carvalho indicated, Parks' photographs had emphasized the life of the family, especially among the children, to stunning, revealing effect:

SEVERAL PARKS PIX (INDICATED ON CAPTIONS ARRIVING TUESDAY) ALREADY PORTRAY PERFECT PARENTS HOPLESSNESS

AND CHILDRENS DIFFERING ATTITUDES TOWARD LIFE AND FATE: THE QUIET ONE HIDING BEHIND DOOR, THE ANGRY ONE CONTORTED, FLAVIO BROODING NAKED ETC. . . . FAMILY UNCELEBRATES ANY FEAST, SELDOM GROUP COMPLETELY AND NATURALLY TOGETHER (FOR MEALS THEY HAVE ONLY THREE PLATES, EAT IN RELAYS) BUT GORDON WILL TRY FOR THAT RARE MOMENT TOGETHER (WITHOUT TOGETHERNESS).[76]

The telex reveals that by April 3—with only a few days left until his planned departure—Parks worked to satisfy the modified assignment he and Foote had negotiated with the help of assistant managing editor Hunt. At *Life*, photographers were typically obliged to follow "scripts" prepared for them by editors, who "wrote out their expectations for stories and their suggestions for pictures, [clarifying] objectives in advance."[77] This methodology, established early in *Life*'s history by the magazine's powerful picture editor Wilson Hicks, was still standard practice in 1961. While his attention had been diverted over the first couple of weeks by his obsession with Flávio and the other children, Parks also made numerous images of José, the ostensible subject of his assignment.[78] Later, recalling his lack of enthusiasm for the coverage *Life* had ordered, Parks recounted the objectives he had been assigned:

I thought for a moment about the details of the *Life* assignment in my back pocket: "Find an impoverished father with a family of eight or ten children. Show how he earns a living, the amount he earns a year. Explore his political leanings. Is he a Communist or about to become one? Look into his personal life, his religion, friends, his dreams, frustrations. What about his children—their schools, their health and medical problems, their chances for a better life?"[79]

Now, having seen the results of his first rolls of film, and with evident pressure from the editorial office in New York, Parks and the team in Rio began to fill in the requested details:

GORDON NOW WORKING ON TEN POSSIBLE PIX TO MAKE STORY POINTS . . . AND TIEIN FAMILY WITH THE CITY AND THE WIDE WORLD AROUND IT.

CHECKLIST: ONE OR POSSIBLY TWO POLITICAL SHOTS INCLUDING FAVELA RALLY, TWO EMPHASIZING INFLUENCE OF RELIGION (CATHOLIC PRIEST AND POSSIBLY HOLYROLLERISH PRAYER MEETING), MOTHER DELIVERING LAUNDRY TO RITZY APARTMENTHOUSE, FATHER LOOKING FOR WORK AND SCRAPS AT CONSTRUCTION SITE, FLAVIO AND KIDS AT NEARBY STREET WITH LOADED SHOPWINDOWS, SCHOOLTEACHER BERATING FAMILY, FLAVIO AT CLINIC, DEATH IN THE FAVELA. CANT GUARANTEE ALL BUT SHOULD GET MOST INCLUDING DEFINITELY RALLY AND RELIGION.

ANSWERING YOUR [MESSAGE] MANY ARE TEXT NECESSITIES RATHERN PIX. AS PROMISED RESEARCH WILL WRAPUP YOUR NEEDS INCLUDING STREAMOF-CONSCIENCE QUOTES FROM WHOLE FAMILY ON WHAT THEY HOPE FOR IN LIFE, ON SCHOOL AND HOSPITALS, FROM PARENTS ON HOPLESSNESS, RELIGION AND REVOLUTION ETC.[80]

Parks' later rolls of film closely conform to the coverage de Carvalho promised New York. Some of the scenes had likely been photographed by the time of the telex, so precisely do they follow the descriptions of the Rio bureau chief; others were yet to be documented, and differ from the checklist descriptions in interesting ways. Parks' extensive coverage of José da Silva shows him eating dinner with the family, reading, carrying a load of scrap lumber, working in his stall, and attending church. Some of these images are posed in a manner that suggests stage direction by Parks, with willing participation by José, to capture those distinct aspects of daily life requested by *Life*'s editors. The few photographs of Nair da Silva working, napping, and caring for her children, by contrast, evidence more personal investment from Parks than obligation to his editors. They appear to be captured on the fly rather than planned; and they reflect clear sympathy for the mother, who seems perpetually exhausted. Despite his efforts, Nair in many ways remains a cipher in Parks' coverage.

Some of Parks' contact sheets reveal the lengths he went to in hopes of capturing images of emblematic importance to the story. One roll of film is devoted to virtually identical photographs of Catacumba from a distance. Parks painstakingly positioned himself so that he could depict Rio's iconic statue of Cristo Redentor (Christ the Redeemer) looming above the favela: he made twelve exposures, tracking the distant figure through the cloud cover shrouding Corcovado mountain. An early-morning scene of Flávio dressing for the day while the rest of the family sleeps is staged to document this everyday event for the story; the little boy maintains his position, holding his shirt up as if to put it on, as Parks snaps the shutter twenty-two times (see fig. 37 in Amanda Maddox's essay in this volume). Finally, knowing how interested his editors were in José da Silva's political views, Parks followed him to a political demonstration in Catacumba for state *deputado* Amando da Fonseca, the favela's controversial representative to the legislative assembly.[81]

Greatly affected by his assignment, Parks felt disquiet each evening as he returned to the upscale Hotel Excelsior in nearby Copacabana, after working in the favela from early until sundown.[82] Perhaps this is what prompted him, late in his stay, to take Flávio and Mário to this beachside community, where he took pictures of the two boys encountering a world of privilege outside their experience and beyond their imagining. He photographed them cavorting on the beach, walking the famous serpentine-designed sidewalks, gawking at the windows of luxury shops, and talking with well-dressed tourists eating at a patio restaurant (fig. 9). Recalling the episode later, Parks wrote:

> I was filled with confusion and guilt during my final days in the Catacumba. Flavio, like thousands of other children, would die as the doctor had predicted. His family and all those other families would sink deeper into the mire of that stinking slope. It seemed futile to believe

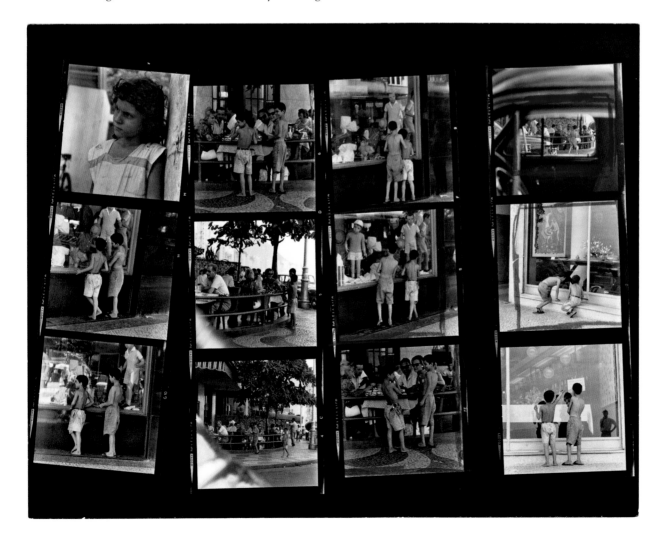

FIG. 9 Gordon Parks, Proof sheet, Set No. 62170, Take No. 4, R-6, 1961. The Gordon Parks Foundation

otherwise. I could not help but compare the good fortune of my own children with the fate of these others. Fate might have so easily reversed the circumstances. I had told myself that Mario and Flavio's trip to the beach might stick with them, might give the incentive for their eventually escaping their miserable world. But I knew differently. I had exposed them to an impossible dream, and I would be leaving in a day or so.[83]

His photography completed, Parks left for New York on April 9, having worked on the story for nearly twenty days.[84] He had shot more than fifty rolls of film.[85] The assignment was not over, however: José Gallo, de Carvalho, and others at the Rio bureau pressed on, informing Foote that they were still "preparing detailed research on da Silva family, Catacumba favela and overall favela problem."[86] For his part, Parks continued work on his impressions of the visit, to be published in the form of a diary. When it appeared in *Life*, the last entry recounted his departure:

> I said goodbye to Flavio and the family today. "Gorduun, when do you come back?" he asked.
>
> "Oh someday soon," I lied. Or was I lying?
>
> "You come back to *favela* to see Flavio, yes?"
>
> "Someday soon, Flavio," I said. Now I was telling myself that perhaps I could manage it in some way, even take him out of this place.
>
> He walked with me to the car, rubbing my hands as we went. There was a scream and I looked back to see Maria chasing Mario up the hill with a stick.
>
> Flavio was grinning as I pulled away. "Don't forget, Gorduun, *Americano*, come back to *favela*, come back." Then he ran quickly back to the hill and I lost sight of him among the jungle of the buildings.[87]

. . .

After landing in New York on April 10, Parks conveyed the last of his film to Time-Life's offices, with caption information and proof sheets from the rolls processed at the Rio bureau.[88] Working with Tim Foote, lead picture editor Ray Mackland, and the film editor's department, most likely its principal, Margaret "Peggy" Sargent, Parks set to work selecting images for possible inclusion, a process he had begun in Brazil. Sargent, a former assistant to *Life*'s venerable photojournalist Margaret Bourke-White, used her magnifying loupe to closely examine contact sheets of Parks' film. Together they selected individual frames to be printed in the Time-Life photo lab. Often, editors would order as many as a hundred photographs enlarged to 8 x 10-inch or 11 x 14-inch prints, which would then be considered for publication.[89]

During the next several weeks, work accelerated on the five-part series, which would ultimately fill sixty-three pages in five issues. Staff photographer Dmitri Kessel, who had extensive experience photographing in the region, was the primary lensman employed for the series; but in addition to his work and Parks', a number of other photographs and illustrations were commissioned or sourced, and edited for possible use.[90] At *Life*, layout of photographs and other images dominated the early stages of a feature's design; words were secondary. The layout process favored during this period, described later by staff writer Loudon Wainwright, was methodical and extensive:

> Each week's *Life* began as a single sheet of paper, a numbered list of the pages for that issue. This sheet was called a mock-up, and it was basically a simple diagram showing the location of all the advertisements and the space available for stories, which the list makers labeled "edit content." The mock-up also showed the order in which previous sections, or "forms," of the magazine were scheduled to go to press. Thus this spare document was something of a timetable as well as a map, and a managing editor skilled at reading it and alert to the several possibilities of moving pages around forms or even from one form to another could tailor the issue as he went along.
>
> As the magazine grew and took shape over the period of several weeks it took to close any single issue, the mock-up would change somewhat; a few ads would be moved around to open up better space for stories, other ads might be dropped or new ones placed. And it would gradually fill up, with inclusions to show where all the stories would appear and what they were. In the last days of any issue's making, only a few blank spaces were left in the mock-up.[91]

Parks was excited enough by his results to express hope that the story would feature on the magazine's cover, and receive lengthy placement inside: perhaps as many as fourteen pages, including his diary entries. Yet for much of the essay's production, Parks had little direct input, as other departments and contributors played their critical roles in developing the finished photographic essay. Far from being unusual, this multistage process was the norm at *Life*. Foote, who had grown equally committed to the story of Flávio and the photographs, reassured Parks that the pictures had received an enthusiastic response from all who had seen them.[92] While the magazine sometimes published more than two hundred photographs in a weekly issue, only occasionally would the managing editor commit even twelve pages to a photographic essay.[93]

Art director Charles Tudor, who worked "shoulder to shoulder with Thompson during the crucial phase of deciding how to use the pictures," likely collaborated in designing initial drafts of Parks' story. His routine with the managing editor was honed over years of experience:

> Making his way to the layout table and standing next to his cigar-smoking boss, Tudor would exchange an opening grunt or two with him. Then, while Thompson flipped through stacks of pictures, the two men engaged in an odd dialogue of guttural noises and body signals, shrugs, arm gestures and raised eyebrows. Some pictures would be thrown into one pile, others into another. . . . Thompson would offer Tudor rough sketches he'd made on little layout pads designed for the purpose. Tudor would accept these with a final, somewhat dubious

arching of his eyebrows. Then he would grab up the smaller of the piles of pictures on the table and glide out the door.[94]

By early May, a preliminary layout had been completed. Foote called Parks into the office with disappointing news. The coverage had been cut. Reviewing the story layout, Parks saw just one of his photographs of Flávio integrated with work by others, including a portrait across the spread by Dmitri Kessel. Despite the quality of his work, despite his extraordinary experience with the da Silvas, despite his status as a star photojournalist, his visit promoted in the Brazilian newspapers: despite everything, Parks' singular reportage was used merely as a lesser element of the magazine's larger story on Latin America. Parks was deeply disillusioned over what he saw as the unfair rejection of his photographs. Writing about the incident later, he blamed the decision on managing editor Thompson, and—by extension—his ally Tudor.[95]

Then, to the photographer's surprise, the story was saved, by an unusual reversal of fortune. On May 5, *New York Times* journalist Tad Szulc reported on comments made the previous day by President Kennedy's secretary of state, Dean Rusk, in a front-page story titled "Rusk Calls Latin Poverty 'Real Issue' in Hemisphere." Foote excitedly called Parks to his office. "'Read this,' he said. 'It could make the difference.'"[96]

> The United States sees the battle against poverty as the "real issue" in the Western Hemisphere, Secretary of State Dean Rusk said today. . . .
>
> It is the gap between the rich and the poor in Latin America, Mr. Rusk said at a news conference, that helps penetration by the Soviet Union and Communist China and weakens the hemisphere. . . .
>
> Mr. Rusk said there was now a "considerable crystallization" of anxiety in Latin America over the Communist penetration in Cuba. He added that Cuba's new position as "a declared member of the Sino-Soviet bloc" turned the whole problem into "an urgent question." . . .
>
> Emphasizing the importance of development programs in Latin America, Mr. Rusk said that current revolutionary movements, as was the case with Cuba in the early days of the Castro movement, are based "upon the rising expectations" and the need to reduce the gap between the privileged and the under-privileged peoples. . . .
>
> Along these lines, Mr. Rusk said, the United States is expected to call soon for an inter-American conference on social and economic problems. The parley, which is to bring together finance and economics ministers, may be held at Montevideo, Uruguay, sometime in July.
>
> Thus far, the United States has authorized $500,000,000 for a special social development fund under President Kennedy's program. Final action in the Senate to appropriate the money is scheduled for next week.
>
> But it was expected that between now and July, the United States would advance new proposals for the hemisphere's development.[97]

Foote shared the Rusk article with the managing editor. A short while later, a fuller layout was in play. Parks later recalled Thompson's about-face as instantaneous: "Late that same afternoon Flavio's full story was scheduled for Part Two of the Latin American series."[98]

Thompson famously thrived on the changing winds of current events, and often anchored *Life*'s feature stories to "news-pegs," as they were sometimes called. The entire Latin American series, from its conception, was pegged to Kennedy's policy priorities and the Alliance for Progress. Now Secretary Rusk's urgent comments firmly established poverty relief as central to the administration's goals. Foote, by taking the *Times* story to Thompson, had read his boss well:

> The real distinction between Ed Thompson and the other managing editors of *Life*, past and future, lay in his greed for crisis. Whereas the orderly [John Shaw] Billings on the early magazine and Ralph Graves in the last years of *Life* took great pride in running tidy operations where things clicked right along according to plan, Thompson seemed to feel trapped with plans that committed him too firmly in advance. He sought opportunities to wipe them out. Perhaps it was his restless nature, perhaps it was his newspaper training, more likely it was his conviction that *Life* always had to have an urgent character about it: in any case, Thompson clearly preferred making big changes at the last minute to any other editor's prerogative.[99]

With weeks still to go, Parks' reportage was ensured a discrete, anchoring position in the series. Caught up in *Life*'s comprehensive redesign, scheduled to be put into effect just two issues before his, Parks' pages were likely worked on by Bernard Quint, Tudor's deputy and the magazine's leading layout designer. Quint had been assigned to advise George Hunt about the coming refresh; one of the primary goals was a simplified, more graphic presentation of the magazine's flagship photo essay section. Parks, who worked with Quint on some of his best-known picture stories, felt in safe hands with him as lead designer: "[Quint] was one art director that all the *Life* photographers wanted to work on their stories. . . . He was very dramatic and he wasn't afraid to take chances. . . . He would throw his whole heart into it."[100]

On all *Life* photo spreads at this time, "early layouts were revised, tossed out, reinstated. . . . Writers turned out new headlines to fit new layouts, lengthened or shortened captions and textblocks as versions changed."[101] This fitful process typically continued through several drafts and many weeks. As the layout was modified, as photographs fell in or out, editors, staff writers, and copyreaders—guided by Foote—incorporated both editorial perspectives and narrative information drawn from José Gallo's reporting and research and Parks' experience. Text played a distinctive role in *Life* stories: "Captions and blocks were meant to accompany, explain, sometimes even justify, the photographs themselves. They had, by logical decree, to 'read out' of the photos: some references to the pictures as well as the subject of the story had to appear in the first line or two."[102] Written and edited to fit into a confined space, these texts took

on an institutional voice unique to *Life*—a kind of patois, at once terse and hyperbolic, resulting from a peculiar combination of efficiency and overstatement.

In early June, mere days before publication, the Rio bureau continued to forward background information for the writers' use, and answered detailed questions about selected photographs to be included in the story. While some original telex communications between Rio and New York did not survive in Parks' archive, the few that do reveal the precision and depth of research conducted for the story. One extensive report sent by de Carvalho characterizes the da Silva family's destitution in hard numbers. Including recent spikes in inflation, José and Nair earned the equivalent of $300 the previous year, about $25 per month, far below the average income for a Rio family of five and well beneath even the average for a favela family.[103] The bureau also reported their meager expenses:

> FAMILY BUYS AVERAGE OF 18 KILOS OR 40 LBS MONTHLY OF BEANS COSTING TOTAL TWO DOLLARS AND 20 KILOS OR 44 LBS OF RICE COSTING DOLLAR 80 CENTS. REMAINING FUNDS SPENT ON DRIEDSALT MEAT ABOUT FOUR DOLLARS MONTHLY MACARONI ABOUT DOLLAR MONTHLY PLUS SALT SUGAR COFFEE OTHER FOOD AND ESSENTIALS. THEY KNOW FOR SURE ONLY HOW MUCH RICE AND BEANS THEY EAT.[104]

De Carvalho's notes include dark references to the challenges facing a family at this level of poverty. José da Silva, badly hurt in a 1958 construction accident in Copacabana, had only twice received his monthly pension from Brazil's Institute for Retirement and Social Welfare (IAPI), "critically short of funds due political despoilation and corruption."[105]

De Carvalho also reported on Flávio's precarious state of health since Parks' departure:

> DURING ASTHMATIC CRISE HIS NORMALLY TALLOW SKIN TURNS FAINT BLUE, VEINS THROB AND THROAT SWELLS IN INTENSE EFFORT TO BREATH. IN LAST 30 DAYS HE SUFFERED THREE VERY BAD SPELLS OF SEVERAL DAYS EACH, IN EACH CASE HE BEGAN DOING FAMILY'S WORK BEFORE REALLY OVERCOMING CRISIS.
>
> CURRENTLY HES ILL AND FEVERISH WITH BAD FLU BUT HAS NOT STOPPED WORK NOR TAKEN ANY MEDICINE OR TREATMENT OF ANY KIND. HIS DIET IS OFCOURSE DEFICIENT AND HES KILLING HIMSELF WITH CONSTANT EFFORT TO KEEP FAMILY GOING. SAID OUR JOSE GALLO WHO WORKED HIMSELF THROUGHOUT WITH PARKS YOU CAN'T SAY FLAVIO IS DYING TODAY. HE WILL DIE TOMORROW OR THE DAY AFTER. MEANING HE WILL DIE IN A YEAR, TWO YEARS, CERTAINLY BEFORE HE GROWS UP.[106]

Early in the month, *Life* sent the June 16, 1961, issue to the rotary presses of their longtime printer R. R. Donnelly. After four to five days of round-the-clock printing, trimming, binding, and addressing, Donnelly shipped just over 7 million issues from their mid-U.S. flagship plant in Chicago, and branches in Philadelphia and Los Angeles, to subscribers and newsstands.[107] The issue was on its way to *Life*'s readers.

· · ·

As editors worked on the June 16 issue through May and June, Henry Luce continued his magazine's push to support President Kennedy's anticommunist initiatives. Early in May, he signed on to an unconventional Kennedy plan to free the more than 1,200 Cuban exiles captured by Castro's forces during the Bay of Pigs invasion. After Castro sarcastically suggested that he might trade most of the captives for five hundred industrial tractors and bulldozers, Kennedy engaged three prominent citizens to enlist everyday Americans in the cause, encouraging them to donate funds to purchase the farm machinery.[108] Luce threw his support behind the private committee formed to shepherd the plan, despite fierce opposition from the Republican Party and skepticism from senior staff at his magazines that the idea amounted to paying ransom.[109] The controversial "Tractors for Freedom" program advanced into July, drawing unexpected support from donors throughout Latin America, including many Brazilians. "Where Dr. Castro had expected his generosity [in offering the exchange] to be vaunted," *The New York Times* opined, "it was the 'traditional generosity of Americans' that won the hemispheric praise."[110] After Castro repeatedly revised his ransom upward, the mission fell apart, in a minor embarrassment for the president. Those who donated funds to rescue the rebel fighters had their money returned.[111]

In late May, Luce asked John Steele, Time Inc.'s Washington, D.C., bureau chief, to convey one of his recent company speeches to the president in advance of a scheduled lunch between the two. Luce's address, delivered on May 15 to Time Inc. executives in publishing, editorial, and advertising, functioned as a pep talk, marching orders for the coming year, and a statement of institutional challenges. But the speech was also a declaration of political orientation and advocacy. Steele, introducing the typescript to Kennedy, noted that "while it contains a good deal of intramural company talk which may be of no particular interest to you, I do believe you will be interested in [Luce's] main theme. It is an expression of his views concerning U.S.-Soviet relations. The speech will not be given distribution, save in this instance."[112]

Stating plainly to his executives what would soon be hinted at in the June 2 issue launching the series on Latin America, Luce called on his journalistic army to become propagandists in the Cold War:

> Tonight, at this moment, I will speak of "we" as meaning simply we of TIME Inc. And I propose to you that we of TIME Inc. now register in our minds and wills that from here on out the dominant aim and purpose of TIME Inc. shall be the defeat of the Communist movement throughout the world. Is that a declaration of private war? . . . No—the term is out of date in this organization age. But even the organization man doesn't have to wait for the government to do everything. Every individual and every organization in the land can strike a blow for Liberty and against Communism—now.[113]

While he was rarely afraid to express his political expectations of his editors, Luce's blunt and audacious speech repeatedly summoned his leadership to reorient their mission in support of the cause and the president, and—regardless of their objections and the higher goal of objectivity in journalism—to bring their staffs along:

> It is time for America to make its decision irrevocably clear to all the world. The President . . . has done his best to make things clear by ringing words, many of which we know by heart. It is time now for all Americans. It is especially time for those who, like ourselves, claim to be the most alert and the best informed and the most sensitive. . . .
>
> In all fields ours is a journalism of engagement. Our deepest satisfaction is to be engaged in the progress of man. And our duty is to be engaged against the evil that threatens him. . . . In such an engagement we need to be at our professional best, telling the truth well. In the field on which we fight I hold that truth, well told, is the best propaganda.

On May 26, after their meeting, Luce wrote the president: "And many thanks for lunch which, for my part, I found most agreeable personally and most rewarding professionally. I will follow through on two or three specific matters of mutual concern." While he left these matters unnamed, Luce would continue to exchange favors with Kennedy. The series on Latin America, beginning the following week, would be one of Luce's gifts.

. . .

"Freedom's Fearful Foe: Poverty," part 2 in the series, was published on Friday, June 16 (pp. 222–237). Opening with a single photograph of Flávio's sister Isabel, crying next to her ill and exhausted father José, Parks' dramatic picture story better exemplifies the secondary tagline, posted above the didactic title on the first page. What U.S. readers were about to see was "A Beaten Family in Rio Slum." Unfolding between pages 86 and 98, with just thirteen photographs representing his twenty days of coverage (including one by José Gallo taken with Parks' camera, of the photographer cradling the infant Zacarias da Silva; see fig. 38 in Amanda Maddox's essay in this volume), Parks' story would soon be regarded as one of the most compelling photographic essays of his career, and in the history of the magazine. The stark black-and-white photographs represented his acute distress over what he had witnessed, and his mission—made explicit in his March 24 interview with *Jornal do Brasil*—to draw attention to the crisis of poverty, in hopes that it would be addressed. Made by a seasoned photojournalist at the peak of his considerable abilities, the Flávio story, as it came to be known, was intended as a clarion call for empathy, compassion, and ultimately public action.

While Parks' photographs were certainly powerful and indelible, not easily ignored or forgotten, their emotional force depends to a considerable extent on their selection, sequencing, and arrangement on the pages of the magazine. A number of the original prints used for reproduction survive in the collection of New York's International Center of Photography, along with others of the same vintage, apparently last-minute eliminations by the editors. Comparing these with the many frames marked on Parks' proof sheets, by *Life*'s film editors or the photographer himself, the final selection seems to have resulted from a combination of imperatives: preference for formally strong, graphic, and aesthetic images; desire to tell a comprehensive story about the family's situation and represent the individual members; a special interest in Flávio's diligence, spirit, and suffering; and the formal relationship of some photographs to others across the pages. The editors' earlier expectation that the photo essay would focus on the family's father was no longer relevant. Only two of the included photographs showed José da Silva, and while he is discussed in the accompanying text, he is a marginal figure in the story.

The scale of *Life*'s large page spreads—about 14 x 21 inches when opened—contributed considerably to the impact of the photo essay, as did the design revision masterminded by Hunt and Quint, which greatly simplified the photography layouts from earlier convention. Three of the spreads make full use of the page, with single images printed to the edge on four (or in one case, three) margins. These are the first, third, and fifth spreads, and they alternate rhythmically with spreads two and four, which contain arrangements of multiple smaller images. With many of the photographs running across the gutter, the design connects the pictures—suggesting that we may read meaning into their juxtaposition and organization. The final two photographs in the essay are quite small, printed one to a page, and function as codas to the main story.

The first photograph opens the photo essay amid suffering, crisis, and darkness. It has less descriptive value than symbolic force: neither José nor Isabel plays a central role in the story about to unfold. But Parks' depiction of a conflict between parent and child, placed at the outset, makes clear that readers will find little order and comfort in this household. This was likely a powerful message for the many middle-class readers who read *Life* for its frequent features on homes, the good life, and suburbia.[114] This was the opposite of that.

The second spread introduces the favela with a small photograph at bottom left, and three vertical images, butted edge-to-edge and reaching from top to the bottom of the pages. The central image shows Catacumba from a distance, described in the caption as a "hillside jumble of squatters' huts beneath Rio's famous statue of Christ."[115] The image to its left, of Flávio's brother Mário screaming in pain from a dog bite, and to its right, of Zacarias playing beneath a shack's flimsy support posts, frame the central overview. Together they describe the slum as a place where children face imminent danger playing on "filth-strewn paths." The hill and rocky earth depicted in this cluster of images combine to suggest the formal geometry of a globe, reinforcing the impression that the favela is a world of chaos (or, as the headline characterizes it, a "Hillside of Filth and Pain"). The smaller image at lower left, of mother Nair carrying water up the steep hill with

two daughters in tow, underscores the inaccessibility of the da Silva home and the absence of running water. In two pages, with an economy of expression, these four photographs introduce us to the da Silvas and dramatize their struggle.

The third spread, a single photograph, brings us inside the family's home. This iconic image shows Flávio, awake at dawn, preparing for the day ahead. His face is turned away, and his arms are blurred with movement; we first meet him as a force of energy, of determination and hard work. In contrast to the exhausted and impotent shape of his father, sprawled on the same bed on the story's first pages, Flávio, it is evident, is the family's caretaker. The caption makes this explicit, describing how his morning actions begin everyone's day. At this scale, the photograph also illuminates the poverty of the da Silvas' home: the walls are rough, mismatched wood planks and corrugated metal, ill fitted and gapped from inexpert construction.

The next two pages expand our understanding of Flávio, with three images of the frail but wiry boy bustling about the shack, cleaning up, preparing food, feeding the baby. The combination, two pictures to the left, a larger one to the right, conveys his conscientiousness and determination. The layout connects the photographs through the repeated motif of Flávio's dynamic arms and hands; and as our eyes move left to right, we see him framed closer and closer to the foreground. The three image captions and one text block on these pages economically describe this undaunted boy, communicating not only his responsibilities and struggles but his hopes for a better future: "Some day I want to live in a real house, on a real street, with pots and pans and a bed with sheets," he is quoted as saying. But another paragraph contradicts his optimism:

> It would be nice to believe [Flávio's] labor of love and courage will triumph. But it won't. Disease threatens constantly in the *favela*. (Last year in Rio, some 10,000 children died of dysentery alone.) And disease has touched Flavio. Wasted by bronchial asthma and malnutrition he is fighting another losing battle—against death.

The last two-page spread literalizes this dramatic assertion. On the right, a striking vertical image shows Flávio distressed and weakened in bed, his arms splayed, his convex rib cage evidence of his chronic asthma. On the left across the spread, an image of death in the favela: the body of a neighbor laid out on a bier, illuminated by candlelight. The juxtaposition is one of foreboding; but it also casts this story as a religious parable, with both bodies in postures of Christ-like suffering and sacrifice. In the caption we read that the image of Flávio was made on a Sunday, the boy's only day of rest from caring for his family: "'I am not afraid of death,' he explained earnestly to Parks. 'But what will they do after?'" The two photographs also remind us of the remote figure of Christ, looming over Catacumba, from earlier in the story.

The final two pages are dominated by text, and introduce Parks as a central figure in his own story. Headlined "Photographer's Diary of a Visit in Dark World," and written in the form of dated diary entries, this text describes in greater detail the dynamic within the family, the personalities of the individual children, and Parks' increasing involvement in his subjects' lives. Though he later credited Tim Foote with encouraging him to keep a diary during his stay, evidence suggests that this text was constructed from notes and memory, begun partway through Parks' assignment and extensively revised over time.[116] *Life* frequently celebrated its famous photographers in its pages, and Parks already had a well-developed reputation as an empathetic correspondent. "*Life* sent me on these stories because I think they knew that I would get involved," he later said frankly. "They expected it. It depended a lot on my emotional stamina to give the story some meat. The editors were smart—they sensed the need for this kind of humaneness in the magazine."[117]

The editorial imperative behind the series' focus on Latin America is expressed in the picture story's initial text block, which overlays the first image of Isabel and her father: "The anguish which poverty inflicts is cruel and varied—statistics cannot convey its accumulated torments and degradations. But poverty always has a human face." Straining to justify the article's peculiar collision of emotional imagery, instructive information, and anticommunist agitprop, Foote continues:

> The plight of the Da Silvas, seen as individuals, evokes human compassion. Viewed historically, their condition and that of other hopeless millions in Latin America, spell sharp danger—and an economic challenge to the free world. For the most part clustered in pockets (despite being two times the size of the U.S., Latin America has relatively little tillable land) largely in dislocated city slums, the teeming poor are a ripe field for Castroist and Communist political exploitation (LIFE, June 2).

This last sentence, with its direct reference to "We Must Win the Cold War," the twenty-fifth-anniversary editorial that preceded the launch of the Latin American series, expresses the reductive, fear-based idea backgrounding the series: Poor people are the raw fuel of communism. Why this might be so is not addressed, but the editors' political, patronizing framework for "Crisis in Latin America" is spelled out emphatically:

> This danger and this challenge will lend urgency next month when Western Hemisphere leaders meet in Uruguay to help President Kennedy's new "alliance for progress" program get started. The free world offers liberty and free economic development as a way for backward lands to help themselves. If that system cannot be made to work, neither the system nor liberty itself will last.

Life had published articles about Brazil, or at least mentioning it, many times before Parks' story on poverty in the favelas appeared. The magazine's very first issue, from November 23, 1936, included a feature on the country, with offensive, retrograde views and language now deeply embarrassing to read: "Brazilians are charming people but are incurably lazy," the unidentified author wrote. "The original Portuguese conquistadors did not

bring their wives, married Indian aborigines, and their descendants added the blood of Negro slaves to the strain. The mixture did not work."[118] While "Freedom's Fearful Foe: Poverty" and other installments of the Latin American series never hark back to such racist stereotypes, Foote's reference to "backward lands" reminds us that derogatory references to poverty often veil condescension toward sovereign nations, and prejudice against the poor.

While the magazine's editors used their text to support President Kennedy's foreign aid and development initiative, Parks' photographs aimed in an entirely different direction. At once descriptive, shocking, and compassionate, they immersed the magazine's readers into direct engagement with the suffering of a particular child, his family, and his community. Far from condescending, they utterly personalized and made intimate the tragedy of poverty, in a way that punctured the magazine's conception of indigence as an abstract lure to an ideological foe.

. . .

The impact of Parks' photo essay was instantaneous among *Life*'s vast audience. The June 16 issue ultimately reached 6,905,946 subscribers and newsstand buyers.[119] This enormous number was slightly above average for the year to date, indicating the magazine's wide readership at the time, near the historic peak of its circulation. The public for Parks' Flávio story went well beyond those who paid for their copies, however. For many years, the magazine's ad salesmen trumpeted a 1938 study of *Life*'s audience, which suggested that an average of fourteen readers saw each copy purchased.[120] This proved a powerful incentive for companies to advertise in the magazine's pages. *Life*'s "pass-along" appeal, whereby issues were shared among buyers and their family, friends, and business customers, was certainly a real phenomenon; but many historians believe the original study overestimated the number. In 1972, as the magazine ended its run, a more conservative pass-along rate of 4.63 was found.[121] Using this multiplier, perhaps low for 1961 when the magazine was considerably more popular, the potential viewing audience for "Freedom's Fearful Foe: Poverty" would have been nearly 32 million people, or one out of every six people living in the United States.

Life customarily measured readers' enthusiasm for its features by the volume of letters received by its editors. Parks' photo essay immediately elicited messages of praise and concern by the dozens. Some envelopes also included money to help the family, and many other writers asked how they could contribute funds, used clothing, or other items for the da Silvas. Some people even offered to personally adopt Flávio.[122] The onrush of these spontaneous donations and offers of charity—501 letters in the first three weeks—took the magazine staff by surprise.[123] And the New York headquarters was only the beginning. Many letters and checks arrived at Time Inc. bureaus across the United States and around the world, and staffers soon received word of other exceptional acts of charity. Some readers sent money directly

to the U.S. embassy in Brazil; California's Meals for Millions pledged 1,000 kilos of food to help the *favelados* of Catacumba; and numerous churches in the United States sent donations to Brazil's "bishop of the slums," Dom Hélder Pessoa Câmara, whose Rio-based Banco da Providência assisted poor families living in the favelas.[124] To handle the flood of support, *Life* urgently organized a company-wide response and directed all Time Inc. bureaus to channel "voluntary contributions for the Da Silva family" to the magazine's headquarters in New York.[125] One letter was immediately flagged as significant: the Children's Asthma Research Institute and Hospital (CARIH) contacted its hometown Time-Life bureau in Denver, offering to admit Flávio as a patient and provide two years of medical care, on-campus lodging, and oversight, free of charge.[126]

Impressed that so many readers were moved to help Flávio and the da Silvas directly, and particularly with CARIH's remarkable offer, senior staff at *Life* committed to an extraordinary course of action. The magazine's editors and publisher discussed using reader funds to bring Flávio to Denver for treatment, and debated saving the da Silvas from a life of poverty. By June 21, publisher C. D. Jackson made the decision to move forward. He wrote the Rio bureau and asked staff there to begin planning the operation: "Please advise soonest your thoughtful opinion as to best use of money," he telexed de Carvalho.[127] Jackson assigned his own assistant, Ruth Fowler, to oversee the effort from his offices.

Fowler wrote to Parks and José Gallo with details of this new plan, which would reunite them in Rio to carry out the first steps. While internal correspondence and memoranda demonstrate that the magazine's staff was motivated by sincere commitment to readers' enthusiasm, and by a desire to help Flávio and his family, Fowler revealed that *Life*'s editors were envisioning rich material for a follow-up story: "I don't know whether Ed [Thompson] or George [Hunt] mentioned the possibility of getting a Brazilian photographer to photograph you [Parks] photographing José and Flávio! But I think this is important as we will want a record of your trip, etc. for future promotional purposes."[128]

The magazine's Letters department struggled to coordinate responses to the many impassioned inquiries that flooded in. To handle the growing volume, staff members wrote standardized replies to simplify answering the diverse range of inquiries.[129] More immediately, *Life* published an auxiliary to its regular "Letters to the Editors" section in the July 7 issue (see pp. 238–243). Introducing this two-page feature, titled "Special Report: A Great Urge to Help Flavio," editors wrote: "The photographic essay, 'Freedom's Fearful Foe: Poverty,' has evoked a uniquely urgent and moving response . . . loos[ing] a flood of inquiries, suggestions, expressions of sympathy and, far more than that, generous donations and magnanimous offers from LIFE's readers."[130] In addition to printing a sample of the letters, an editor's note at the conclusion of the section subtly solicited additional contributions, and informed readers of the magazine's evolving plans to rescue Flávio and his family:

Because donations of food and clothing for the Da Silvas or other families in the *favela* would be subject to Brazilian duty charges which the slum families could not pay, no packages should be sent until some distribution plan is set up. Cash contributions may be sent by check or money order to The Flavio Fund, care of LIFE Magazine, Time and Life Building, New York 20, N.Y. These will be used to move the Da Silvas into modest quarters, set up Flavio's father in a regular job and bring Flavio himself to a hospital for treatment.[131]

A small portion of the letters published and excerpted in *Life* referred directly to the political agenda underpinning the Latin America series. Irena Penzik of Whitestone, New York, wrote: "If we continue in our preoccupation with the material luxuries of life, the whole world of Flavios will walk down the Communist path, and we'll have no one but ourselves to blame." And William B. Brown of El Cajon, California, implored: "Let us first beat the Russians to the distant star in Flavio's eyes."[132] A far greater number of readers responded, in the view of one *Life* staffer reporting to the publisher, because of "the emotional and intellectual impact of LIFE's pictures and story." Furthermore, she continued, people

> are looking for something they can do individually—and taking Flavio for their personal project. They've been worked to a fever pitch about "ask what you can do" and given nothing. This story, with both personal and political implications, seems for them perhaps the first answer to that question.[133]

The letters and donations accelerated after the July 7 appeal, and staffers regularly updated Parks and *Life*'s editorial and publishing offices about the growing number of responses and the rapidly accumulating funds. Most of the donations, they noted, came not from wealthier readers, but "from 'grass-roots' America—people who are not financially well-to-do but who saw LIFE's pictures and considered themselves rich alongside Flavio and his family."[134] The staff also excerpted a range of reader responses to show *Life*'s management the reasons for people's giving:

> "Please find my first of many more donations for little Flavio's better life: $10. As long as I work—I am just a hotel waitress—I will send money all I can to help him." . . . "My six-and-a-half-year-old grandson is visiting me and asked me to send his 4¢ to help Flavio; I gave him enough to make $1." . . . "I am only 14 and can't give much, but I guess every little bit helps. We are so fortunate in the United States that I hope and pray that 'soon' the people of the U.S. can do something to really help all of South America. I give these $4 cheerfully and with hope." . . . "I hope this $2 of beer money helps." "I have a family of five and am only a wage earner. This $36.40 check was for a set of dishes which we really needed. We decided the Da Silva family needed this money much more than we needed new dishes."[135]

Many letters were addressed to Parks personally. "The personal contact of Gordon Parks with the Da Silvas has been immensely important," wrote one staffer. "This letter from a woman in Texas is typical: 'Gordon Parks should be very proud that a person of his race was the first to find these people. Let him know that we white southerners, deep in the heart of Texas, truly regard him as a wonderful man. I have been a victim of asthma for almost 40 years. How lucky I have been and didn't realize how lucky until I saw that picture of this very ill child.'"[136]

Life's plan to move Flávio to Denver, and the family out of the favela, drew a small number of cautionary warnings from readers: "The only criticism voiced of the Flavio project," the staffer wrote, "about ten or [fifteen] letters of the total—is that giving a "Cinderella experience to one boy, and dramatizing it, is not going to solve the problem of poverty in Latin America, or even in the favela."[137] The magazine took this criticism seriously. A few of *Life*'s form letters explicitly compared the magazine's endeavor to evolving plans for President Kennedy's Alliance for Progress, and expressed the magazine's view of the Flávio campaign as a microcosmic version of the foreign aid program, aimed at "saving" one family rather than an entire nation or region.

By late summer, the Flavio Fund had surpassed $24,000.[138] Publication of Parks' original photographic essay and the subsequent follow-ups brought in 3,635 letters, more than 3,300 of which included contributions.[139] While this significantly exceeded the average number of letters received for an issue and was considerable by historic standards, it was not the greatest response *Life* had received for a story. Ten years earlier, in July 1951, a short article titled "How to Have a Bone-Dry Basement" received 4,138 letters. Almost a decade before that, the March 1942 issue drew more than 5,000 letters—not for the World War II coverage that dominated the pages, but in response to a short instructional article about homemade hats.[140] By 1961, *Life*'s editors knew well they could not predict which stories would garner the most reaction. Increasingly, however, it appeared that Parks' Flávio story would "top any other of the past decade."[141]

. . .

On June 28, Parks flew back to Rio de Janeiro. He was met at the airport by José Gallo and George de Carvalho, and together they headed directly to Catacumba to visit the da Silvas. The family was overjoyed to see Parks, who had improbably pledged to Flávio only two and a half months earlier that he would return someday soon.[142]

Gallo had continued seeing the da Silvas in the interval since Parks' April departure, feeling an unusual sense of personal responsibility. Visiting the favela several times a week, he took the children new clothes, made by his wife, Celia; helped José stock his kerosene stand with fresh fruits and vegetables to augment his meager sales; and drove Flávio and his siblings to sightsee or get haircuts. While de Carvalho later characterized Gallo's small kindnesses as bringing "glimmerings of hope" to the da Silva family in the period leading up to *Life*'s publication of the story, Parks' unexpected return meant that "a bright new world opened up."[143] After the exchange of greetings, the photographer conveyed the extraordinary

FIG. 10 Contract between Time Inc. and José and Nair da Silva regarding transport and care of Flávio da Silva, c. June 1961. Gordon Parks Papers, Manuscript Division, Library of Congress, Washington, D.C.

news of *Life* readers' generosity, and of CARIH's offer to treat Flávio's asthma in the United States. *"Graças a deus!"* Nair exclaimed—Thanks be to God. Together with her husband, she immediately agreed to sign a contract authorizing Parks to resettle Flávio from Rio de Janeiro to Denver for an unspecified period of time (fig. 10).[144] "Keep him in hospital as long as necessary," said José da Silva, "but please bring him back cured and well."[145]

Concerned to not overwhelm the da Silvas, the journalists chose to withhold news of their efforts to find a new home for the family. The search, well under way by the time of Parks' arrival, was difficult. Bureau staffers under Gallo's guidance struggled to identify an appropriate new location, even placing "house wanted" ads in local newspapers. A number of early candidates were deemed too expensive or impractical for the family. Finally, a one-story bungalow was located in a housing settlement for workers with a population of 7,000, located thirty-five kilometers northwest of Catacumba by road, in the suburban neighborhood of Guadalupe. De Carvalho described the community to *Life*'s editors as "clean, orderly, and spacious, with all the basic utilities which Americans take for granted but Brazil's favelas woefully lack: streets, sidewalks, sewers, tapwater, electricity, schools, police protection and public health facilities."[146] The bureau purchased the house on July 1 for 750,000 cruzeiros, Brazil's currency at the time. Roughly equivalent to $3,000 in U.S. dollars, de Carvalho noted, the bungalow was similar in value to a U.S. home costing $7,500, well below the median price for the time. With the clock ticking until Flávio's departure, Time Inc.'s agents took possession that same day and immediately put professional electricians and plumbers to work, repairing and updating the aging residence through the weekend. A dozen local workmen volunteered to assist;

as one said of the da Silvas, "These people had a hard time. . . . We know because many of us came to this project from the favelas. We want them to start out right and we're glad to help."[147]

While the Rio bureau dedicated itself to planning the family's future, Parks once again documented their life in the favela. He brought along a 35mm movie camera on his return, and hired a local crew, led by cinematographer Rex Endsleigh, then set about filming Flávio's last days in Catacumba before he left for the United States. Parks shadowed the family in their shack and out in the favela, filming scenes he had previously recorded in still photographs. The da Silvas, awaiting Flávio's departure, dutifully carried on with their work and home routines while Parks blocked his shots and gave direction. This footage, intended for a "simple short documentary" about their daily life, as de Carvalho described it, grew to fifteen hundred meters, or approximately an hour's worth of coverage.[148]

Flávio seemed hardly to comprehend what was happening. In contrast to his parents and siblings, who expressed varying degrees of excitement and relief at the news of their changed circumstances, the eldest son simply smiled and carried on with his household chores, surprising the Time Inc. team with his imperturbability and maturity. De Carvalho observed only that "he hummed to himself and rushed to stare at the sky every time an airplane flew high over the tangled favela shacks," curious about his first plane ride a few days hence.[149] The bureau engaged a Rio lawyer to assist with Flávio's departure; working pro bono, he secured a passport, exit permit, and U.S. entry visa in only forty-eight hours. To ensure his safe travel and to observe U.S. law, the team took Flávio to a Brazilian doctor, who provided confirmation that he didn't have tuberculosis.[150] On Monday, July 3, Parks and

```
                                                    3

stand the effect of this instrument and that we do hereby
approve and confirm it of our own free will and volition.  We
also understand that this instrument may not be changed orally
but only by a further written instrument executed with due
formality by each of us with the written approval of Time,
Incorporated.

        IN WITNESS WHEREOF, we have hereunto set our hands
and seals this        day of           , 1961.

                                    Flávio Da Silva        [L.S.]
    Witness
                                    Jose Da Silva          [L.S.]
    Witness
                                    Nair Da Silva          [L.S.]
    Witness
```

Gallo collected Flávio and brought him to Parks' hotel. There he bathed—his first time ever in a bathtub. Parks later remembered that "the water was black. The first attempt only loosened the surface dirt. It finally took three tubs of hot water . . . to get through the twelve years of dirt ingrained in his skin."[151] Afterward, they went to a boys' clothing store, where they purchased clothes and shoes for Flávio to travel in, overlooking the clerks' looks of contempt for the favela child (p. 57). Flávio walked out, Parks' recalled, "looking like a student from Eton."[152]

That same day, a team gathered by the bureau visited the main Rio branch of Sears, Roebuck, where they methodically selected provisions for the new home in Guadalupe. Working from the store's morning opening through two-thirty p.m., they purchased a sofa, a table, and chairs; bedroom sets and linens; a gas stove and Kenmore refrigerator; dishes, pots, and pans; and a radio, an electric iron, soap, and ten toothbrushes. Discounted by Sears to 231,134 cruzeiros, or roughly $900 U.S., the home's furnishings were "the simplest and cheapest essentials, meeting the criteria set by *Life* readers," de Carvalho telexed New York. With the home refurbished and furniture paid for, "we finally believed it ourselves, and told the family their new home would be ready for them to move in by Wednesday."[153] The family was ecstatic, Parks wrote: "The children went into hysterics. . . . Nair accepted the word in stunned silence as she slumped on the bed with Zacarias in her arms. José da Silva reacted strangely, his eyes holding us between his awe and disbelief."[154] The next day the family began preparations for the move, Nair washing all the clothes while José shuttered his kiosk and Flávio packed up the few things they chose to take with them. Across town, Sears delivered the new furnishings, and supportive neighbors came by to put everything in place.

Parks' filming had drawn attention throughout Catacumba, and after hearing of the da Silvas' changed fortunes, some *favelados* reacted with resentment. Maria, Luzia, and Mário were even attacked, Parks later reported.[155] On Wednesday, July 5, freshly bathed and dressed in their best clothes, the da Silvas left the shack in the early morning, attended by a small team from the Rio bureau and a few sympathetic friends. They descended the hillside in a line, bundling their possessions to the bottom, where a crowd gathered at the favela's entrance to watch them leave. Rex Endsleigh and Parks' crew documented the solemn scene on film, while *Life* freelancer Paulo Muniz made still photographs of the descent. One bystander grabbed his shoulder, Parks remembered: "'What about us? All the rest of us stay here to die!' she demanded. I looked at her for a moment, answerless, then moved away."[156] The family climbed into a Volkswagen Kombi with Parks and the others. Flávio stared at the favela out the window as they pulled onto the Avenida Epitácio Pessoa, his eyes misting over.[157]

On the way to their new home, the family stopped at Sears, Roebuck, which had offered *Life* a discount on clothes and toys. It was their first time in a mainstream department store. Brazilian reporters, alerted to the unfolding story by Time Inc., waited with notepads, cameras, and klieg lights at the ready. The family was startled by the attention, and the children ran gleefully among the racks, grabbing at product displays. Photojournalists followed after, "posing them in incongruous situations" until José Gallo took control of the chaos.[158] Attended by salespeople, the family selected clothes—an outfit for each, with shoes, changes of underwear, and pajamas. The girls got plastic tiaras, de Carvalho reported, all the children received candy, "and there on the second floor they saw the toy department. It was irresistible but they were well behaved and radiantly happy to choose one toy each. It was Christmas in July, their first Christmas."[159] After posing for the gathered newsmen, they resumed their journey.

Following the BR-101, Brazil's major north-south highway, the van steered northwest of central Rio, then turned into the Guadalupe district around two p.m., arriving at Rua Oito, 22 (22 Eighth Street). Exiting the van outside their new home, they were greeted at the gate by neighbors, many of whom had helped prepare the house over the previous five days (fig. 11). Parks, Muniz, and Endsleigh all documented the arrival with their cameras. "The family went in almost timidly," de Carvalho wrote:

NERVOUSLY FATHER JOSÉ NODDED AND BOWED TO HIS NEW NEIGHBORS. MOTHER NAIR ASKED IN HER THIN TIRED VOICE, "IS THIS FOR US?" ONCE INSIDE THE CHILDREN RACED AROUND IN DELIGHT, IMMEDIATELY AT HOME. THEY PULLED OUT DRAWERS AND TRIED THEIR BEDS. LITTLE LUZIA, WHO ALWAYS TRIED SO PATHETICALLY HARD TO KEEP CLEAN IN THE FAVELA, SLIPPED SHYLY INTO THE BATHROOM. FLAVIO LOOKED AT EVERYTHING AND ASKED QUIETLY, "WILL MY FAMILY REALLY LIVE HERE WHILE I'M GONE?"[160]

FIG. 11 Gordon Parks, Detail of proof sheet, Set No. 63020, Take No. 2, C-1, 1961. The Gordon Parks Foundation

With two small bedrooms, a combination living-dining room, kitchen and bath, and porches looking onto yards at front and rear, the modest house was in fact a model home, the first built in the district. The backyard held a guest cottage. A flowering vine, planted ten years earlier by the daughter of Brazil's fabled leader Getúlio Vargas, spread across a lattice in the front yard.[161] While José and the children explored, Nair entered the kitchen. Neighbors had unpacked and set up all the new amenities: the furnishings were in place, the cabinets fully stocked with dishware, the refrigerator full of food. Lunch was cooking on the stove, plenty for everyone. It was a surreal scene: in a heartbeat, seemingly, the da Silvas' world had shifted on its axis.

Reporters followed the van from Sears to witness the family's resettlement. They interviewed José and Flávio, along with Parks, Gallo, and de Carvalho. The Time Inc. bureau distributed the *Life* issues of June 2, 16, and 30, with Parts 1–3 of the Latin American series, and shared key information: details of the surprise intervention by the magazine's readers, the amounts spent to set up the da Silvas in their new life, and plans for Flávio's asthma treatment in the United States. Asked whether the magazine had considered aiding Catacumba's population, de Carvalho replied that if it did, it would seek guidance from Carlos Lacerda, governor of Guanabara State (the Brazilian province that included Rio), an outspoken advocate for eradication of the favelas and relocation of their

inhabitants.[162] Parks revealed many behind-the-scenes details, including the surprising news, reported by the *Tribuna da Imprensa*, that "he wished, but was not able, to adopt the boy Flavio. Parks divorced his wife . . . and the law does not permit a divorced person to adopt a child."[163]

The neighbors and journalists finally exited in late afternoon, leaving the family to settle into its new home. Returning at eight p.m., Parks and Gallo found Flávio uneasy about departing from his family so soon after the move. Worried, the boy pulled de Carvalho aside to ask solemnly if the magazine would use some of the donation funds to buy his stepfather a truck. He then packed his new suitcase and donned the travel clothes purchased days earlier.[164] His mother, Parks noticed, had ignored Flávio through much of the day, in a self-protective withdrawal:

> When the time to leave arrived, Flavio came up behind her and touched her arm. "I've come to say good-bye, Momma," he said. Nair didn't move. Puzzled, he looked toward me. I motioned him toward her. This time he attempted to put his arm around her. "I'm sorry but I have to go now, Momma." Suddenly Nair turned and, in a spasm of grief, enclosed him tightly in her arms, sobbing hoarsely. "Go, my son. God protect you." Confused, Flavio took some coins from his pocket and pressed them into his mother's hand. Then he hurriedly picked up his suitcase, took my hand, and pulled me from the house.[165]

José da Silva accompanied Flávio to Galeão International Airport, where the boy was scheduled to depart at 11:45 p.m. on a Varig flight with Parks and Gallo. The press converged on the small group. Bathed once again in floodlights, under the scrutiny of the cameras, Flávio stood bravely but finally lost his composure, crying and burying his head against Parks' hip. Hurriedly they exited to the apron, where José said good-bye outside the waiting Boeing 707. "Bring Flavio back," he said once more, "cured and well."[166] In the first-class cabin, Flávio tensed throughout takeoff, relaxing only once the plane was in the air. After the dinner service, he finally fell asleep, exhausted from his extraordinary day, and Parks photographed him sprawled in his seat (p. 62):

> I looked at him, wondering what he was dreaming about. Whatever his dreams, they could not possibly prefigure the life he was about to begin. Nothing in his experience could prepare him for that. It was enough to know that he was heading for something far better than he was leaving.[167]

. . .

After a brief layover in New York, Flávio arrived in Denver on July 7, the same day *Life* published readers' letters about him. His first plane ride had gone surprisingly well; despite persistent coughing, he suffered no asthma attacks. Greeted at the Children's Asthma Research Institute and Hospital by curious children, parents, and staff, Flávio and Parks were photographed heavily, making their arrival a spectacle equal to the da Silva family's visit to Sears (fig. 12). When he entered the hospital, the excitement of the journey ended for Flávio: he was formally admitted and immediately underwent medical examination, attended by Parks and Gallo.

Photographs by Hikaru "Carl" Iwasaki, a Denver-based freelancer sent to cover the next stage of the unfolding story, show Flávio disoriented amid the unfamiliar figures in lab coats, their probing scrutiny, and the bright, sterile environment (pp. 64–67). Over the next several days and at intervals through July, August, and into September, doctors conducted an extensive round of studies, including sometimes painful physical exams, body measurements, multiple X-rays, and blood, allergy, and stool tests. Gallo served as interpreter, helping Flávio to answer the doctors' questions. In general, his health was found to be stable, with only mild symptoms of asthma, but the medical team noted a worrisome fact: "[Flávio's] physical examination revealed an undernourished and underdeveloped 12 year old boy, whose weight and height corresponded to a 6-7 year old boy, by U.S.A. standards."[168] Parks, who witnessed the initial exam, observed that in addition to his malnutrition, "his teeth were in terrible condition. His feet were badly infected. His hearing was impaired because of massive accumulations of wax in his ears. There was the language barrier, cultural shock, and, as far as the doctors were concerned, he was still a candidate for tuberculosis."[169] Flávio stayed in the hospital for monitoring throughout his first week at CARIH.

Lewis Bernstein, head of psychological services, took pains to acknowledge the cultural barriers complicating an adequate assessment of Flávio's intelligence, manual dexterity, visual recognition, and other markers of mental and emotional development:

> It is unfair to compare him to norms for American children, but it is estimated that he is . . . functioning at approximately the level of an average nine year old American child who has been brought up in an adequate

FIG. 12 Gordon Parks, Untitled (Flávio da Silva Arriving at Children's Asthma Research Institute and Hospital), Denver, Colorado, 1961. The Gordon Parks Foundation

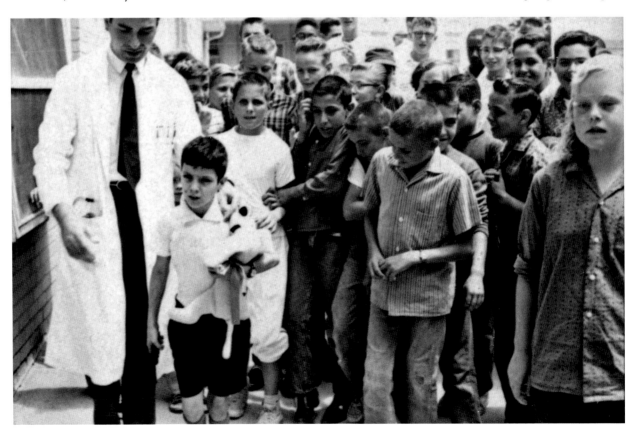

environment. When one considers the extreme deprivation which Flávio has experienced throughout his life, this estimate is not discouraging.[170]

Pointing out Flávio's alertness and receptivity to his new surroundings, Bernstein projected that "he will adjust well at school, and learn the language adequately. . . . It is our present estimate that his intellectual functioning will show marked gains in the next several years."[171]

Meanwhile in Brazil, after the breathless coverage of the da Silva family's good fortune, a counterreaction developed within government and in the media. On July 6, the day after Parks and Gallo's departure with Flávio, Brazilian authorities arrested Parks' cinematographer Rex Endsleigh and seized the second part of his documentary film footage and taped audio. While Parks had taken the first 1,500 meters from the country, an additional 2,500 meters (or ninety minutes) of raw footage with the da Silvas' departure from the favela, the stop at Sears, and arrival at their new home was confiscated by order of Ascendino Leite, chief of Brazil's Service of Censorship and Public Diversions. Early reports indicated that Leite, a former journalist himself, had declared the film "communist propaganda" and "against the national interests."[172] De Carvalho rushed to resolve the problem, defending the magazine's intentions in a statement to journalists at Rio's Department of Political and Social Order: "[The film] will be exhibited in clubs and social groups with a philanthropic aim as a part of a campaign that LIFE started two weeks ago, to stir up North American public opinion about the problems of Brazilian slums." After meeting with Leite, de Carvalho purchased an export license, formally submitted the film for review, and the censor declared the matter resolved. The brief spectacle seemed deliberately engineered to embarrass Time Inc., in retaliation for *Life*'s cultural intrusion.[173]

Endsleigh's detention provoked an onslaught of commentary about *Life*'s endeavor and created a minor public relations crisis for the magazine. On Saturday, July 8, several Rio newspapers published articles and editorials addressing the confiscation, Parks' photographic essay, and the fate of the da Silvas. *Life*, stated one journalist, "did not commit a philanthropic act or one of human solidarity. It took advantage to show to the eyes of the world . . . a false understanding of the social and economic problems. In view of this problem which involves evident hidden intentions, our attitude can only be that of protest."[174] Another editorialist wrote:

> The powerful magazine (powerful in reporting and political interests) repeated then the capitalist fable: they showed the world our José [da Silva] . . . as the symbol of poverty in Latin America and turn[ed] him afterwards into a charming millionaire, thanks to the magnanimous spirit of good neighborliness of its seven million North American readers. Now that José can no longer be the symbol of poverty in Latin America, naturally because he has his own house . . . why doesn't the fabulous LIFE transfer [its support] to another Brazilian slum dweller?[175]

Not all the Brazilian press was negative. One writer excoriated Leite for the episode: "Ascendino knows that LIFE is not a scandalous or malicious magazine. It depicts the world as it really is, not as the poets would like our planet to be. This is the mission of the Press. We are not gardeners or confectioners."[176] Another, pleased to see the controversy was over, wryly noted that the quick resolution meant that

> there was not time for our nationalists in their unfortunate stupidity and bad faith to begin to mobilize the Brazilian public opinion against this honest attempt to show the poor way of a country of rich possibilities. They, the nationalists, would be incapable of mobilizing public opinion in order to solve the problem of the slums, but would be the first to hinder any solutions.[177]

Manchete, Brazil's most popular weekly picture magazine, settled for a trenchant satire by its cartoonist Claudius, mocking the entire *Life* episode as an absurdist spectacle (fig. 13).[178]

Having returned to New York from Colorado, Parks visited *Life*'s headquarters on Sixth Avenue, where four rolls of film from his latest visit to Brazil had been delivered for processing and editing, along with additional rolls by Paulo Muniz covering Parks' visit and the moving of the da Silvas.[179] Days later, film from Carl Iwasaki, documenting Flávio's early efforts to make a new life for himself, arrived as well from Denver, to be included in the magazine's planned update.

A significant change had taken place at *Life* during Parks' absence. On July 1, Ed Thompson, who had led the magazine throughout Parks' tenure, since his arrival in 1948, was formally ousted as managing editor, and assigned by Luce to the newly created (and nebulously defined) position of "editor." Thompson understood the transition, incorrectly, as a promotion: disguised as a rise up the ladder, it was in fact a brutal fall from the top of *Life*'s masthead, at the height of the magazine's popularity. Thompson's replacement was George Hunt, his ambitious deputy, who had secretly lobbied Luce for the position.[180] Hunt set to work on the coming issues without missing a beat.

The editorial team worked quickly to write and lay out the story. De Carvalho sent four lengthy telexes to Time-Life headquarters on July 12 and 13 with a detailed account of the magazine's feverish efforts to move the da Silva family and bring Flávio to CARIH, and the family's progress in their new home. *Life* writers used these extensive notes, and updates from Denver about Flávio's first days, to compose the text blocks and captions that would accompany the photographs by Parks, Muniz, and Iwasaki. The follow-up was published in the July 21 issue as *Life*'s "Story of the Week" and titled "The Compassion of Americans Brings a New Life for Flavio" (see pp. 244–257). It had been just over a month since Parks' original photo essay had appeared. On the cover of the issue, a color portrait by Iwasaki shows Flávio beaming with joy from his hospital bed in Denver, clutching a stuffed dog. Below, the tagline reads "Flavio's Rescue: Americans bring him from Rio slum to be cured."

FIG. 13 Claudius, "'Life' na Favela"
("*Life* in the Favela"), *Manchete,*
July 22, 1961

The photo essay extends to twelve pages and includes thirteen photographs, approximately the same length as Parks' original story. The opening text introduces the first pair of images, by Parks and Iwasaki, juxtaposed portraits of Flávio that cleverly update and invert the earlier story's page spread of foreboding: "It is the same boy—lying then on a slum bed, skin tight on delicate bones, eyes old with anguish; and now, swinging skyward, shouting, *"Está Bom!"* a grin blooming on his face."

Following the format of the original photo essay, *Life*'s editors used each page spread to illustrate episodes of the family's whirlwind progress since the end of June. The second spread, with photos by Parks and Muniz, shows the da Silvas' march from the favela and their new home in Guadalupe, under the title "Out of the Shanty-Town Slum to a Place Fit to Live In." The third spread is headlined "Parting—With Tears and New Shoes"; Parks depicts Flávio trying on his new footwear and saying good-bye to his mother from their new home, while Muniz captures the little boy clinging to Parks for comfort as the media presses in at the airport. The fourth spread includes one full-bleed photograph across both pages: a stunning image by Iwasaki of Flávio seated, with doctors studying his X-rays in the background—as the caption reads "Bewildered Patient in U.S." Across the last two spreads, four pictures by Iwasaki show Flávio's first days in Denver, heralded as "A Happy Start in a Friendly World": playing sports, learning words in English, and making new friends.

. . .

On July 24, Parks' original story was distributed across Latin America in the pages of *Life en Español*, the magazine's Spanish-language international edition (fig. 14). Time Inc. launched LIFESpan, as company staff called it, in 1953, to help "strengthen communications between the U.S. and our neighbors south of the border."[181] While the magazine carried translations of stories from *Life*, its pages also included original content: for example, in March 1961, John F. Kennedy chose *Life en Español* as the exclusive forum for his first public announcement of the Alliance for Progress, in an effort to reach readers in Latin America.[182] By that spring, circulation of the magazine had reached new heights; it was Time Inc.'s first export periodical to exceed 400,000 in sales.[183] The July 10 issue, featuring the first part of "Crisis en América Latina," reached 442,681 readers across Central and South America—a record high due, editors believed, to the presence of Fidel Castro's face on the cover.[184] Two weeks later, the Flávio story reached 413,814 readers, the magazine's fourth-highest readership for the latter half of 1961.[185] In Brazil, the issue likely sold more than 12,000 copies.[186] While the da Silva family's story had been well documented in the Brazilian press and was still fresh in readers' minds, the July 24 issue gave Flávio's compatriots their first opportunity to see the original photographs. The layout of the story—titled "La Miseria, Enemiga de la Libertad"—was nearly identical to that in the English-language version of *Life*, with Parks' diary entries slightly truncated to fit on a single page.

The Inter-American Economic and Social Council, with representatives from throughout the Americas, convened a special meeting at the resort town of Punta del Este, Uruguay, on August 5, in order to formally establish the Alliance for Progress. The United States, as primary financier of the aid programs under

FIG. 14 "La Miseria, Enemiga de la Libertad," *Life en Español*, July 24, 1961

discussion, dominated the conference, while adopting a public posture of egalitarianism alongside the other nations. "There are more than twenty countries involved," Richard Goodwin, a State Department official, tellingly wrote President Kennedy, "and we have to talk to them first to make sure everyone understands what's supposed to happen; otherwise we'll just end up with two weeks of speeches."[187] On August 17, all the countries in attendance signed the Declaration and the Charter of Punta del Este, the latter officially "establishing an Alliance for Progress within the framework of Operation Pan America." U.S. representatives reaffirmed President Kennedy's earlier commitment of more than $1 billion in funding, and suggested to the gathered nations that investment from all international sources could top $20 billion over ten years. Signatories committed to work toward an average annual rate of per capita economic growth of 2.5 percent, achieve price stability for goods and services, and set targets for social goals such as access to public education, reducing adult illiteracy, and improving availability of water and sewers. An international panel, dubbed the "Wise Men," would review all proposals for aid.[188] After reading a telex from Washington bureau chief John Steele describing the agreement, Henry Luce called on *Life en Español*'s editors to run a story giving "proper emphasis to the obligations of Latin American countries to deliver on their part of the bargain, i.e., to put their own houses in order economically, politically, socially."[189]

Brazilian president Jânio Quadros hedged his country's participation in the Alliance for Progress. While he sent a delegation to Punta del Este and supported the charter, Quadros tried to assert his country's independence and appease its nationalists; he dispatched Vice President João Goulart on a provocative trade mission to both the Soviet Union and China while the conference was in session.[190] Quadros invited the charismatic Ernesto "Che" Guevara, who held positions in the new Cuban revolutionary government, to Brasília to be publicly honored immediately after the conference ended. Shortly thereafter an explosive rumor circulated, spread by Guanabara State governor Carlos Lacerda, that the president intended to suspend Congress and install himself as dictator. This succession of events proved fatal to Quadros' political survival, and eight days after the Alliance was formed, on August 25, he resigned. Stating that he wanted "a Brazil for Brazilians," Quadros blamed his departure on mysterious "forces of reaction . . . including some from abroad," that blocked and thwarted his efforts "to lead the nation along the road to true political and economic liberation."[191] The Soviet Union immediately blamed the United States for pressuring Quadros into resigning.[192] After a brief constitutional crisis, during which more than two hundred students stormed the U.S. embassy demanding return of the president, the Brazilian congress seated Goulart as the country's new leader, albeit with the imposition of new limits on presidential power. Many deputies shared the view, also held by the U.S. government, that Goulart would be even friendlier to Soviet and Cuban interests.[193]

· · ·

Meanwhile, the da Silvas struggled to adapt to their changed circumstances. On July 15, just days after moving, Nair gave birth to her ninth child, a daughter named Celia, in tribute to José Gallo's wife.[194] Accustomed to the favela, and absent Flávio's stewardship, the children at first made a mess of their new environment. Nair gradually habituated herself to keeping the household, and to using appliances she had never imagined having. José da Silva moved his brother Julio and his family into the guest cottage at the rear of the Guadalupe home. Together the brothers put the favela kerosene shack up for sale and made plans to launch a trucking and hauling business. By September, José Gallo found a secondhand 1946 truck and used reader donations to make the down payment, with the balance to be paid from da Silva's earnings.[195] However slowly, the family adjusted, and the three eldest siblings enrolled in a nearby school for the coming semester. Dom Hélder visited the da Silvas and pledged to support their transition. After visiting friends at Catacumba, Flávio's sister Maria told de Carvalho, "I never want to live in the favela again. Never never never."[196]

Through the latter half of 1961, Flávio adjusted to his treatment, his new home in Denver, and the beginning of his formal education by fits and starts. In late July, CARIH's founder and president, Arthur Lorber, wrote George Hunt that José Gallo, departing after two weeks, was forced by Flávio to take presents to the da Silva family: his new stuffed dog for his brother Zacarias; his toy airplane and car for his siblings; and his patient's weekly allowance for his parents.[197] Despite this generosity, Flávio struggled initially to fit in. Fearful of the unfamiliar people and surroundings, distressed at the frequent medical testing, and traumatized by separation from his family, with attendant sense of withdrawal from his importance in their lives, he frequently lashed out at his fellow patients; he made few friends during his first months at CARIH. "He was quick to fight," a *Life* reporter observed, "with the gutter tactics he had learned for self-preservation in the favela: eye-gouging, choking, the knee in the groin."[198]

While some of his adult supervisors were slow to sympathize with the difficulties Flávio faced in fitting in with the other students—many of whom were jealous of the attention he had received—several made sincere, dedicated efforts to help him adapt. Principal Virginia Hansen of Cheltenham, the local school he would attend, volunteered to tutor Flávio in English during the weeks before the start of the school year. A local couple, Portuguese-born José Gonçalves and his wife, Kathy, volunteered to host Flávio each weekend, so that he could learn English with Kathy and play with their three young boys, Rick, Mark, and Neil. In September, when Flávio entered the first grade, surrounded by much younger children, his teacher Eleanor Massey devoted herself to his progress.[199] In his first-quarter report, Massey wrote:

> Adjusting to a formal classroom and 31 other first graders must have been quite a challenge to Flavio. The fast shifting of authoritarian personnel must also have given

him some concern. The ordinary frustrations which these occasions would involve must have been a considerable task to deal with. With an especially low point of tolerance it seems somewhat remarkable that Flavio has made the excellent progress now showing up during the past three weeks. He now volunteers information as well as asking for it—and seems to be enjoying his schoolwork as well as his classmates. His keen sense of humor, no doubt, has helped him in this adjustment. He loves to tease and argue. He is quite unhappy with himself when he makes an error. He does not like to deviate from routine. He enjoys attention and loves to participate in musical activities.[200]

Medically, Flávio saw considerable improvement from the time of his arrival, growing nearly two inches and gaining five pounds by December. After two dramatic asthma flare-ups, he experienced only minor, controllable symptoms from October on.[201] CARIH's executive director, Israel Friedman, wrote José Gallo in Brazil a detailed update shortly after Flávio began school. Despite his progress, Friedman noted, an unusual paradox persisted in the boy's nature:

> He does miss the heavy responsibilities of adulthood that he exercised each day in his home in Rio in having sole care of his younger brothers and sisters. It is a curious, touching thing watching this boy develop. He is learning to enjoy the pleasures and carefree moments of childhood which he did not have previously and yet wishes more freedom and responsibility in line with his former adult-type living and behavior attitudes.[202]

At the end of December, Flávio experienced his first Christmas at the Gonçalves family's Denver home (pp. 80, 81). Though out of contact with his parents and siblings for nearly six months, he had found many new friends concerned for his future. As Parks later wrote:

> Flavio received gifts not only from the Gonçalves family but also from many *Life* readers who had not forgotten him on this day: two transistor radios, water colors, blue jeans, a set of matched marbles, new shoes, three ties, a water pistol, a billfold, fountain pen, socks, a hat, a baseball and glove, and money. Grinning broadly, he sat on the floor in his pajamas amid the presents and wrappings, perhaps convinced at last that there was indeed a *Papai Noel*.[203]

. . .

Many of *Life*'s contributors had specified how they wanted their donations used, and the magazine meticulously tracked these designations. While most expressed a desire to help Flávio individually, or the da Silva family, a number of readers asked whether the family's neighbors, the other residents of Catacumba, could be helped as well. Reporting these requests to *Life*'s publisher, the Letters department advised: "We should be ready to widen the project to include other families, to help the favela."[204] By late summer, as funds continued to accumulate, C. D. Jackson made the decision to launch a campaign to improve Catacumba.

On Friday, August 11, Ruth Fowler appeared at the Brazilian Press Association (ABI) in Rio de Janeiro, with José Gallo by her side, to announce the magazine's intentions. *Life*'s readers had been generous, Fowler said, so much so that the magazine now expected to commit up to $20,000 to recuperation of the favela.[205] While preliminary plans called for installation of plumbing up the hillside, a sewer system, paved stairways, and electricity, Fowler expressed the magazine's desire to work closely with authorities in Rio and Guanabara to determine the best course of action. Dr. José Artur Rios, director of Rio's State Service for Favela Rehabilitation (SERFA), was present at the press conference; in addition, Fowler said, a formal plan would be presented to Governor Lacerda the following week.[206] *Life* intended its operation as a pilot program to inspire future efforts, Fowler stated; to ensure success, she announced her intention to meet with representatives of Catacumba's *favelados*.[207] On Monday night, August 14, after contacting numerous government officials and representatives from Brazilian and American corporations, charitable organizations, and societies, Fowler visited Catacumba, accompanied by Gallo and de Carvalho, to speak with residents. While her dialogue with the *favelados* was an extraordinary expression of commitment, Fowler's consultation with Lacerda and Rios was shrewd politically: the two officials were known as architects of the state's plan "to remove favelados & erase favelas," as de Carvalho noted in a memo to Fowler.[208] After ten days in Brazil, Fowler departed, leaving the project in Gallo's hands.

President Quadros' resignation and the ensuing political crisis slowed the rehabilitation project somewhat.[209] Planning continued, however, and by mid-September a schedule had been established and the *favelados* had registered with the government as a formal association, called the Society of Residents and Friends of Catacumba, or SOMAC. By the end of 1961, four hundred residents had enlisted, gathering each Tuesday night for general meetings, which Gallo also attended. Subcommittees emerged as well, including one devoted to public works projects for the favela, and a women's auxiliary offering lessons on home care, sickness prevention, and hygiene.[210] At the beginning of October, SOMAC completed its first construction project, supported by the Flavio Fund: a basic community center. This roughly eleven-by-sixteen-foot space was designed to accommodate SOMAC meetings, provide a public telephone, and serve variously as a locked storehouse for tools and supplies, a registration center for a community census, and a distribution point for donated food.[211] By mid-month, the first major public works project began—an extensive effort to terrace and pave the favela's hillside pathways with stairs, dig and line sewer ditches alongside, and construct bridges to cross the sewers. Four crews of volunteer residents, averaging 150 in number, performed the work on Sundays and holidays, using cement provided at deep discount and guided by a SERFA engineer.[212] Future plans were developed for a water supply system, with a complex network of pumps to distribute water up the hillside.[213] The Rio bureau telexed New York: "Catacumba project going

along very well within adopted principle of self-help. Our main task has been to supply favelados with means with which they can aid themselves."[214]

In October, *Life* sent a letter to readers who had contributed to the Fund without specifying how they wanted their donations to be used, asking their permission to support installation of a plumbing system for Catacumba.[215] The collective answer was yes—and even more money was sent.[216] By November's end, *Life* had received $26,309.34 and was committed to using part of that sum for Catacumba.[217] It is clear that *Life* saw support for the favela as a microcosm of the work under way to promote and strengthen the Alliance for Progress: in de Carvalho's words, the effort would be a "pilot model for a major continental campaign of local self-help backed by people-to-people donations from the U.S."[218] In time, a "people-to-people" program, Partners of the Alliance, would be launched, connecting U.S. states with Latin American countries. California partnered with Chile, Idaho with Ecuador, Oregon with Costa Rica, and Utah with Bolivia, among others, so that U.S. citizens could provide funding as well as tools, machinery, and other supplies to support economic and social development in sister communities.[219]

Hearing of *Life*'s success, Peace Corps director Sargent Shriver, brother-in-law of President Kennedy, visited Catacumba on November 9 during a mission to finalize Brazilian participation in the Corps, the U.S. volunteer program for social and economic development. Arriving with Governor Lacerda, Shriver spoke to José Gallo about SOMAC and the progress and costs of the stairway project. Sweating through his shirt in the midday sun, he scrambled up the steep hillside and quizzed residents about their participation in the enterprise and their feelings about the construction. Late for a luncheon at the U.S. ambassador's residence, Shriver shook hands with Gallo and SOMAC's leaders and congratulated them on their achievement—"very fine job indeed"—before taking his leave.[220]

One year after Parks' photo essay was published, SOMAC and the Catacumba project had become, as Ruth Fowler had hoped, a model for others to study. Visitors from throughout Brazil and other Latin American countries arrived periodically to observe its progress and methodology. By June 1962, all twelve of the favela's main paths had been converted to stairways, and smaller byways were now under construction.[221] Despite this, new *Life* administrator Peter Hoyt, assistant to the business manager, nearly shut down the project after being asked by his superiors to "see if he couldn't close out that Rio business."[222] Fowler intervened, writing a long report to Hoyt summarizing the da Silva family's move, Flávio's health and welfare, and the improvement of Catacumba. Trying to justify the extraordinary logistical undertaking and ongoing expenses, Fowler argued that "at least one and perhaps two additional stories will appear in the pages of LIFE about Flávio, his development and his future."[223] In defense of the magazine's efforts to intervene in the lives of these distant Brazilians, Fowler concluded with a simple statement of purpose.

LIFE's objective in dealing with this matter is to:

1. Protect the interests of the da Silva family, which we believe we have done as humanely and as generously as is appropriate.

2. Protect the interests and welfare of Flávio da Silva, which we believe to be in progress, and

3. Contribute in a specific way to the welfare of the 20,000 residents of Catacumba favela practically and sympathetically, concurrent with their agreement and the technical skills made available by the government of the state of Guanabara, Brazil.[224]

Her defense worked. Hoyt proceeded to firm up the project's finances, and in November, Time Inc. formally established the Flavio Fund at Manufacturers Hanover Trust Company of New York. This trust fund would disburse money for the ongoing work at Catacumba and for Flávio's continuing expenses. Fowler and Gallo remained as trustees, and *Life*'s commitment continued.

. . .

At the end of June 1962, Fowler stopped off in Denver for a two-day visit with Flávio, en route to Seattle for business. Now halfway through his time at CARIH, Flávio spent summer weekends after his first school year with the Gonçalves family, both in the city and at their cabin in the Denver foothills. With José, Kathy, and their sons, he experienced the typical summer idyll of an American middle-class boy, enjoying movies, ball games, picnics, and fairs; fishing and camping; tourist trips along the Colorado River; and his first Fourth of July parade (pp. 82–85).[225] In a letter to José Gallo before her visit, Fowler speculated about what it would mean to keep Flávio in the United States at the conclusion of his treatment—flirting, perhaps, with the idea of adopting him, or lobbying the Gonçalves family to do so. "I doubt whether I'll be able to . . . ," she wrote,

> but I will try to find out what Flavio's attitude seems to be about going home or staying here. . . . Through all of my concern for him, and realization that he seems to love his life in the United States, I never forget that he is Brazilian and thus his future belongs to his own country probably, even though his youth might be spent here. Also, I know he loves his family, but time is dimming that picture a bit, and in the long run he might be able to do more for them if he could stay here in school.[226]

Shortly after Fowler's visit, CARIH clinical psychologist Robert Titley gave Flávio a battery of tests, updating his intake studies. He was now functioning just one or two years behind his age group, the doctor found. His "great gains . . . in the areas of intellectual, emotional, and social functioning," Titley concluded, "could not be described as dramatic, but simply as a predictable change in a child who, with apparent potential, blossomed in a setting and culture where potentials can be realized."[227] With an abundance of "practical intelligence," Flávio might one day be a skilled workman, the doctor forecast, perhaps a mechanic or machinist. Taking note of his

progress, Fowler wrote a memo urging *Life*'s managing editor, George Hunt, to consider publishing an anniversary feature, updating readers about Flávio and improvements to the Catacumba favela.[228] For whatever reason, Hunt decided against running such a story.

As Flávio's time in Denver neared its end, elaborate preparations began for the conclusion of his term at CARIH and Cheltenham school. Testing showed that his bronchial asthma was virtually dormant, with no flareups in many months. Though doctors were optimistic about his health, as a preemptive measure they trained Flávio to handle any future asthma attacks once he returned to Brazil.[229] Other indicators established that his intellectual and emotional progress had been real, if incremental: he tested at or above average in both linguistic and arithmetic sections of the Stanford Achievement Test, and was judged to have matured considerably in work habits, self-control, attitudes toward both authority and teamwork, and sense of personal responsibility.[230] Many of the adults who supervised him regarded Flávio as a natural leader (fig. 15).

Despite this, a pained sense took hold among most of his doctors, teachers, and test examiners that for all his improvement, Flávio faced very real limitations in his educational and professional future. Adeline Kosmata, his second-year teacher, could not help inflecting her final review with a patronizing tone: "It has been a pleasure and a challenge to work with Flavio. He does try so very hard, and I do wish for him the very best."[231] Jonathan Weiss, the clinical psychologist CARIH assigned to Flávio's final assessment, unsparingly suggested that previous examiners' optimism about his potential was contradicted by consistently below-average intelligence tests. He bluntly stated that:

> Flavio's social skills and charm, and the high level of motivation he manifests . . . lend him the air of brightness which this Examiner noted as well. Discounting these factors, however, one must describe Flavio as a boy who is possessed of very limited capacities for abstract thinking and for performances which require a creative turn of mind. . . . In planning for Flavio's education therefore, it would seem unrealistic to stress his acquiring broad intellectual skills, and is recommended instead that thought be given to manual training in an area of interest to Flavio.[232]

Increasingly anxious about the emerging consensus, Fowler consulted the chief of CARIH's clinical psychology section, Dr. Robert Alvarez. Alvarez speculated that Flávio likely suffered from a critical lack of early education: "There's a certain peak favorable time for learning various skills . . . and he was past the peak when he arrived." In addition, the doctor suggested, cultural dislocation might be an aggravating factor:

> I can't imagine anything more drastically, radically different than his home background in Brazil and his current. This is a big leap into middle-class social America in terms of language, in terms of many, many, many things. . . . It's a big disruption to take a child, even of Flavio's

FIG. 15 Unidentified photographer, Flávio da Silva at Children's Asthma Research Institute and Hospital (CARIH), ca. 1963. National Asthma Center Records, Beck Archives, University Libraries Special Collections and Archives, University of Denver

age, away from their parents, and in Flavio's case especially since it's another country, another language.[233]

While José da Silva had asked Parks to bring Flávio back "cured and well" at the conclusion of his hospital stay, Fowler's distress at CARIH's bleak outlook—and José Gallo's pessimistic view of the da Silvas' home environment—led the two stewards to make a radical decision. Despite the common view in Denver, Fowler and Gallo were not ready to give up on Flávio's future. Rather than return home to vocational education, Fowler felt that he should attend a private boarding school, far removed from his family's dysfunction. After numerous inquiries, Gallo selected one in São Paulo, the country's populous business metropolis, about 450 kilometers from Rio de Janeiro.[234] The Instituto José Manuel da Conceição, founded in 1928, was a highly regarded religious school with a student body of about three hundred, operated by the Presbyterian Church of Brazil.[235] Flávio would continue his education there, after returning home for a short visit with his family.

As the end of his stay drew nearer, Flávio felt great trepidation at his impending departure, and he openly agitated with teachers and his housemasters to remain in the States. He was particularly direct with the Gonçalves family, pleading with them to adopt him so he could live with them in Denver.[236] While José Gonçalves was matter-of-fact with Flávio about the importance of returning to his family and culture, Kathy was deeply conflicted about his uncertain future.[237] She had thrown herself into her fostering duty from the outset, and had grown quite attached to Flávio, yet she strove constantly to maintain his sense of connection to Brazil, and to his parents and siblings. She had grown more and more alarmed by the da Silvas' silence throughout Flávio's time at CARIH: he wrote his family many letters and received none in return. Kathy had even corresponded with Ruth Fowler about his sense of abandonment and loneliness, asking her whether José Gallo might intervene with the boy's parents.[238] Now, despite her own fears, she put considerable effort into easing Flávio's mind about his return

and immersed herself in planning his departure. Her attempts to take charge precipitated a heated conflict with CARIH's medical director, Dr. Samuel Bukantz. The hospital, he asserted, not the Gonçalves family, had responsibility for Flávio's welfare.[239] She was relieved of her formal responsibility as his English-language tutor. Little changed in his weekend routine, however; the Gonçalves' guardianship, though unofficial, had only solidified over time, and as his two-year anniversary approached, Kathy felt bonded to Flávio's destiny. She later remembered:

> Flavio hated so much the thought of going home. All of his memories of the past were so negative. And I hated to see him go. But I told him that he was prepared now to become a good Brazilian. He never understood this. He just kept saying, "I don't want to go back to live with my father." Poor Flav. I felt so sorry for him. Here he was trying to bear the huge responsibility of being a symbol, when he couldn't even realize what he was meant to symbolize. He was like a son, and I would have taught him forever.[240]

On July 27, 1963, Flávio was discharged from CARIH, his course of treatment completed.[241] Fowler, who had arrived from Time-Life headquarters, accompanied the now fourteen-year-old on his first train trip cross-country to New York, along with Cheltenham principal Virginia Hansen, whom she had invited along to ease the return to Brazil.[242] In his final moments at CARIH, Flávio sat tearfully in his room, gripped by feelings of abandonment. A series of good-byes awaited: first, at the Denver train station, from the Gonçalves family; then, during a brief visit together in New York City, from Gordon Parks.[243] Taking his last opportunity, Flávio asked the photographer to adopt him so he could stay in the United States. "I'm sure your father wouldn't allow it," Parks replied. "Your family will be anxious to see you. They are all expecting you." Flávio pleaded: "But I would rather stay here with you. Don't you want me?" Yes, Parks said quietly; but it was impossible.[244]

And so Flávio's residency in the United States ended. Accompanied by Hansen, he boarded an overnight flight back to Brazil and his family. *Life* editors, more concerned for Flávio's privacy at this stage than for any potential story, decided not to cover his return for the magazine.[245] Though his minders attempted "to slip him quietly into Brasilia," in Fowler's words, to avoid the media attention they feared would greet him in his hometown, somehow the secret got out, and reporters and photographers met Flávio's plane at the airport on July 31. Stories ran in several Rio newspapers, including *Correio da Manhã*, *O Jornal*, and *Diário de Notícias*. While some articles were neutral or positive, others adopted a jingoist perspective, sensationalizing the boy's return as a manifestation of American arrogance. *O Globo* reported that Flávio had arrived in Brazil "rebellious," "full of himself," with "airs of superiority," and that his Portuguese had been badly degraded—so much so that his mother complained he could no longer understand her.[246]

This culturally defensive response mirrored a trend more generally observed in the press since ratification of the Alliance for Progress two years earlier.

The more that U.S. media outlets attempted to influence the country's affairs, historian Peter Bell has written, "the more virulent became the nationalist reaction in Brazil."[247] After the Punta del Este conference in 1961, Time Inc. magazines were accused, not only in Brazil but throughout Latin America, of being agents of the U.S. government. And indeed, internal memoranda reveal that Henry Luce himself directed his magazines to publish admiring appraisals of the Alliance's formal launch: recapping their coverage, chief of correspondents Dick Clurman wrote Luce that "our reports from Rio, Buenos Aires and Caracas—all fresh this week in response to your inquiry—still warmly herald the program as the greatest thing that has happened to U.S.-Latin relations in many years."[248] Some governments in the region countered Time Inc. by launching attacks through their own media allies. In Mexico, where *Life en Español* was widely distributed, a mild critique in the magazine of the country's Catholic church leadership provoked a coordinated opposition campaign in the press, including this characteristic headline: "Time-Life: Trojan Horse of North American Journalism."[249] A threatened boycott of its titles, as well as rumors that its journalists might be deported, led to considerable nervousness among Time Inc.'s business and editorial leadership.[250] These fears were exacerbated when a *Time* stringer in Santiago, Chile, was jailed, charged with threatening the internal security of the state for "transmitting news deemed tendentious by the government."[251] Heightened anxiety about how its publications and personnel were viewed in Latin America prevailed at the company throughout the early 1960s.

Hoping to lessen the negative coverage of Flávio's return, Rio's new Time Inc. bureau chief, John Blashill, wrote local newspapers a lengthy missive, defending the company's motives. "They can do what they want with the letter," he told Fowler, "ignore it, publish it, take excerpts from it or use it as guidance."[252] Recounting the series of events that led to Flávio's hospitalization and his subsequent life in Denver, Blashill championed the improvement in the boy's health, his progress in school, and his resilience facing challenges—those he had overcome, and those still in front of him. "It is not easy," Blashill argued, "for any adult—much less for a boy of 12 or 14—to leave his own home, be suddenly transplanted, alone, into another culture and language, and then return to his native land."[253]

Remarkably, Blashill revealed to the Brazilian media that *Life* had established a trust fund for Flávio's future—information kept even from his parents. The magazine's efforts, he emphasized, were made

> [on] behalf of the thousands of readers who saw a special streak of human warmth in Flavio's eyes and were moved, spontaneously, to do something to help him. *Life* did not ask for the money, nor can we explain exactly why so many of our readers felt compelled to send it. . . . But never in our memory has any person whom we have photographed evoked such an immediate and overwhelming response from our readers.

We are very aware that we have undertaken a great and lasting responsibility by breaking into Flavio's life. We are also very aware that once having done so, there is no turning back. We have no intention of making Flavio into a North American, nor even of "Americanizing" him. We have no intention of capitalizing on Flavio for publicity purposes—quite the contrary, we feel that publicity, especially at this delicate time of transition, may do him serious harm.

But we also have no intention of abandoning him. . . . We are under moral compulsion to act, in conjunction with his family, as Flavio's friend and financial guardian until such time as Flavio feels himself prepared to become an active, contributing member of Brazilian society. We accept our responsibilities gladly, but not lightly. We are dealing with the life of a young human being.[254]

Privately, Blashill confided in Fowler that Flávio's homecoming was, in fact, extremely stressful: "There was language barrier, place smells like a stable, and to Flav it must have looked like pigpen. They don't make much effort to keep it up. This morning when we picked him up to return to São Paulo and school, I think he was close to traumatic shock." José Gallo would accompany him for the first few days, Blashill wrote, hoping to keep Flávio's transition on track, "but there's no doubt about it, this is the hard part."[255]

. . .

While Flávio began a new stage of his education at boarding school, *Life*'s involvement in Catacumba's capital improvement program continued. Gallo maintained his attendance at SOMAC's regular resident association meetings, supporting community projects from the trust account as necessary. The weekend construction team made steady progress paving the favela's byzantine network of walkways and stairs, and began cementing the sewer channels that had been dug alongside.[256] SOMAC remained an archetype of the Alliance for Progress community self-help model, also satisfying Guanabara's participation requirements for receiving official funding. Highlighting recent achievements in Catacumba, a *New York Times* writer reported that the favela's success had inspired a large-scale Alliance program to promote "eradication, urbanization or improvement" across the city, with new community self-help initiatives under way or planned in an additional twenty-three shantytowns.[257] In Gallo's eyes, the residents' group was not just a beneficiary of *Life*'s reader contributions; it was the most remarkable manifestation of the photo essay's widening impact.[258] The community's poor conditions, illustrated so vividly in Park's photographs, were continuously being ameliorated. The *favelados*' quality of life steadily improved. And SOMAC's favorable outcomes galvanized others to take similar action.

As 1963 ended, the recent assassination of John F. Kennedy exacerbated already existing schisms between the United States and Brazil. President João Goulart's relationship with the American government had been fragile from the beginning; his leftist affinities and emerging

alliances with the Soviet and Cuban governments caused considerable suspicion in Washington. Recent U.S. efforts to isolate and discredit him deeply frustrated the Brazilian president.[259] Of late, the Alliance for Progress had sidestepped the national government entirely, directing aid instead to autonomous public agencies, the private sector, and, in the words of one participant, "states which were headed by good governors [who] we think strengthened democracy."[260] Despite the weakening connection between his country and the United States, Goulart had greatly admired America's young president and respected his leadership. He felt far less bound to U.S. interests after Kennedy's death.[261] With the Brazilian economy suffering, threatened by rising inflation and spiraling foreign debt, Goulart felt his hand was forced. In early 1964 he signed a law requiring international investors, including American companies, to reinvest the majority of their profits within the country rather than remove them.[262] Further actions to nationalize and socialize the economy provoked outrage from wealthy Brazilian interests. An agrarian reform measure expropriated untilled farmlands, prompting landowner revolts in Guanabara, Minas Gerais, and other states; another decree seized several oil refineries from private ownership, transferring them to Petrobras, the national petroleum monopoly.[263]

On March 31, 1964, a right-wing coalition of military generals and state governors launched a coup. Goulart was rapidly overthrown and exiled. U.S. officials had maintained close communication with the generals who spearheaded the revolt, and the Brazilian public widely suspected the Americans of directing and funding the seizure of power.[264] Kennedy's successor, Lyndon Johnson, swiftly wrote a supportive message to the provisional leadership; Secretary of State Dean Rusk publicly backed the new regime. Washington viewed this government as a better partner, especially in its anticommunist interests, and it was an article of faith that monetary aid could now flow more easily to Brazil than before, with greater empowerment of American and corporate interests.[265] Adolf Berle, a former U.S. ambassador who had helped launch the Alliance three years earlier, greeted the changeover with great optimism: "Now it seems the Alliance for Progress may really go forward in Latin America."[266]

Governor Carlos Lacerda was prominent among the Brazilian leaders backing the coup. Long outspoken in his opposition to Goulart, he had been one of the primary beneficiaries of the Alliance's "islands of sanity" policy, by which the United States selectively directed aid to Brazilian leaders opposing the president.[267] Over time, Lacerda received more than $15 million from the U.S. Agency for International Development (USAID) and the Inter-American Development Bank (IDB) to underwrite home construction on the outskirts of Rio de Janeiro, a crucial component of his initiative to solve the city's slum problem.[268] Under this urban renewal plan, Guanabara State scheduled favelas—particularly those in Rio's Zona Sul (South Zone)—to be bulldozed and repurposed for upscale real estate development. The police were used to forcibly relocate *favelados* to remote lower-income housing projects and apartment complexes. This capitalist

expropriation of land from poor residents was popular with many citizens, long disenchanted with the city's sprawling slums.[269]

By fall 1964, eight of the approximately two hundred favelas in and around Rio, including one near Catacumba, had been razed, with most of the residents moved to settlements in Senador Camará and Bangu, miles from the city center. To honor the recently deceased president and his signature initiative, these relocation communities were named Vila Kennedy and Vila Aliança. José Gallo reported to Ruth Fowler that the progress of Lacerda's program greatly worried members of SOMAC, as it landed "like a cold shower on the spirit and enthusiasm of many active people of our project. Their main doubts," he wrote, "were whether it was worth continuing sacrificing their time . . . and facing the possibility of being moved."[270] Rio's media deepened their malaise: in early 1965 Gallo wrote Fowler that one newspaper, without evidence, repeatedly listed Catacumba among the favelas scheduled for immediate eradication.[271] In addition to being "an ugly and depressing sore in the beautiful scenery of Rio," he suggested, the favela was considered vulnerable because "where it is located is almost as valuable as [land] in very expensive Copacabana where a square meter . . . is worth a small fortune."[272] Despite the reports, Gallo reassured residents that the community was unlikely to be removed anytime soon. After speaking to state officials, he felt strongly the favela would survive for at least another five years.

Indeed, bureaucratic logjams, slow construction of the new low-cost housing, and community opposition plagued the eradication program, and officials struggled to meet their scheduled relocation deadlines. Further challenging progress, a 1966 housing survey of Rio de Janeiro, carried out by a team of American architects and urban planners and funded by USAID, concluded that "rehabilitation of many favelas could be more feasible than eradication and resettlement of the residents in new housing."[273] Not only did modernization and improvement of existing housing redress poverty at lower cost and with greater efficiency, the study's authors found, but Guanabara's plan introduced dramatic negative consequences for the displaced *favelados*. Serious challenges accompanied relocation to Vila Kennedy and Vila Aliança, as *The New York Times* reported: "They are in isolated suburban areas, far from the favela dwellers' jobs. There are no large local industries, and unemployment is rife. Transportation costs to jobs take up 20 per cent or more of take-home pay."[274] Observers inside and outside Brazil were rapidly determining that far from helping the poor, Rio's slum-clearing program was simply creating a new generation of favelas.

On August 28, 1966, Catacumba's residents proudly celebrated SOMAC's latest accomplishment: a new medical post and community center.[275] Coming shortly before elections in Rio, the opening-day party was well attended by both federal and Guanabara State deputies, eager to secure the thousands of votes in the favela.[276] Just one year later, Gallo wrote Fowler that the building was thriving well into the night, with residents visiting the clinic and participating in movie screenings, dancing events, craft and hygiene classes, and meetings of the residents' association.[277] The building also proved critical during a catastrophic fire in August 1967 that destroyed more than sixty of Catacumba's homes: "the center of practically all help operations," Gallo reported, the community building accommodated "medical first [aid], food preparation and distribution," and "sheltered homeless people, including many babies and children."[278]

Other improvement projects carried forward, and new initiatives were launched; construction of the favela's vast network of sewers, for example, made continued progress, however slow. Civic groups financed construction of a new police station. Individual homeowners were inspired to renovate their own units, or run electricity and pipe water to the section they occupied.[279] Fowler and Gallo still aspired to complete the community-wide plumbing system, long mired in the planning stages. At Fowler's urging, Andrew Heiskell, chairman of Time Inc.'s board and an advocate of the Catacumba project, agreed to personally lobby a U.S. company to donate the needed industrial-scale pumps.[280]

In June 1967, Gallo wrote to inform Fowler of his retirement from the Rio bureau. Given his wartime military service and advancing age, Brazilian law mandated his departure. Nevertheless, Gallo planned to stay on as a freelance employee, to augment his pension and to "continue watching Flávio and the Favela Project as always."[281] Fowler, who had heard rumors of his departure, replied: "I must admit to feeling that I have lost something very special when I cannot instantly visualize you in our office in Rio." She expressed relief that Gallo would continue to represent Time Inc. in their shared mission, and continue as trustee for the Flávio and Catacumba funds.[282]

At the beginning of 1968, Gallo wrote Fowler with urgent news: the state government had formally announced plans to clear the six favelas surrounding the Lagoa Rodrigo de Freitas.[283] He expected that Catacumba, the second largest, would be bulldozed within three years and residents resettled to an apartment complex at a newly developed site, São Conrado, a short distance away. Many of the *favelados*, Gallo said, were optimistic about this plan, given the chance to remain near jobs, friends, and family. Later that year, however, Guanabara officials lost control of the favela eradication project to a new federal program, CHISAM (Coordenação de Habitação de Interesse Social da Área Metropolitana do Grande Rio, or Coordinating Agency for Social Housing in Metropolitan Rio.[284] The Brazilian government established CHISAM to better organize the challenging logistics of house and apartment construction, forcible relocation of the *favelados*, and clearing of the favelas. CHISAM's objective, in its own words, was

to help low income families acquire their own homes and develop a sense of ownership in them as well as confidence in the authorities; to take them out of their surroundings and give them new horizons and opportunities; and to reclaim them socially and economically so that they can take part in constituted society.[285]

With the favela's days numbered, Gallo spent Catacumba Trust resources sparingly, if at all.[286] The *favelados*' feeling of disquiet continued as plans for their removal transferred out of the state government's hands and into CHISAM's. A survey found that 81 percent of Catacumba's residents were aware of the threatened eradication of their community, and twice as many people opposed the move as favored it.[287] Repeated delays plagued the project through 1968, 1969, and into the following year. Finally, on August 31, 1970, CHISAM announced that Catacumba would be the next favela to be eliminated. Most of its residents would be relocated not to São Conrado, as had been hoped, but instead to the Penha district, far north of the Lagoa.[288] On September 25, after a few last brief postponements, Guanabara governor Francisco Negrão de Lima finalized what his predecessor Lacerda had set in motion years earlier, signing a public decree formally expropriating the hillside lands under Catacumba.[289] CHISAM's coordinating official Gilberto Coufal set October 1 as the date to begin removing the favela's population.[290] The government meticulously planned the program of displacement, targeting a daily average of fifty families and anticipating a period of forty-five working days.

On Thursday, October 1, the first residents were moved. By prior arrangement with CHISAM, a leadership group of SOMAC directors volunteered to leave first with their families, twenty-eight in all, apparently to demonstrate cooperation with the authorities.[291] The following day, eradication began in earnest. More than forty bulldozers arrived to begin clearing the hillside. The first vacated shacks were burned, the smoke streaking the sky. The media warned Rio drivers that removal would dramatically interrupt traffic near Catacumba.[292] On October 5, and periodically thereafter, CHISAM ran an advertisement in *Jornal do Brasil* and other Rio newspapers:

RELEASE

Favela of Catacumba

In coordination of housing interests in the greater Metropolitan area, Rio-CHISAM and the Ministry of the Interior communicate to the people of Rio de Janeiro that, with the collaboration of the Government of the State of Guanabara, it will be removing 12,000 slum dwellers from the Catacumba favela, in Lagoa, to the new COHAB-GB settlement in Penha, as of October 5, 1970. In the greater interest of social progress, I call for the cooperation of all, especially drivers, who should avoid Avenida Epitácio Pessoa, where the work of removal will be evident. For your own benefit, please cooperate with the authorities.

Rio de Janeiro, Guanabara, October 2, 1970
Antônio Carlos Nunes[293]

Just as Catacumba's rehabilitation had been widely studied, so was its elimination; CHISAM coordinators gathered to watch destruction of the shacks and relocation of the residents alongside state directors of COHAB-GB, the public company responsible for planning, construction, and management of low-cost housing for the poor in Guanabara.[294] Writing Fowler about the favela's destruction, Gallo mentioned an additional irony: SOMAC's community building, constructed with funding from *Life* readers for the benefit and betterment of Catacumba's residents, was commandeered by CHISAM to serve as headquarters for the demolition crews, social workers, and functionaries carrying out the eradication, and for the armed units enforcing removal of the *favelados*.[295]

On November 25, fifty-six days into the destruction, Catacumba's last remaining residents were removed, 136 in all, on a convoy of buses. A total of 2,340 families, more than 13,000 people, were dispersed from their homes (fig. 16). Most were transferred to the Guaporé-Quitungo housing complex, newly constructed in Penha, in the North Zone of Rio; others went to houses or apartments in Cidade de Deus (City of God) near Jacarepaguá, to the west.[296] Other citizens, too poor to maintain homes, were shifted to camps at "proletarian parks" in Paciência, on the far west side. Over the next several days, there was a concerted effort to exterminate Catacumba's population of more than 30,000 rats; this delayed by several days the bulldozing and burning of the shacks still dotting the hillside.[297] The evacuation complete, CHISAM's onsite workers vacated the community center. Briefly the pride of the favela, it was one of the last buildings to be knocked down.[298]

The razing of Catacumba brought an abrupt end to the community Parks photographed in 1961. In his final report to the publisher's office at *Life*, Gallo expressed no regrets:

Now that the favela is disappearing and the hill of Catacumba will no longer be one "good" example of poverty and human degradation, I think, Ruth, that it will never be too exhaustive to mention the proficiency of the Catacumba project. I even think that it is worth [mentioning], repeatedly, that it was so well elaborated that its good benefits will be carried on by the *favelados* of Catacumba wherever they go.

The other day I met one of Catacumba's residents down town and we talked on the favela being moved, etc., etc. His reaction surprised me very significantly when he said: "we are going to be moved and not all of us will be staying in the same place. . . . But what really counts is the spirit of community, feeling of self-respect, [and] courage to struggle [with] a miserable life we all learned from the Society. The Society, indeed, did a lot of good for many of us."

These words, I must say, enclose a message of gratitude to which I want to include my own to you, to Mr. Heiskell and to many other prominent persons from Time Incorporated and, above all, to the *Life* readers. Without your enthusiasm, incentive and material support, none [of this] would have been done. The Catacumba resident I met in the street will never know how happy he made me with his words. And for that I want, from the deepness of my heart, to thank you all too.[299]

. . .

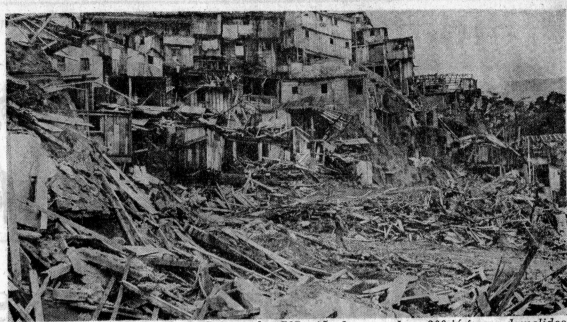

Dos 1 857 barracos da Favela da Catacumba, 707 estão desocupados e 200 já foram demolidos

Nôvo ambiente leva alegria a ex-favelados da Catacumba

Sem nostalgia ou arrependimento — embora a saudade às vêzes aperte um pouco — os ex-moradores da Favela da Catacumba estão perfeitamente integrados em seu nôvo ambiente, o conjunto residencial Guaporé-Quitungo, na Penha.

As 800 famílias transferidas até agora superaram os temores iniciais — distancia dos locais de trabalho, aumento das despesas e problemas de colégios para as crianças — para viver a tranquilidade de quem mora em local seguro, sem ameaça de desabamento de um dia para o outro, ao menor sinal de chuva.

A longa espera

Há um mês foram transferidos os primeiros moradores da favela: diretores da Sociedade de Moradores e Amigos da Catacumba e *birosqueiros* (proprietários das tendinhas). Até o dia 15 estarão desocupados todos os 1 857 barracos da favela, completando-se a transferência.

Os 12 mil favelados da Catacumba aguardavam a remoção há dois anos, pois o local estava condenado pelo Instituto de Geotécnica e não oferecia a menor segurança. Cada chuvarada levava panico aos moradores, que ficaram muito satisfeitos quando souberam da remoção e começaram inclusive a ajudar as autoridades.

No dia 1.º de outubro a sede da Somac — Sociedade de Mora-

A sensação de segurança faz as crianças felizes na Penha

FIG. 16 "Nôvo ambiente leva alegria a ex-favelados da Catacumba" ("New Environment Brings Joy to Ex-*Favelados* of Catacumba"), detail of p. 25, *Jornal do Brasil*, November 2, 1970

José Gallo regularly updated Ruth Fowler on Flávio's life after his return to Brazil (fig. 17). Although reportedly he benefited from his experience at the boarding school in São Paulo, Flávio had increasing difficulties getting along with teachers and fellow students and was expelled in January 1966.[300] He returned home to live with his family in Rio and enrolled in a school near his home.[301] Gallo continued to visit him, advise him and his parents about his education and employment, and pay for critical expenses from the Flavio Fund through the end of the decade. On March 5, 1970, a month before Flávio's twenty-first birthday, Fowler wrote to inform him, for the first time, that *Life* had maintained a trust for his future benefit. He would receive the remaining funds later that year:

> I believe, Flávio, you should accept this money when it comes to you as an enormous evidence of affection and confidence that many people feel toward you. All these people would want you to use the money carefully and wisely, because you will be one of those fortunate few who now has a special start . . . and perhaps someday [will] help someone else along.[302]

On November 10, with bulldozers still crisscrossing the hillside of Catacumba, *Life* forwarded $5,273.85 to Flávio's Rio bank account.[303] He was on his own.

Life's editors considered running updates on Flávio numerous times through the years. In 1967, they went so far as to assign George de Carvalho, who had left the Rio bureau, to revisit the city and draft a follow-up on Flávio, then eighteen, as well as the in-progress rehabilitation of Catacumba.[304] His piece went unpublished. Despite Ruth Fowler's persistent advocacy, the magazine never ran another story on the episode. After July 1961, only a single printed response to a reader's letter acknowledged *Life*'s continued engagement with the subject of one of its most celebrated photographic essays.[305]

The magazine published its final weekly issue on December 29, 1972. Early the following year, clearing up old business in advance of her retirement, Fowler notified a colleague at Time Inc. that $6,611.69 remained from the Catacumba Trust. At her request, Gallo had tracked down a small group of SOMAC members who been relocated near one another: they were eager to set up a medical clinic close to their homes. Conferring with Gallo, Fowler decided the remaining funds should be used to establish and equip the new facility: "Thus, we should be able to clear the whole thing up in six months, [and] at the same time maintain our commitment to the contributors to the original fund and make a very practical contribution to the *favelados*."[306] For the two Time Inc. compatriots, dedication to the project continued despite their departures from the company that had launched the initiative, and the disappearance of the favela itself.

Through the years, Flávio and Gordon Parks kept in intermittent contact, writing occasional letters. In the autumn of 1975, Parks enlisted with publisher W. W. Norton to write a book about Flávio. The following August, he returned to Rio to visit, photograph, and interview his old friend, now twenty-seven years old, and to meet his wife, Cleuza, and their sons Flávio Jr. and Felipe Luiz. During the visit, Flávio signed a contract, agreeing to share his memories in exchange for five percent of any earnings Parks received.[307] At intervals Gallo joined them to reminisce; the trio had last been together during Flávio's 1961 move to Denver. American photographer Jeanne Moutoussamy, who made the trip as Parks' assistant, took pictures of the reunion (figs. 18, 19). Together the group visited Nair and the rest of Flávio's family, finding the Guadalupe house in distressingly poor condition. Parks described the change in the family's fortunes with an edge of despair: the yard was "as dull and scarred as a deserted battlefield," the interior "a disorderly rubble of broken furniture."[308] The three men climbed Catacumba's old hillside above Avenida Epitácio Pessoa, now covered in tall grass and bearing little trace of the favela and its residents. By the end of the decade, the hill would be reforested and designated an ecological preserve—the Parque Natural Municipal da Catacumba.

Parks published *Flavio* in 1978. The book's foreword begins with a revealing admission of self-doubt: "As a photojournalist I have on occasion done stories that have seriously altered human lives. In hindsight, I sometimes wonder if it might not have been wiser to have left those lives untouched, to have let them grind out their time as fate intended."[309] In the pages that followed, Parks described the making of his photo essay and traced its impact, with special focus on the particulars of Flávio's experience in the favela, at the asthma hospital in Denver, and back home in Brazil. *Flavio*, unlike the picture story,

FIG. 17 José Gallo, Flávio, São Paulo, Brazil, 1965. The Gordon Parks Foundation

124

is a narrative portrait of one person's experience of poverty, from childhood into adulthood. While it is one of his most compelling books, sales did not meet Parks' or the publisher's expectations.[310] Appearing seventeen years after he first encountered his most enduring subject, Parks' remarkable story had relinquished its once profound stature in American culture. In early 1999, he visited Flávio one more time, while participating in the filming of a documentary about his own life, *Half Past Autumn: The Life and Work of Gordon Parks*. Their short visit together marked the last time they would see each other. The photographer died on March 7, 2006.

Over the years, many have attempted to explain the lasting appeal of the photographic essay that has often been described as Parks' greatest. The direct impact of the Flávio story—not only on the readers who saw the pictures in *Life*'s pages, but on the subjects of the photographs themselves—constitutes a significant and unusual moment in the history of magazine photojournalism. In retrospect, one could credit a series of apparently fortuitous circumstances for the photo essay's reverberating effects: Flávio's extraordinary spirit and charisma; Parks' images, with their indelible description of one boy's life and a community's poverty; their commissioning in the context of Cold War geopolitics, at a time of heightened tension; the professionalism and skill of *Life*'s editorial team; the magazine's cultural force, and its wide popularity with the American middle class; the story's controversial reception in Brazil, whose media resisted what they perceived as the country's stereotyping and fought back; and most important, the unanticipated and unaccountable response of *Life*'s readers, an outpouring of generosity from a diverse body politic moved to send support, in hopes of improving the lives of Flávio, his family, and their favela, a hemisphere apart. Finally, after all that, the

readers' hopes were advanced by a progression of tireless Samaritans, from Flávio's teachers and the Gonçalves family, to Gallo and Fowler, to unnamed members of SOMAC, who all committed their energies to what they saw as their calling.

During the heyday of the classic photo essay, each story in *Life* would end in the routine flipping of pages, as one feature followed another, and as each issue was replaced by the next in weekly succession. The readers' relationship with the subjects of the photographs would typically stop there. Gordon Parks' Flávio story had a different trajectory. The life of this picture story continued onward, outlasting its first publication—carried forward by its audience in a remarkable venture to rewrite the outcome, and change destiny.

FIG. 20 Untitled (The da Silva Family), Rio de Janeiro, Brazil, 1961. The Gordon Parks Foundation

1 "Rio Memorandum: Translation of Extract from 'Tribuna da Imprensa,' dated 6th July, 1961," Time Inc./Rio de Janeiro. Gordon Parks Papers, Manuscript Division, Library of Congress, Washington, D.C.

2 Timothy Foote (*Life* assistant editor), "Crisis in Latin America," *Life*, June 2, 1961, 81.

3 Henry R. Luce, "The Aim of Life," *Life*, June 2, 1961, 1.

4 "We Must Win the Cold War," *Life*, June 2, 1961, 64.

5 Years later, longtime *Life* writer and editor Loudon Wainwright acerbically noted about this issue that "the highest echelons of Time Inc. management regularly confused their journals with some nonexistent arm of government." *The Great American Magazine: An Inside History of* Life (New York: Alfred A. Knopf, 1986), 274.

6 Alan Brinkley, *The Publisher: Henry Luce and His American Century* (New York: Alfred A. Knopf, 2010), 358.

7 "Address by President John F. Kennedy at the White House Reception for Members of the Diplomatic Corps of the Latin American Republics, March 13, 1961," reprinted in Jeffrey F. Taffet, *Foreign Aid as Foreign Policy: The Alliance for Progress in Latin America* (New York and Abingdon, England: Routledge, 2007), 200–201.

8 "The Menacing Push of Castroism," *Life*, June 2, 1961, 88.

9 Parks' last appearance on *Life*'s masthead under the heading "Photographic Staff" came in the issue of May 30, 1960. His departure is confirmed by a *Life* newsletter for its ad salesmen from November 7 of that year, which notes that "early this spring, Parks left the full-time staff . . . to take on some freelance assignments. But he remains a LIFE contract photographer and a large part of his brilliant work will continue to appear in LIFE's pages." Gordon Parks Papers, Special Collections, Wichita State University Libraries, Wichita, Kansas. A Time Inc. internal memo from Ed Rhett to Bernard Barnes, marked "Confidential: Negro Employment in Time Inc.," and dated June 12, 1961, states: "The most 'meaningful' jobs that we ever had filled by negroes were LIFE Photographer (Gordon Parks) and LIFE writer (Earl Brown). Both are now gone. No negro is in a meaningful job today." Time Inc. Archives, New-York Historical Society, New York.

10 Parks first appeared on *Life*'s masthead in the August 22, 1949, issue. He had contributed numerous stories as a freelancer, and had photographs published multiple times, during the previous year.

11 Erika Doss, "Visualizing Black America: Gordon Parks at *Life*, 1948–1971," in *Looking at* Life *Magazine*, ed. Erika Doss (Washington, DC: Smithsonian Institution Press, 2001), 229.

12 Parks' photography assignments were recorded on index cards at *Life*. Not all resulted in publication, but most did. Gordon Parks Papers, Special Collections, Wichita State University Libraries, Wichita, Kansas.

13 Stanley Price (*Town* magazine) to Gordon Parks, November 20, 1963. Gordon Parks Papers, Special Collections, Wichita State University Libraries, Wichita, Kansas.

14 Brinkley, *The Publisher*, 441–42.

15 Ibid. *Life*'s then managing editor Edward K. Thompson also described the financial crisis in his memoir *A Love Affair with* Life *& Smithsonian* (Columbia: University of Missouri Press, 1995), 247.

16 *Life* was Time Inc.'s most expensive periodical, far ahead of *Time*, *Fortune*, and *Sports Illustrated*; by 1961 it cost $10,450,000 annually (or $3,222 per page) to produce. Internal memorandum on editorial expenses, 1961. Time Inc. Archives, New-York Historical Society, New York.

17 Brinkley, *The Publisher*, 440.

18 Dora Jane Hamblin, *That Was the* Life (New York: W. W. Norton, 1977), 304.

19 Thompson, *A Love Affair with* Life *& Smithsonian*, 247–48.

20 Hamblin, *That Was the* Life, 216.

21 Brinkley, *The Publisher*, 253.

22 Wainwright, *The Great American Magazine*, 306.

23 "What We Like We Hope You Will Like," *Life*, June 2, 1961, 2.

24 Wainwright, *The Great American Magazine*, 291–92.

25 Gordon Parks, *Flavio* (New York: W. W. Norton, 1978), 58.

26 Ibid.

27 *Life*'s masthead first lists Foote as an assistant editor in the July 28, 1958, issue.

28 Wainwright, *The Great American Magazine*, 227, 230.

29 Parks, *Flavio*, 60.

30 Quoted ibid.

31 Inaugural Address of President John F. Kennedy, January 20, 1961, John F. Kennedy Presidential Library and Museum, www.jfklibrary. org/Research/Research-Aids/Ready-Reference/JFK-Quotations/Inaugural-Address. aspx.

32 The Task Force is quoted in Jeffrey F. Taffet, "Changing Course in Latin America: Influences from Eisenhower, Modernization Theorists, Kennedy, and the Cuban Revolution," in *Foreign Aid as Foreign Policy: The Alliance for Progress in Latin America*, 22.

33 Jeffrey F. Taffet, "Implementing the Alliance for Progress: The Initial Theoretical, Political, Management, and Marketing Problems," in *Foreign Aid as Foreign Policy: The Alliance for Progress in Latin America*, 43–45.

34 "Address by President John F. Kennedy at the White House Reception for Members of the Diplomatic Corps of the Latin American Republics, March 13, 1961," quoted in Taffet, *Foreign Aid as Foreign Policy: The Alliance for Progress in Latin America*, 201.

35 "Editorial: 'El Plan Kennedy,'" *Life*, March 24, 1961, 30.

36 Brinkley, *The Publisher*, 422–25.

37 Henry R. Luce to President John F. Kennedy, July 21, 1961. John F. Kennedy Presidential Library and Museum, Boston.

38 James L. Baughman, "Who Read *Life*? The Circulation of America's Favorite Magazine," in *Looking at* Life *Magazine*, ed. Erika Doss (Washington, DC: Smithsonian Institution Press, 2001), 41–42. See also Brinkley, *The Publisher*, 427.

39 Henry R. Luce to President John F. Kennedy, February 8, 1961. John F. Kennedy Presidential Library and Museum, Boston.

40 President John F. Kennedy, "Filmed and Taped Remarks of the President for the *Life* Magazine Television Show, on NBC," White House press release, March 2, 1961. John F. Kennedy Presidential Library and Museum, Boston.

41 Henry R. Luce, "The American Century," *Life*, February 17, 1961, 65.

42 Brinkley, *The Publisher*, 415–19.

43 Quoted ibid., 418.

44 Henry R. Luce, "Needed: A General Theory for U.S. Action in World Affairs," speech at the University Club, New York, January 28, 1961. Time Inc. Archives, New-York Historical Society, New York.

45 Hired in August 1945, José Gallo was Time Inc.'s longest-serving staffer in the Rio de Janeiro bureau in 1961, according to Clara Applegate (Time-Life News Service) to Richard Clurman (chief of correspondents), internal memorandum on Rio bureau staff, April 17, 1962. Time Inc. Archives, New-York Historical Society, New York.

46 José Gallo's responsibilities were typical of the role researchers played in *Life*'s reporting of international stories: "They didn't actually compose the text, a task for the writers, but they checked the finished text and captions for accuracy. . . . [Now] they are known, appropriately, as reporters." Thompson, *A Love Affair with* Life *& Smithsonian, 40.

47 "Único negro de 'Life' vem fotografar favelas," *Tribuna da Imprensa*, March 15, 1961, 2. Accessed at Biblioteca Nacional Digital, Brazilian National Archives, Rio de Janeiro.

48 "Negro de 7 máquinas vai morar na favela," *Tribuna da Imprensa*, March 21, 1961, 2. Accessed at Biblioteca Nacional Digital, Brazilian National Archives, Rio de Janeiro.

49 Carolina Maria de Jesus, *Quarto de despejo: Diário de uma favelada* (São Paulo: F. Alves, 1960). Published in English in the United States as *Child of the Dark: The Diary of Carolina Maria de Jesus* (New York: E. P. Dutton, 1962).

50 George de Carvalho, "Rio Dispatch 4614: The Flavio Story," telex message from Time Inc./Rio de Janeiro to Time Inc./New York, July 12, 1961. Gordon Parks Papers, Manuscript Division, Library of Congress, Washington, D.C.

51 Janice Perlman. *Favela: Four Decades of Living on the Edge in Rio de Janeiro* (Oxford: Oxford University Press, 2010), 70.

52 Ibid., 62, 66–67, 69.

53 Robert M. Levine and John J. Crocitti, "Seeking Democracy and Equity," in *The Brazil Reader: History, Culture, Politics*, eds. Levine and Crocitti (Durham, NC: Duke University Press, 1999), 225.

54 George de Carvalho to Tim Foote, Ruth Fowler, et al., "Updating Flavio's Family," telex message from Time Inc./Rio de Janeiro to Time Inc./New York, September 18, 1961. Gordon Parks Papers, Manuscript Division, Library of Congress, Washington, D.C.

55 Perlman, *Favela: Four Decades of Living on the Edge in Rio de Janeiro*, 69.

56 Parks, *Flavio*, 13–14.

57 The name is spelled with an accent in Portuguese; the accent was dropped in *Life*

articles and in Parks' 1978 book *Flavio*.

58 "Brazil in Throes of a Nightmare: President-Elect Quadros Is Faced with Insolvency and Soaring Inflation Rate," *The New York Times*, January 11, 1961, 49, 74.

59 Peter D. Bell, "Brazilian-American Relations," in *Brazil in the Sixties*, ed. Riordan Roett (Nashville: Vanderbilt University Press, 1972), 80.

60 Tad Szulc, "Brazil Reduces Import Subsidies: Drastic Economic Measures Introduced by Quadros to Check Inflation," *The New York Times*, March 15, 1961, 13.

61 Juan de Onis, "Oil Concerns Fight Rio Move to Seize a Profit 'Windfall,'" *The New York Times*, March 23, 1961, 47, 49.

62 Tad Szulc, "U.S.-Brazil Talks Close in Discord over Cuba Issue: Berle and Quadros 'Agreed to Disagree'—New Bid to Neutralists Indicated," *The New York Times*, March 4, 1961, 1, 6.

63 Getúlio Vargas, "Vargas's Suicide Letter, 1954," Brazilian National Archives, Rio de Janeiro, trans. Robert M. Levine, reprinted in Levine and Crocitti, "Seeking Democracy and Equity," 222.

64 Bell, "Brazilian-American Relations," 81.

65 Internal communications from Time Inc.'s Rio bureau and within the New York offices convey Brazilian and U.S. officials' strenuous objections to *Time*'s own version of this confrontation. See George de Carvalho, telex message from Time Inc./Rio de Janeiro to Time Inc./New York, March 17, 1961. Also Ed Jackson to Tom Griffith and Bob Christopher, confidential memorandum, March 18, 1961. Time Inc. Archives, New-York Historical Society, New York.

66 Tad Szulc, "Quadros Affirms Brazil's U.S. Ties: In Message to Congress, He Backs Aims in Americas—Seeks Red Bloc Trade," *The New York Times*, March 16, 1961, 8.

67 Arthur M. Schlesinger, Jr., *A Thousand Days: John F. Kennedy in the White House* (Boston: Houghton Mifflin, 1965), 187. Quoted in Bell, "Brazilian-American Relations," 78.

68 Mário's name was rendered without the accent in *Life* articles and in Parks' 1978 book *Flavio*. Abia's name was given as "Albia."

69 Parks, *Flavio*, 22.

70 "[Parks'] assignment was to portray poverty, and, on seeing the da Silva shanty, he

went no further." De Carvalho, "Rio Dispatch 4614: The Flavio Story."

71 José da Silva was actually Flávio's stepfather. The eventual *Life* article did not report this, and Parks' 1978 book *Flavio* was not especially explicit about this fact.

72 "Fotógrafo americano trouxe 7 máquinas para fazer reportagem em prêto e branco nas favelas do Rio," *Jornal do Brasil*, March 24, 1961, 2. Accessed at Biblioteca Nacional Digital, Brazilian National Archives, Rio de Janeiro. The following four text paragraphs, with their translated quoted passages, concern the same article.

73 George de Carvalho to Tim Foote et al., telex message from Time Inc./Rio de Janeiro to Time Inc./New York, April 3, 1961. Gordon Parks Papers, Manuscript Division, Library of Congress, Washington, D.C.

74 This information is gleaned from stamps and annotations on the versos of Parks' earliest contact sheets from the series, which indicate the first three "takes," or batches, of film were processed and proofed at the Time Inc. bureau in Rio de Janeiro. These are preserved in the archive of The Gordon Parks Foundation, Pleasantville, New York.

75 De Carvalho to Foote et al., telex, April 3, 1961. "LATAM" is shorthand for Latin America. "Binonvilles" is a misrendering of *bidonvilles*, a French word roughly equivalent to *favelas*.

76 Ibid.

77 Wainwright, *The Great American Magazine*, 110.

78 This information is gleaned from identification and close examination of numbered contact sheets made from Parks' first three "takes" of film—those identified as processed and captioned before de Carvalho's April 3, 1961, telex was sent. The Gordon Parks Foundation, Pleasantville, New York.

79 Parks, *Flavio*, 14.

80 De Carvalho to Foote et al., telex, April 3, 1961.

81 Just before Parks' visit, da Fonseca was accused by reporters of protecting a local businessman who had expropriated land designated for a new primary school in Catacumba. "Amando da Fonseca impede construção de nova escola para favela de Catacumba," *Jornal do Brasil*, March 4, 1961, 10. Accessed at Biblioteca Nacional Digital, Brazilian National Archives, Rio de Janeiro.

82 "Translation of Extract from 'Diário de Noticias,' dated 6th July, 1961," Time Inc./Rio de

Janeiro. Gordon Parks Papers, Manuscript Division, Library of Congress, Washington, D.C.

83 Parks, *Flavio*, 51.

84 Parks mistakenly wrote in his 1978 book *Flavio* that he spent more than five weeks in Rio de Janeiro; his error likely arose from his misreading the date "3/4/1961" on the earliest telex preserved in the Time Inc. files on the story. Parks interpreted this as March 4 rather than the correct April 3, as indicated by his handwritten annotation next to the date. Gordon Parks Papers, Manuscript Division, Library of Congress, Washington, D.C. Parks' return to New York on April 10 is confirmed by the customs stamp in his passport. Gordon Parks Papers, Special Collections, Wichita State University Libraries, Wichita, Kansas.

85 Stamps and annotations on the versos of Parks' earliest contact sheets from the series indicate that he photographed at least fifty-three rolls of film, including thirty-three of black-and-white 35mm film, seventeen of black-and-white 120 film, and three of 35mm color slide film. Gordon Parks Foundation, Pleasantville, New York.

86 De Carvalho to Foote et al., telex, April 3, 1961.

87 Gordon Parks, "Photographer's Diary of a Visit in Dark World," *Life*, June 16, 1961, 98.

88 "Alas Gordon took office contacts of several rolls": George de Carvalho to Timothy Foote et al., telex message from Time Inc./Rio de Janeiro to Time Inc./New York, dated June 8 (1961) in pencil. Gordon Parks Papers, Manuscript Division, Library of Congress, Washington, D.C.

89 Wainwright, *The Great American Magazine*, 242–43.

90 "The following is a list of the Time Inc. people in the New York office who are journalistically equipped with a special knowledge of Latin America . . ." Clara Applegate (Time-Life News Service) to Richard Clurman (chief of correspondents), internal memorandum, n.d. (1960s). Time Inc. Archives, New-York Historical Society, New York.

91 Wainwright, *The Great American Magazine*, 191.

92 Parks, *Flavio*, 61–62.

93 More than two hundred photographs: Brinkley, *The Publisher*, 229. Twelve-page length: Thompson, *A Love Affair with* Life *& Smithsonian*, 211.

94 Wainwright, *The Great American Magazine*, 243–44.

95 Parks, *Flavio*, 62–63. Parks'

account of this episode appears to have been dramatized to some extent in the retelling, and it is unclear how much jeopardy his reportage truly faced. Further, while he suggests he nearly resigned in protest, Parks had already left his staff position the year before.

96 Ibid., 64.

97 Tad Szulc, "Rusk Calls Latin Poverty 'Real Issue' in Hemisphere," *The New York Times*, May 5, 1961, 1, 10.

98 Parks, *Flavio*, 65.

99 Wainwright, *The Great American Magazine*, 186.

100 "Gordon Parks Interviews," conducted by Michael Torosian, 1997, transcript, 11, 22. Gordon Parks Papers, Special Collections, Wichita State University Libraries, Wichita, Kansas.

101 Hamblin, *That Was the Life*, 28.

102 Ibid., 115.

103 The da Silvas' per capita annual income in cruzeiros, Brazil's 1961 currency, is measured at $30 U.S., compared with the Rio per capita of $80, and the favela per capita of $40. De Carvalho to Foote et al., telex, dated June 8 (1961).

104 Ibid.

105 Ibid. Details of José da Silva's construction accident and missing pension payments were included in Brazilian newspaper reports after Parks' return, as evidenced by translations prepared by the Rio bureau of Time Inc., now held among the Gordon Parks Papers, Manuscript Division, Library of Congress, Washington, D.C.

106 De Carvalho to Foote et al., telex, dated June 8 (1961).

107 The description of the printing process at R. R. Donnelly is from Wainwright, *The Great American Magazine*, 248.

108 R. Hart Phillips, "Castro Proposes 'Deal' on Captives," *The New York Times*, May 18, 1961, 8; also Tad Szulc, "President Urges All to Help Send Tractors to Cuba," *The New York Times*, May 25, 1961, 1, 10.

109 C. D. Jackson (publisher) to Ed Thompson (managing editor), internal memorandum, May 31, 1961. Time Inc. Archives, New-York Historical Society, New York. Time Inc.'s corporate archive includes several senior staff memos expressing consternation on this matter.

110 Tad Szulc, "Latins Backing U.S. on Tractors: Castro's Offer to Exchange Rebels Boomerangs in Propaganda Field," *The New York Times*, May 28, 1961, 119; also "Brazil

Legislators Contribute," *The New York Times*, June 24, 1961, 4.

111 Damon Stetson, "U.S. Tractor Unit Closes Its Books," *The New York Times*, July 9, 1961, 28.

112 John L. Steele to President John F. Kennedy, May 22, 1961. John F. Kennedy Presidential Library and Museum, Boston.

113 Henry R. Luce, "Address by Henry R. Luce," speech for Time Inc. executive dinner, New York, May 15, 1961. John F. Kennedy Presidential Library and Museum, Boston.

114 *Life*'s predominantly middle-class readership in 1950s–1960s: Baughman, "Who Read *Life*?," 44–45. *Life*'s frequent address of affluence, home ownership, suburban life: Brinkley, *The Publisher*, 237–38, 395–96.

115 "Freedom's Fearful Foe: Poverty," *Life*, June 16, 1961, 88.

116 For example, Parks sent his last diary revision to New York by telex from California, where he was convalescing more than a month and a half after his return from Rio, during the issue's final stages of editing.

117 Interview with Susan L. Rife, "Renaissance Man," in *A Passionate Vision, A Precious Talent: Gordon Parks*, ed. Ed Arnone (Wichita, KS: The Wichita Eagle and Beacon Publishing Company, 1994), 34.

118 Quoted and discussed in Wainwright, *The Great American Magazine*, 77.

119 "Publisher's Interim Statement—Magazine (LIFE): Period Ending September 30, 1961," Audit Bureau of Circulations, October 27, 1961. Time Inc. Archives, New-York Historical Society, New York.

120 The Continuing Study of Magazine Audiences, or CSMA, was commissioned by Time Inc. and challenged by media rivals for many years. Brinkley, *The Publisher*, 223.

121 Baughman, "Who Read *Life*?," 42.

122 Parks, *Flavio*, 65. Two letters excerpted in "Special Report: A Great Urge to Help Flavio," *Life*, July 7, 1961, 15–16, include offers to adopt; others are preserved in the Time Inc. Archives, New-York Historical Society, New York.

123 Hamblin, *That Was the* Life, 155.

124 George de Carvalho, "Rio Dispatch 4619" (second take of "The Flavio Story"), telex message from Time Inc./Rio de Janeiro to Time Inc./New York, July 13, 1961. Also "Rio

Memorandum: Translation of Extract from 'Diário de Noticias' dated 6th July, 1961."

125 Ruth Fowler (assistant to the publisher) to Mabel Foust (Letters department), memorandum, June 22, 1961. Time Inc. Archives, New-York Historical Society, New York.

126 Letter from Arthur B. Lorber, CARIH president, to *Life*, excerpted in "Special Report: A Great Urge to Help Flavio," 15.

127 De Carvalho, "Rio Dispatch 4614: The Flavio Story."

128 Ruth Fowler to Gordon Parks, George de Carvalho, and José Gallo, Memorandum, June 27, 1961. Gordon Parks Papers, Manuscript Division, Library of Congress, Washington, D.C.

129 Ultimately *Life* created twenty-four variant letters for use at different stages of the company's response from June through the end of 1961. Time Inc. Archives, New-York Historical Society, New York.

130 "Special Report: A Great Urge to Help Flavio," 15.

131 Ibid., 16.

132 Ibid., 15–16.

133 Mabel Foust to C. D. Jackson, memorandum, July 14, 1961. Time Inc. Archives, New-York Historical Society, New York.

134 Roger Keith, "Flavio Mail: As of 9 a.m., Friday, July 14, 1961," memorandum. Time Inc. Archives, New-York Historical Society, New York.

135 Ibid.

136 Ibid.

137 Ibid.

138 Mabel Foust, memorandum to the file, August 10, 1961. Time Inc. Archives, New-York Historical Society, New York.

139 Mabel Foust to C. D. Jackson et al., memorandum, July 25, 1961. Time Inc. Archives, New-York Historical Society, New York.

140 Hamblin, *That Was the* Life, 155.

141 Foust to Jackson, memorandum, July 14, 1961.

142 De Carvalho, "Rio Dispatch 4619."

143 Ibid.

144 Contract for the care and transport of Flávio da Silva, prepared by New York law firm Cravath, Swaine & Moore, signed June 28–29, 1961, by José and Nair da Silva, and Gordon Parks and José Gallo on behalf of Time Inc. Time Inc. Archives, New-York Historical Society, New York. An additional original is in the Gordon Parks Papers, Manuscript

Division, Library of Congress, Washington, D.C.

145 De Carvalho, "Rio Dispatch 4619."

146 Ibid.

147 Ibid.

148 "Simple short documentary": Ibid. Fifteen hundred meters: Article translated as "Prohibited Film About Slums Is Philanthropic," *Tribuna da Imprensa*, July 7, 1961, translation prepared by Time Inc./Rio de Janeiro Bureau. Gordon Parks Papers, Manuscript Division, Library of Congress, Washington, D.C.

149 De Carvalho, "Rio Dispatch 4619."

150 Ibid. Also Parks, *Flavio*, 68, 84.

151 Parks, *Flavio*, 76.

152 Ibid.

153 De Carvalho, "Rio Dispatch 4619."

154 Parks, *Flavio*, 73.

155 Ibid., 77.

156 Ibid., 78.

157 De Carvalho, "Rio Dispatch 4619."

158 Parks, *Flavio*, 79.

159 George de Carvalho, "Rio Dispatch 4623" (third take of "The Flavio Story"), telex message from Time Inc./Rio de Janeiro to Time Inc./New York, July 13, 1961. Gordon Parks Papers, Manuscript Division, Library of Congress, Washington, D.C.

160 Ibid.

161 De Carvalho, "Rio Dispatch 4619."

162 "Translation of Extract from 'Diário de Noticias,' dated 6th July, 1961."

163 "Rio Memorandum: Translation of Extract from 'Tribuna da Imprensa,' dated 6th July, 1961."

164 De Carvalho, "Rio Dispatch 4623."

165 Parks, *Flavio*, 82–83.

166 De Carvalho, "Rio Dispatch 4623."

167 Parks, *Flavio*, 84.

168 Dr. Samuel Bukantz, "Initial Medical Evaluation: Name, da Silva, Flavio," memorandum for the files, Children's Asthma Research Institute and Hospital, Denver, September 22, 1961. Gordon Parks Papers, Manuscript Division, Library of Congress, Washington, D.C.

169 Parks, *Flavio*, 94.

170 Lewis Bernstein, Ph.D., "Interim Psychological Test Evaluation: DA SILVA, Flavio," memorandum for the files,

Children's Asthma Research Institute and Hospital, Denver, July 12, 1961. Gordon Parks Papers, Manuscript Division, Library of Congress, Washington, D.C.

171 Ibid.

172 "*Life* Photographer Imprisoned Yesterday: Took Negative Scenes of Guanabara," translation from *Ultima Hora*, July 7, 1961, prepared by Time Inc./Rio de Janeiro Bureau. Gordon Parks Papers, Manuscript Division, Library of Congress, Washington, D.C.

173 "Humanitarian Feeling Caused the Censor to Close the Case of the Film Made with Slum Dwellers," translation from *O Jornal*, July 8, 1961, prepared by Time Inc./Rio de Janeiro Bureau. Gordon Parks Papers, Manuscript Division, Library of Congress, Washington, D.C.

174 "The Famous Decree of Capistrano," translation from *O Dia*, July 8, 1961, prepared by Time Inc./Rio de Janeiro Bureau. Gordon Parks Papers, Manuscript Division, Library of Congress, Washington, D.C.

175 "Fable," translation from *Luta Democrática*, July 8, 1961, prepared by Time Inc./Rio de Janeiro Bureau. Gordon Parks Papers, Manuscript Division, Library of Congress, Washington, D.C. Text lightly edited.

176 "Rio Memorandum: 'Ascending, Ascending,'" translation from *A Noite*, July 8, 1961, prepared by Time Inc./Rio de Janeiro Bureau. Gordon Parks Papers, Manuscript Division, Library of Congress, Washington, D.C.

177 "Slum, America, and Nationalism," translation from *O Jornal*, July 8, 1961, prepared by Time Inc./Rio de Janeiro Bureau. Gordon Parks Papers, Manuscript Division, Library of Congress, Washington, D.C.

178 Claudius, "'Life' na favela," *Manchete*, July 22, 1961, 100.

179 This information is gleaned from stamps and annotations on the versos of Parks' contact sheets. Gordon Parks Foundation, Pleasantville, New York.

180 Wainwright, *The Great American Magazine*, 291–93.

181 Andrew Heiskell, Time Inc. chairman of the board, quoted in "Time Inc. Discontinues Spanish-Language Life, Lifts Domestic Rates," *The Wall Street Journal*, October 6, 1969. Time Inc. Archives, New-York Historical Society, New York.

182 "Brief History of LIFE En Espanol," memorandum, October 1966. Time Inc. Archives, New-York Historical Society, New York.

183 Bill Gray (director of international editions) to LIFE en Español Edit Staff, memorandum, May 26, 1961. Time Inc. Archives, New-York Historical Society, New York.

184 Circulation: "Magazine—Life En Espanol—Publisher's Statement: For 6 Months Period ending December 31, 1961," Audit Bureau of Circulations, February 26, 1962. Castro cover: Marilyn Minden to Tom Dozier, memorandum, Life International, November 9, 1962. Time Inc. Archives, New-York Historical Society, New York.

185 "Magazine—Life En Espanol—Publisher's Statement: For 6 Months Period ending December 31, 1961."

186 Ibid.

187 Quoted in Taffet, "Implementing the Alliance for Progress," 31.

188 Ibid., 34.

189 Albert Furth (assistant director) to Bill Gray, memorandum, August 19, 1961. Time Inc. Archives, New-York Historical Society, New York.

190 Jeffrey F. Taffet, "Brazil and the Alliance for Progress: Undermining Goulart and Rewarding the Military," in *Foreign Aid as Foreign Policy*, 99.

191 "Quadros of Brazil Resigns; Blames Forces of Reaction: President Under Fire on His Cuba-Soviet Policy—Students Protest," *The New York Times*, August 26, 1961, 1, 4.

192 "Moscow Assails U.S. on Quadros: Says It Forced Him to Quit Because of His Policies," *The New York Times*, August 27, 1961, 33.

193 Taffet, "Brazil and the Alliance for Progress," 99.

194 George de Carvalho, "Rio Dispatch 5085" ("Updating Flavio's Family"), telex message from Time Inc./Rio de Janeiro to Time Inc./New York, September 18, 1961. Gordon Parks Papers, Manuscript Division, Library of Congress, Washington, D.C.

195 Ibid.

196 Quoted in George de Carvalho, "Rio Dispatch 4627" (fourth take of "The Flavio Story"), telex message from Time Inc./Rio de Janeiro to Time Inc./New York, July 13, 1961. Gordon Parks Papers, Manuscript Division, Library of Congress, Washington, D.C.

197 Arthur B. Lorber to George Hunt, July 25, 1961. Time Inc. Archives, New-York Historical Society, New York.

198 Jack Fincher (reporter) to Loudon Wainwright (articles editor), telex message from Time Inc./Denver to Time Inc./New York, June 11, 1962. Gordon Parks Papers, Manuscript Division, Library of Congress, Washington, D.C.

199 Parks provides a detailed description of Flávio's early adjustment in *Flavio*, 99–114.

200 Eleanor Massey, first-grade report for Flávio da Silva, Cheltenham School, Denver, January 1961. Gordon Parks Papers, Manuscript Division, Library of Congress, Washington, D.C.

201 Dr. Samuel Bukantz, "Interim Medical Report #1: Name, DA SILVA, FLAVIO," memorandum for the files, Children's Asthma Research Institute and Hospital, Denver, December 19, 1961. Gordon Parks Papers, Manuscript Division, Library of Congress, Washington, D.C.

202 Israel Friedman (executive director, Children's Asthma Research Institute and Hospital, Denver) to José Gallo, September 6, 1961. Gordon Parks Papers, Manuscript Division, Library of Congress, Washington, D.C.

203 Parks, *Flavio*, 112.

204 Mabel Foust to C. D. Jackson, memorandum, July 14, 1961. Time Inc. Archives, New-York Historical Society, New York.

205 Though such measures are uncertain, $20,000 U.S. in 1961 is approximately equivalent to $160,000 in 2017, adjusted for inflation.

206 "Rio Memorandum: Translation of Extract from 'Correio da Manhã,' dated 12th Augt., 1961. 'LIFE' is implementing a campaign for aid to Rio Slum-dwellers." Time Inc./Rio de Janeiro Bureau. Gordon Parks Papers, Manuscript Division, Library of Congress, Washington, D.C.

207 "Rio Memorandum: Translation of Extract from 'Diário da Noite,' dated 12th Augt., 1961. 'LIFE' wishes to recuperate 'CATACUMBA,'" Time Inc./Rio de Janeiro Bureau. Gordon Parks Papers, Manuscript Division, Library of Congress, Washington, D.C.

208 George de Carvalho to Ruth Fowler, "Rio Memorandum: Flavio Fund, Rio Notes," August 14, 1961. Time Inc. Archives, New-York Historical Society, New York.

209 De Carvalho, "Rio Dispatch 5085."

210 Jayme Dantas to Ruth Fowler, telex message from Time Inc./Rio de Janeiro to Time Inc./New York, December 12, 1961. Gordon Parks Papers, Manuscript Division, Library of Congress, Washington, D.C.

211 George de Carvalho to Ruth Fowler, October 18, 1961. Gordon Parks Papers, Manuscript Division, Library of Congress, Washington, D.C. Also De Carvalho, "Rio Dispatch 5085."

212 Ibid.

213 De Carvalho, "Rio Dispatch 5085."

214 Jayme Dantas to Ruth Fowler, December 12, 1961.

215 George Hunt to Flavio Fund Contributors, October 23, 1961. Time Inc. Archives, New-York Historical Society, New York.

216 "Flavio," memorandum to the file, November 28, 1961. Time Inc. Archives, New-York Historical Society, New York.

217 Mabel Foust, "Office Memorandum: Flavio Round-Up," November 28, 1961. Time Inc. Archives, New-York Historical Society, New York.

218 George de Carvalho to John Boyle (chief of correspondents), October 11, 1961. Time Inc. Archives, New-York Historical Society, New York.

219 Taffet, "Implementing the Alliance for Progress," 44–45.

220 David St. Clair, "Rio Mailer No. 335: Sargent Shriver of the Peace Corps Visits 'Life's' Rio Favela," November 14, 1961, Time Inc./Rio de Janeiro Bureau. Gordon Parks Papers, Manuscript Division, Library of Congress, Washington, D.C. Also Jayme Dantas to Ruth Fowler, December 12, 1961.

221 José Gallo, telex message from Time Inc./Rio de Janeiro to Time Inc./New York, June 12, 1962. Gordon Parks Papers, Manuscript Division, Library of Congress, Washington, D.C.

222 Ruth Fowler to José Gallo, June 19, 1962. Time Inc. Archives, New-York Historical Society, New York.

223 Ruth Fowler to Peter Hoyt, "SUBJECT: Flavio da Silva," memorandum, June 19, 1962. Time Inc. Archives, New-York Historical Society, New York.

224 Ibid. Text lightly edited.

225 Parks, *Flavio*, 125–26.

226 Ruth Fowler to José Gallo, June 19, 1962.

227 Robert Titley, "Follow-up Psychological Report: DA SILVA, Flavio," memorandum for the files, Children's Asthma Research Institute and Hospital, Denver, July 30, 1962. Gordon Parks Papers, Manuscript Division, Library of Congress, Washington, D.C.

228 Ruth Fowler to George Hunt, memorandum, n.d. [June 1962]. Time Inc. Archives, New-York Historical Society, New York.

229 Parks, *Flavio*, 141.

230 Eleanore Paski, Adeline Kosmata, et al., "Stanford Achievement Test: Flavio da Silva," memorandum for the files, Children's Asthma Research Institute and Hospital, Denver, March 26, 1963. Gordon Parks Papers, Manuscript Division, Library of Congress, Washington, D.C.

231 Ibid.

232 Jonathan H. Weiss, Ph.D., "DA SILVA, Flavio" (final psychological report), memorandum for the files, Children's Asthma Research Institute and Hospital, Denver, March 21, 1963. Gordon Parks Papers, Manuscript Division, Library of Congress, Washington, D.C.

233 "Dr. Alvarez, Psychologist, Children's Asthma Research Institute and Hospital" (transcription of telephone conversation between Dr. Robert Alvarez and Ruth Fowler), n.d. [April–July 1963]. Gordon Parks Papers, Manuscript Division, Library of Congress, Washington, D.C.

234 José Gallo to Ruth Fowler, with attached "Translation of letter received from Flavio's school," January 28, 1966. Gordon Parks Papers, Manuscript Division, Library of Congress, Washington, D.C.

235 Details about the school are from "O JMC Institute: Another Blog by Eduardo Chaves," www.jmc.org.br. Also Parks, *Flavio*, 152.

236 Ibid., 130–32.

237 Ibid. Also author interview with José and Rick Gonçalves, Littleton, Colorado, July 17, 2016.

238 Ruth Fowler to Kathy Gonçalves, January 19, 1962. Gordon Parks Papers, Manuscript Division, Library of Congress, Washington, D.C.

239 Parks, *Flavio*, 132–33.

240 Quoted ibid., 133–34.

241 Parks, *Flavio*, 143. While a date of July 27 matches other evidence of Flávio's travel back to Brazil, his discharge was noted as July 28 in the hospital's official "Roster of patients: 1958–81 with move to NJH campus," 31. Records of National Asthma Center (NAC)/Children's Asthma Research Institute and Hospital (CARIH), Beck Archives, Library/Special Collections, University of Denver.

242 Ruth Fowler to Roy Alexander, Edgar Baker, et al., memorandum, August 12, 1963. Time Inc. Archives, New-York Historical Society, New York.

243 Parks, *Flavio*, 146–51. Also "Back to Brazil Last Week Went

Flavio da Silva . . ." in *F.Y.I.* (Time Inc. employee newsletter), August 9, 1963. Gordon Parks Papers, Manuscript Division, Library of Congress, Washington, D.C.

244 Parks, *Flavio*, 150.

245 Fowler to Alexander, Baker, et al., August 12, 1963.

246 John Blashill (Time Inc. Rio bureau chief) to Ruth Fowler, telex message from Time Inc./Rio de Janeiro to Time Inc./New York, August 5, 1963. Time Inc. Archives, New-York Historical Society, New York.

247 Bell, "Brazilian-American Relations," 86.

248 Richard Clurman (chief, U.S. and Canadian news service) to Henry Luce et al., memorandum, October 2, 1961. Time Inc. Archives, New-York Historical Society, New York.

249 "Translation from El Universal, Mexico City, October 6, 1961/Time-Life: Trojan Horse of North American Journalism, by Jose C. Alvarez." Time Inc. Archives, New-York Historical Society, New York.

250 Andrew Heiskell to Henry Luce et al., memorandum, October 9, 1961. Time Inc. Archives, New-York Historical Society, New York.

251 John Boyle to Albert Furth, memorandum, October 11, 1961. Also Jim Pitt (publicity director) to Andrew Heiskell et al., October 11, 1961. Time Inc. Archives, New-York Historical Society, New York.

252 John Blashill to Ruth Fowler, telex message from Time Inc./Rio de Janeiro to Time Inc./New York, August 2, 1963. Time Inc. Archives, New-York Historical Society, New York.

253 Ibid.

254 Ibid.

255 Blashill to Fowler, August 5, 1963.

256 Fowler to Alexander, Baker, et al., August 12, 1963.

257 Jacquelyn Gross, "As the Slum Goes, So Goes the Alliance," *The New York Times Magazine*, June 23, 1963, 57.

258 José Gallo to Ruth Fowler, September 10, 1964. Gordon Parks Papers, Manuscript Division, Library of Congress, Washington, D.C.

259 Taffet, "Brazil and the Alliance for Progress," 100–114.

260 Carlos F. Diaz-Alejandro, quoted in Bell, "Brazilian-American Relations," 89.

261 Taffet, "Brazil and the Alliance for Progress," 113.

262 Ibid. Also Juan de Onis, "Brazil Curbs Profit Transfer,"

The New York Times, January 18, 1964, 28.

263 "Moves for Expropriation Anger Brazil Landowners," *The New York Times*, February 18, 1964, 5. Also Tad Szulc, "Brazil Prepares to Seize Farms and Refineries," *The New York Times*, March 10, 1964, 13.

264 Bell, "Brazilian-American Relations," 89–91.

265 Taffet, "Brazil and the Alliance for Progress," 111. Also Tad Szulc, "Brazil Coup Affects Whole Continent; Overthrow of Goulart Is Expected to Bolster the Moderates and Set Back the Communists," *The New York Times*, April 5, 1964, E4.

266 Quoted in Bell, "Brazilian-American Relations," 91.

267 Taffet, "Brazil and the Alliance for Progress," 111; and Bell, "Brazilian-American Relations," 89.

268 Juan de Onis, "U.S. Team Urges Rebuilding, Not Demolition, of Brazil Slums," *The New York Times*, August 12, 1966, 12.

269 Leandro Benmergui, "The Alliance for Progress and Housing Policy in Rio de Janeiro and Buenos Aires in the 1960s," *Urban History* 36, no. 2 (2009), 313–14.

270 Gallo to Fowler, September 10, 1964.

271 José Gallo to Ruth Fowler, February 8, 1965. Gordon Parks Papers, Manuscript Division, Library of Congress, Washington, D.C.

272 Ibid.

273 De Onis, "U.S. Team Urges Rebuilding, Not Demolition, of Brazil Slums."

274 Ibid.

275 José Gallo to Ruth Fowler, August 23, 1966. Gordon Parks Papers, Manuscript Division, Library of Congress, Washington, D.C.

276 José Gallo to Ruth Fowler, September 20, 1966. Gordon Parks Papers, Manuscript Division, Library of Congress, Washington, D.C.

277 José Gallo to Ruth Fowler, June 19, 1967. Gordon Parks Papers, Manuscript Division, Library of Congress, Washington, D.C.

278 José Gallo to Ruth Fowler, September 18, 1967. Gordon Parks Papers, Manuscript Division, Library of Congress, Washington, D.C. Also "Incêndio destrói sessenta barracos na Favela da Catacumba," *Jornal do Brasil*, August 3, 1967, 2. Accessed at Biblioteca Nacional Digital, Brazilian National Archives, Rio de Janeiro.

279 George de Carvalho, "A

Personal Report: Flavio and the Favela," memorandum, February 2, 1967. Gordon Parks Papers, Manuscript Division, Library of Congress, Washington, D.C.

280 Ruth Fowler to José Gallo, July 13, 1967. Gordon Parks Papers, Manuscript Division, Library of Congress, Washington, D.C.

281 Gallo to Fowler, June 19, 1967.

282 Fowler to Gallo, July 13, 1967.

283 José Gallo to Ruth Fowler, January 8, 1968. Gordon Parks Papers, Manuscript Division, Library of Congress, Washington, D.C.

284 Janice Perlman, "The Failure of Influence: Squatter Eradication in Brazil," in *Politics and Policy Implementation in the Third World*, ed. Merilee S. Grindle (Princeton, NJ: Princeton University Press, 1980), 258.

285 Quoted ibid., 258–59.

286 Gallo to Fowler, January 8, 1968.

287 Perlman, "The Failure of Influence," 254, 261.

288 "Favelados da Catacumba vão ser todos removidos até o fim deste mês para a Penha," *Jornal do Brasil*, September 1, 1970, 5.

289 "Decreto da Catacumba pode sair 2.a," *Jornal do Brasil*, September 25, 1970, 5.

290 "Informe-JB: Lance-livre," *Jornal do Brasil*, September 23, 1970, 10.

291 "Penha e Cidade de Deus recebem as primeiras 28 famílias da Catacumba," *Jornal do Brasil*, October 2, 1970, 5. Sociologist Janice Perlman later reported that CHISAM deliberately "denatured" SOMAC's leadership, by coopting many of its directors to support eradication and serve on a vigilante committee assigned to maintain order during the clearing of Catacumba. Perlman, "The Failure of Influence," 261–65.

292 "CHISAM transfere 43 birosqueiros no. 2.0 dia de mudança da Catacumba," *Jornal do Brasil*, October 3, 1970, 7. Also "Barracos da Catacumba são queimados," *Jornal do Brasil*, October 3, 1970, 1, and "Mudança na Catacumba pára trânsito," *Jornal do Brasil*, October 2, 1970, 1.

293 Advertisement by CHISAM, Ministério do Interior, and Banco Nacional de Habitação, *Jornal do Brasil*, October 5, 1970, 40.

294 "Cohabs se reúnem com CHISAM," *Jornal do Brasil*, October 10, 1970, 5.

295 José Gallo to Ruth Fowler,

October 28, 1970. Gordon Parks Papers, Manuscript Division, Library of Congress, Washington, D.C.

296 "Remoção na Catacumba chega ao fim," *Jornal do Brasil*, November 25, 1970, 5. Also "Catacumba terminará com um incêndio," *Jornal do Brasil*, November 26, 1970, 1.

297 "DNERu (Departamento Nacional de Endemias Rurais) utiliza venemo que exterminá ratos antes de queimar resto da Catacumba," *Jornal do Brasil*, November 28, 1970, 5. Also "Rato ameaça se espalhar na Zona Sul," *Jornal do Brasil*, November 29–30, 1970, 1.

298 Gallo to Fowler, October 28, 1970.

299 Ibid.

300 Gallo to Fowler, January 28, 1966.

301 José Gallo to Ruth Fowler, May 20, 1966. Gordon Parks Papers, Manuscript Division, Library of Congress, Washington, D.C.

302 Ruth Fowler to Flávio da Silva, March 5, 1970. Gordon Parks Papers, Manuscript Division, Library of Congress, Washington, D.C.

303 Ruth Fowler to Bill Bishop, "F.Y.I.: Today we forwarded a check . . . ," memorandum, November 10, 1970. Time Inc. Archives, New-York Historical Society, New York.

304 De Carvalho, "A Personal Report: Flavio and the Favela."

305 "Letters to the Editors," *Life*, February 18, 1966, 20.

306 Ruth Fowler to Bill Bishop, "Termination of checking account relating to Catacumba Favela Trust," memorandum, February 9, 1973. Time Inc. Archives, New-York Historical Society, New York.

307 Agreement between Gordon Parks and Flávio da Silva, August 12, 1976. Gordon Parks Papers, Manuscript Division, Library of Congress, Washington, D.C.

308 Parks, *Flavio*, 187.

309 Ibid., 7.

310 Accounting records from the publisher, W. W. Norton, and correspondence between Parks and editor Evan Thomas reveal returned copies, low royalty balances, and general disappointment over the book's sales. Gordon Parks Papers, Manuscript Division, Library of Congress, Washington, D.C.

Favelas: Aesthetics, Politics, Memory

Beatriz Jaguaribe and
Maria Alice Rezende de Carvalho

When Gordon Parks arrived in the Catacumba favela in March 1961, Rio de Janeiro had recently ceased to be the capital of Brazil. Brasília, which officially assumed that title on April 21, 1960, was projected as a showcase of modernity: an iconic site for the idea of the future-in-the-present, the blueprint modernist city that would introduce novel forms of urban living, socialization, and culture throughout the deserted central plateau of Brazil. For a peripheral nation struggling to overcome its history of rural exploitation, oligarchic entrenchment, and economic dependence, Brasília advertised the future. No assemblage of constructions, therefore, could be more antithetical to the impulse behind the building of Brasília than the existence of Rio de Janeiro's numerous favelas. Yet because of their overt presence in the city's landscape, their vital connection to popular culture, and their association with poverty, Rio's favelas questioned modernist agendas of social inclusion or exclusion.

The early 1960s were an especially tense time in Latin America, as the opposing forces in the Cold War—namely, the United States and the Soviet Union—were staking claims in the continent in the wake of the Cuban revolution of 1959. Gordon Parks' forceful reportage and wrenching photo essay on Flávio da Silva and his family, published in *Life* magazine on June 16, 1961, mirrored the rhetoric of the larger global dispute. Under the catchy headline "Freedom's Fearful Foe: Poverty," the introductory text to Parks' photo essay emphasized that "the teeming poor are a ripe field for Castroist and Communist political exploitation." There was extensive coverage in the Brazilian press of Parks' sojourn in Rio and his photography in Catacumba, and the *Life* reportage was not directly discredited.[1] His photographs were dramatic, particularly such images as that of the martyred Flávio lying on a bed partly covered by a threadbare blanket, intense suffering etched into his lean face (p. 39). Also jarring were the pictures of the da Silva children amid their squalid surroundings (pp. 12–17, 30–37, 40–43). These photographs indicate an intention to heighten not only the social critique but also the emotional catharsis. Even with the charged tone of the text, Parks' skillfully executed photographs, his personal engagement with Flávio and his family, and the da Silvas' blatant and excruciating poverty could not be easily dismissed. As a prominent African American photographer capturing the miserable conditions of a white *nordestino* (northeastern) family in a Rio favela, Parks upset naturalized stereotypes. Eventually the *Life* magazine story was crudely countered by reportage published in the widely circulating Brazilian magazine *O Cruzeiro* (see the essay by Sérgio Burgi in this volume), which sent Henri Ballot to photograph and write about an indigent Puerto Rican family in Spanish Harlem. But what is relevant about the cultural representations surrounding the favelas of Rio is that Gordon Parks' engagement with Flávio, the rest of the da Silva family, and, by extension, the favela of Catacumba brought to the forefront the ambivalent relations of Brazilian society to the phenomenon of the favela itself.

In the 1960s, the favelas of Rio de Janeiro differed among themselves, as they do today. Endowed with scenic views, the communities in the South Zone of the city were home to an extensive labor force for nearby well-to-do neighborhoods. Although favelas in the South Zone were not as poor as those in the more proletarian North Zone, the West Zone, and the outskirts, the living conditions—in shacks, often constructed of planks, crates, and cardboard—were most dire. Immigrants from the state of Minas Gerais and, beginning in the 1940s and 1950s, from the poverty-stricken Northeast formed the bulk of Catacumba's population.[2] Unlike traditional favelas that were associated with samba schools, such as Mangueira and Salgueiro, Catacumba had no claim to fame before Parks' photo essay was published (figs. 21, 22).

In the nineteenth century, the lands of Catacumba were leased to the Baroness da Lagoa Rodrigo de Freitas. In accordance with her will, upon her death the steep hillside terrain passed to her slaves. In 1925 the lease expired and the federal agency that maintained jurisdiction over the land began to divide it and sell the plots. The baroness's heirs went to court, and land disputes went on for decades.[3] Although Catacumba was small, its shacks, which cascaded down the side of a hill, were clearly visible in the landscape of the wealthy neighborhood of Lagoa (lagoon). Located at the heart of the South Zone facing the Rodrigo de Freitas lagoon, and near the beach neighborhoods of Ipanema and Copacabana, Catacumba was considered a fairly comfortable community by the standards of Rio favelas in the 1960s. According to Janice Perlman, an American scholar who has written extensively about Rio's favelas and who lived and conducted research in Catacumba in 1968, the motley assortment of shacks belied the complex social organization and spatial layout of the community, which was divided into various zones.[4] As is usually the case with favelas located on hills, the homes nearest the asphalt road, at the foot of the favela, were of better quality and had access to piped water, transportation, and active commerce. Later arrivals typically perched their shacks at the top of the hill and endured the hardest life, whatever the arresting views. Independent of their income, all favela residents faced the entrenched prejudice of non-*favelados*, as well as insufficient schools, day care centers, and medical facilities. With the lack of plumbing at favelas, as Parks himself learned, the sight of women and children balancing large tin cans of water on their heads was common. During tropical storms that assailed the city, mudslides and flooding claimed many lives in the favelas.

Disparaging press reports about favelas focused on crime rates, natural disasters, and the tribulations of scarcity. Yet favela residents were deeply involved in the workings of the city, not simply as an affordable labor force but also as creative agents pursuing forms of social organization, community engagement, and the overall improvement of their lives.

Favelas were found in all Brazilian cities, but those of Rio de Janeiro held special status because of their relationship with the popular culture of the former capital. During the first lengthy period of Getúlio Vargas' presidency, from 1930 to 1945, samba—closely identified with Rio's favelas—was broadcast nationwide over

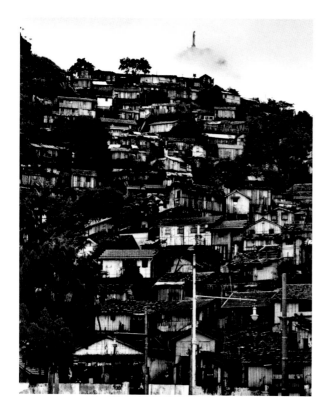

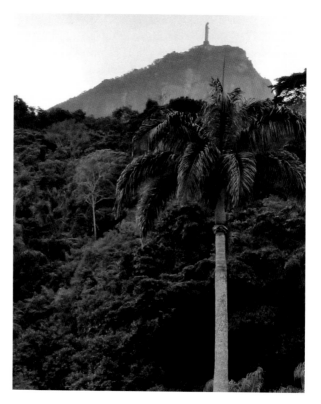

FIG. 21 (LEFT) Gordon Parks, Catacumba Favela, Rio de Janeiro, Brazil, 1961. The Gordon Parks Foundation

FIG. 22 (RIGHT) Catacumba Park (Parque Natural Municipal da Catacumba), 2017. Courtesy Beatriz Jaguaribe

public radio. Samba schools were (and still are) embedded in favela communities throughout the city. Whereas Carnival festivities and samba gained approval, the favela itself was largely considered a blight on the urban landscape. Furthermore, the value given to favelas for their musical contribution did not necessarily enter other areas of artistic endeavor.

If there was an abundance of favela composers, dancers, and musicians, there were practically no favela writers. High rates of illiteracy, lack of educational opportunities, meager financial gain, and elitist control of the literary world were among the obstacles to the rise of popular authorship. Carolina Maria de Jesus' bestseller *Quarto de despejo: Diário de uma favelada*, published in 1960 and translated into several languages afterward (in English, *Child of the Dark: The Diary of Carolina Maria de Jesus*), was a notable exception. De Jesus' prose detailed the daily struggle to live in the hunger-plagued environment of the Canindé favela in São Paulo. As a poor black woman writing her diary in a mostly illiterate community, de Jesus was an anomaly. Although her authorship was a singular phenomenon, the realistic depiction that permeates her writing would be the dominant mode for representing favela life. The emphasis on verisimilitude, the search for an authentic rendering of life experiences, and the use of diverse realist aesthetics as tantamount to reality itself provided a common interpretative vocabulary for the artistic representations of favela life in film and fiction.[5] Whereas de Jesus spoke of her individual plight and offered no political redemption, the precursor films of the Cinema Novo, such as *Rio 40 graus* (1955) and *Rio Zona Norte* (1957), both directed by Nelson Pereira dos Santos, concentrated on class privileges, racial encoding, and the struggle for justice. *Cinco vezes favela* (1962), the landmark film of the Cinema Novo, consisting of films made by five different directors,

exposed the social conflicts of favela dwellers in an exploitative society. Realism in these films served a social agenda that not only sought to denounce social oppression but also pointed toward the possibility of a different future. Favela dwellers in a variety of guises—young boys roaming the city, plying their wares; talented composers seeking their share of recognition; immigrants struggling to get by; shady outlaws—were shown as the active protagonists in social conflicts. This implied a vision of class society that trusted in the resilience and moral strength of the oppressed. The poor were exploited, yet they were also potentially revolutionary agents.

By contrast, *Black Orpheus* (1959), directed by French filmmaker Marcel Camus, offered an aesthetic, celebratory vision of the favela as a colorful, vibrant, festive samba community thriving amid picturesque poverty and cheerful precariousness (fig. 23). Before Camus' film, which set the Greek myth of Orpheus and Eurydice on a Rio hillside, the favela had been the subject of another foreign gaze. At the behest of Nelson Rockefeller, head of the Office of the Coordinator Inter-American Affairs, Orson Welles was commissioned in 1942 to film the culture and peoples of Brazil as part of the U.S. propaganda effort referred to as the "Good Neighbor Policy." To the dismay of both Rockefeller and the bureaucrats of the Vargas regime, Welles emphasized the plight of a group of northeastern fishermen, and also highlighted samba and Afro-Brazilian artists of the Rio favelas.[6] Sent on a similar mission from 1940 to 1942, the American photographer Genevieve Naylor likewise disappointed the propaganda efforts of the Vargas regime by taking pictures of all ranks of Brazilian society, including many portraits and street scenes featuring the poor.

Unlike Welles and Naylor, Parks arrived in Rio in 1961 not on a government assignment. Yet the commission to photograph poverty for *Life* magazine in one of

the city's favelas was associated with the U.S. government's desire to correlate dire poverty and the potential for communist affiliation (see the essay by Paul Roth in this volume).

In Brazil, after Vargas' downfall in 1945 and the establishment of democratic rule, the Constitution of 1946 legalized the Brazilian Communist Party, although by 1947 it was again illegal. The Party's electoral growth and the creation of "popular democratic committees" in poor neighborhoods and favelas led the archdiocese and the municipality of Rio to envision the creation in 1947 of the Fundação Leão XIII, or Pope XIII Foundation in an effort to negate communist influence. Designed to repudiate the previous repressive practices of the Vargas regime besides resisting the advance of communism, the foundation sought to boost Christian morale among favela dwellers while tackling poverty, primarily through social support and charity. Although Catholic clergy insisted on dialogue and promoted material assistance, they were not truly interested in furthering the agency of the working classes by allowing them to pursue autonomous modes of representation.[7]

In the 1950s, while it was still the capital of Brazil, Rio was energized by an intense political debate. Public intellectuals, certain political parties, and favela grassroots activists were delineating agendas for the future and discussing policies of social transformation.[8] In this atmosphere of expectation, the Catholic Church chose a recently ordained bishop, Hélder Pessoa Câmara, as its main policy maker for the poor. He was at the vanguard of the debate about Church policies toward the poor in accordance with its social calling. Câmara organized the successful 36th International Eucharistic Congress in Rio de Janeiro in 1955 and then participated in the creation of the Cruzada São Sebastião, or Saint Sebastian Crusade, whose main objective was to eradicate all of Rio's favelas in ten years. Its principal achievement was the construction of a housing project with 945 modernistic apartments in the prosperous Leblon neighborhood. This was the first instance of lodging *favelados* close to the original locations from which they had been removed.

Although favela neighborhood associations established the FAFEG in 1963, an umbrella organization representing the interests of favela dwellers, their autonomy was constantly challenged by the state, the municipal authorities, and the Catholic Church.[9] During the 1960s, the U.S. government financed the building of four housing complexes—Cidade de Deus (City of God), Vila Kennedy, Vila Aliança (Alliance), and Vila Esperança (Hope).[10] The funds for these projects came from the Alliance for Progress—a U.S. cooperation program that sought to accelerate economic development in order to deter the advance of communism in Latin America.

Parks' *Life* assignment took place when Brazil was governed by Jânio Quadros, an erratic president who was sworn into office in late January 1961 but abruptly

resigned before the end of August the same year. When João Goulart, the vice president, assumed office, he attempted to endorse left-leaning reformist policies; these were met with great resistance from high-ranking military officers and conservative sectors of the middle class and the business world. Although Parks' photo essay and his personal engagement with Flávio and Catacumba were not directly influenced by the turbulent political circumstances in Brazil at the time, the *Life* assignment was ingrained in the Cold War rhetoric against communism. As is well known, Parks' photo essay elicited an outpouring of donations from U.S. readers. Flávio's life had all the ingredients of a highly emotional narrative of adversity, suffering, and stoic endurance. It was compelling for readers precisely because it was an individual story, striking an empathetic chord through that singularized appeal. Parks' commitment ultimately saved Flávio. In his writings, Parks never mentioned the political associations within the favelas, nor did he address any possibilities of empowerment. His exchanges with the favela dwellers of Catacumba were mediated largely by reporter José Gallo, who served as his interpreter. Parks' grasp of the favela was premised on his eyewitness testimony. His focus was on the humanitarian pathos of the individual caught in a web of scarcity and despair.

In 1964, the military coup that toppled the government of João Goulart imposed control and censorship on political life. The burgeoning favela associations that were gaining political clout were crippled by authoritarian measures of political repression. Eradication of the favelas, rather than their urbanization, became official policy until the late 1970s.

The favela of Catacumba disappeared from the physical landscape in 1970. Visitors to the present-day Catacumba Park (Parque Natural Municipal da Catacumba) will find few vestiges of the community that once occupied its site (figs. 24–26). A few placards summarizing the history of the park mention the obliterated favela. What does remain of Catacumba, however, is in the memories of its former residents, and in the scattered images and narratives that survive in books, magazines, newspaper clippings, and other such records. Among the images preserving the memory of Catacumba, Gordon Parks' photographs feature prominently (p. 11).

If the memory of demolished favelas has been largely erased, the presence of current favelas in the landscape of the city is more visible than ever. Between 2000 and 2010, Rio's population grew from 5,857,994 to 6,320,466. While the non-favela population of the city increased by 5 percent, the favela population increased by 19 percent.[11] The official policy of favela eradication has been abandoned since the 1980s. Not only have favelas expanded numerically, but their material conditions have considerably improved as far as sanitation, urban infrastructure, and access to consumer goods. Even with these material gains, since the 1980s the favelas of Rio have been identified as fertile terrain for the city's brutal drug trade. Successive security policies, including the most ambitious one, which began with the introduction of Police Pacification Units in 2008, have proved unable to reduce or control the violence. If the scenario is bleak in terms of security measures, health services, and education, the same cannot be said of the political and cultural relevance of these communities. While favelas continue to be contested spaces, through political activism, cultural production, community tourism, and novel forms of authorship, they have also become a trademark of Rio de Janeiro. The subject of extensive academic research and the target of numerous urban planning projects, favelas also feature prominently in the media and are the frequent subject of films and documentaries, novels, and journalistic reportage. Although favela communities are increasingly expressing their rights, this does not necessarily mean that such rights are not continually violated.

In the 1960s, Gordon Parks' humanistic photography galvanized attention and mobilized U.S. readers, who sought to provide relief to a single, specific favela family with their donations. During the same period, the engaged cinema of a leftist intelligentsia sought to extol the poor toward a critical revolutionary stance. The Brazilian military dictatorship ended in the mid-1980s, and the first direct presidential election after the 1964 military coup was held in 1989. Amid corruption scandals, a controversial impeachment process, and disabling economic and political crises, Brazil is currently seeking alternatives for the future. Despite many drawbacks, the consolidation of the democratic regime in the past few decades has allowed favela dwellers and leaders to create novel forms of empowerment. Photographers, writers, academics, and anonymous people from the favelas are now increasingly telling their own stories and histories, and on their own diverse terms.

1 Fernando de Tacca, "O Cruzeiro versus Paris Match e Life," in As origens do fotojornalismo no Brasil, um olhar sobre O Cruzeiro, 1940–1960, ed. Helouise Costa and Sérgio Burgi (Rio de Janeiro: Instituto Moreira Salles, 2012), 283–284.

2 Janice E. Perlman, Favela: Four Decades of Living on the Edge in Rio de Janeiro (Oxford: Oxford University Press, 2010), 67.

3 Ibid., 66.

4 Ibid., 69.

5 Beatriz Jaguaribe, Rio de Janeiro: Urban Life Through the Eyes of the City (London: Routledge, 2014).

6 Welles' Brazilian footage for the project was never released as intended. The 1993 documentary It's All True: Based on an Unfinished Film by Orson Welles shared some of its scenes.

7 Maria Alice Rezende de Carvalho, "A cidade como bem público," in Cidade Integrada (Rio de Janeiro: Instituto de Arquitetos do Brasil, 2012), 84–85.

8 Rafael Soares Gonçalves, Favelas do Rio de Janeiro: História e direito (Rio de Janeiro: Pallas/PUC, 2013), 155.

9 FAFEG stands for Federação das Associações de Favelas do Estado da Guanabara, or Federation of Associations of Favelas of Guanabara State.

10 Marcelo Burgos, "Dos parques proletários ao Favela-Bairro: As políticas públicas nas favelas do Rio de Janeiro," in Um século de favela, ed. Alba Zaluar and Marcus Alvito (Rio de Janeiro: Fundação Getulio Vargas, 1999), 25–60.

11 Fernando Cavallieri and Adrian Vidal, "Favelas na cidade do Rio de Janeiro: O quadro populacional com base no Censo 2010," report no. 20120501, IPP/Prefeitura da Cidade do Rio de Janeiro, May 2012, p. 6, http://portalgeo.rio.rj.gov.br/estudoscariocas/download%5C3190_FavelasnacidadedoRiodeJaneiro_Censo_2010.PDF.

FIG. 24 Catacumba Park
(Parque Natural Municipal da
Catacumba), 2017. Courtesy
Beatriz Jaguaribe

FIG. 25 Catacumba Park
(Parque Natural Municipal da
Catacumba), 2017. Courtesy
Beatriz Jaguaribe

FIG. 26 View of Lagoa Rodrigo
de Freitas from Catacumba Park
(Parque Natural Municipal da
Catacumba), 2017. Courtesy
Beatriz Jaguaribe

Gordon Parks' photo essay engendered considerable controversy in the Brazilian media, particularly in *O Cruzeiro*, an illustrated weekly known for its nationalist positions. In retaliation against the *Life* story, *O Cruzeiro* sent Brazilian photographer Henri Ballot to New York City to report on poverty in America. Exploring Spanish Harlem and the Lower East Side in Manhattan, Ballot kept a diary of his experiences and encounters. After recording street scenes in these destitute neighborhoods, he discovered Puerto Rican immigrants Felix and Esther Gonzalez and their six children, who lived in a derelict one-room apartment in a tenement building on the Lower East Side. Ballot depicted the Gonzalez children as they played in alleys, lived together in cramped quarters, and endured the struggles of life in a run-down, dangerous area of the city. His reportage, which closely recalled Parks' portrayal of the da Silvas and the Catacumba favela, was published in *O Cruzeiro*'s October 7, 1961, issue in a twelve-page spread, "New American Record: Misery." *Life*'s sister magazine, the newsweekly *Time*, challenged the *O Cruzeiro* story, stating that Ballot had set up a photograph of one of the Gonzalez children covered in cockroaches. On November 18, *O Cruzeiro* responded in kind, publishing the investigation "Henri Ballot Unmasks American Report." Featuring interviews with members of the da Silva family and photographs of their old home in Catacumba, Ballot's follow-up challenged Parks' original coverage and charged him with staging some of the scenes he photographed. Competing articles by U.S. and Brazilian press outlets continued to contest and perpetuate these dueling accusations, effectively distracting readers from the subject of both stories: the dire poverty that the da Silva and Gonzalez families lived daily, typical of communities in both countries and around the world.

HENRI BALLOT 1961

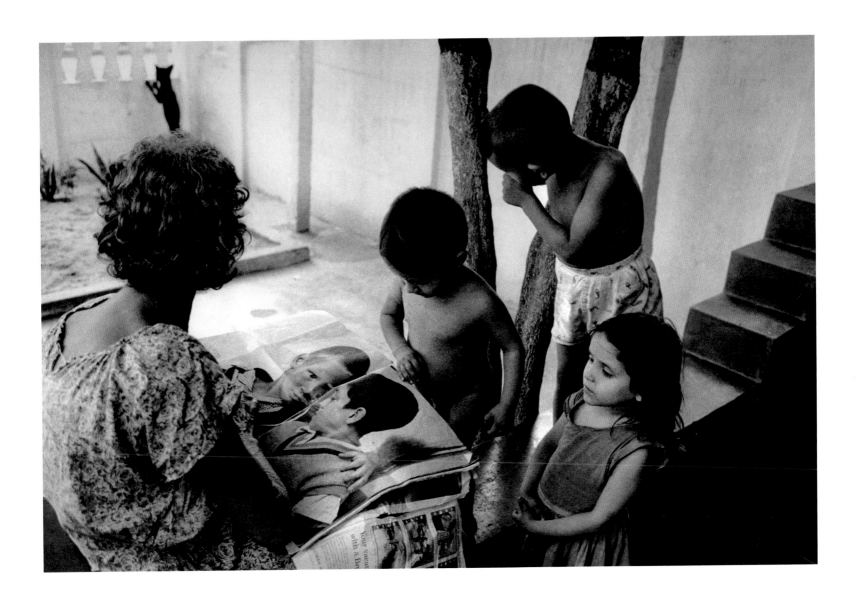

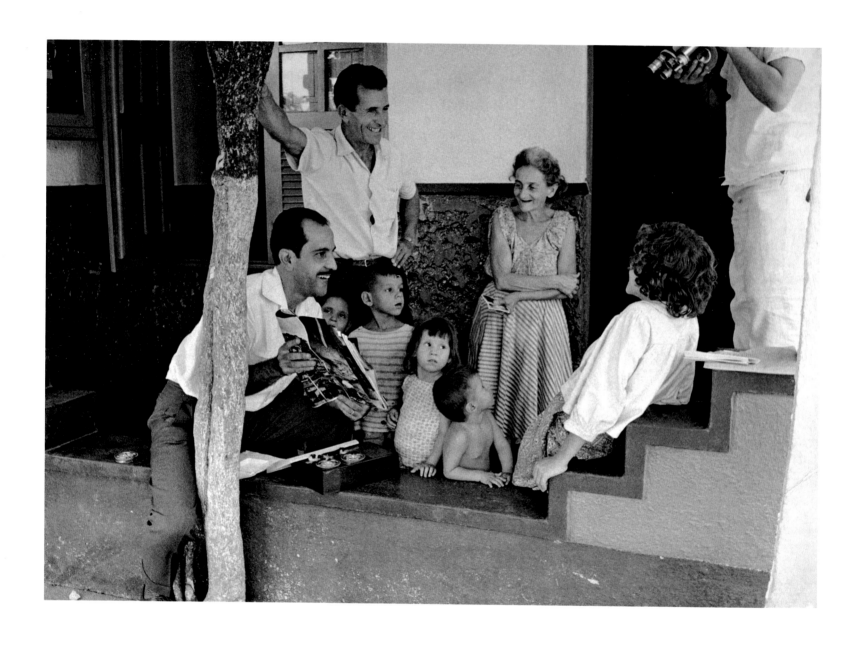

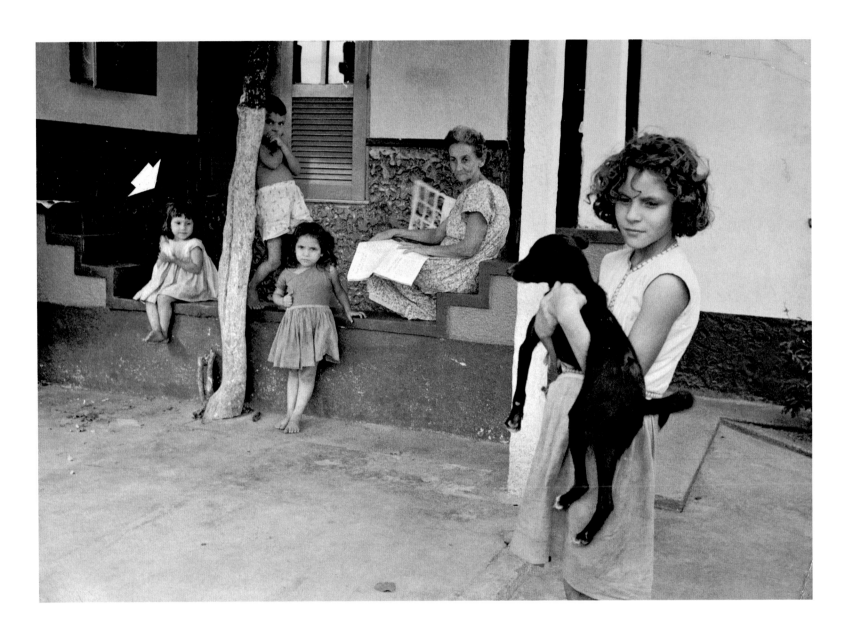

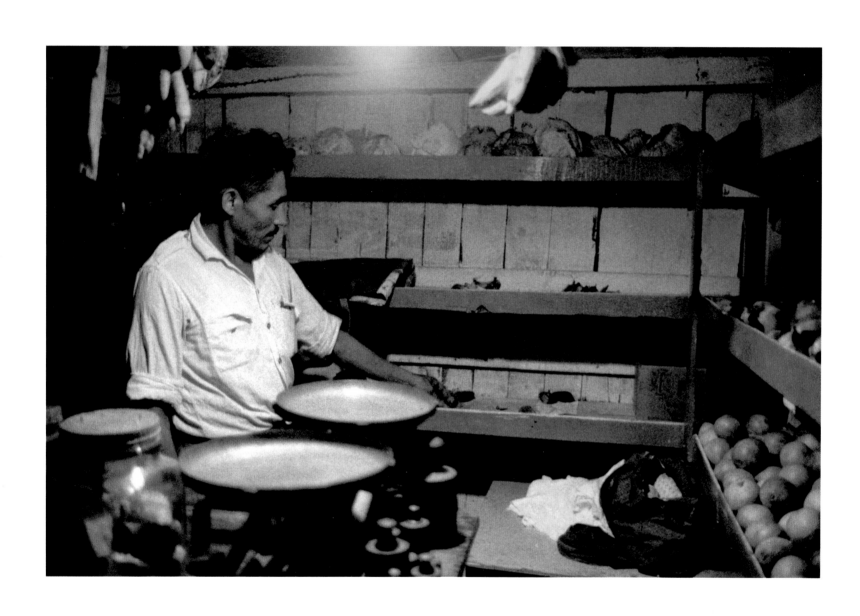

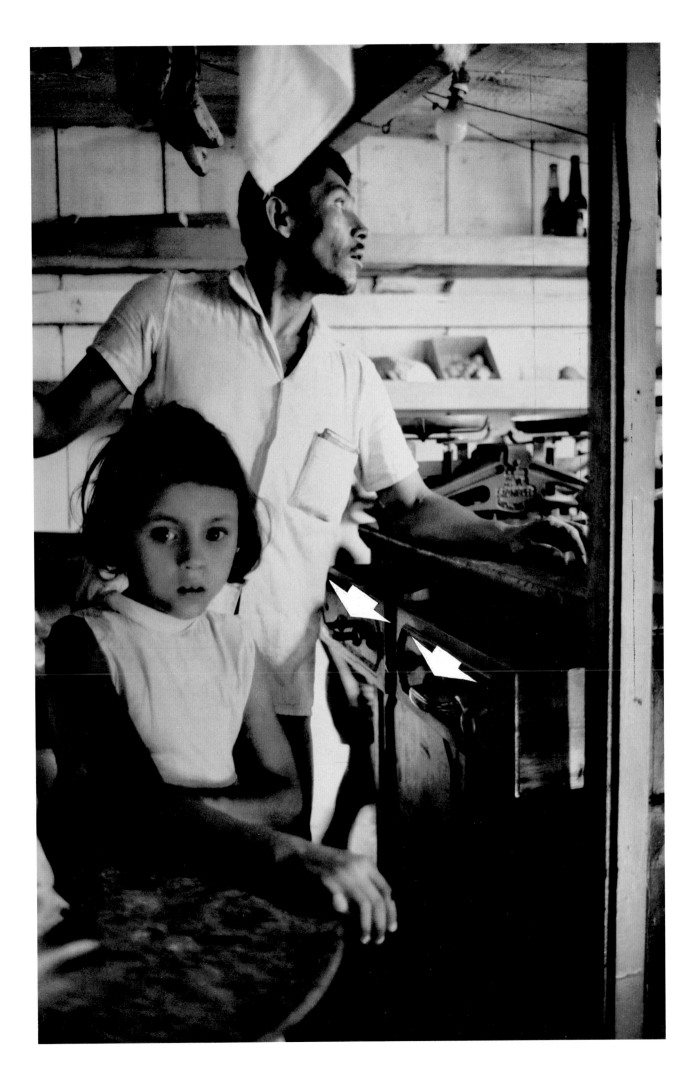

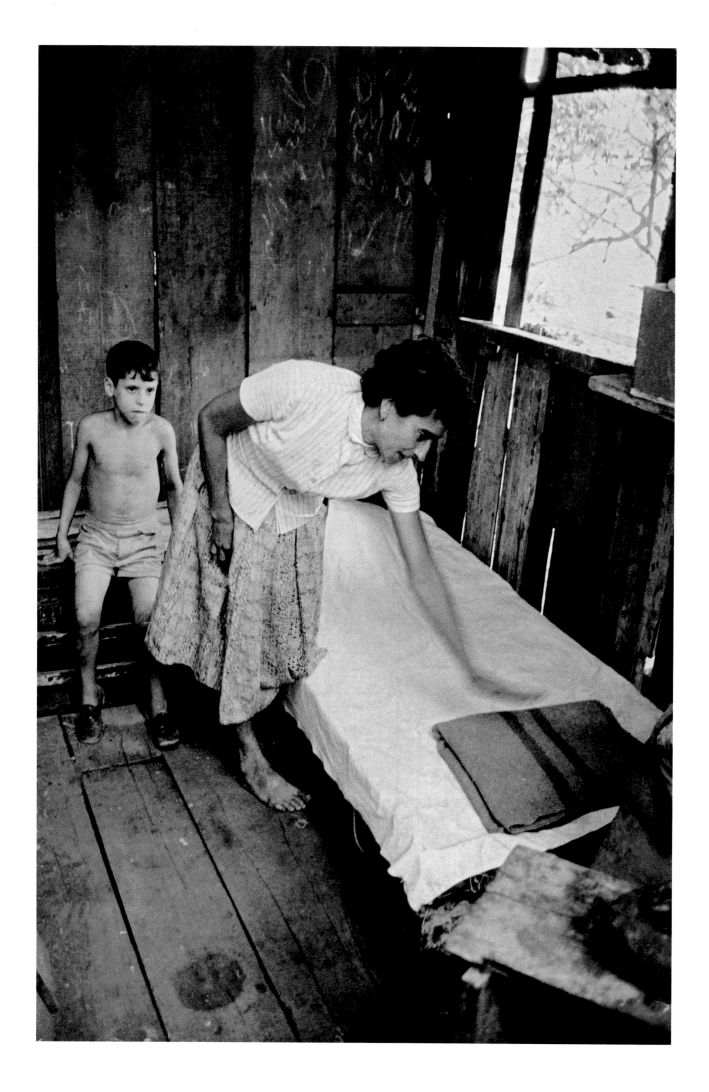

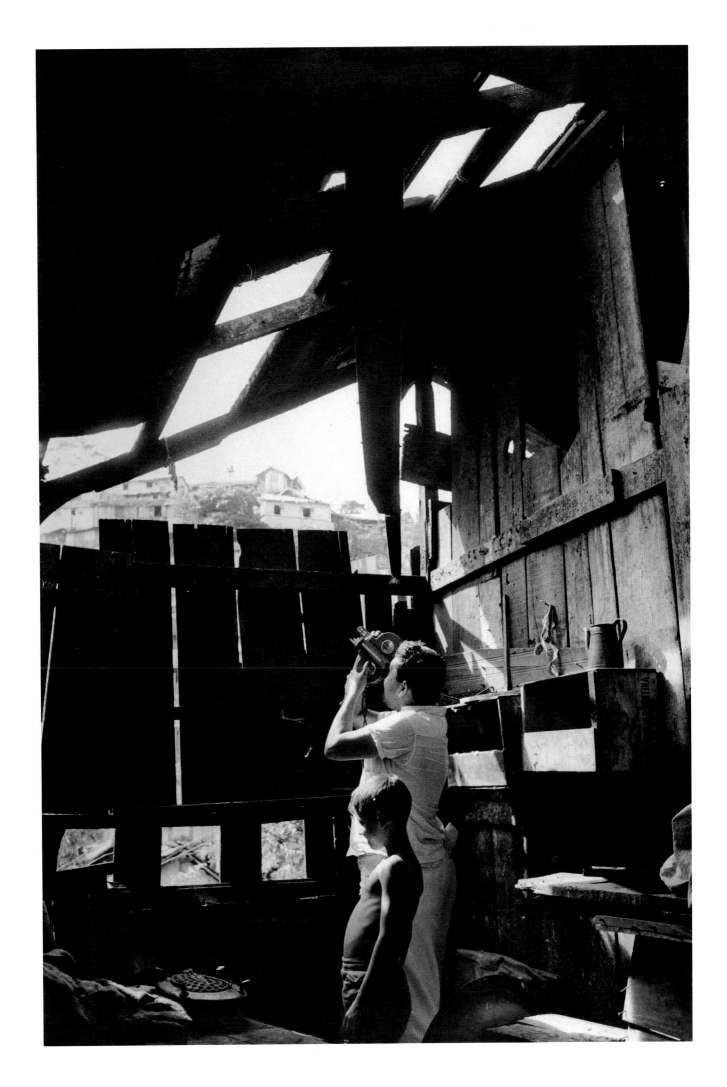

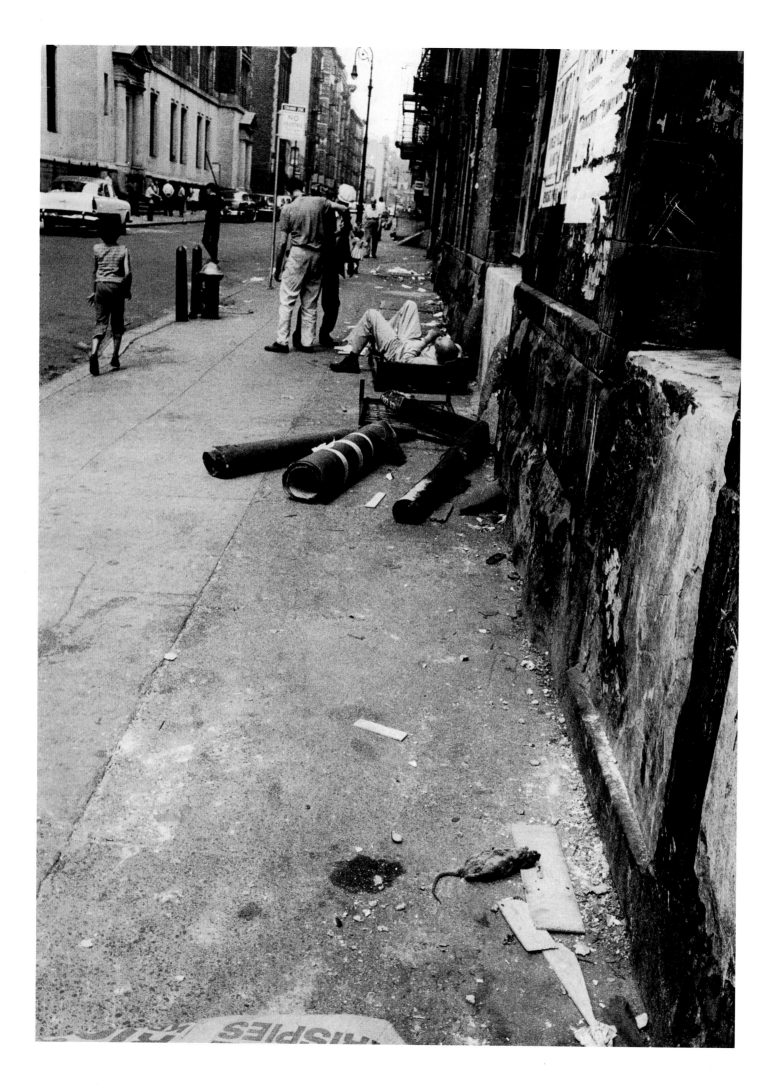

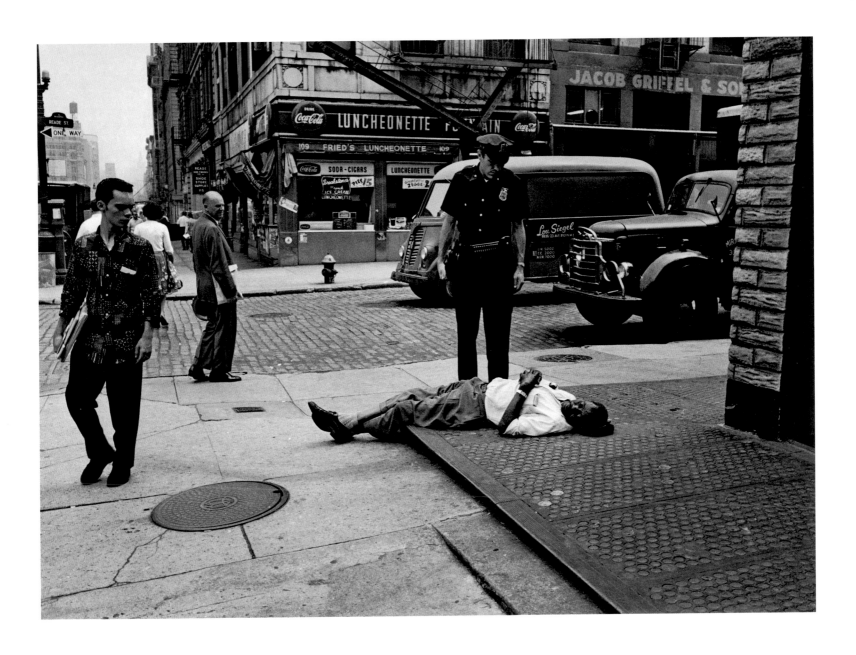

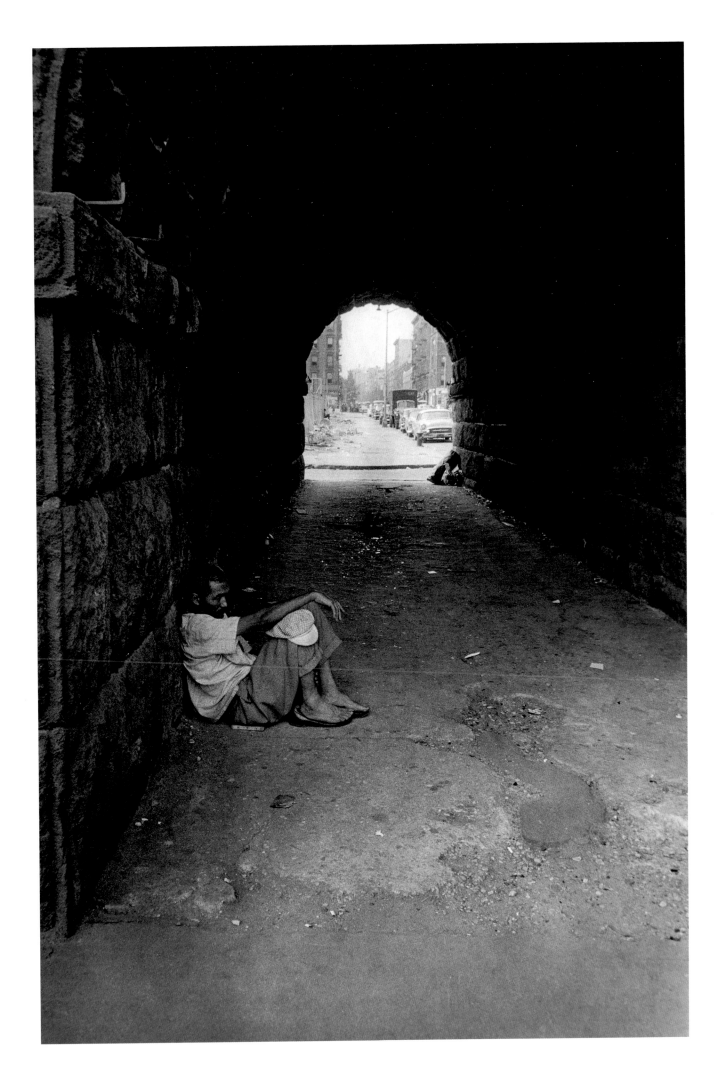

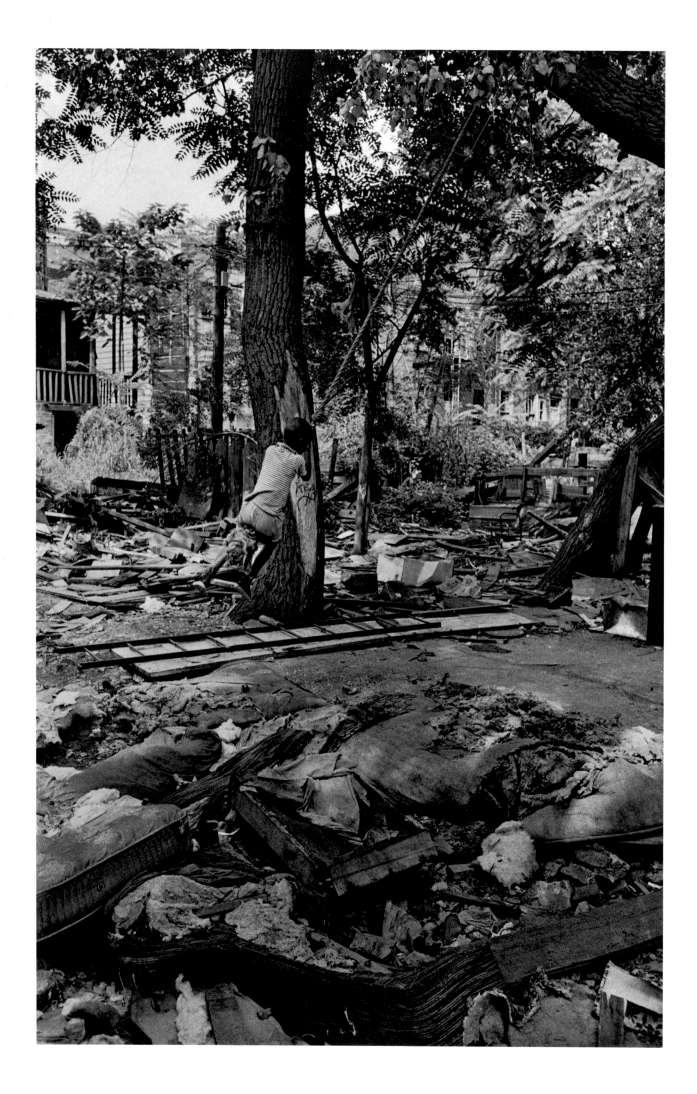

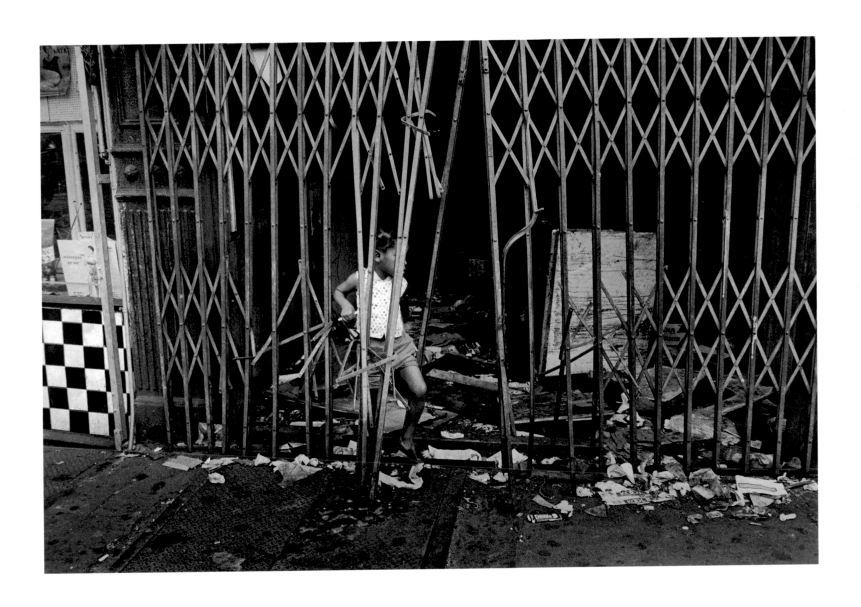

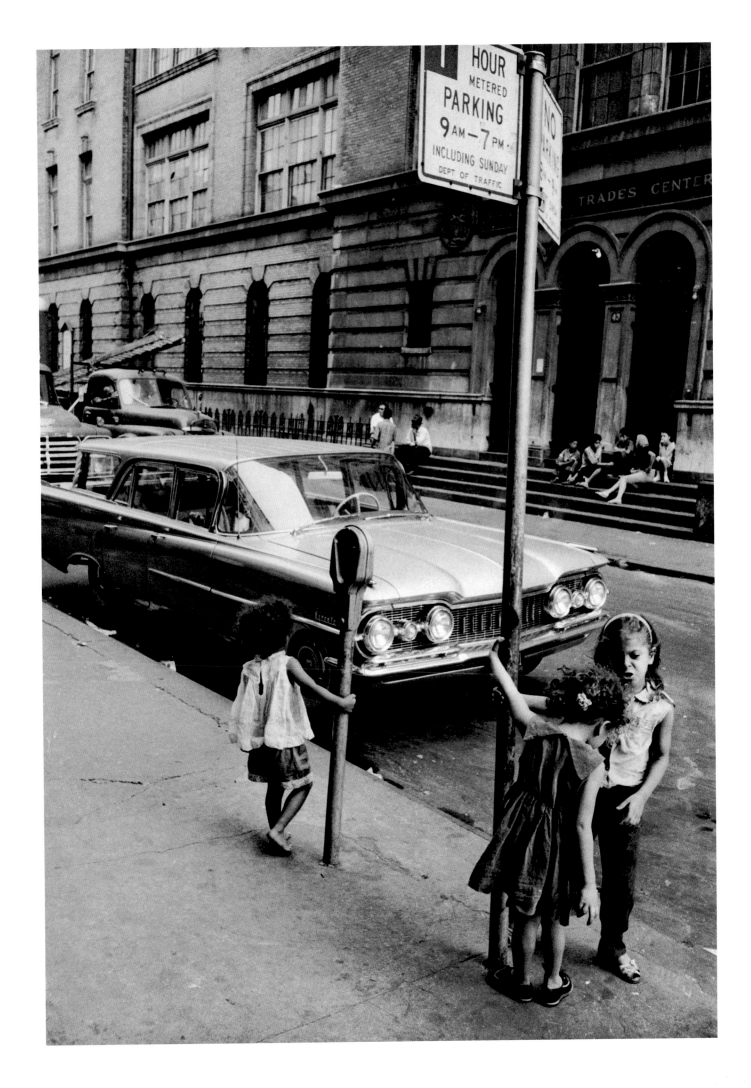

157

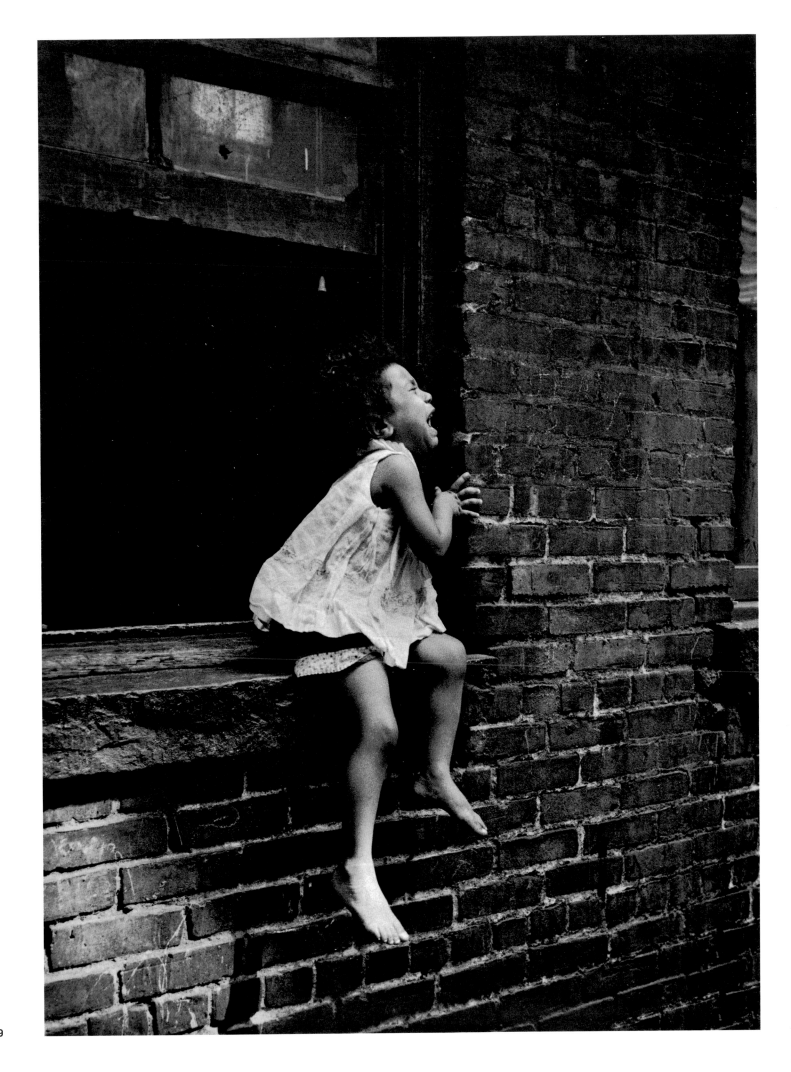

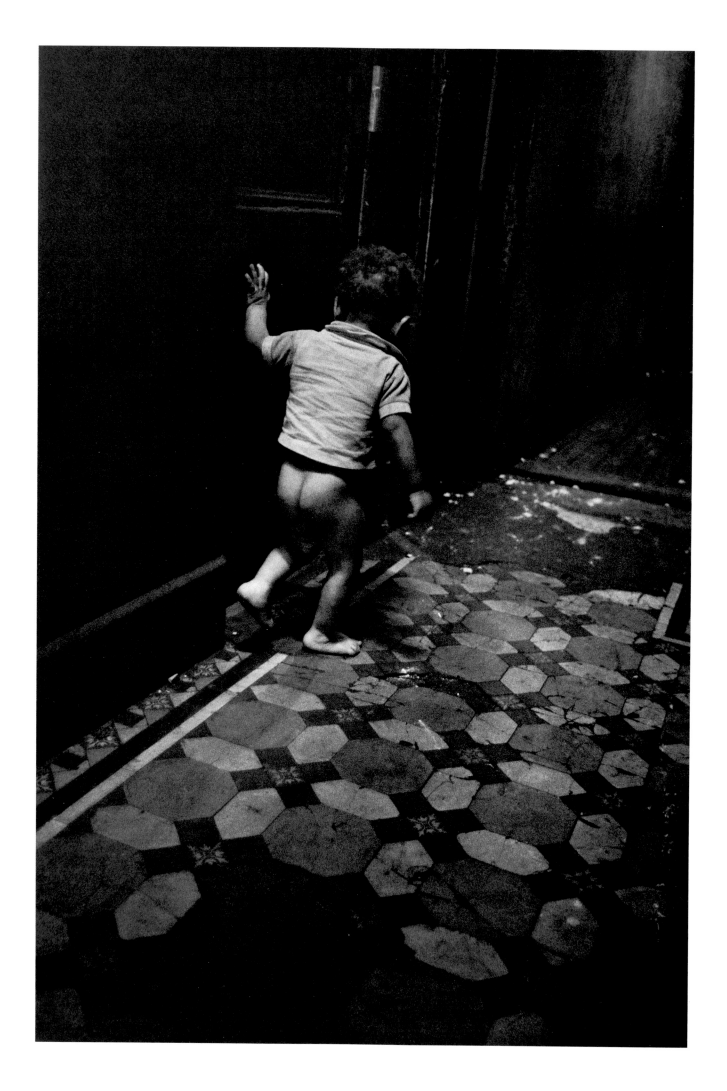

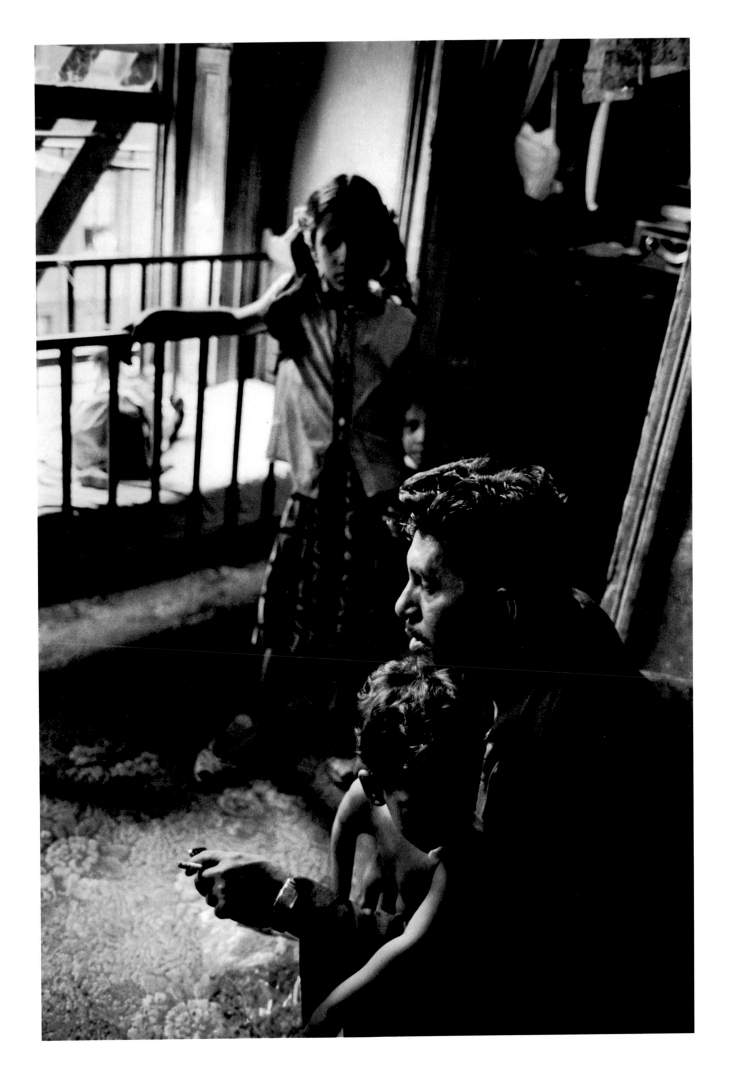

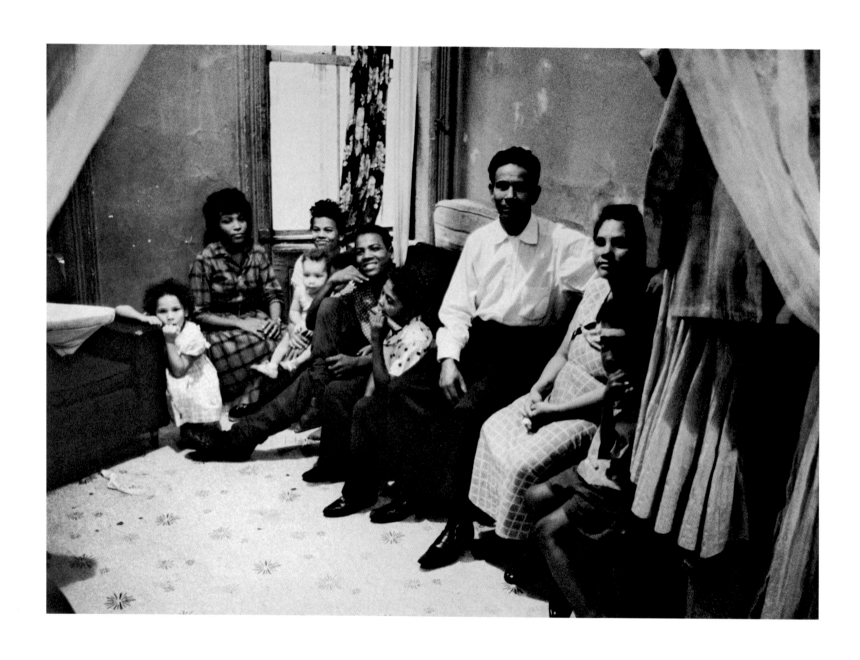

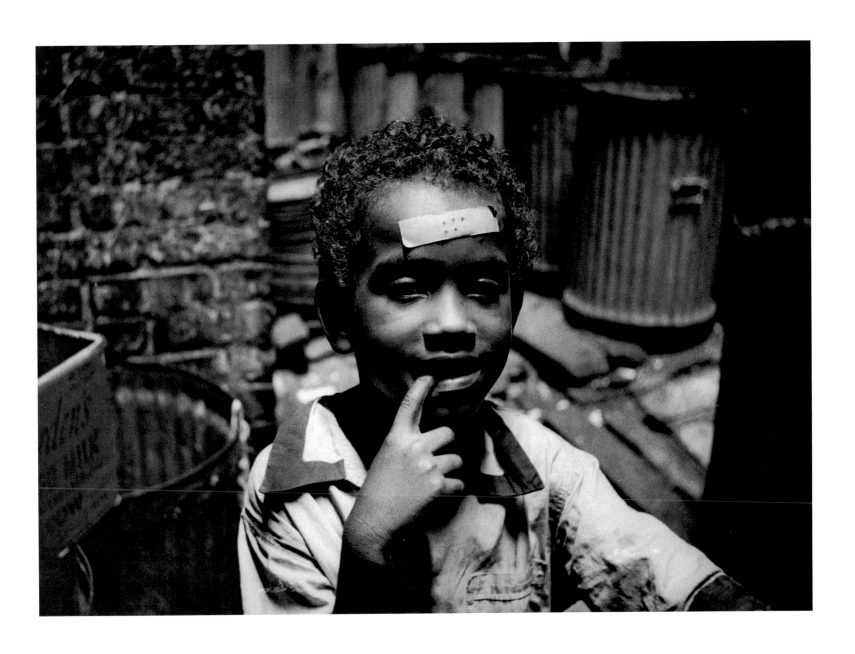

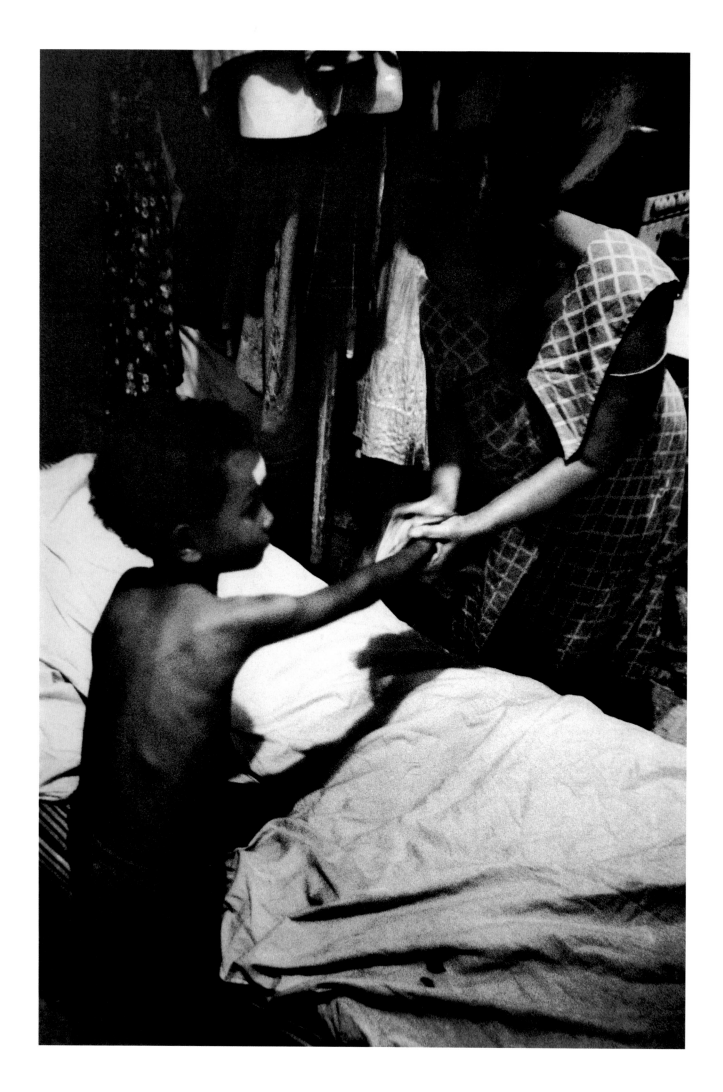

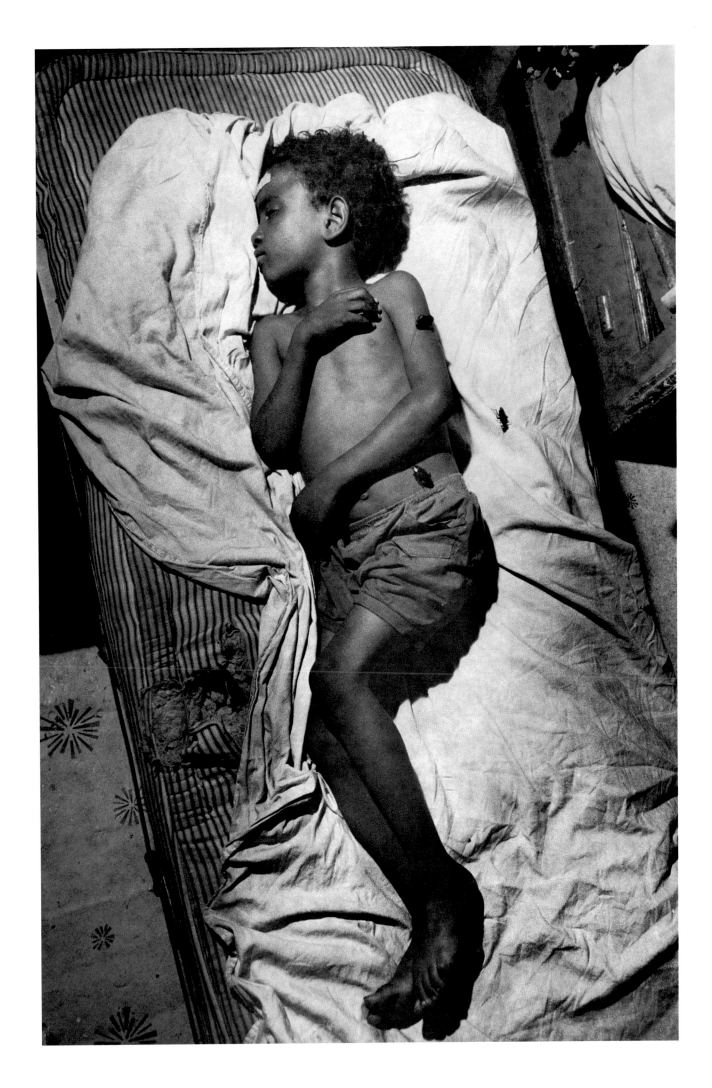

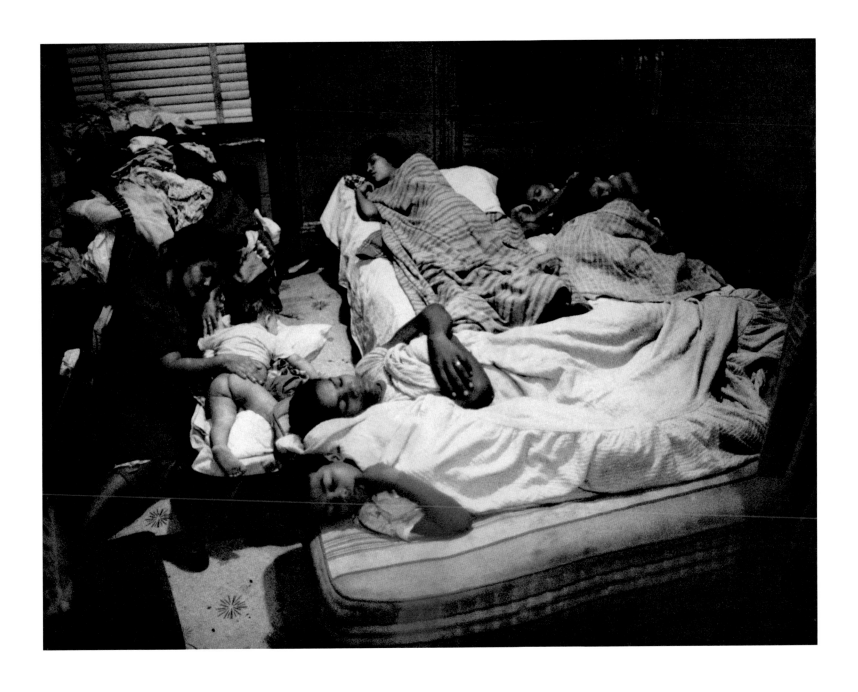

O Cruzeiro Versus *Life*: Gordon Parks in Rio de Janeiro and Henri Ballot in New York

Sérgio Burgi

In 1961, an extraordinary international editorial battle broke out between two popular illustrated weeklies, *Life* and the Brazilian magazine *O Cruzeiro*. It began with a photo essay by Gordon Parks published in the June 16, 1961, issue of *Life*. The essay, titled "Freedom's Fearful Foe: Poverty," focused on the poverty and suffering of a family living in the Catacumba favela of Rio de Janeiro, and especially on the oldest son, Flávio, a twelve-year-old with serious respiratory problems. The article had a remarkable impact in the United States: an unanticipated outpouring of donations from *Life* readers raised enough money for the magazine to purchase a home for the da Silva family in Rio's northern Guadalupe district, allowing them to leave the favela. Philanthropy also paid for Flávio to travel to the United States for treatment in a Colorado hospital. These developments provided the cover story of the July 21 issue of the magazine, just five weeks after Parks' photo essay had appeared.

The story of Flávio and his family's relocation also had considerable repercussions in Brazil, particularly in Rio de Janeiro. The city had been replaced in April 1960 as the capital of Brazil—the new capital, Brasília, symbolizing the country's striving toward modernization—and was undergoing significant political and economic change. Publication of a photo essay detailing poverty in Rio in this famous American magazine, and in *Life en Español*, the Spanish-language version distributed throughout Latin America, was bound to be controversial.[1]

The Rio favelas—shantytowns built on hillsides and in wastelands informally occupied by the poorest parts of society—arose at the end of the nineteenth century, during extensive social changes related to the abolition of slavery, the proclamation of the Republic, and, later, the return of troops from the religious and civil war of Canudos in Bahia, who set up camp on the Morro da Providência (Providence Hill) near downtown Rio, considered the first favela in Brazil. Just as decisive were plans for the urban renewal of the city center and the "Tear it down" policies of Mayor Francisco Pereira Passos at the beginning of the twentieth century, as well as the opening of a principal thoroughfare, the Avenida Central (renamed Avenida Rio Branco), the modernization of urban transport, and the gradual southward expansion of the city.

The federal district government and its elite leaders failed to match these dramatic changes with policies that would reduce social inequality and improve the living conditions of the poorest citizens—including a good portion of the black population, newly freed from slavery.[2] The period of industrialization, which intensified in the 1940s, led to increased urbanization and internal migration, notably from the semiarid Northeast to Rio and São Paulo and elsewhere in the Southeast. This consolidated the vertiginous growth that, in only five decades, would radically invert the ratio between Brazil's urban and rural populations.

In 1961, when Gordon Parks arrived in Rio, the Catacumba favela represented conditions known to city residents for more than seven decades. Ex-slaves and ex-soldiers and their families had established encampments on the Morro da Providência, squatting in the center of the city while they awaited promised housing during the early years of the Republic.[3] In the 1950s, as more people seeking employment migrated to Rio, primarily from the Northeast, many occupied the slopes around the Lagoa Rodrigo de Freitas, a lagoon in the affluent southern part of the city. Overcrowding on the hillsides worsened, with no public policies to support or manage migrant resettlement during a period of major population displacement. Industrialization after World War II, led by American and European investment and funded with capital from the Brazilian consumer goods and capital goods industries, was built around a model for national integration rooted in the intensive development of an automobile industry and road networks. As a result, the car, the bus, and the truck would become the dominant means of transportation between cities and outlying regions, to the detriment of more efficient solutions such as railroads and waterways, for both people and cargo.

José da Silva, who arrived from Paraíba in the Northeast, typified many Brazilians who migrated to large metropolises in search of opportunities in industry and the service sectors. *Life*, which enjoyed the largest circulation of any illustrated magazine in the United States, chose to present his family as an example of misery and indigence in Brazil, as part of a series of articles on the dangers of the advancing socialist revolution. The series was meant to advocate for President John F. Kennedy's Alliance for Progress, which opposed the ideologies of the left in Latin America through economic, social, and political initiatives. *Life*'s coverage of the da Silva family, and principally Flávio, provoked a strong reaction from the public and from many other news publications—and specifically from journalists and editors of *O Cruzeiro*, which assumed an ideological and nationalistic tone. The decision by *Life* to show the poverty of a white favela family, in a country that typically associated favelas with Brazil's black population, factored into the Brazilian magazine's response.

In 1961, Brazil was facing a profound political crisis. This almost reached the proportions of a civil war in August, when President Jânio Quadros unexpectedly resigned, and conservative groups and part of the military resisted the legal inauguration of Vice President João Goulart, who was more left-wing than Quadros and was backed by labor unions and worker and socialist parties. *Life* published Parks' photo essay in this context, at a time when Brazil's internal political disputes reflected the ideological polarization of the Cold War. This would come to a head the next year with the Cuban Missile Crisis, and in Brazil led to the right-wing coup that installed a military regime and dictatorship in 1964, with covert support of the U.S. government; the regime, which lasted twenty long years, mirrored regimes in other South American countries during the same period.

To better understand *O Cruzeiro*'s role in Brazil during this period, it is important to recall its origins and evolution. A publication of the media group

Diários Associados, founded and directed by journalist Assis Chateaubriand, *O Cruzeiro* began as an illustrated national weekly magazine in 1928 (eight years before *Life*).[4] In its early years, through 1940, it made extensive use of illustrations and photography in a wide range of articles, with regular contributions from writers, poets, and visual artists. Chateaubriand intended *O Cruzeiro* as a variety and news magazine; he considered it central to building a media group with liberal tendencies, which championed a sustainable and independent Brazilian economy. The magazine endorsed the rise of economic protectionism and the Revolution of 1930.[5] With the revolution, Getúlio Vargas became president, ending the dominance that elite landowners had held since the late empire and the proclamation of the First Republic in 1889. The magazine was bolstered by advertising and commercial sponsors, critical during the interwar period that saw significant urbanization and a burgeoning industrialization. Brazil, now led by a new generation of urban middle-class politicians conscious of shifting political and economic realities, was divided between being a society built on mass consumerism and market forces like the United States and being a planned and centralized socialist economy like that of the USSR.

In the early 1940s, *O Cruzeiro* underwent a change in its editorial policy, strengthening the link between journalism and photography. It contracted a French photographer, Jean Manzon, who had worked for *Paris Match* and *Vu*, to reorganize its photography department. Manzon emphasized photojournalism as the magazine's main asset, but he put the medium at the service of a sensationalist editorial line more concerned with providing spectacle and commentary than factual, objective, impartial reportage. Despite this tendency to stage the content of chosen themes—or perhaps precisely because of it—*O Cruzeiro*'s circulation grew, achieving weekly numbers of more than 700,000 in the mid-1950s. Such growth encouraged the magazine to invest heavily in contracting new photographers and journalists. Between 1946 and 1951, when Manzon left, many photographers joined the staff, including Henri Ballot, Luiz Carlos Barreto, Luciano Carneiro, Flávio Damm, José Medeiros, and Indalécio Wanderley. This new generation arrived after the end of Vargas' second, dictatorial regime (1937–1945), and after the country's first free elections, which initiated nearly two decades of democratization until the 1964 military coup. In the 1950s and early 1960s, this new crop of writers, photographers, and graphic artists contributed to a marked shift in direction for *O Cruzeiro*, to a more humanistic journalism and photojournalism.

The new photographers at *O Cruzeiro* were inspired and influenced by recent international photography and journalism—including photo essays by photographers such as W. Eugene Smith, Robert Doisneau, and Willy Ronis—that had appeared in *Life* and other illustrated magazines and by the establishment of the Magnum agency in 1947. These novel examples of photo reportage had a humanist and markedly authorial tendency. At *O Cruzeiro*, photographers increasingly challenged the magazine's dominant mode of photojournalism as spectacle, striving instead for an objective and documentary approach and incorporating themes related to the culture and people of Brazil.

Photographer Henri Ballot (1921–1997) joined the staff of *O Cruzeiro* during the same period as Luciano Carneiro, who, along with José Medeiros, led this new generation of photographers. The son of a French engineer and aviator and a Brazilian woman, Ballot was born in Pelotas, in the southern state of Rio Grande do Sul. When he was two years old, his parents moved the family to France. By the time he was seventeen, Ballot was already a trained pilot, like his father, and worked for Aéropostale, the French airmail service and predecessor of Air France, among whose other pilots was Antoine de Saint-Exupéry. At the beginning of World War II, Ballot was imprisoned by German forces in Spain for four months for removing French airplanes from the path of the invading army. After he was released, he became a pilot in the Free French Air Forces in England. He had a serious crash toward the end of the war, when his plane was hit by German antiaircraft fire; luckily, he landed in an area controlled by American troops. Ballot was taken to a hospital in Colorado, where he remained in a coma for months. During his long recovery after regaining consciousness, he learned photography in the hospital alongside fellow patients. Ballot returned to France and, in 1949, decided to relocate to Brazil. Soon after arriving in São Paulo, he secured work as a photographer for *O Cruzeiro*.

Between 1949 and 1968, Ballot produced many important documentary photo essays. Between 1952 and 1957 he accompanied the brothers Orlando, Cláudio, and Leonardo Villas-Bôas on their pioneering Roncador-Xingu expeditions to the Diauarum region of Mato Grosso, recording some of the first moments of contact with the indigenous peoples of the Xingu (figs. 27–30). He also documented the negotiations that culminated in the creation of the Xingu National Park (today Xingu Indigenous Park) in 1961. Among his other subjects were migrants from northeastern Brazil to São Paulo (*retirantes*), coastal peoples of the Southeast (*caiçaras*), samba schools and favelas of Rio, and the building of the Trans-Amazonian Highway. Ballot's archive of more than 13,000 photographs is now part of the collection of the Instituto Moreira Salles.[6]

In 1961, *O Cruzeiro* sent Ballot to New York to document poverty in the city, in direct response to *Life*'s depiction of the Rio favelas. Parks' reportage powerfully conveyed the miserable living conditions of the da Silvas in the slums of Catacumba, and Ballot's work in New York took the same approach, exposing the poverty of parts of Manhattan. On October 7, *O Cruzeiro* published Ballot's photographs, heralding the report on the cover with a headline just as sensationalist as the title of Parks' story: "Reporter Henri Ballot Discovers a New American Record in New York: Misery" (fig. 33; pp. 258–273).[7]

Ballot preceded his work in New York by research and consultations with various organizations that assisted underprivileged Hispanic communities in the city. He walked through run-down areas of Manhattan—namely,

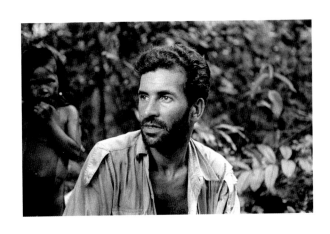

FIG. 31 Diary of Henri Ballot with notes taken for "Nôvo recorde americano: Miséria" ("New American Record: Misery"), July 25–August 14, 1961. Instituto Moreira Salles

FIG. 32 Diary of Henri Ballot with notes taken for "Nôvo recorde americano: Miséria" ("New American Record: Misery"), July 25–August 14, 1961. Instituto Moreira Salles

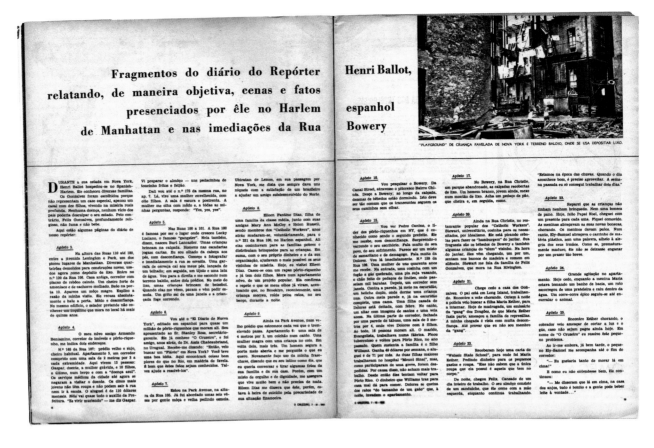

Fragmentos do diário do Repórter relatando, de maneira objetiva, cenas e fatos presenciados por êle no Harlem de Manhattan e nas imediações da Rua

Henri Ballot, espanhol Bowery

East Harlem and the Bowery—and photographed the neighborhoods and residents. His early coverage included the poor and marginalized population of East 100th Street, which Bruce Davidson would later feature in his photo essay of that name. Despite false starts and explorations that yielded little, Ballot was determined to make an objective and impartial record of the social inequalities that existed in the United States. After more than twenty days of work, he chose to interview and photograph the Gonzalez family, originally from Puerto Rico: parents Felix and Esther, and their six children, including nine-year-old Ely-Samuel (pp. 159–167).[8] The family lived in a small apartment on Rivington Street, on the Lower East Side—not too far from Wall Street, the symbolic financial heart of the country.

Ballot chronicled his first walks and his daily impressions of the city, as well as his encounters with the Gonzalez family, in a revealing diary (figs. 31, 32). This, along with correspondence, news clippings, and a unique set of some 150 vintage photographs, preserves a comprehensive record in an archive at the Instituto Moreira Salles. The archive includes another project, one that directly challenges Parks' photo essay; several prints document visits by Ballot with the da Silva family in Rio during the early fall, after he returned from New York (pp. 141–147). This coverage appears to have been triggered by a counterreaction to Ballot's New York story in *O Cruzeiro*. The weekly newsmagazine *Time*, sister publication of *Life*, attacked the veracity of Ballot's story in an article titled "Carioca's Revenge" in its issue of October 20 (fig. 34). These images by Ballot, published in "Henri Ballot Unmasks American Report" in the November 18 issue of *O Cruzeiro*, illustrate the photographer's efforts in turn to point out fabrication and manipulation in Parks' original

coverage (pp. 274–281).[9] José and some of the da Silva children were interviewed, in their new home and at their former Catacumba shack and José's kerosene stall. The dispute between the Brazilian and American media outlets manifested in mutual disparagement of the original stories (fig. 35). The dossier put together by Ballot on his reportage, which reveals the impact of the episode on his professional career and sheds light on how it affected him personally, is preserved in his archive. It makes clear the two principal consequences for Ballot: he was forced to live with *Time*'s accusation that he had manipulated and staged images for his article, especially a shocking photo of Ely-Samuel Gonzalez in bed with cockroaches crawling over his body, a charge he emphatically denied; and he was refused entry to the United States after *O Cruzeiro* published his story.

An analysis of Ballot's images of New York, his diary, and other documents does not reveal any desire to manipulate the facts. Instead, his photographs reflect contemporary exemplars such as Bruce Davidson and Helen Levitt, or members of the Photo League, who had been making detailed documentations of street life and social themes in New York City since the 1930s.

From an editorial standpoint, Ballot's photo essay on the Gonzalez family was designed to explicitly emulate the strong narrative and graphic power of Parks' images of Rio. The layout in *O Cruzeiro* directly correlates Ballot's New York images to those featured in Parks' photo essay in *Life*. The overt comparison suggests that *O Cruzeiro*'s editors felt it necessary to issue an unequivocal response, with Ballot's story proving that poverty in the United States was no different from poverty as it existed in Rio de Janeiro. In retrospect, this was a questionable editorial decision. By presenting Ballot's work

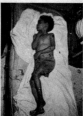

FIG. 34 (LEFT) "Carioca's Revenge," *Time*, October 20, 1961. Instituto Moreira Salles

FIG. 35 (RIGHT) "'O Cruzeiro' vingou o que a 'Life' fez no Brasil . . ." (*O Cruzeiro* avenged what *Life* did in Brazil), editorial cartoon from *Diario de Noticias*, October 3, 1961. Gordon Parks Papers, Manuscript Division, Library of Congress, Washington, D.C.

as a page-by-page comparison without making a critical assessment of the independent quality and effectiveness of the photographs, *O Cruzeiro* inadvertently exposed the Brazilian photographer, and the magazine itself, to criticism of the methods used to produce the report. Visually weaker than Parks' essay, the *Cruzeiro* article and its layout invited the inference that Ballot's reportage had possibly been subject to manipulation.

Consideration of two page spreads, each at the conclusion of the two original photo essays, demonstrates where the critical process of juxtaposition and emulation loses a good part of its editorial and narrative force. *Life*'s striking final spread (pp. 232–233), which ends with one of Parks' most emblematic portraits of Flávio, is considerably stronger than the two images that conclude Ballot's report in *O Cruzeiro* (pp. 270–271), despite the clear attempt to give similar narrative momentum to the end of his story. The issue here is not whether Ballot's second image, showing Ely-Samuel, was manipulated. Rather, in directly correlating visual narratives of a similar topic, *O Cruzeiro* highlights Parks as the editorial model, and unwittingly demonstrates how much more arresting the images and story in *Life* were than Ballot's photo essay, both visually and emotionally. This prompts another reason to question *O Cruzeiro*'s editorial approach, which presents a counternarrative rather than an original account. Without the aesthetic and formal elements needed to convey the impact of the Gonzalez family's poverty, *O Cruzeiro*'s response to *Life* ultimately elicited questioning and doubt from the public at large.

If there had been more editorial commitment to Ballot's monthlong documentary effort in New York, and less ambition to directly counter the agenda of the emblematically American magazine, an alternative editing of the reportage in *O Cruzeiro* might have highlighted the quality of the work Ballot produced. This could easily have been done, to judge from the images found in his archive. The editorial dispute based on comparison of the competing stories ultimately proved unnecessarily stressful, but also inconsequential, for both publications, foundering on the superficial argument that both photographers had staged key images. The conflict also prompted questions about the integrity of the photographic image, and of photojournalism itself. In the end, readers were distracted from meaningful analysis and discussion of the real editorial questions behind both magazines' intentions: those of *Life*, which meant for "Freedom's Fearful Foe: Poverty" to support U.S. government policies in Latin America; and those of *O Cruzeiro*, which, by publishing a report on poverty in the United States in a sensationalistic and nationalistic article, opportunistically hoped to consolidate and build its readership and advertising base at a time when it was losing ground.

This episode shows how the ideological and sensationalist approaches of the press can contaminate the objectivity and specificity of the facts: in this case, both the da Silva family in Brazil and the Gonzalez family in the United States were living real, concrete versions of the misery experienced by the poor in their respective countries, which were, however different, equally discriminatory. Both families lived at the bottom of the social pyramid and were fighting for survival. And in this sense, the photographs by Parks and those by Ballot are truthful and enlightening.

It is through such conflict and inherent tension between reporters and photographers who work in the mass media, and their editors, that the specific dynamics

of each press vehicle emerge. In the case of *O Cruzeiro*, by the 1950s the magazine's photojournalism was being influenced by more humanist and engaged objectives. Its photographers produced reportage that was more authorial in tone and presented in essay form, shaping a visual language around more profound and elaborate examinations of subjects.

However, the distinction between communication—as a process that is potentially provocative, questioning, objective, and enlightening—and propaganda—which involves deliberate manipulation—allows one to recognize (using the example of Parks and Ballot) that images produced under the auspices of photojournalism with the clear intention of communicating can easily be transformed into propaganda, according to their usage and context. When this happens, as sociologist Herbert J. Gans has pointed out, the function of the press is steered by the actions of editors as "builders" of the nation and society, administrators of the symbolic arena.[10] In the context of illustrated magazines, the original intention of photojournalists to convey facts directly and objectively may be maintained through precise and carefully edited relationships between text and image; but it may also be transformed on the page, to convey a message of a symbolic and ideological nature.

The clash between *Life* and *O Cruzeiro* would mark the future paths of both Parks and Ballot, and of Flávio da Silva himself. Both photographers faced monumental challenges as they sought to construct and maintain the integrity of their original narratives in the context of their respective publications' ideological undertones. They were effectively trapped in the great symbolic arena of communication and propaganda, exemplified by the editorial duel between two leading illustrated magazines that were also competing, at the time, for leadership of the Latin American market: their international editions in Spanish replicated all the original materials published in the magazines, for distribution throughout the region.

In the information society of today, photographic images have increasing relevance, particularly given new electronic means for dissemination of visual narratives such as social networks and digital corporate journalism. Yet they still contend with many of the same issues associated with this historic confrontation between *Life* and *O Cruzeiro*, wherein questions of authorship, documentation, editing, ethics, staging, and political and ideological sensationalism shroud the images with multiple layers of possible meaning and interpretation. It is interesting to note how—within what was effectively a common experience of poverty shared by individuals living in different hemispheres, so thoroughly documented in the photographs of both reports—public discussion centered on the question of manipulation and reduced confidence in the objectivity of the medium. This episode allows us to better understand the permanent and dual function of photography as representation and interpretation, and, simultaneously, as a direct, documentary, and figurative record of a given moment in space-time, using an apparatus that effectively informs the viewer of the materiality and specificity of that location. The world of technical images, here thought of in philosopher Vilém Flusser's terms, requires that we are always able to discern the dual and thus potentially ambiguous aspects of every image before us. This still remains the main challenge.

1 The Spanish-language version was published on July 24, 1961.

2 Slavery was abolished in Brazil in 1888.

3 The First Brazilian Republic lasted from 1889 to 1930; a coup in the latter year installed Getúlio Vargas as president.

4 Francisco de Assis Chateaubriand Bandeira de Mello (1892–1968) became Brazil's most powerful press baron in the 1930s.

5 The revolution, which ended the First Republic, resulted from a movement led by three states—Minas Gerais, Paraíba, and Rio Grande do Sul—and entailed the removal of one president, the rejection of another, and eventually the coup that installed Getúlio Vargas.

6 The nonprofit cultural organization, founded by banker and politician Walter Moreira Salles, promotes the visual arts, music, and literature and libraries; it has centers throughout Brazil.

7 "O repórter Henri Ballot descobre em N. York um novo recorde americano: Miséria," *O Cruzeiro*, October 7, 1961.

8 The family surname was rendered in the magazine as "Gonzalvez"; *Time* spelled it "Gonzales." See "O caso Flávio," with research by Fernando de Tacca, http://www.studium.iar.unicamp.br/caso_flavio/05.html.

9 "Henri Ballot desmascara reportagem americana," *O Cruzeiro*, November 18, 1961.

10 See, e.g., *Democracy and the News* (Oxford and New York: Oxford University Press, 2003).

In 1976, Gordon Parks flew to Rio de Janeiro once again to photograph and interview Flávio, in preparation for a book he was writing about their experience. It had been thirteen years since they had last seen each other. Flávio, now twenty-seven, welcomed Parks, José Gallo, and Parks' assistant, photographer Jeanne Moutoussamy, to the home he shared with his wife, Cleuza, and his two sons, Flávio Jr. and Felipe Luiz. Over numerous conversations, Flávio reminisced about his family's relocation from the favela and his years in the United States. Recounting his life back in Brazil, Flávio discussed his troubled time in a São Paulo boarding school, described his work history and current job as night watchman at a wealthy estate, and expressed his wish to provide a better life for his family. Reluctantly, he took Parks and Gallo to visit the rest of his family, still living in the house that *Life* and its readers had bought in Rio's Guadalupe district. Greeted by Nair, who seemed to have aged well beyond her years, and Flávio's many siblings, Parks found the house in a sad state of disrepair. José da Silva was largely absent, appearing only to demand money from his wife before leaving again. Flávio was deeply embarrassed by the condition of the house and by his family's return to poverty. Before Parks left Brazil, he visited Catacumba with Flávio and José Gallo; the favela was now a lush hillside, unrecognizable as the shantytown where the da Silvas had once lived. In 1970, despite years of improvements made with funds donated by *Life* readers, the state government demolished Catacumba and forcibly relocated its residents to other Rio communities. As the trio climbed the hill in search of the spot where the da Silvas' shack had stood, the only signs they found of the settlement were a few broken stairs and patches of land, remnants of the favela's open sewers. When parting ways, Flávio asked Parks to help him return to the United States, clearly longing for the adoptive country he had left behind.

1970–1977

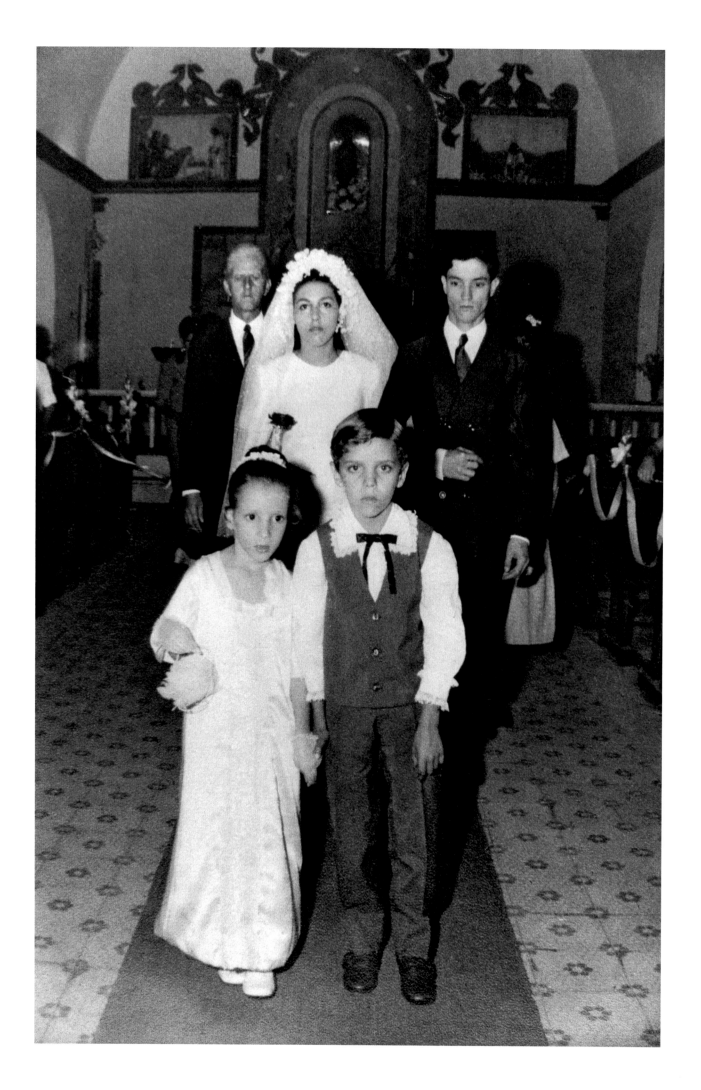

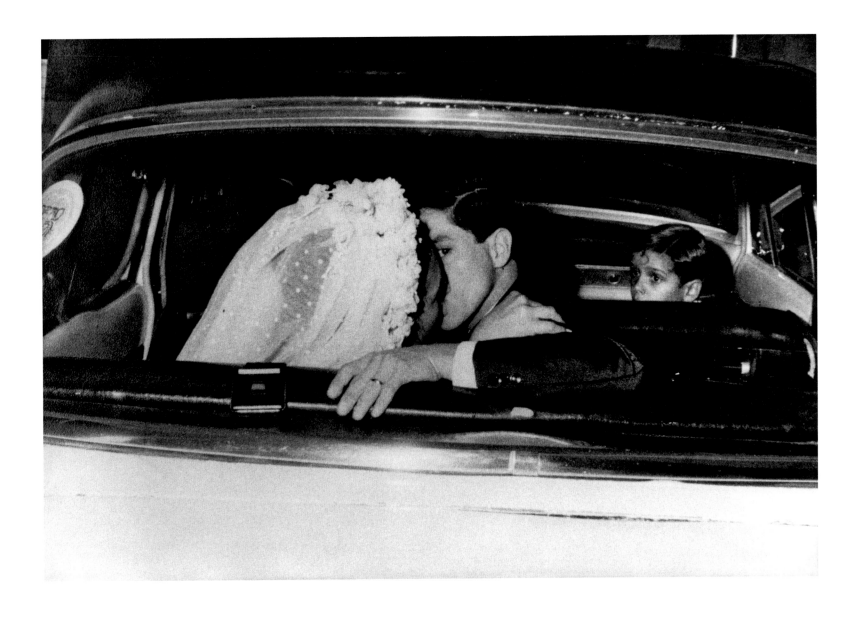

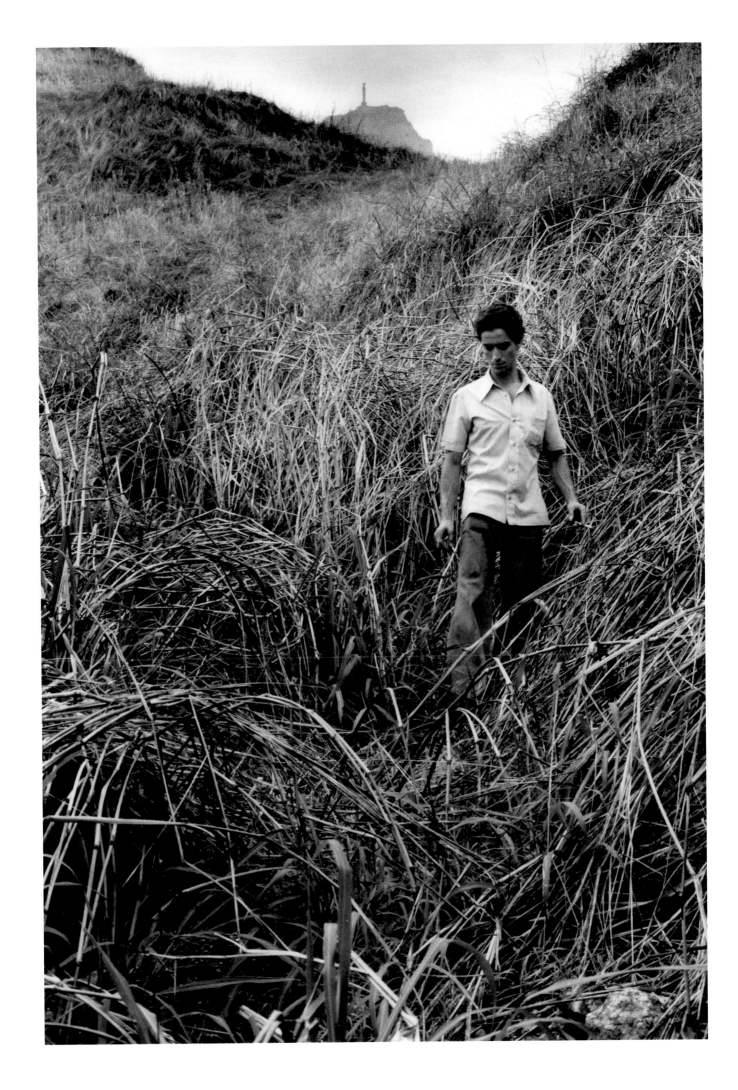

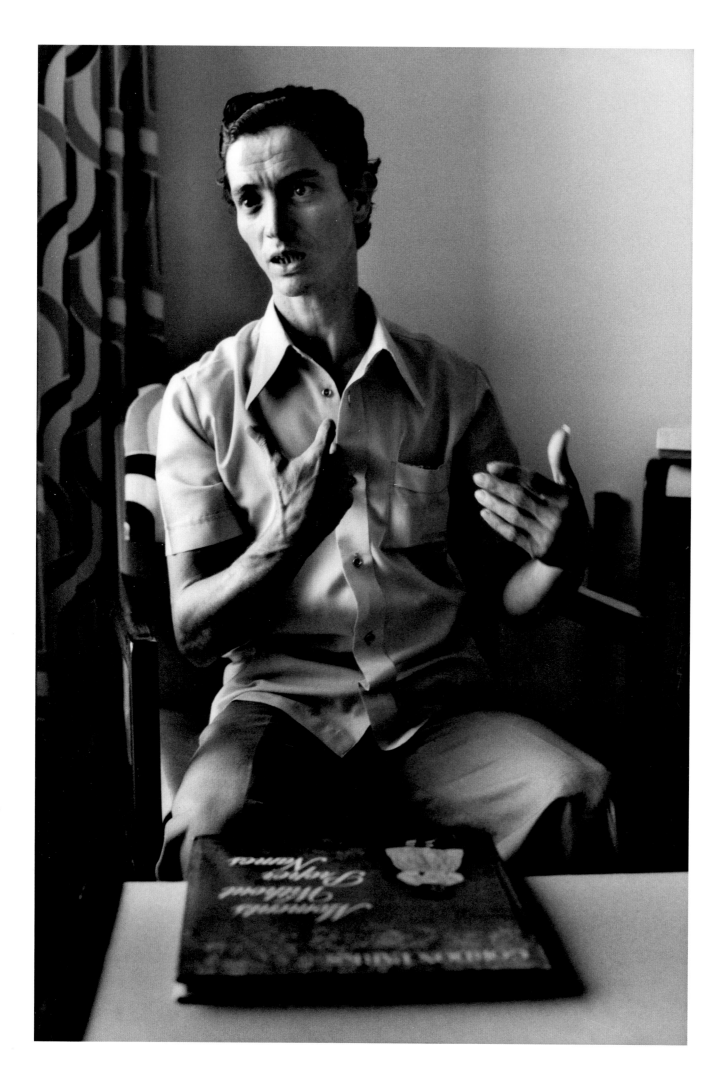

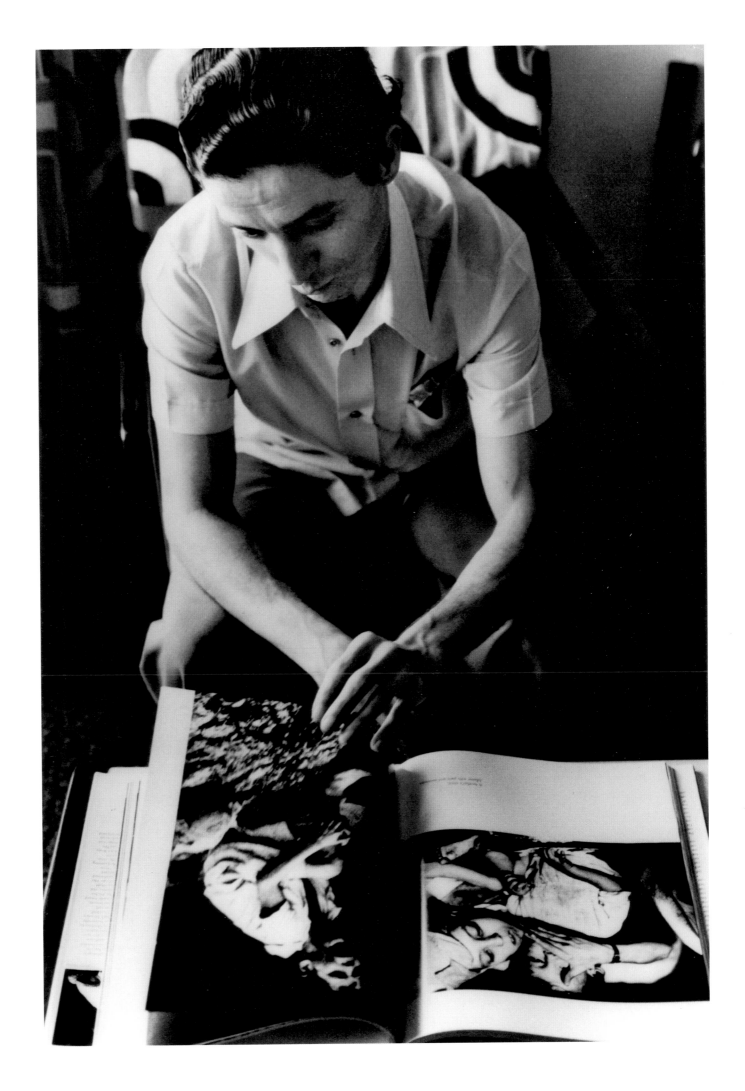

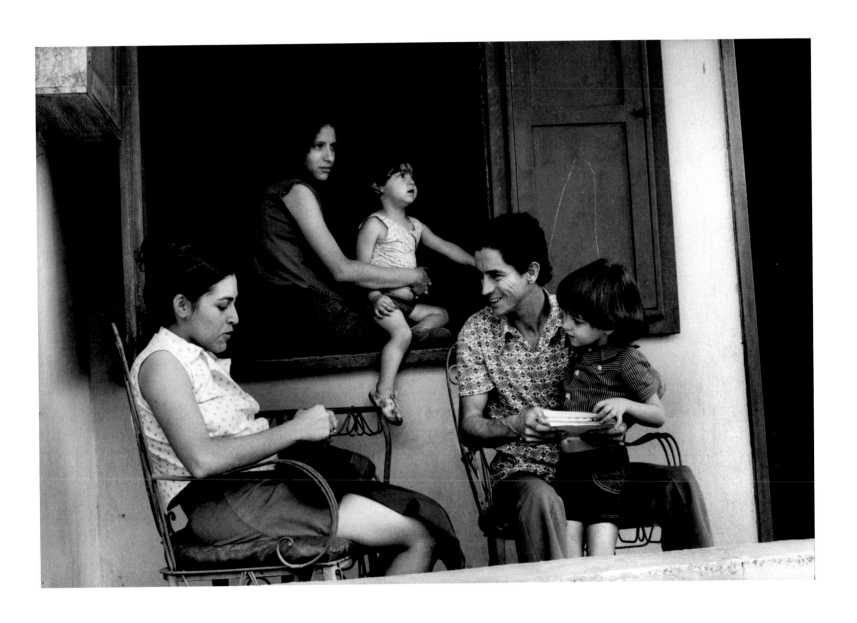

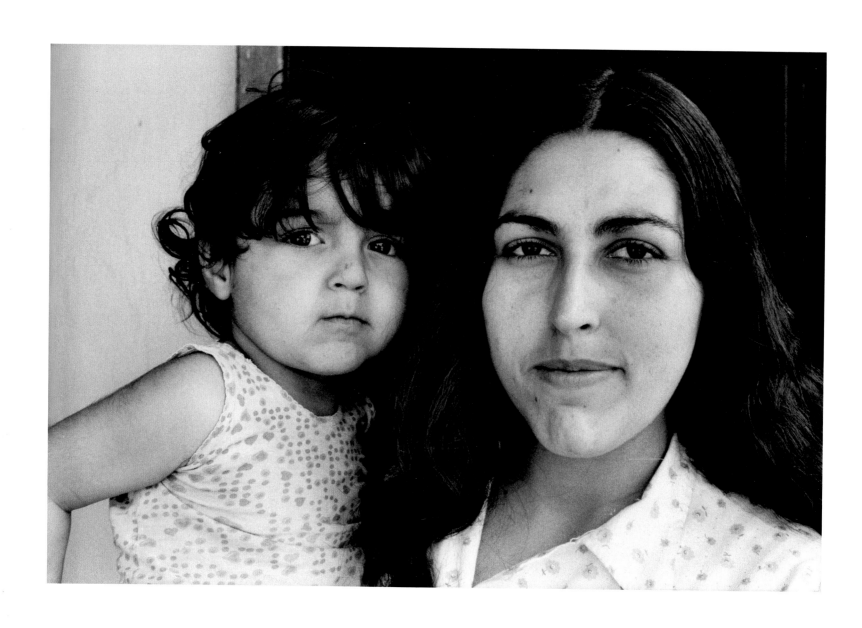

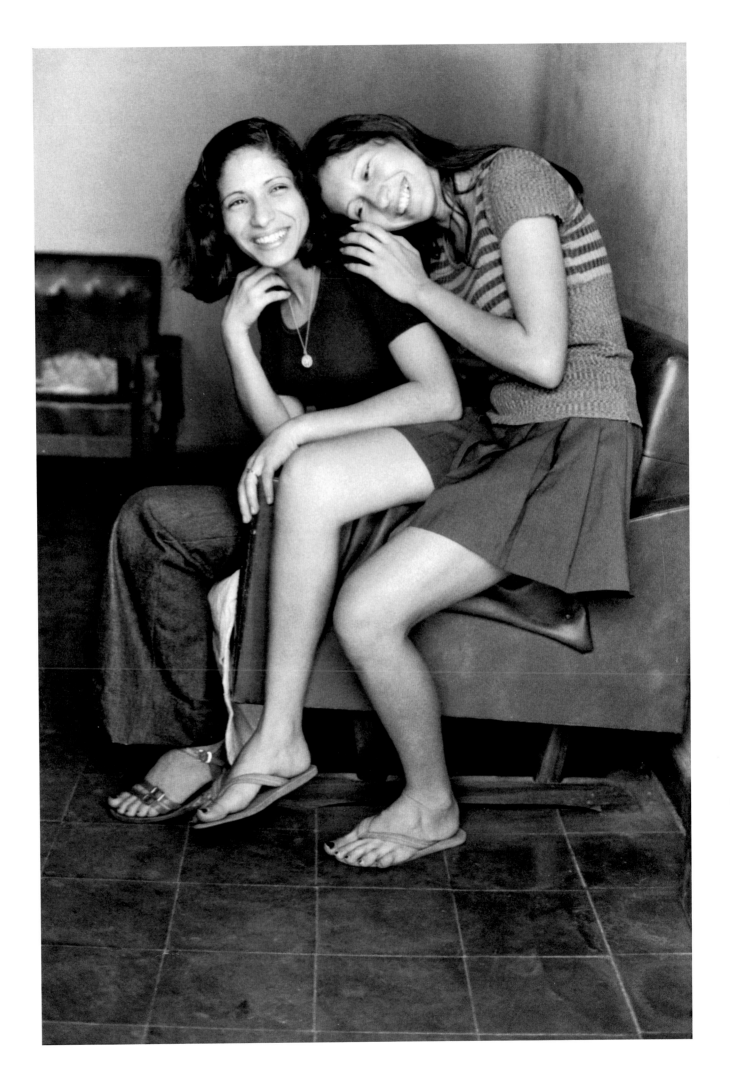

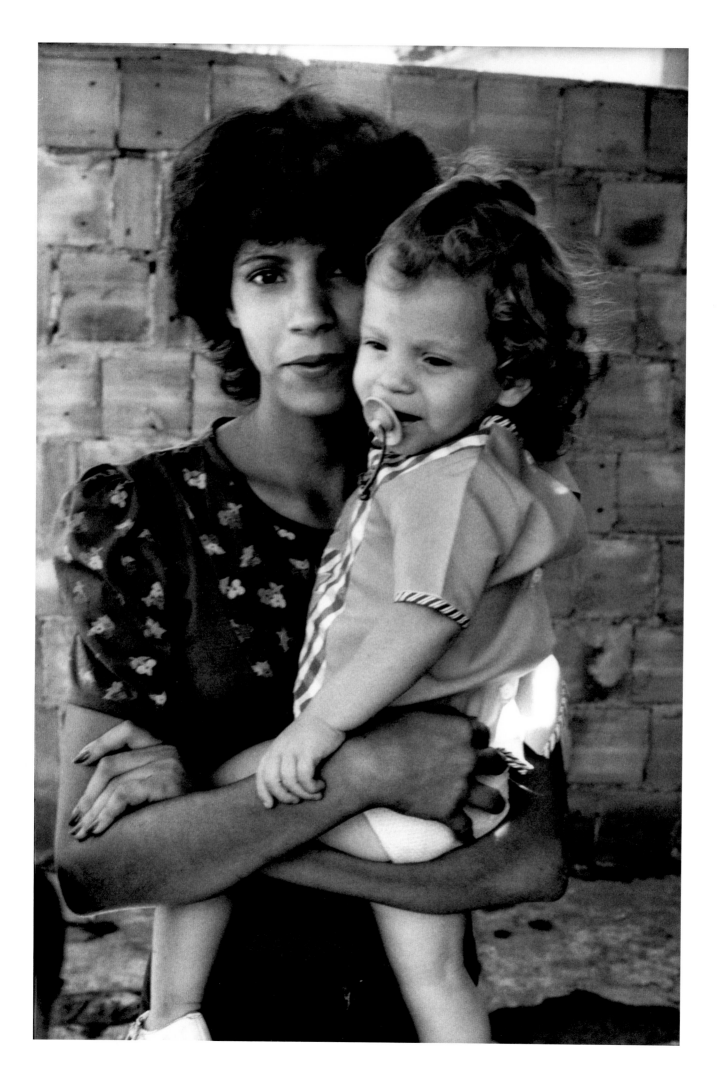

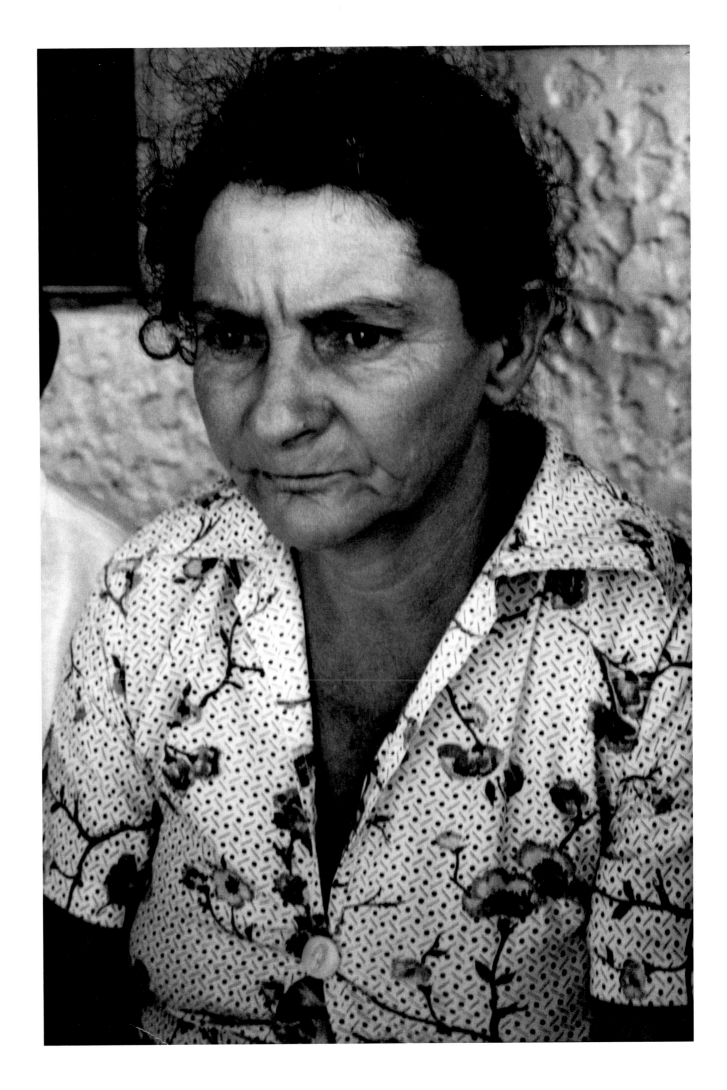

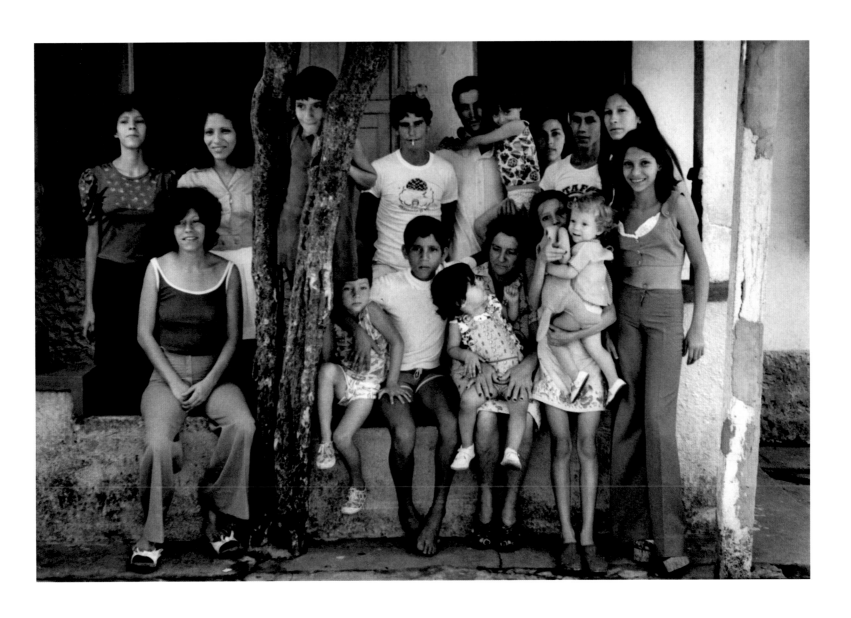

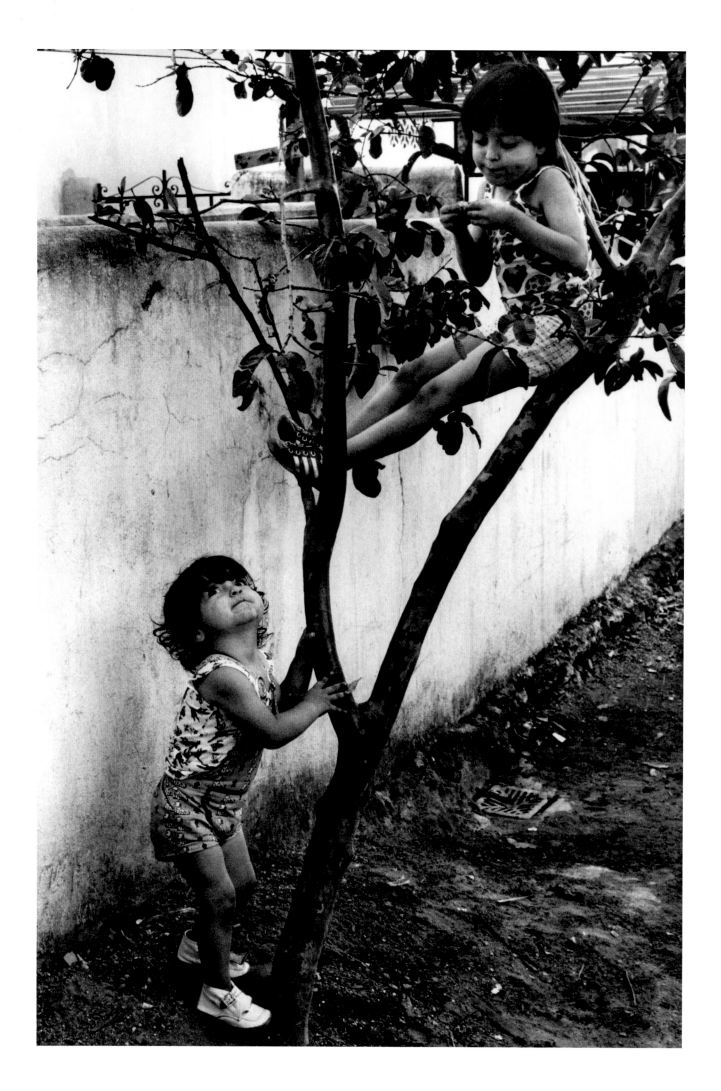

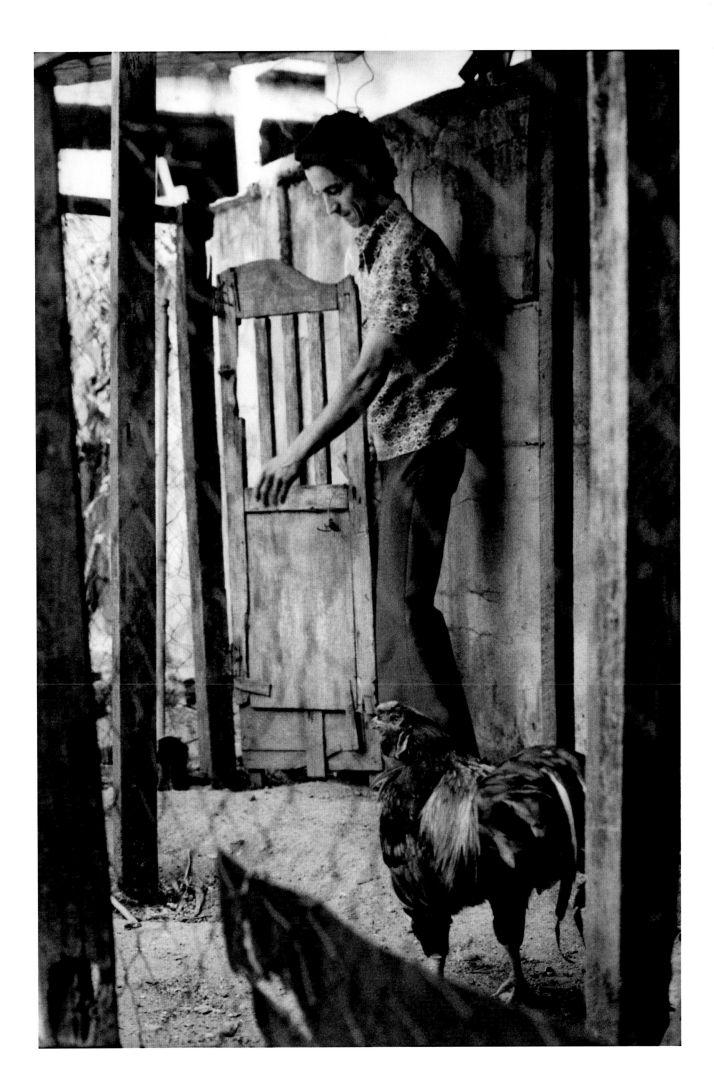

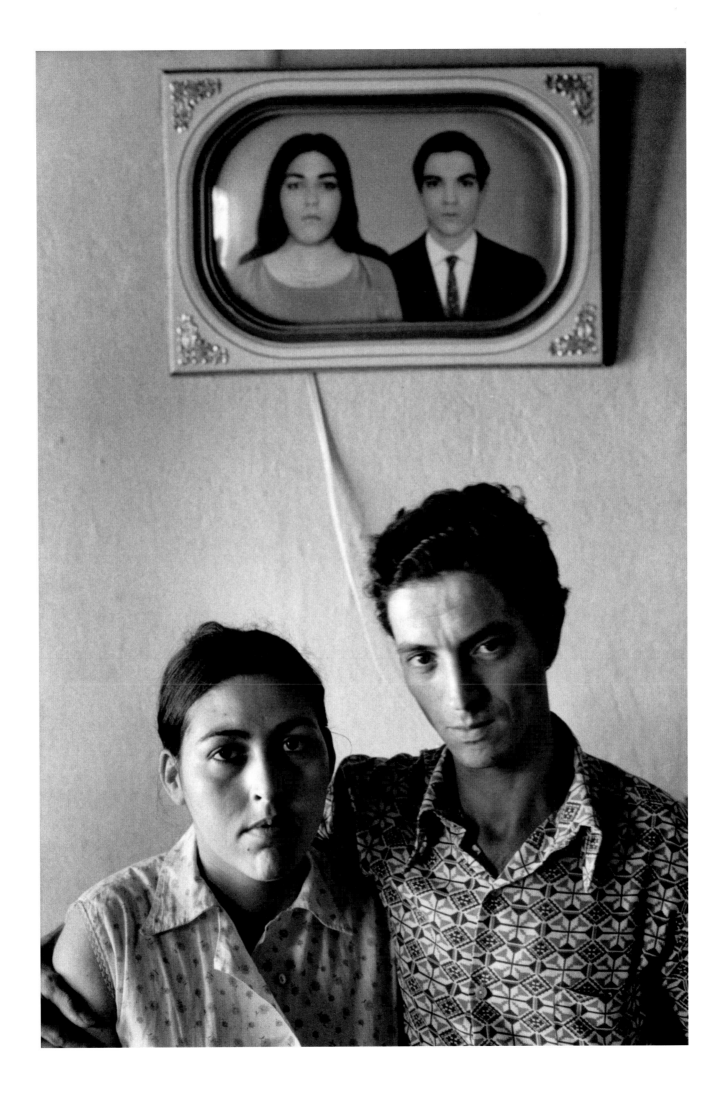

Rio de Janeiro 19 December 1977

Dear Gordon Parks thanks very much for your nice letter. I am SORRY I havent answered sooner But I have Been working for 8 months every moth.

I am sogled to write for you Gordon teling you abut the typewriter. mr. José Gallo did not do anyten to get it fixet bcoz in my house he never comes jost to tel mi that you was coming to Brazil in 1976, wel the typewreter have been ther for 6 months then José seand to mi a telegrom to get the machine in the LIFE offece. Dear gordon I am very sorry that you didnt nau alut Isabel she is married. et may 21 af 1977. my family ar all very well Gordon plase dont write in the broak alut we have taking af José Gallo in the Intercontinental hotel OK. my fraend houe is the brook going wen is going to be published?

nou I am wating your letter that you sopast to write mi. Dear Gordon ar you cameing to Bjazil wen the brook is published dont forget you tel mi that you wad came.

my mother and all the alhers are ok.

happy christmas and a happy naui year

From Flavio to gordon Parks.

In 1999, Gordon Parks returned to Brazil yet again, thirty-eight years after his original photo essay and twenty-three after his previous visit with Flávio. Accompanied by an assistant, Johanna Fiore, and a film crew making a documentary about his life, Parks found Flávio, now fifty years old, living in a shed behind the house that *Life* had purchased with reader donations in 1961. Since Parks' visit in 1976, Flávio and Cleuza had had a third child, a daughter, but in 1990 they separated. Four years after that he lost his job, and since then he had survived on occasional construction work. As they revisited the *Life* story and their experience together, the photographer renewed his lasting bond with Flávio and his family. He wasn't bitter about his current situation, Flávio said, calling Parks a father figure who had helped the da Silvas at a time of need. Together they traveled to a favela in Rio and compared it with the long-destroyed muddy hillside of Catacumba. As Parks departed Rio, Flávio reassured him that while his life had been difficult, he would continue to work hard, and would rebuild his family's now dilapidated home and then build himself a new house. It was the last time they would see each other. Parks died seven years later, in 2006.

1999

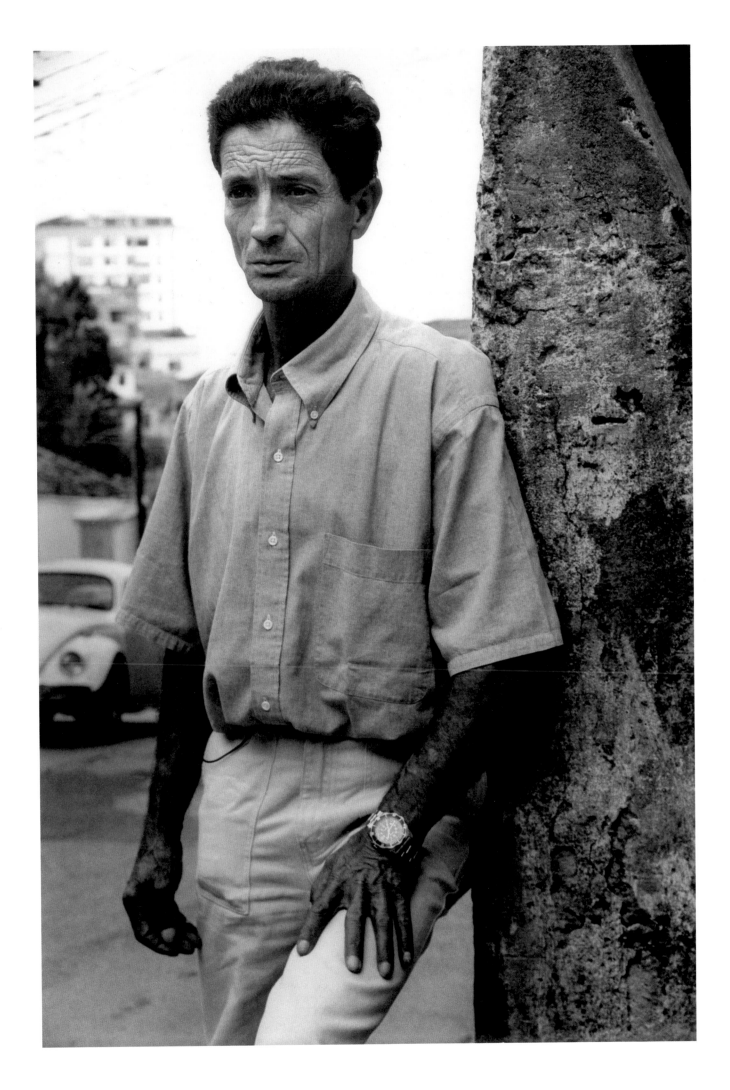

23 ▽ 23A 24 ▽ 24A 25 ▽ 25A 26 ▽ 26A 27 ▽ 27A

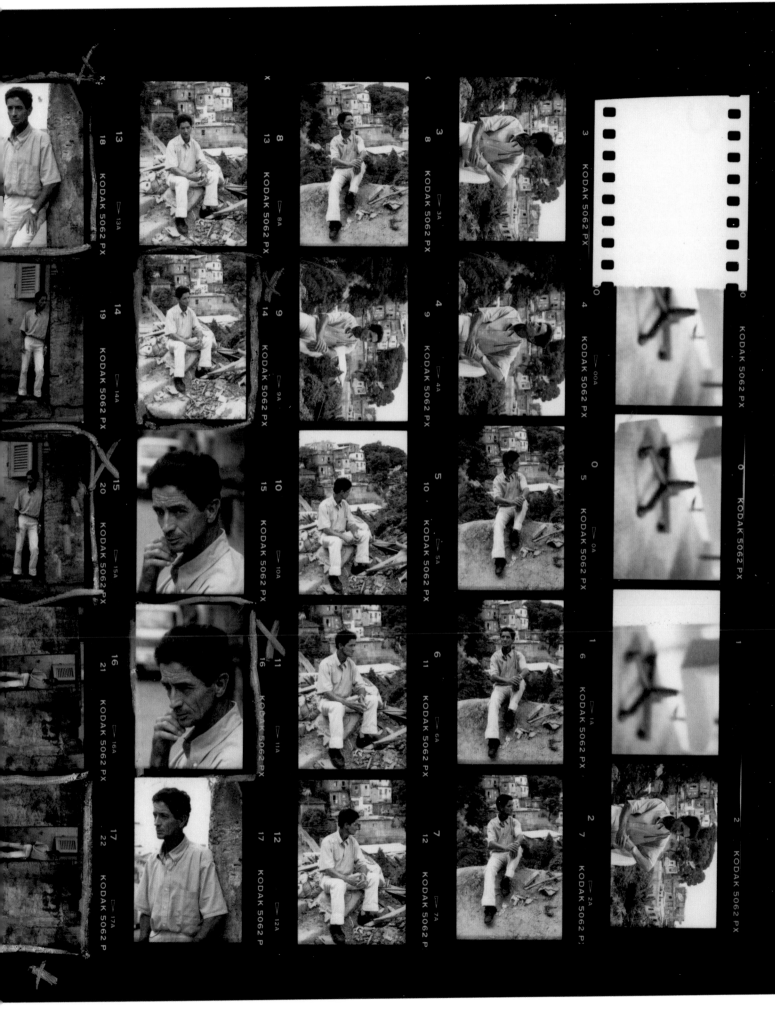

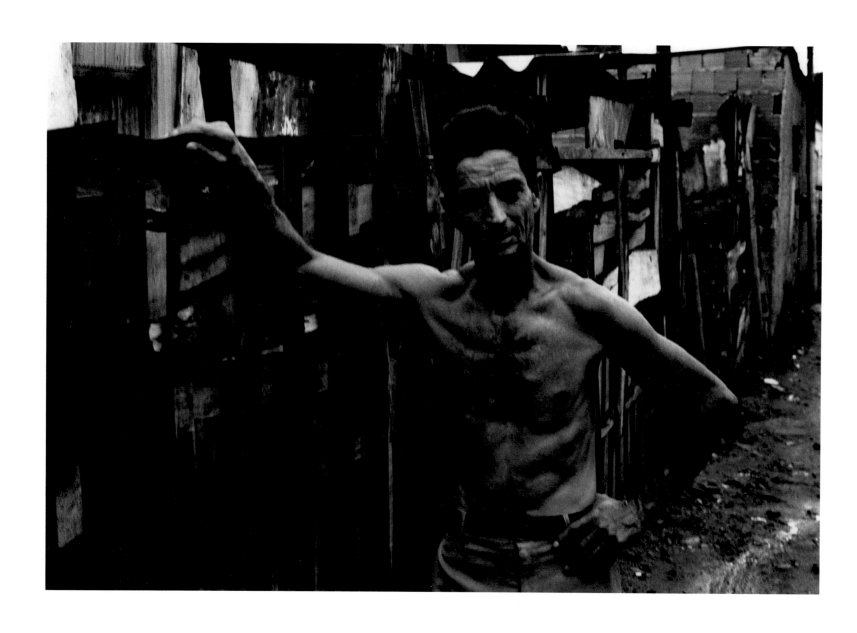

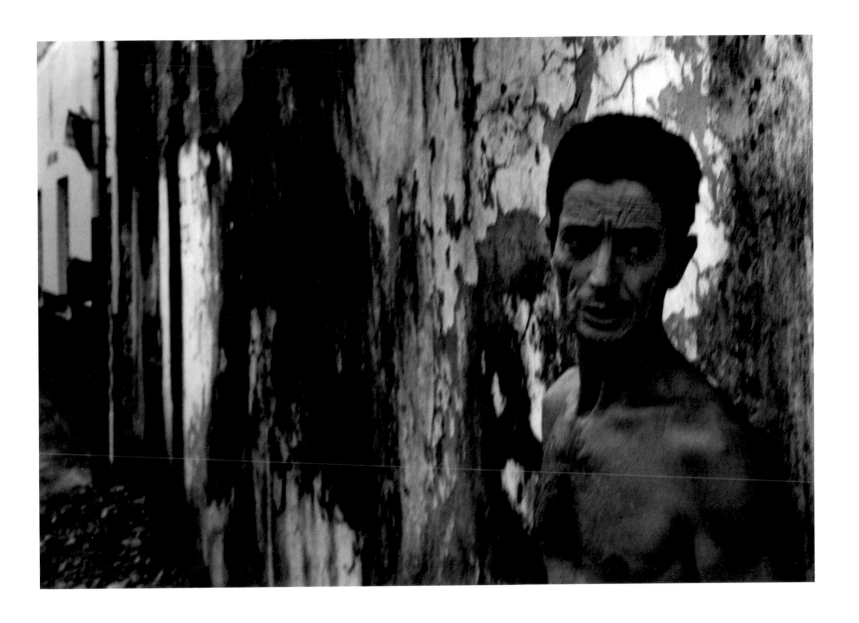

Nothing Is Changeless:
The Flávio Story Retold

Amanda Maddox

In 1933, F. Scott Fitzgerald published an essay titled "One Hundred False Starts" that articulated the difficulty of generating stories from personal experiences. In that essay he wrote:

> Mostly, we authors must repeat ourselves—that's the truth. We have two or three great and moving experiences in our lives—experiences so great and moving that it doesn't seem at the time that anyone else has been so caught up and pounded and dazzled and astonished and beaten and broken and rescued and illuminated and rewarded and humbled in just that way ever before. Then we learn our trade, well or less well, and we tell our two or three stories—each time in a new disguise—maybe ten times, maybe a hundred, as long as people will listen. . . . Whether it's something that happened twenty years ago or only yesterday, I must start out with an emotion—one that's close to me and that I can understand.[1]

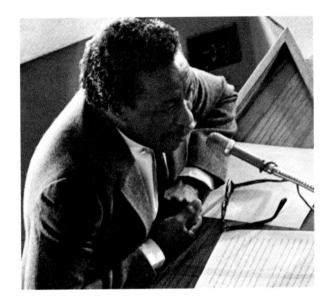

FIG. 36 Gordon Parks speaking at Nobel Conference, *Gustavian*, 1970. Courtesy Gustavus Adolphus College Archives

Lecturing on the subject of creativity decades later in 1970 (fig. 36), Gordon Parks quoted the above passage (eliding Fitzgerald's introductory line about repetition) in an effort to convey the importance of experience on his own work. He went on to cite his encounter with Flávio da Silva in a Rio de Janeiro favela—which spawned two popular photo essays published in *Life* magazine in 1961—as both an example of a "great and moving" moment in his career and a case study whereby "understanding was more important than technical skill."[2] By the time Parks delivered this lecture, the story of Flávio had already proven significant enough for him that it effectively encouraged what Fitzgerald termed repetition and disguise—it merited retelling. Recognizing the power of this story, Parks seemingly operated on the principles outlined by Fitzgerald: by 1968, Parks had developed a short film and several chapters of a book, both titled *Flavio*. Within that same period, even *Life* repurposed and recontextualized images from the original photo essay in books dedicated to subjects that ranged from Brazil to birth control. Parks continued to revisit the story of Flávio periodically over the next several decades, with his most comprehensive look at the subject presented as a book published in 1978. As Professor Jay Prosser summarizes, Flávio

"becomes vehicle for Parks's palinode," a term defined as "an autobiographical mode for how we might reflect on the losses and oversights inevitable in the progression of our work."[3] The repetition and mutation of this story—in various versions, formats, contexts, and historical moments—arguably becomes its defining characteristic, distinguishing it from nearly every other assignment or project Parks undertook. Introduced as the subject of investigation by a photojournalist, Flávio facilitated a creative transformation for Parks, whose practice evolved from collaborative to directorial, with content that morphed from fact to fiction in service of telling the story again and again.

From its inception, the *Life* assignment that sent Parks to Brazil in spring 1961 and introduced him to Flávio da Silva amounted to an artistic intervention by the photographer. According to one unpublished draft of Parks' manuscript for the book *Flavio*, the original story generated by the editorial board involved photographing "beautiful women."[4] Disappointed by that topic, Parks suggested he report on poverty instead, motivated by a personal connection to the subject and an interest in returning to Rio de Janeiro to investigate "poverty at its worst in the infamous favelas ringing the city."[5] Other accounts, including the description of the assignment as published in *Flavio* (told as a flashback), assert that the assignment always concerned poverty and contained the following directive: "Find an impoverished father with a family of eight or ten children. Show how he earns a living, the amount he earns a year. Explore his political leanings. Is he a Communist or about to become one? Look into his personal life, his religion, friends, his dreams, frustrations. What about his children—their schools, their health and medical problems, their chances for a better life?"[6]

Given that this assignment had been proposed in conjunction with the magazine's "Crisis in Latin America" series—designed to reinforce anticommunist ideologies that aligned with President John F. Kennedy's recently announced Alliance for Progress policy—and was promoted by the cover line "Shocking Poverty Spawns Reds," a story on women "seemed beside the point," as Parks himself acknowledged.[7] He also claimed that "the [*Life* editorial] board insisted upon my shooting only one photograph of poverty in seven separate Latin American countries," a notion difficult to reconcile if Parks spent at least three weeks in Brazil.[8] However, he may have simply conflated memories of the original pitch with the first layout pass to feature his work from Brazil: a double-page spread with a picture of Flávio lying in bed (p. 39) opposite "a strikingly beautiful photograph of a woman, shot by Dmitri Kessel."[9] And his response to seeing the first layout, whereupon he walked out of the offices of *Life* with the work he generated in Brazil and promptly crafted a letter of resignation, appears to be a dramatization: by 1961, Parks was no longer on staff at the magazine. His name did not appear in the masthead that year, because he worked on contract (see the essay by Paul Roth in this volume). Such inconsistencies in the origin story of the assignment offer the first glimpses of

FIG. 37 Gordon Parks, Proof sheet, Set No. 62170, Take No. 4, C-1, 1961. The Gordon Parks Foundation

how Parks' memory shaped the myth that surrounds the story of Flávio, and how facts got muddled in the service of telling the tale effectively.

Though working on assignment for *Life* in Brazil, Parks did not follow the guidelines provided, but instead heeded the advice of assistant editor Timothy Foote to "misinterpret [his] instructions" while in the field.[10] The story "Freedom's Fearful Foe: Poverty," published in *Life* on June 16, 1961, bears this result: Parks elected to report on twelve-year-old Flávio, rather than the patriarch of the da Silva family, José, in no small part because he identified with the boy born into poverty. Often described by Parks as a chance encounter, with Flávio's smile the catalyst that encouraged the photographer and his interpreter, José Gallo, to follow the boy to his family's shack, the meeting between Parks and Flávio may have been predestined. Before Parks' arrival in Rio, "*Life* teams talked to many dozens of favela families and prepared a list of ten. . . . The da Silva family was first on the list and the first one [Parks] visited. His assignment was to portray poverty and, on seeing the da Silva shanty, he went no further."[11] While *Life* "hewed strongly to a professional code of objectivity, or at least the appearance of such," and Parks also declared that "from the outset of each assignment to its very end, I reported objectively," both functioned as engineers, crafting every element of the story.[12]

At *Life,* the magazine's editors and advisors ultimately determined the contents of any photo essay, which included the copy, the selection and presentation of pictures, and the advertisements interspersed among the page spreads. While *Life* staff regarded photographs "with the sort of reverence and awe generally ascribed to fine art" and let "photographers be 'artists,'" photojournalists employed by the magazine had little control over how pictures generated for the assignment would be cropped, captioned, or formatted for publication.[13] Even attempts by such esteemed photographers as W. Eugene Smith to influence these decisions with predesigned layouts were subject to editorial oversight. These constraints meant that any artistic control exercised by the photographer typically occurred on the level of picture-making: the photographer determined how best to document an assigned subject and, in cases like the Flávio story, decided which subjects to depict. For assignments produced abroad such as this, photographers did not always have a chance to view film before it was sent to *Life* in New York, where editors selected pictures for publication. To judge from messages exchanged between *Life*'s offices in Rio and New York, the process of building this particular story differed; Parks delivered at least his last rolls of film by hand and proposed some captions while he was still in Rio.[14] Nevertheless, the final presentation of the story—with an introductory

text that equated the da Silva family with the "teeming poor" upon which "Castroist and Communist political exploitation" would prey, and the poignant captions—was determined by *Life* editorial staff.

As a seasoned photojournalist who had worked for Roy Stryker at the Farm Security Administration between 1942 and 1944, and for *Life* since 1948, Parks knew how to shape a photo essay by the time he received this assignment. In his 1970 lecture on creativity, he reflected that "understanding was more important than technical skill" when it came to photo essays such as this one, and that "sharing confidences had to be made before . . . the camera intrude[d] on [the subject's] privacy."[15] But these statements belie how his engagement doubled as intervention, especially as it concerned the contents of the favela photographs. In order to document the da Silva family, for instance, Parks and *Life* had to obtain permission from José da Silva, who agreed to participate on the condition that he was compensated financially.

From images of Flávio and his brother Mário at Copacabana—Parks made good on his promises to escort the boys to the beach (p. 51)—to a picture of Flávio posed with one leg akimbo while standing on the bed, Parks directed the da Silva children in order to capture some of these moments and gestures with his camera. An investigation by photographer Henri Ballot on behalf of the Brazilian magazine *O Cruzeiro*—which attacked the authenticity of Parks' reportage in the favela and questioned the motives behind *Life*'s decision to represent poverty in Brazil rather than the United States—elaborated on certain moments that Parks allegedly staged. Ballot accused Parks of removing a wall of the family's shack in order to better illuminate the room (pp. 30–31) and photographing a supposed nighttime scene during the daytime because of lighting requirements. (See the essay by Sérgio Burgi in this volume.) In an interview with Flávio's sister Maria, Ballot learned that she "didn't sleep with Mário in the cradle, as is shown in the photograph. We, the older ones, slept down below. . . . It was [Parks] who told us to pose like this for the photograph."[16] The contact sheet featuring the roll of film that includes this image also shows alternative frames where the children appear awake and rustling under the blanket, reinforcing the idea that Parks manufactured the scene (fig. 37).

Parks openly admitted to using his camera on occasion "as a means of persuasion . . . conducted with a sense of fair play"; in the case of the Flávio story, this approach comes to bear not only in the photographs themselves, but also in the daily diary excerpts published in the context of the photo essay and used to supplement the photographs.[17] These first-person accounts contained anecdotes about the da Silva family that tugged at the heartstrings, such as the statement that "their mother doesn't have time to give the love [the children] need—and the father seems incapable. So any hand that touches with gentleness is dear."[18] Diary passages also revealed how Parks intervened in their lives by taking Flávio and Mário to Copacabana, dropping his camera to grab a knife wielded by Maria, feeding the children, and giving them money. At the very end of the photo essay, just

below these entries, is a picture of Parks carrying Flávio's baby brother Zacarias up the hillside; the photographer appears like a member of the da Silva family as well as a character in the story and a hero (fig. 38).

These written contributions effectively thrust Parks into an authorial role, an unusual position for photojournalists at *Life*, given that "words men"—reporters or correspondents—often accompanied them on such assignments.[19] During the course of his stay in Rio, Parks was instructed to keep a diary as another means of collecting information about his experience, likely because his editor recognized that the scope of the story had shifted when he received the first telex from Parks while in the field, which mentioned Flávio. A telex from Time Inc. Rio bureau chief George de Carvalho to editor Tim Foote in April 1961 substantiates Parks' compliance with this directive, stating: "Gordon now starting to writeup his own human daybyday impressions which should be fine bonus: hes going through fantastic personal experience . . . interviewing Gordon on hourslong tape to get it down for him, you and bureau research."[20] The addition of text granted Parks more space—and introduced another outlet—in which to communicate his observations and attempt to tell his version of the story, while also providing the reader with greater insight into the family's daily habits and the children's individual personalities. These entries were undoubtedly edited and styled by *Life* staff after being submitted by Parks, but they nevertheless present his perspective and elevate him to the status of storyteller.

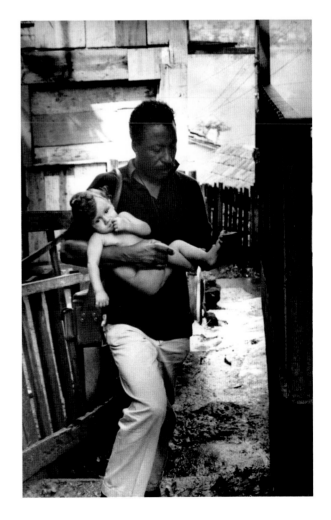

FIG. 38 José Gallo, *Life* Photographer Gordon Parks holding da Silva child, Rio de Janeiro, Brazil, 1961. International Center of Photography, The LIFE Magazine Collection, 2005 (1600.2005)

Much like the photographs Parks generated—an attempt to "objectively" report a story that sprang from a substantial emotional investment—the diary entries introduced the possibility of subjectivity. Telexes sent by Parks from the Time Inc. office in Beverly Hills (where he'd been sent to recover from the emotional stress induced by the Flávio story, when preparations for its publication were under way) to New York on June 3, 1961, feature text that constituted the last two published diary entries, dated April 7 and 9. It seems doubtful that Parks took the diary with him to Los Angeles if editors were in the process of laying out the story; he may have relied on memory to craft at least these entries, if not others. While editor Genevieve (Gene) Young, who worked with Parks on several books during the 1960s and 1970s, corroborated that he would have kept a diary if ordered to do so, it was never catalogued within his archive and may have existed solely as a narrative device rather than a physical object. Parks even insinuated as much, saying that the diary had been "reshaped and expanded" from several notebooks.[21] Irrespective of the existence of the diary, it is clear that the written "excerpts" introduced fiction into the report on Flávio, something that Parks embraced, experimented with, and relied on in terms of his artistic practice.

The transformation of Parks' job from photojournalist to author vis-à-vis this specific assignment signals a momentous creative shift fostered by the story itself. Declared a blockbuster by *Life* for the numerous unsolicited donations and letters of interest it yielded, the first photo essay was quickly followed by a so-called sequel that updated readers on the status of Flávio, the da Silva family, and the favela—the three recipients of funds contributed by readers. This second photo essay necessitated sending Parks back to Rio—not only as a reporter who would cover aspects of the story, but also as an emissary of *Life*. The magazine hired stringers to help document activities that took place around Flávio's departure for Denver, where he would be treated for asthma at a clinic. Implicit in this arrangement was the fact that Parks would be featured in these images, portrayed again as a heroic character in the "rescue" mission, delivering Flávio from the favela (and, implicitly, from his death). This second visit afforded Parks the opportunity to broaden his own photographic reportage; he recorded the family's relocation from Catacumba to a new home in the Guadalupe district, as well as Flávio's farewell and his journey to the United States (fig. 39). But most of the coverage in the second photo essay showcased Flávio in Denver, with images made by stringer Carl Iwasaki (pp. 63–79).

For his part, Parks used the return trip to Brazil in July as an opportunity to pivot from his hard-won trade as a photographer into other media, expanding his creative production to include filmmaking. In late June, shortly before the trip, he purchased a 35mm Arriflex movie camera expressly to shoot moving footage of the favela. On a customs form Parks declared that the camera would be used for "reporting," as he returned to Brazil in the role of a photojournalist under the auspices of *Life*. He affirmed the documentary value of his footage

in a later interview: "I made that film simply because when I came back [to Brazil] and even when people saw the still pictures they refused to believe such conditions could exist."[22] Though Parks ultimately had other ambitions for the film, it was important to categorize the moving footage as documentary in style. He filmed in the favela alongside Rex Endsleigh, whose footage was temporarily confiscated by the Brazilian government and subjected to examination by the Serviço de Censura de Diversões Públicas (SCDP), or Public Entertainments Censorship Service. This department monitored films made in Brazil, approved (or censored) their contents, and certified their distribution, as well as exportation.[23] Officials interrogated Endsleigh almost immediately after Parks left for New York with Flávio, and this may explain potential constraints related to the film *Flavio*. Was the footage Endsleigh retained after Parks returned to New York intended for inclusion in the film? Were those film reels misplaced or never delivered, and did their absence determine the contents or length of Parks' film? Was Endsleigh somehow linked to the disappearance of audio recordings of children and ambient sounds in the favela that Parks hoped to feature but never managed to locate? Did this attempt at censorship eventually breed its own form of fiction, controlling how Parks and *Life* represented the favela? *Life* downplayed the event as a mix-up, but it may have forced the magazine to characterize Parks' film as "not commercial and . . . destined for free exhibition in clubs like Rotary and Lions in the United States . . . to mobilize public opinion to help in the

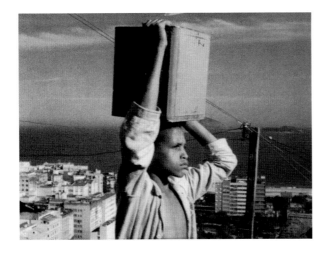

fight against the underdevelopment in the Americas and especially to raise more donations to help needy families in the slums."[24]

In a letter from 1962, however, Parks revealed his aspiration for a more grand production: he envisioned screening the film at the Cannes Film Festival. This idea likely stemmed from the recent success of *Black Orpheus*, a film by French director Marcel Camus that depicted a fictional love story set in a favela in Rio, and which was shot on location in the Morro da Babilônia favela. Released in 1959 and criticized as a foreigner's glamorized portrayal of everyday misery, *Black Orpheus* won the Palme d'Or at Cannes that year. Around the time Camus' film introduced the favela to a global audience, filmmakers associated with the nascent Cinema Novo movement in Brazil were simultaneously representing the favela on their own terms in such films as *Couro de gato* (Cat Skin), a short submitted separately for inclusion at the Cannes Film Festival in 1962. Influenced by Italian Neorealism and conceived to effect political and social change, Cinema Novo was premised on creating "an antithesis to the Hollywood stereotypes and production system."[25] (See the essay by Beatriz Jaguaribe and Maria Alice Rezende de Carvalho in this volume.) While Parks was likely unaware of this genre in 1961, as it was still coalescing, *Flavio* showcased some of the same aesthetic and ideological principles—use of non-actors, guerrilla-style handheld filming, black-and-white film, sociopolitical themes—that characterized Cinema Novo. The opening sequences of *Couro de gato* and *Flavio* are similar, both featuring a boy who walks up the favela hillside, balancing a can of water on his head (fig. 40). These twinned artistic visions of life in the favela suggest that Parks hoped to create something more than a promotional short for *Life*.[26]

At least two cuts of the film *Flavio* had been made by 1963. Parks had no experience as a filmmaker at that stage in his career, meaning he probably leaned heavily on Elektra Studios, the production company behind the film. Upon depositing material with Elektra in 1962, Parks stated, "If I am absent because of conflict in schedule, or other reasons which prevent me from carrying out my function as director, I agree that the project proceed without delay."[27] Both versions of the film had the same moving footage of the favela interspersed

with various still photographs Parks made on his first trip, many of which were never printed or published in *Life*. They also relied on a short script, written by Parks, told from the perspective of Flávio and narrated by a boy. Both versions of the film open with a pan of the Catacumba hillside, but Parks does not identify the favela by name and offers very little information about the location. He also neglects to explain the political context of Kennedy's anticommunist initiative that prompted his own trips to Brazil in 1961, and chooses not to address the turmoil that ensued when President Quadros abruptly resigned in August 1961, about a month after Parks shot his footage in the favela. Rather than issue a pointed critique of the socioeconomic situation in Brazil, the film functions as an expanded, close-up observation of poverty as it affected one family, who represented millions of other families.

There is relatively little plot development, as the film simply highlights daily activities in the da Silva shack—cooking, eating, cleaning, sleeping, entertaining one another. But within the longer version of the film, which has a running time of eighteen minutes, Parks establishes a more complex vision. The voiceover in this cut of the film begins with Flávio introducing himself and orienting viewers, stating that he lives in the hillside above Rio de Janeiro. What follows is a pastiche of profiles for individual family members, punctuated by scenes of everyone coexisting in the shack. Short vignettes, illustrated by still photographs, illuminate the personalities of Flávio's siblings—for example, Luzia is compared to a cat because she "is always licking herself,"

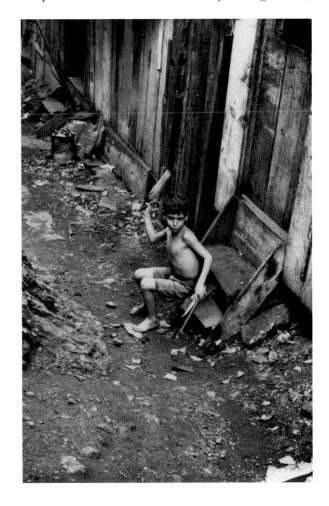

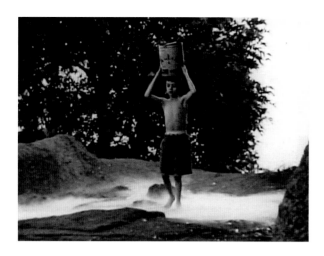

while Mário is the "bad one," a judgment reinforced by jarring cinematic jump cuts to a menacing portrait of him, as well as an image of him brandishing a sword (fig. 41). But the caption on the verso of the print of this image reads "Mario defending home," which, if accurate, reveals how Parks could repurpose and reimagine what he witnessed. The most extreme examples of his directorial intervention appear in the moving footage. Henri Ballot accused Parks of doctoring the introductory scene of Flávio walking up the hill by using dry ice to simulate fog (fig. 42) and staging the shot of men carrying a coffin. Accounting records maintained by *Life* confirm the purchase of dry ice and a coffin, thus confirming that this documentary film involved some smoke and mirrors.

Eventually a nontheatrical distribution company, Films Incorporated, made 16mm copies of the shorter cut of *Flavio*—with an approximate running time of twelve minutes—available to libraries across the United States, classifying it a pedagogical tool rather than a work of art. A small study guide produced by educational publisher McGraw-Hill accompanied this version of the film. Intended to serve educators, the booklet provided a directed reading of key scenes and explored the relationship between still photography and motion pictures. Though basic and concise, the guide also explained how Parks employed such cinematic techniques as panning, dissolving, cutting, and zooming. It asked readers to consider the psychological effects of these technical and aesthetic choices and, along these lines, offered its own interpretation with respect to the ending of the film: "The concluding scenes of *Flavio* offer still views of Flavio's sisters and brothers, each dissolving into the other. The still photographs and the dissolving motion create an inner motion in the eye of the viewer; the mind experiences a mood of hopelessness. In the dissolving still comes a triumph of visual communication: the still is motion."[28] With the last shot of the film representing a return to the first shot of the Catacumba hillside, the guide posed some final questions: "Are we back where we started? . . . Has the film really 'ended'? Would you call this film a documentary?"[29] By posing these questions, it seems the author of the study guide is conveying and inviting skepticism.

Despite the delayed release of the cuts of the film and the study guide, Parks persisted with the belief that a feature-length film about Flávio could be developed. In correspondence as late as 1977 he expressed hope for a longer film. This possibility was kept alive until then, and remained dormant in the intervening years, largely because of the book *Flavio*. Developed as an idea around 1966, when Parks had to fulfill a two-book contract with Harper & Row, the project would allow him to present the story in a format comparatively unrestricted by length and not limited to content produced while in Brazil in 1961. And unlike film, a collaborative medium requiring Parks to "work through and with others, including several people upstairs who are going to control the money all the way," writing allowed for complete control "outside of an argument with [his] editor."[30] In other words, the book theoretically provided a forum for Parks to tell, invent, update, revise, and shape the story as he wished.

Correspondence from editor Gene Young reveals that Parks had still not delivered complete manuscripts for either contracted book to the publisher by 1970, although he had drafted the first three chapters of what would become *Flavio* a few years earlier. After extensive edits proposed by Young in 1968, Parks revised but subsequently shelved the manuscript. He could not embark on the research and travel necessary to update and complete the story on Flávio and at the same time turn his attention to what would be his first feature-length Hollywood film, *The Learning Tree*, based on his semiautobiographical novel about a boy growing up in Kansas published in 1964—just after he had completed work on the *Flavio* film.

Parks did not revisit his text about Flávio in earnest until sometime in 1975, by which time Young had become an executive vice president at another publisher, J. B. Lippincott, as well as Parks' third wife (fig. 43). In an interview that year, Parks maintained that he had all but abandoned photography: "I haven't touched a camera, possibly since 1968 . . . simply because I wanted to get away from it for a while and try to figure out a new approach to photography. Photography used to pay for my indulgences in poetry, in writing, music, whatever. Now the other things pay for the luxury of sort of doodling around in photography, that is, doing the things that I want to do without having to worry about a deadline or whether or not it's going to be published."[31]

Not only did the year 1968 signify the moment when Parks temporarily stopped working on the *Flavio* book and theoretically transitioned from photojournalism into filmmaking and other creative arenas, but it also marked the publication of his photo essay about the Fontenelle family in *Life*.[32] Parks often related his experience of covering that story—about a destitute African American family of ten in Harlem; their relocation to a new home on Long Island, facilitated by *Life* and Parks, was soon followed by a devastating fire that killed two family members—to his time in the favela with the da Silvas. He invoked that comparison in his foreword for the book *Flavio*, finally published in 1978 (fig. 44). Despite the differences in their situations, these two families "shared the same tragedy, a private tragedy but one [also] very public," because of Parks' involvement on behalf of *Life*.[33] And in both cases, Parks wondered "if it might

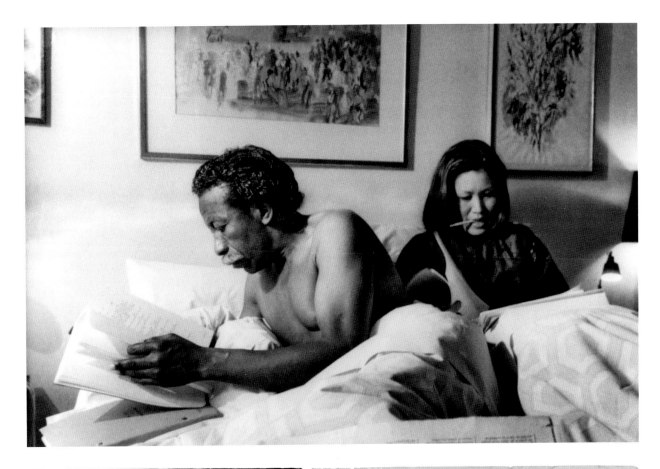

not have been wiser to have left those lives untouched, to have let them grind out their time as fate intended."[34]

The book *Flavio* begins with this revelation from Parks, and in many respects the narrative that unfolds in the subsequent pages is a long-form confession as much as it is "the only book-length account of photographing one subject" that Parks ever produced.[35] He opens his fore-word with a sentence that not only outlines his conun-drum, but also explains the complication of the narrative he constructs: "As a photojournalist I have on occasion done stories that have seriously altered human lives."[36] Trained to tackle assignments with some perceived stand-ard of journalistic objectivity, Parks approached the task of writing this before-and-after tale of Flávio as a research project. Because some fifteen years had transpired since *Life* published the photo essays, Parks had to embark on a fact-finding mission if he wanted to bring the narrative into the present day and chronicle the "after" story of Flávio's life as it had progressed in the interim. Between 1961 and 1963, Parks had seen Flávio only once—dur-ing a brief stopover in Denver en route to somewhere else; he had received letters from him periodically over the years. Neither Parks nor *Life*'s readers were well in-formed about Flávio's stay at the asthma clinic in Denver, about what had transpired when he returned to Brazil, or about what had happened to members of his family and the favela. To remedy this in his publication, Parks relied on correspondence files maintained by *Life*, which contained a wealth of source material. Through the files Parks gained access to Flávio's medical records from the clinic, progress reports from his teachers, numerous let-ters between Ruth Fowler, the assistant to publisher of *Life*, and José Gallo about the status of the favela project and Flávio's return to Brazil, and other assorted internal *Life* telexes, memos, and notes. Parks referred to these documents in his text to the extent that his editor warned him that his research was too thin and too dependent on the knowledge of others. To supplement the information he gleaned from ephemera in the *Life* files, he interviewed the Gonçalves family—who had hosted Flávio in Denver and who now provided Parks with snapshots to incor-porate in his book—as well as others acquainted with Flávio between 1961 and 1963. He also traveled to Brazil in 1976 to reunite with Flávio; this provided an occa-sion for Parks to conduct further interviews from which he could reconstruct details of the story and update the narrative. While in Brazil he photographed Flávio and various family members, including his wife, Cleuza, and their two sons.

This meeting—which was essential if Parks planned to conclude his book in the present day—was part of a well-planned research trip, one that Parks knew he would have to make back in 1967 when he outlined the book. In the published version of *Flavio*, however, Parks credited a random interaction with a man while he was shopping for shoes in Buenos Aires as the reason for the trip, which he described as if impromptu. Notes from Gene Young reveal that she encouraged Parks to invent this story, ar-guing that "somehow the real purpose of the trip—just to see Flavio so you can get an end to the book—is not very acceptable. Can you pretend that you had other business in South America (what? a photo assignment!) and decided to go to Rio to see how Flavio was? Also, for the sake of verisimilitude, cut down the duration of your visit to Rio to a week or five days."[37] Young had also urged Parks to treat his diary as "raw material" to be "reshaped, fleshed out, rearranged and rewritten, rather than quoted verbatim" because the narrative should be conveyed as a story.[38] Even the flap copy for the book perpetuates fiction, referring to the "intimately painful diary Parks kept during his three-month stay with Flavio and his beaten family" in 1961.

Parks had already composed and edited the first three chapters of the book in 1968—years after his initial encounter with Flávio, it bears noting, and undoubtedly cobbled together from correspondence he could access from *Life* files, the published photo essays, and assorted memories, some of them elicited by reviewing contact sheets, according to Young. But a comparison of later drafts reveals that he revised these chapters again before he published *Flavio* and fabricated at least one element found in them. The most substantive change he made to this section of the book concerned the "melandro" that he first introduced in a draft of the book around March 1977. With the help of a 1962 memo on peasant migra-tion and *nordestinos* (northeasterners), which featured a description of a *malandro* as "an odd mixture of bum, sharp operator, slick dresser (by *favela* standards) and criminal," Parks invented a character named Dantas and fabricated a subplot about him lurking in Catacumba at night.[39] Did Parks or his editors feel it necessary to inject a phony story line about crime as it related to the favela, because of stereotypes about *favelados* or opinions that more dramatic scenes should punctuate the narrative? Whatever the rationale behind the creation of this char-acter, Parks did not entirely cover his tracks—Dantas was the surname of a second-in-command in *Life*'s Rio office whose name cropped up on various telexes that Parks used for his research.

Of his experience in the favela in 1961, Parks wrote that he took comfort in the notion that "reality always provided escape," meaning he could descend the hillside and return to his luxurious hotel in Copacabana at any point.[40] But in his multiple, disparate attempts over the course of his career to come to terms with "playing God" and bringing Flávio down the hillside with him, Parks re-peatedly, and increasingly, turned to modes of fiction and metaphor. In this respect he continued to play God, de-termining and controlling how Flávio was represented in a public context.[41] Not only did he serve as an omniscient narrator in *Flavio*, but he effectively silenced his protago-nist, forcing him to sign a contract for legal purposes that stipulated: "The Subject shall have no control over the ed-itorial content of the book, and waives the right to make any objections to statements made in the book about the Subject whether or not such statements are based on ma-terial derived from interviews with the Subject."[42] From fabricating passages to falsifying details, Parks tried to make his decision to "rescue" Flávio more justifiable and palatable within the confines of his written text. In *Voices*

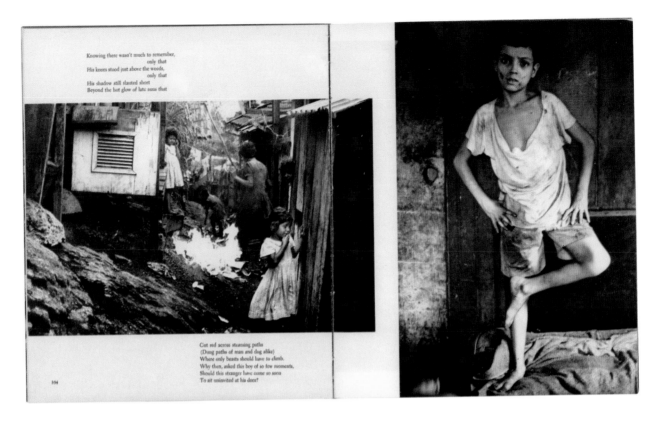

in the Mirror, one of the memoirs where the Flávio story is repeated, retold, and condensed, Parks goes so far as to displace his guilt by blaming the president of the United States for authorizing the "rescue" mission to bring Flávio to Denver: "I suggested that President Kennedy be asked to help. The President's message: 'Bring him on.'"[43] Parks also agreed to pay Flávio five percent of the royalties earned from sales of the book about him. In his continuing effort to revisit the story of Flávio and reengage with his subject, Parks positioned himself as a foil to Christ the Redeemer, the statue on Sugarloaf Mountain that overlooks Rio and that Flávio claimed "turned [its] back on us here in the favela."[44]

That metaphor is reinforced in the poem "Quietly the Stranger Came," inspired by the Flávio story and published in 1975, the year Parks returned to work on his manuscript for *Flavio*. The poem was featured in *Moments Without Proper Names*—one of four books of Parks' poetry released between 1968 and 1978, between drafting the first chapters of *Flavio* and publishing the book—alongside photographs of Flávio, his family, and the favela (fig. 45). The first stanza reads:

> A stranger, uninvited but expected,
> Coming from a distance
> That only a mind could travel,
> Sat silent outside the door,
> Patiently feeling the pulse
> Of this stilt-leg house,
> This minute scab
> On a mountain's festered side.

The figure of the stranger, who is revealed as death by the end of the poem, according to Jay Prosser, initially seems to register as an allusion to Parks himself. In his analysis of this conflation and the resulting confusion,

Prosser questions whether Parks' encounter with Flávio "represent[s] the photographer's redemption from his underworld or his return to it."[46] This predicament tormented Parks and inspired repeated self-reflection, in the form of the book *Flavio* and in chapters incorporated in memoirs published subsequently. However, in these instances Parks served not only as photographer but also as author, able to revise and rewrite the history of Flávio. While the boy's fate was all but sealed when he returned to Brazil in 1963, after which his ties to America faded and *Life* magazine eventually folded, Parks could perpetuate the so-called fairy tale that the Flávio story initially constituted—he could fictionalize hope, and he could rework the ending, again and again. Recalling in *Voices in the Mirror*, Parks made an attempt as late as 1990: "Now and then I get a letter from [Flávio], and invariably it is still filled with hopes of coming back to America. And I write back, knowing that as time passes nothing is changeless."[47]

1 F. Scott Fitzgerald, "One Hundred False Starts," *The Saturday Evening Post*, March 4, 1933, quoted in *The Short Stories of F. Scott Fitzgerald*, ed. Matthew J. Bruccoli (New York: Scribner, 1989), xiii.

2 Gordon Parks, "Creativity to Me," in *Creativity*, ed. John D. Roslansky (Amsterdam: North-Holland, 1970), 87.

3 Jay Prosser, *Light in a Dark Room* (Minneapolis: University of Minnesota Press, 2005), 117, 12.

4 Gordon Parks, *Flavio* manuscript, October 1976. Gordon Parks Papers, Manuscript Division, Library of Congress, Washington, D.C.

5 Gordon Parks, *Flavio* (New York: W. W. Norton, 1978), 58.

6 Ibid., 14.

7 Gordon Parks, *Flavio* manuscript, March 1977, 54. Gordon Parks Papers, Manuscript Division, Library of Congress, Washington, D.C.

8 Parks, *Flavio* (1978), 58.

9 Ibid., 62.

10 Ibid., 61.

11 "The Flavio Story," telex message from George de Carvalho to Time Inc./New York, July 12, 1961. Gordon Parks Papers, Manuscript Division, Library of Congress, Washington, D.C.

12 *Life* "hewed strongly": John Gennari, "Bridging the Two Americas: *Life* Looks at the 1960s," in *Looking at* Life *Magazine*, ed. Erika Lee Doss (Washington, DC: Smithsonian Institution Press, 2001), 271; "from the outset": Parks, *Flavio* (1978), 8.

13 Erika Lee Doss, "Visualizing Black America: Gordon Parks at *Life*, 1948–1971," in *Looking at* Life *Magazine*, ed. Erika Lee Doss (Washington, DC: Smithsonian Institution Press, 2001), 230.

14 Titles ascribed to this assignment and printed on the versos of the contact sheets also reveal how the shape of the story—or at least what *Life* staff understood of the story's contents—evolved over time. See the essay by Paul Roth in this volume.

15 Parks, "Creativity to Me," 87.

16 "Henri Ballot Unmasks American [Report]," translation of "Henri Ballot desmascara reportagem americana," *O Cruzeiro*, November 18, 1961. Gordon Parks Papers, Special Collections, Wichita State University Libraries, Wichita, Kansas.

17 Gordon Parks, *Voices in the Mirror* (New York: Harlem Moon, 2005), 112.

18 "Freedom's Fearful Foe: Poverty," *Life*, June 16, 1961, 96.

19 For reasons that remain unknown, the Rio-based reporter José Gallo, who accompanied Parks to Catacumba, served as his interpreter, and helped facilitate various matters related to the da Silva family and the favela for many years, was not engaged to write the text that accompanied Parks' pictures.

20 George de Carvalho to Timothy Foote et al., telex message from Time Inc./Rio de Janeiro to Time Inc./New York, April 3, 1961. Gordon Parks Papers, Manuscript Division, Library of Congress, Washington, D.C.

21 Parks, *Flavio* (1978), 56.

22 *REEL 3* interview with John Connell, 1969–1970. Gordon Parks Papers, Special Collections, Wichita State University Libraries, Wichita, Kansas.

23 According to one report, which reads as hyperbolic in tone, regulations policed by the SCDP included a law that forbade foreigners from filming in Brazil other than at Sugarloaf Mountain. See "Ascendino, Ascendino," translation of article published in *A Noite*, July 8, 1961. Gordon Parks Papers, Manuscript Division, Library of Congress, Washington, D.C.

24 "Humanitarian Feeling Caused the Censor to Close the Case of the Film Made with Slum Dwellers," translation of article published in *O Jornal*, July 8, 1961. Gordon Parks Papers, Manuscript Division, Library of Congress, Washington, D.C.

25 Thomas E. Skidmore, "Cinema Novo," *Brazil: Five Centuries of Change* (companion website to Oxford University Press, 2010, print edition), Center for Digital Scholarship, Brown University Library, http://library.brown.edu/create/fivecenturiesofchange/chapters/chapter-8/cinema-novo/.

26 One determining factor may have involved film footage produced but seized for review by the government, because of censorship regulations in place in Brazil.

27 Gordon Parks to Abe Liss, March 7, 1962, Wichita State University, Gordon Parks Papers, Box 54, FF 14.

28 Paul A. Schreivogel, *Flavio: A Film Study* (Dayton, OH: G. A. Pflaum, 1970), 6.

29 Ibid., 19.

30 Parks, "Creativity to Me," 86.

31 "Gordon Parks: An Artist Reminisces," *The New York Times*, December 3, 1975, 36.

32 "The Cycle of Despair," *Life*, March 8, 1968, 47–63. A follow-up article, "Editors' Note: Tragedy in a House That Friends Built," appeared in the magazine, May 2, 1969, 3.

33 Parks, *Flavio* (1978), 7.

34 Ibid.

35 Prosser, *Light in a Dark Room*, 117.

36 Parks, *Flavio* (1978), 7.

37 Gene Young to Gordon Parks, notes on *Flavio* draft, November 14, 1976, 23. Gordon Parks Papers, Manuscript Division, Library of Congress, Washington, D.C.

38 Gene Young to Gordon Parks, April 17, 1967. Gordon Parks Papers, Manuscript Division, Library of Congress, Washington, D.C.

39 "Peasant Migrations and City Shanty Towns," Rio Mailer no. 349, March 26, 1962, sent from (Time Inc./Rio de Janeiro) to Phil Payne (*Life* Latin America correspondent). Gordon Parks Papers, Manuscript Division, Library of Congress, Washington, D.C.

40 Parks, *Flavio* (1978), 44.

41 "Unconsciously," Parks wrote, "I was perhaps playing God." Ibid., 9.

42 Agreement between Gordon Parks and Flávio da Silva, August 12, 1976. Gordon Parks Papers, Manuscript Division, Library of Congress, Washington, D.C.

43 Gordon Parks, *Voices in the Mirror* (New York: Doubleday, 1990), 195.

44 Parks, *Flavio* (1978), 34.

45 Gordon Parks, *Moments Without Proper Names* (New York: The Viking Press, 1975), 101–14.

46 Prosser, *Light in a Dark Room*, 117.

47 Parks, *Voices in the Mirror*, 317.

LIFE AND O CRUZEIRO

PHOTOGRAPHIC ESSAYS

LIFE

"FREEDOM'S FEARFUL FOE: POVERTY"

The following pages reproduce the original *Life* story
as it was published on June 16, 1961.

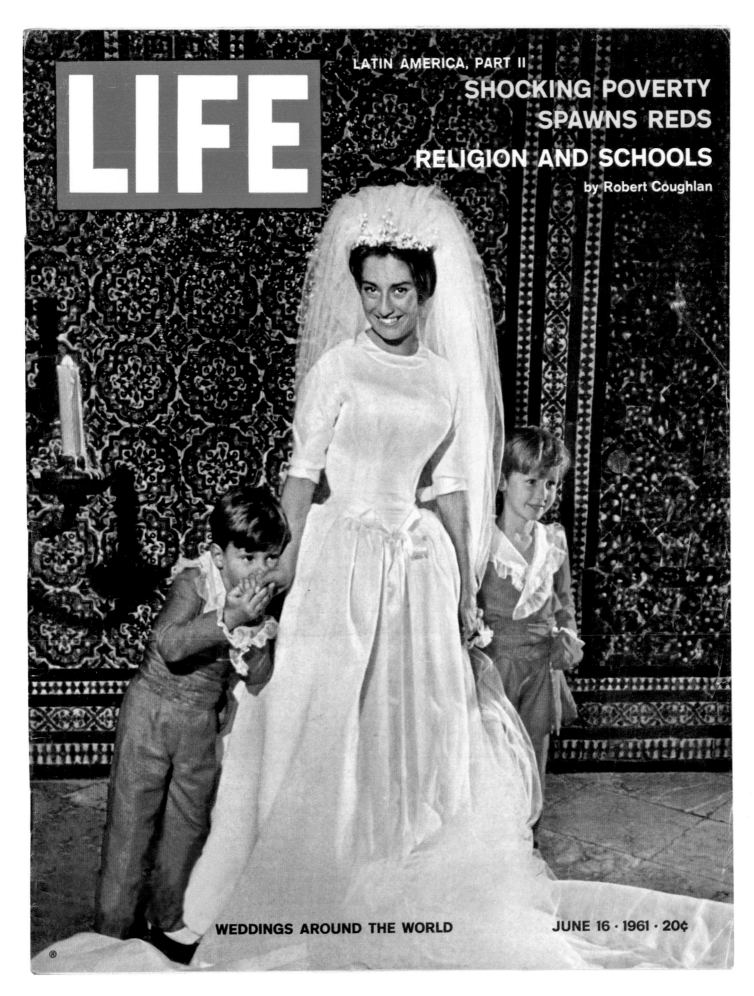

LIFE

LATIN AMERICA, PART II

SHOCKING POVERTY
SPAWNS REDS
RELIGION AND SCHOOLS

by Robert Coughlan

WEDDINGS AROUND THE WORLD

JUNE 16 · 1961 · 20¢

A Beaten Family in Rio Slum

Freedom's Fearful Foe: Poverty

The anguish which poverty inflicts is cruel and varied—statistics cannot convey its accumulated torments and degradations. But poverty always has a human face. This week, to bring alive some brief fragment of the enormous misery poverty works on people today in Latin America, LIFE presents one family—the Da Silvas. They live in a *favela*, a sweating slum of the rich, elegant city of Rio de Janeiro. But their poverty can be found almost anywhere else in Latin America: in the cane lands of northeast Brazil, in Caracas, the capital of oil-rich Venezuela, in the high plains of Bolivia, and in Chile and Ecuador where hundreds of thousands of people exist, wasted by malnutrition and disease.

The plight of the Da Silvas, seen as individuals, evokes human compassion. Viewed historically, their condition and that of other hopeless millions in Latin America, spell sharp danger—and an economic challenge to the free world. For the most part clustered in pockets (despite being two times the size of the U.S., Latin America has relatively little tillable land) largely in dislocated city slums, the teeming poor are a ripe field for Castroist and Communist political exploitation (LIFE, June 2). To counter that threat U.S. and Latin American leaders must face an unsettling set of facts. Under a free economic system in Latin America, industry has been growing solidly, the new middle class has been growing, democratic institutions are taking deeper roots. But, faster than any of these, poverty has been growing too. The population of Latin America has doubled in the past 40 years, may more than treble again by the year 2000. The average yearly per capita income today is only $289. And the ratio of increased income against population growth is among the worst in the world—worse even than Africa.

This danger and this challenge will lend urgency next month when Western Hemisphere leaders meet in Uruguay to help President Kennedy's new "alliance for progress" program get started. The free world offers liberty and free economic development as a way for backward lands to help themselves. If that system cannot be made to work, neither the system nor lib rty itself will last.

Photographed for LIFE
by GORDON PARKS

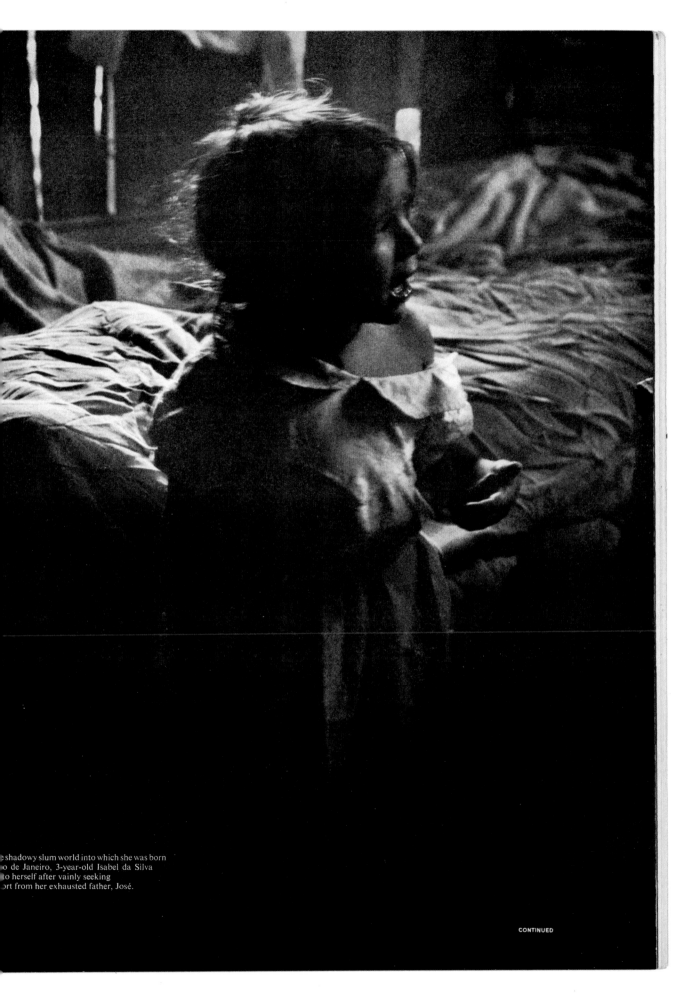

shadowy slum world into which she was born
o de Janeiro, 3-year-old Isabel da Silva
o herself after vainly seeking
ort from her exhausted father, José.

CONTINUED

225

The 'Favela,' a Hillside of Filth and Pain

A figure of Christ looms above the mounting zigzag of shacks which comprise the *favela* where José and Nair da Silva live with their eight children. The statue seems to brood not only upon the *favela*'s hunger and disease but on the sunny elegance of Copacabana Beach and the gleaming villas of Rio beyond the hill.

Like so many others of the 700,000 who swell the slums of the great city, José is a *nordestino*, a refugee from dirt-poor northeast Brazil. He was a construction worker until an accident injured his back. Now he sells kerosene and bleach in a tiny boxlike stall which he and Nair built—as they did their tiny shack—from tin cans, broken orange crates and stolen pieces of lumber. The shop brings in about $20 a month. To get $5 more to buy food, Nair, about to have her ninth child, washes clothes in the only available water—from a spigot at the foot of the hill. The children, who range from 12 years to 17 months, are penned in the shack or roam the foul pathways of the *favela* where the filth of the inhabitants is tossed out to rot. But in inflation-riddled Brazil the *favelados* consider themselves blessed. They are squatters and pay little or no rent.

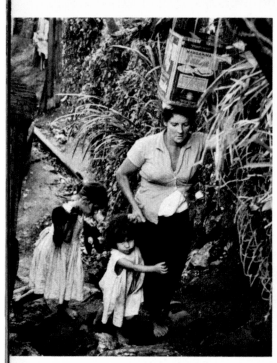

Straining up hill, with Luzia, 6, and Isabel, 3, following, Nair da Silva balances three gallons of water on head.

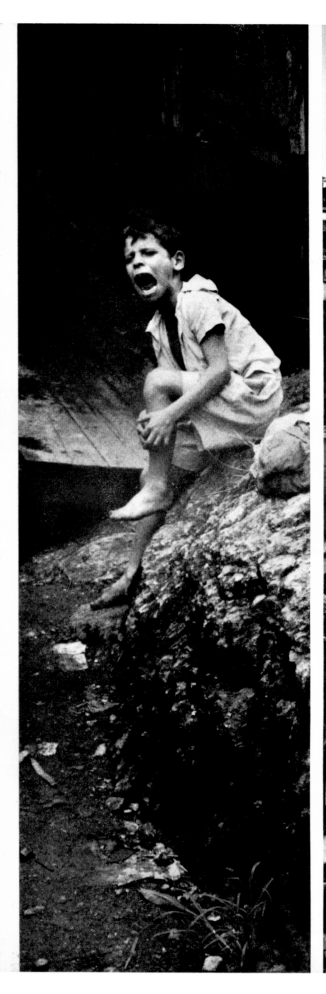

Home for Da Silva family is hillside jumble of squatters' huts (*center*) beneath Rio's famous statue of Christ. On filth-strewn paths Mario da Silva, 8, howls after being bitten by neighbor's dog. The baby, Zacarias, 1 (*far right*), explores the path leading beneath the pilings which support shack.

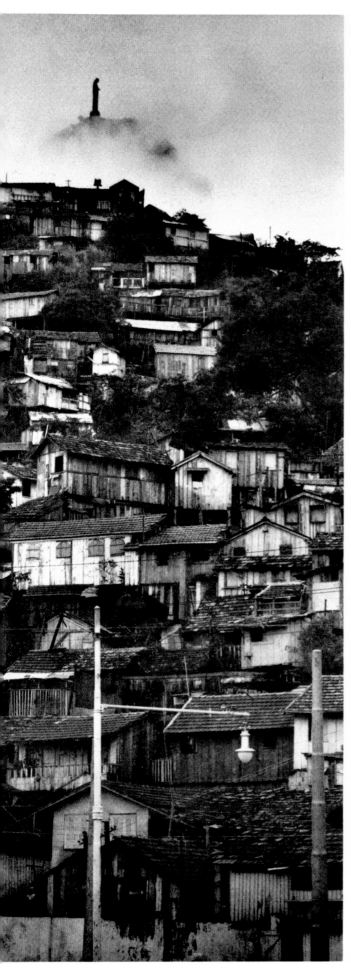

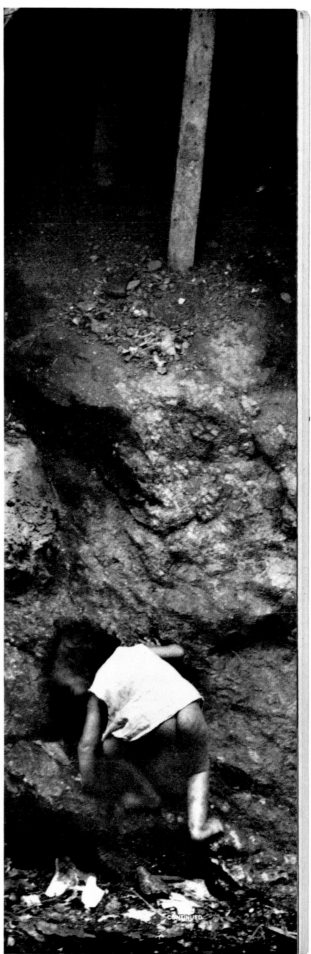

CONTINUED

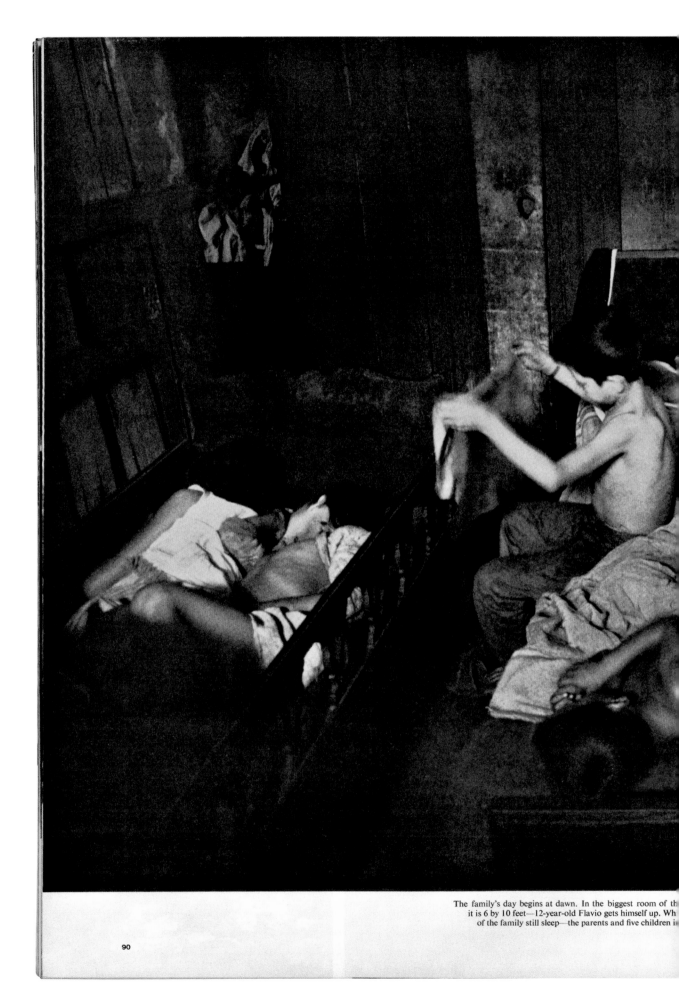

The family's day begins at dawn. In the biggest room of th[e]
it is 6 by 10 feet—12-year-old Flavio gets himself up. Wh[ile]
of the family still sleep—the parents and five children i[n]

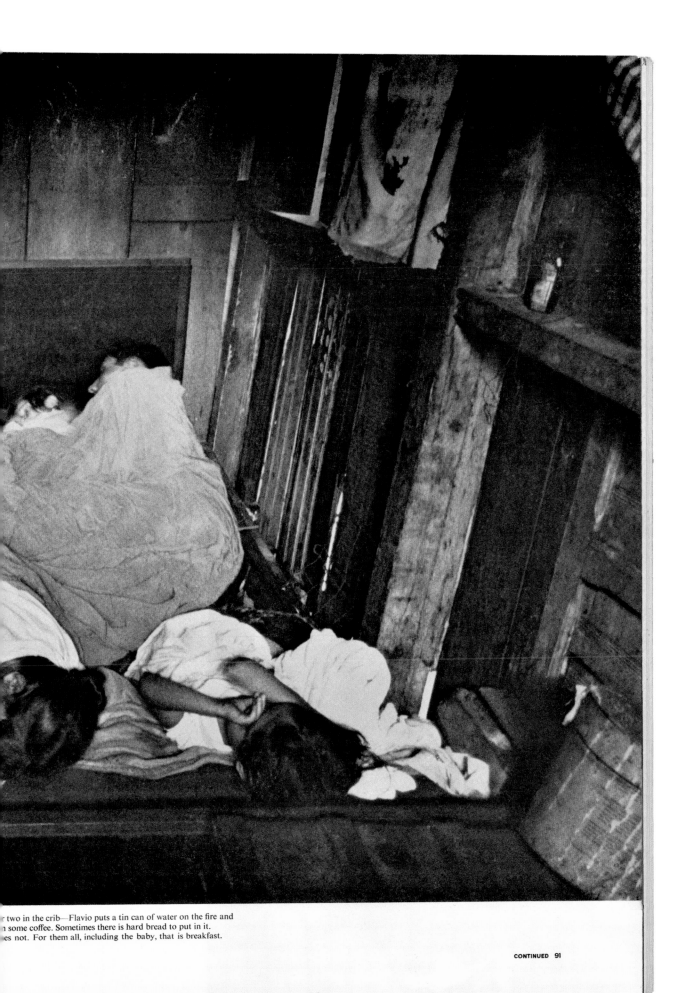

two in the crib—Flavio puts a tin can of water on the fire and
 some coffee. Sometimes there is hard bread to put in it.
es not. For them all, including the baby, that is breakfast.

CONTINUED 91

229

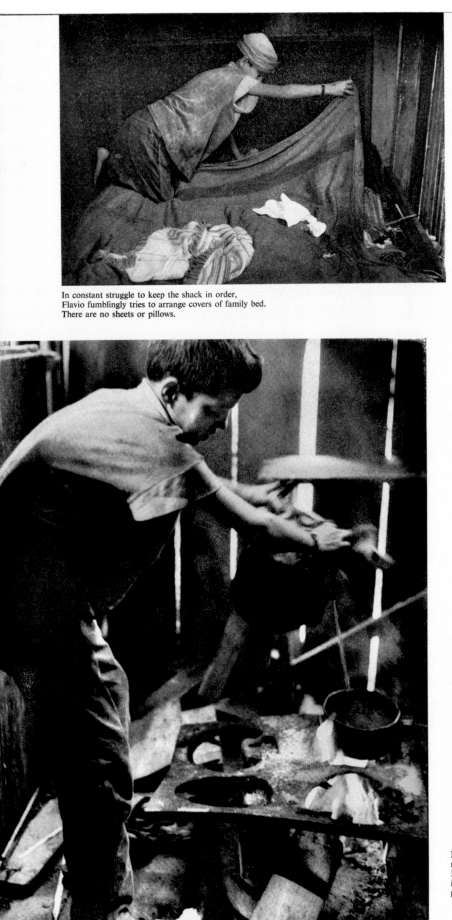

In constant struggle to keep the shack in order,
Flavio fumblingly tries to arrange covers of family bed.
There are no sheets or pillows.

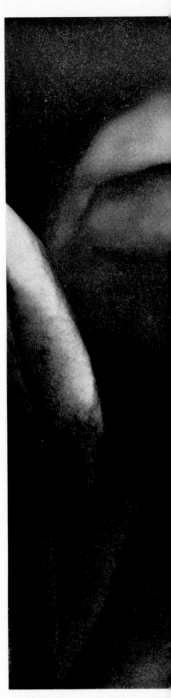

Feeding Zacarias, his 17-month-old brother,
Flavio steadies him with one hand, stuffs
food into his mouth with the other.
Children have to wait until Zacarias is fed
eating to be sure he gets enough.

Pouring water into family's cooking pot, Flavio sta
meal for brothers and sisters.
Flavio says, "Some day I want to live
in a real house, on a real street, with pots and
pans and a bed with sheets."

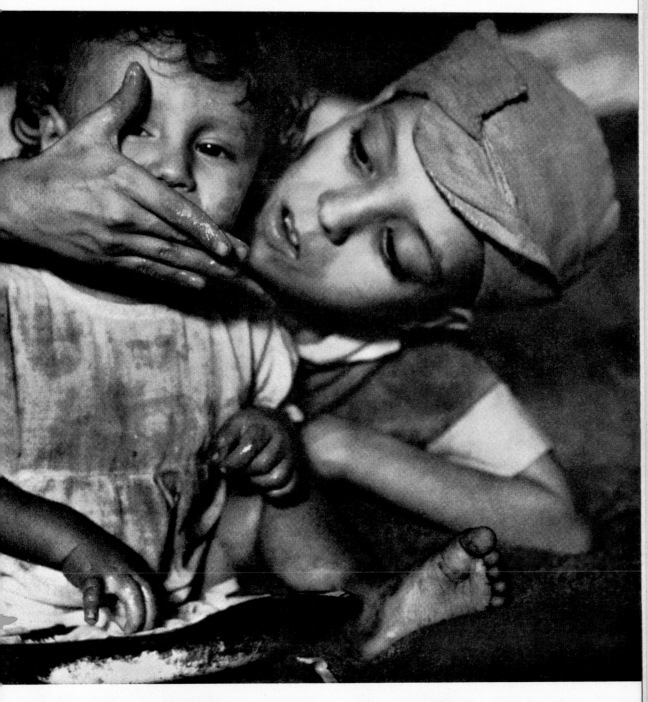

A Boy Burdened with a Family's Cares

e mother, Nair, dreams that some of her children may one day cape the *favela*. José, the father, thinks that he may get money to mpensate for his injury and somehow build up the store. But both them are beaten people. In the family the spark of hope and armth and care which keeps life going comes from the boy Flavio. Flavio can neither read nor write. (Only one of four children in s *favela* goes to school.) But at 12 he is already old with worry. the tormented, closed world of the shack, assailed by the needs d complaints of his sisters and brothers who are always a little ngry, he fights a losing battle against savagery and disorder. The

family has three plates. He washes these as well as the faces of the younger children. He cooks the black beans and rice which make up almost every meal. He feeds and watches over the baby, Zacarias. If his brother Mario attacks his sister Maria it is Flavio who breaks it up and metes out punishment.

It would be nice to believe this labor of love and courage will triumph. But it won't. Disease threatens constantly in the *favela*. (Last year in Rio, some 10,000 children died of dysentery alone.) And disease has touched Flavio. Wasted by bronchial asthma and malnutrition he is fighting another losing battle—against death.

CONTINUED 93

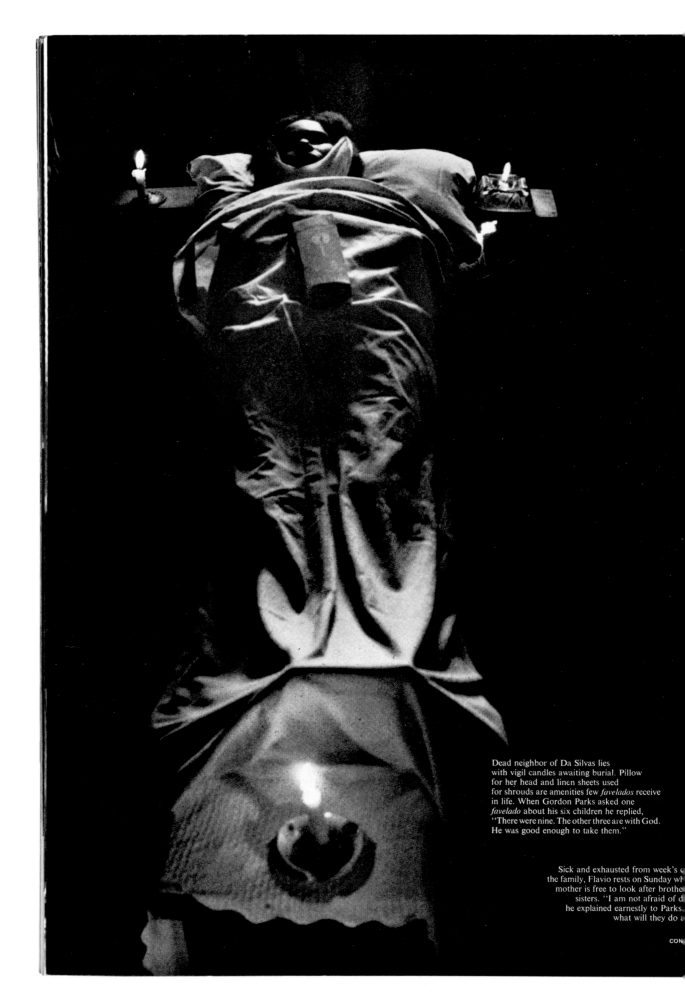

Dead neighbor of Da Silvas lies
with vigil candles awaiting burial. Pillow
for her head and linen sheets used
for shrouds are amenities few *favelados* receive
in life. When Gordon Parks asked one
favelado about his six children he replied,
"There were nine. The other three are with God.
He was good enough to take them."

Sick and exhausted from week's c
the family, Flavio rests on Sunday wh
mother is free to look after brothe
sisters. "I am not afraid of d
he explained earnestly to Parks.
what will they do a

CON

232

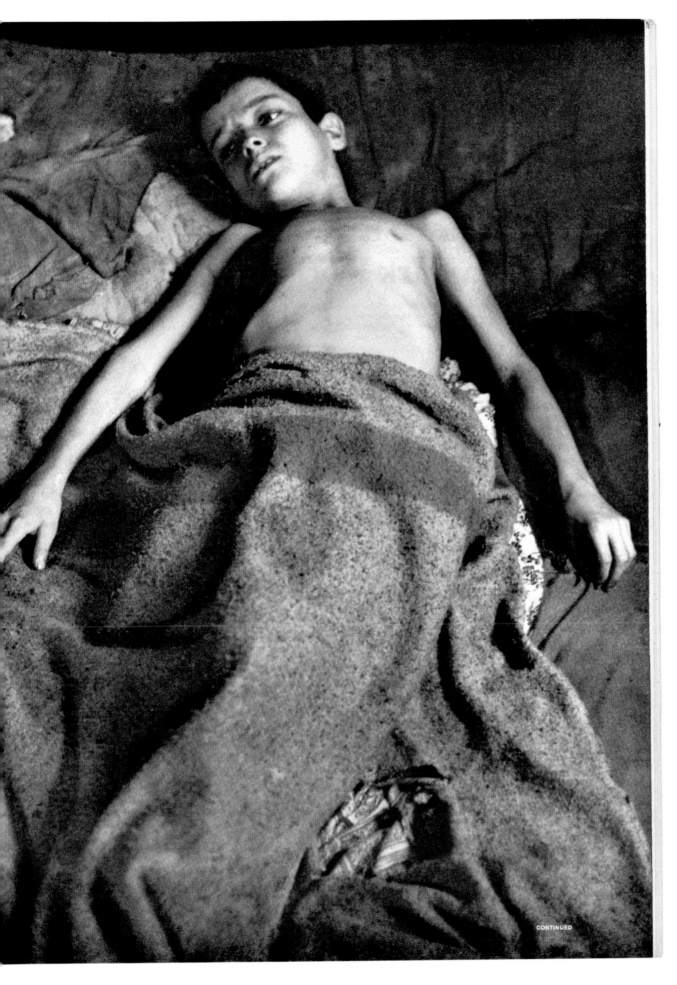

CONTINUED

233

Photographer's Diary of a Visit in Dark World

During the time he spent with the Da Silva family in the favela, *Photographer Gordon Parks kept a detailed day-to-day report. Here are some excerpts from this diary.*

At Copacabana Beach where Gordon Parks took them, M■
and Flavio play in sand. The beach is
10 minutes from their home but neither had ever visite■

MARCH 22

This morning I reached the shack at 7:30. Little Zacarias was crawling around naked in the filth outside. Maria and the rest were swinging in a greasy hammock, stretched from one side of the room to the other. Flavio was cooking black beans and rice for lunch. The kids, at least, seemed glad to see me.

I stepped back to get a shot of the others in the hammock and upset the pot of beans. This sent them all into hysterics. Flavio, who because of his asthma and weak lungs must satisfy his expression of mirth with a broad grin, enjoyed the luxury of real laughter until the strain brought on convulsive coughing. He was so weak from it that I had to hold him.

MARCH 23

I started to give the children small amounts of money today and already I regret it. Except for Flavio, no matter how many cruzeiros you give them they come back for more. No less than five of them ganged up on me today—actually forcing their hands in my pockets, whispering, *"Americano,* mawny, mawny, mawny *Americano!"*

MARCH 24

Flavio was daydreaming when I arrived today—looking out over the shacks, past the football field, the lake, and the great white buildings. Though he is 12 he has never been across the small lake to downtown Rio. None of the kids has—not even to Rio's famous Copacabana Beach, which is only 10 minutes from the bottom of their miserable world. I have promised Flavio to take him there. Maybe one trip outside will give him the added incentive to someday get out of this. I may create a longing impossible to fulfill, but I think it is worth the gamble. When he is dreaming like that he feels lonely. I stood with him. After a while, not knowing just how to express his feeling, he walked over and took my hands, rubbing his face against my arm over and over again.

MARCH 25

Luzia is very pretty and must know

it. She licks herself clean like a little cat. She can be surrounded by filth and emerge from it without a blemish. It is remarkable how she manages this against such odds. After I took pictures of her preening, she was especially intolerable to Maria. Today a neighbor brought a fish which Maria had to clean. She was knifing the guts from its belly when Luzia came up and touched the tail.

Before poor Luzia could duck (and I could focus my camera), Maria smacked her in the face with the messy fish. Instead of tearing into Maria, as I expected, Luzia complained to Flavio. Maria sensed trouble and started to run but Flavio wrestled her to the bed, twisted her arm until she dropped the fish, then slapped her in the face with it. Maria grabbed the knife and went for Flavio's back. Dropping my camera, I grabbed her wrist.

Now I found myself in trouble as she wrenched free and came slashing at my stomach with the knife. I stepped aside, grabbed her from behind and spun her about and shook the knife from her grasp. She dug her teeth into my arm but I held her tightly for a moment or so longer. Then to my surprise she looked up at me and wailed, "Mawny Gorduun! Mawny Mawny!"

MARCH 27

Unlike Flavio, the other children are unpredictable. I am "Gorduun" to them now. And sometimes two or three of them wiggle beneath my arms, grip my fingers tightly and remain so for several minutes. Still, it is not surprising when one, coldly, sticks me with a needle. Either act is committed with the same feeling. It is as if they are testing my responses to their love or violence. Their mother doesn't have time to give the love they need—and the father seems incapable. So any hand that touches with gentleness is dear. But to ignore one of them for long is to abuse them. Their reaction is sullen anger or some kind of violence.

MARCH 28

Maria was plastering her hair with a dirty-gray grease this morning. It

was flecked with brown particles and gave off a rancid odor. When I found out it was drippings from pig fat, I went below and bought her a bottle of perfumed hair oil. Immediately she washed out the other and soaked her hair with the sweet-scented liquid, grinning, smelling and combing as if she were about to meet a handsome prince. She reached for Luzia's broken mirror to inspect her efforts but Luzia refused her, spit at me, stomped my toes and ran. Maria skipped over to the pile of clean rags, yanked out a wrinkled dress and put it on. Kissing me, she skipped out to let her less fortunate girl friends smell her hair.

MARCH 29

Isabel is a small flower of bitterness whose every minute is spent biting, kicking. I have tried in every conceivable way to win a sign of affection from her. Through all this she has never smiled. Not once. Tonight she ran to me and threw her arms about my legs—only to bury her teeth into them. I kept rubbing her hair gently, hoping she might yield to such treatment but then she began to kick my shins. The next moment she let out a painful cry and pointed at her foot. Lifting her to my lap I groped in the darkness for whatever hurt her. A thin rusty nail had entered her foot from the bottom and was protruding through the top. I pulled once; twice. She screamed but the nail hadn't moved. The third time I pulled with all my strength—feeling her pain, suffering her screams. It was out and my hand was smeared with blood. Her mother grabbed a bottle of raw alcohol and doused the wound while Isabel gripped my neck tight. Then I put her on the bed. Her mother's face was contorted with concern. But José, her father, didn't even bother to look at her foot—although he was less than three feet away.

AP■

It was unbearably hot today. ■ looking more dead than alive, ■ shivering and feverish underneath crusty blanket. He squirmed ben■ the covers groaning, "God, what ■ become of me? What's to becom■ me?" A huge black spider cra■ over his leg and little Isabel, stan■ nearby, watched until it reached ■ knee, then, doubling her fist, ■ smashed it. José shrieked and ■ hand shot out and landed aga■ Isabel's face. She stood crying be■ the bed until Flavio took her to■ stove, dunked some crust in c■ and pushed it between her lips. ■ quieted her but then she started ■ ing again. Suddenly, for no appa■ reason, she walked over to Zaca■ the baby, and kicked him in the h■ Then Luzia, in defense of Zaca■ shoved Isabel to the floor. Fl■ stopped sweeping to intervene. ■ Mario's haste to get away he plu■ headlong into his mother who ■ entering the door. She grabbed ■ and cuffed him about the head ■ he fell to the ground scream■ "What'n hell you hit me for?" ■ mother picked up Zacarias and pla■ him on the table where she sat do■ buried her head in her arms. Isa■ her wet sullen eyes on Luzia, ■ gloomily in a corner. "Bitch! Bi■ Dirty bitch!" she muttered. A■ cleaning her feet with cold co■ Luzia went outside, doubled her ■ up and began sucking her thumb■

AP■

This was the day I had promi■ the trip to Copacabana Beach. Wl■ I arrived this morning at 7, Fla■ and Mario were already waiting ■ the entrance to the *favela*, wav■ and jumping excitedly. They had m■ no attempt to dress up so the ■ from the day before still covered th■ bodies. Excepting for soiled, tatte■

CONTIN■

This one's <u>soap</u>!

Not all bath bars you buy today are soap. But Dial is. Real soap without any synthetic detergents in it to dry out skin. And Dial's AT-7 makes it the most effective deodorant soap you can buy.

That's why people who like people like Dial.

Aren't you glad <u>you</u> use Dial Soap!

dial

(*don't you wish <u>everybody</u> did?*)

LATIN AMERICA
CONTINUED

pants, they were naked. I started to suggest their tidying up a bit but their eagerness had got the better of me. They scrambled into the back seat and pleaded for us to go on. As we drove through the valley of gleaming white buildings Mario's hand closed tightly about that of Flavio's and the two of them sat close together, wide-eyed and silent, in the center of the car seat —looking.

Suddenly the whole of the vast, curving waterfront and the thronged beach came into view. The car drove slowly along it.

"Look, look, look," Mario cried. Hundreds of multicolored umbrellas cast pools of shade over the long strip of blinding white sand. Children of the same ages as Flavio and Mario ran about, eating, laughing, playing leapfrog and flying large colored kites.

"Flav," Mario said, turning to his brother, "is this here all the time?"

"Yes, yes, yes of course," Flavio practically shouted.

At first the two were afraid to move about out on the wide, exposed serpentine walks and the expanse of sand beyond. They were just feeling bold enough to move off to the water when a jet liner roared over from behind the buildings. The boys ducked and cringed. After the din died away they joined hands and warily approached

the water. The first time a wave[...] against the beach they scream[...] ran. But within minutes the[...] skipping joyfully and unafrai[...] foamy surf.

Later they walked along, [...] at the elaborately dressed win[...] Rio's expensive stores. I boug[...] food but they were too excite[...] it. When finally it was time to [...] begged for one last ride alo[...] waterfront. So we turned and [...] and Flavio and Mario sat sile[...] we swept past the vision of th[...] and sea.

I said goodby to Flavio a[...] family today. "Gorduun, w[...] you come back?" he asked.

"Oh someday soon," I lied. [...] I lying?

"You come back to *favela*[...] Flavio, yes?"

"Someday soon, Flavio," [...] Now I was telling myself that [...] I could manage it in some wa[...] take him out of this place.

He walked with me to the ca[...] bing my hands as we went. The[...] a scream and I looked back [...] Maria chasing Mario up the h[...] a stick. Flavio was grinning as [...] away. "Don't forget, Gorduun[...] ricano, come back to *favela*[...] back." Then he ran quickly b[...] the hill and I lost sight of him [...] the jungle of the buildings.

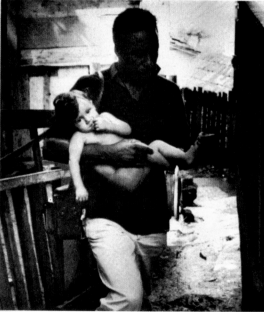

In the *favela*, Parks carries baby Zacarias up the [...] the shack to be cleaned up. He was photogra[...] by LIFE Rio Reporter José Gallo who worked with him on the [...]

NEXT IN SERIES: JUNE 30 ISSUE
BOLIVIA—AID BY U.S.
SHORES UP A REVOLUTI[...]

The "click" of cameras tells you it's summertime!

ummer begins on Wednesday. Are you ready snap the fun?

21st is the day. Summer's the season r best reason for getting the family cam-loaded and ready for fun.

sure you have enough Kodak film for the res you'll want. Whether you shoot -and-white or beautiful color, Kodak makes your pictures sparkle. And the new

cameras by Kodak make them easier than ever to take—cameras like the modern Brownie Starmite (right). It fits the palm of your hand, has flash built in, costs less than $12. See your dealer for exact retail price.

Good shooting!

Price is subject to change without notice.

STMAN KODAK COMPANY, Rochester 4, N. Y.

KODAK'S "THE ED SULLIVAN SHOW" AND "THE ADVENTURES OF OZZIE AND HARRIET"

LIFE

"A GREAT URGE TO HELP FLAVIO"

The following pages reproduce the original Special Report,
with letters from *Life*'s readers, as published on July 7, 1961.

LIFE

A NEW LIFE
FOR IKE: DOWN
ON THE FARM

JULY 7 · 1961 · 20¢

See that tip? It's flexible! It's built on a great White Ow[l]

What a neat and convenient way of smoking! The tip[s]
new, but the cigar is the famous White Owl. The heart[of]
this White Owl is aged 3½ years for exceptional
mildness. Let the new **White Owl Tips** extend
your smoking pleasure. **Only 10¢ each, 5 for 49¢**

14

A Great Urge to Help Flavio

LIFE's readers are moved by the plight of slum family

he photographic essay, "Freedom's Fearful Foe: Poverty" (LIFE, ne 16), has evoked a uniquely urgent and moving response. The picres, taken by Gordon Parks in Rio de Janeiro's *favela*, and his diary out the slum family, the Da Silvas, and their eldest son, Flavio, have osed a flood of inquiries, suggestions, expressions of sympathy and, r more than that, generous donations and magnanimous offers from FE's readers. Presented here is a sampling of the story's mail as both human document and the splendid answer to a tragic cry for help.

wish to have the privilege of aid; the Da Silva family in some all way. I am a widow with two all children. However, I would able to send them a small sum of ney monthly as well as clothes d other material items.

LOUISE MENKIN
Kansas City, Mo.

Your portrait of human misery scribing the plight of the Da Silva nily is impossible to ignore or get. The courage and tenderness the boy, Flavio, is difficult to beve and personally fills me with me. I would like both LIFE and vio to know that he has awaked in us a new need to be of serv to those who truly suffer.

MRS. B. D. NESTOR
Cotati, Calif.

was greatly shocked by the story the Da Silva family and the *fave-* of Rio de Janeiro. I want to ow—and I'm sure many others too—how we can help these peo-. Are there social agencies to help favelados? Can we be sure that at we send will be used to help se who need it most?

ARTHUR WYNN
Cleveland, Ohio

We were deeply moved by your ry. Particularly touching was the e of Flavio, the 12-year-old who the backbone of the family and o is acutely ill with bronchial hma.

The Children's Asthma Research titute and Hospital at Denver is ompletely philanthropic research d treatment center for asthma and er allergic diseases. Its young pants of all races, color and creeds ne from all corners of the earth. We shall be happy to accept Fla da Silva as an emergency pant. There will be no charges or s whatsoever.

ARTHUR B. LORBER, President
Children's Asthma Research
Institute
Denver, Colo.

That picture of the exhausted Fla has reached deep and I beg an portunity to help him. Please let know how I can get some mon to this boy and his family.

JAMES H. MULGANNON
San Francisco, Calif.

Just 10 years ago I walked from the lovely Copacabana Beach up that same smelly hill with my uncle, who was Poland's representative to the United Nations, so that my then pro-Communist leanings could be solidified.

Much has happened since to change my convictions and to make of me an American citizen, proud of my country and its heritage. But the facts of Flavio's life have remained unchanged. If we continue in our preoccupation with the material luxuries of life, the whole world of Flavios will walk down the Communist path, and we'll have no one but ourselves to blame.

IRENA PENZIK
Whitestone, N.Y.

I want to help Flavio da Silva. I can send him money and clothes for himself and his family.

I can give him a home here in Florence and send him to school. I want so much to help ease his burden. I have a beautiful big home and could do much for Flavio.

MRS. OTTO D. SPEAKE
Florence, Ala.

When I came to the heartbreaking picture of little Zacarias da Silva exploring the filth around his home, I broke into tears. Tears of compassion? Or of guilt?

Why do I live in Suburbia, U.S.A., while Nair da Silva lives in a *favela* where never-ending poverty deadens the senses? ("Homes designed with everyone in mind.") Why does my baby drink milk while Zacarias da Silva drinks coffee? ("Pure coffee nectar.") Why do I cook in copper-bottomed pots and pans while Flavio da Silva cooks in a rusty can? (". . . takes the work out of cooking.") Why do I have an automatic washer while Nair da Silva carries gallons of water uphill all day to wash clothes? (". . . soap does everything softer.") There, but for the grace of God, go I.

FRANCES D. BOND
Winchester, Mass.

This situation is not new; it was there in the '30s when, as a child, I knew and played with youngsters like the Da Silvas. Death so often is the only escape.

MICHAEL VAN LAER BALTZER
Cascade, Colo.

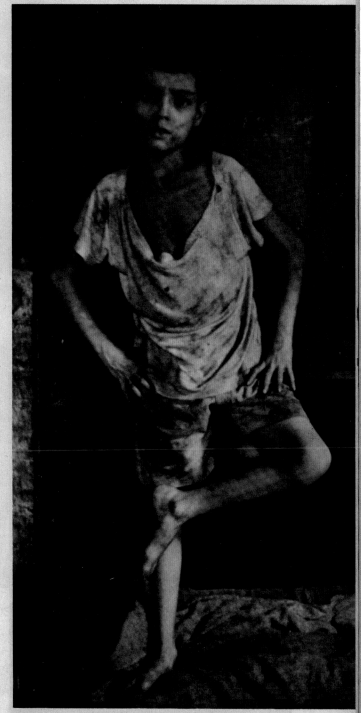

Brave eyes lighting his gaunt face, Flavio stands on a bed in his favela home

CONTINUED

15

241

Let us first beat the Russians to the distant star in Flavio's eyes.
WILLIAM B. BROWN
El Cajon, Calif.

Enclosed is a token, the end result of your most moving essay on the Rio *favela*. If you are wondering whether I realize how many other families on that hill are equally pledged to poverty, yes, I do, and I think we should thank God we do not know their names. The list is too long and our pity, overwhelmed, would yield to inertia.
ENID RUBIN
New York, N.Y.

Our class would like to know how we can get in touch with and send food, money or clothes to the family in your story.
DANIEL CLIFFORD, 8th Grade
Haddam Junior High School
Higganum, Conn.

There are 50 states in the U.S. and 10 provinces in Canada. If your magazine could pick out 60 of the most poverty-stricken areas in Latin America, allot one of these districts to each province or state, then spearhead a campaign in each state for food and clothing and building materials to ship to the allotted districts, I am sure that the results would be staggering.
HARVEY SIMS
Sault Ste. Marie, Ont., Canada

I am a member of an officers' wives' Club here at Castle Air Force Base. The treasury of the club is very small—about $50 a month. I am interested in inquiring how the club could contribute monthly to the sustenance of a *favela* family.
SIGRID BROWNWOOD
Atwater, Calif.

Please, please, see that Flavio gets my two dollars.
WM. T. HARLEY
El Paso, Texas

I read the article about the poor South American family and the 12-year-old boy, only two years older than I am. I called my friend, Sara Jane Sieden. My sister (6 years old) Barbara Leslie Fane also helped us. Yesterday we set up a table and sold things such as old toys, new scarves, old books and new lipsticks. Our parents and grandparents contributed most of the new things and we the used things. We didn't sit down for fear we'd look bored.
When it was over our feet ached but we found that we had over $27. Please be sure to send it to this family.
PATTY FANE
New York, N.Y.

I am a college professor with four children of my own, and you can understand the limitations of my income; but, in the name of God, I hope I have a full realization of the personal responsibility even this little wealth places upon me. I will personally send money every month as long as I live to the Da Silvas if Mr. Parks makes certain *they* get it and not some government clerk.
GEORGE HERMAN
Havertown, Pa.

The touching article and pictures on Rio's slum brings to mind many questions, but the two most annoying ones are—what are the better-off people of Rio and Brazil doing to aid these people? What is the wealthy and powerful Catholic Church doing in these areas?
CATHARINE BOETTGER
Allentown, Pa.

Congratulations on a stirring and powerful piece of work.
The National Council of Catholic Men has just presented a photo essay on the same subject on its ABC-TV religious program, *Directions '61*. We discovered the magnificent work of Dom Helder Câmara, auxiliary bishop of Rio, in helping the *favelados* regain both their practical and spiritual dignity. We were particularly impressed with Dom Helder's ingenious "Bank of Providence" to which the citizens of Rio give the interest on their savings accounts to help the *favelados*.
RICHARD J. WALSH
National Council of Catholic Men
New York, N.Y.

Please tell me what I can do to help that boy and his family. My husband and two of my little boys have also suffered from asthma but we are a typical middle-class family and that means in America that we don't suffer from want.
ELIZABETH B. ROBISON
Westfield, N.Y.

I am only a 13-year-old girl and I am not sure that I could do anything at all to help or encourage this family, but my father is a minister so perhaps he could get the support of the church.
MARGARET LAMAR
Albany, N.Y.

I personally wish to send $10 each month for the family. Especially, I would like to send a set of colorful plastic dishes so that little Flavio might be granted his wish to eat like other people.
B. GIBSON
Mountain View, Calif.

I'm a 14-year-old girl who has no income except what my parents give me. It's sickening to look at my chubby, happy little sister and then look at the babies on the pages. We throw food away simply because there is no one who will eat it. I feel helpless, my hands are tied. But if there is any possible way I could help I'd love to do it.
JO ELLEN BEAN
Wiley Ford, W.Va.

We would like to send this family $10 a month. We also would like to send them two good used bicycles. At least the children could get out of that terrible environment and cycle out to the clean, windswept beach and find some joy in living.
MR. AND MRS. CHARLES CARLISLE
Seattle, Wash.

As I looked at those pitiful beings, I saw not strange people in a remote society of an alien country. I saw myself and my children. There is actually a thin line of defense between me and mine and those poverty-beaten people.
ELLEN VON DEN DEALE
Clifton, N.J.

My own 16-year-old son has h bronchial asthma since he was years old so I know some of terror of a child caught in an as matic attack. Recently, an allerg prescribed for him an inhaler wh he carries with him all the tim This contains medicine which giv relief from asthmatic attacks wh inhaled into the lungs. If there i way in which I could send one these to Flavio, I think he mi benefit from it.
EDITH B. MILLER
Indianapolis, Ind

My name is Paul Beach and I 12 years old. I was just wonder if you could tell me how to get touch with that boy, Flavio. I j don't think that he should have so bad off. I was wondering if th wasn't something I could do him, maybe send him a bat and or some food, and things like th
PAUL BEACH
Menlo Park, Calif

We have five children (three b are all close to Flavio's age). husband is a lawyer and we liv a university town that takes a k interest in these problems. If th add up to assets that might enco age you to arrange his transpor tion to Madison we will do all can to provide him with love, c and an education. Who kno Some day he might return to *favela* and help to turn it int place that will decently house man beings.
ANNE DEWIT
Madison, Wis

As I conceive it, if towns or lages in the U.S. each adopted town or village of equal size Latin America and, through a tional plan devised by your ma zine, sent to our sister town, or some appointed agency, money buy food, the necessary help co be given quickly.
ANITA H. WILK
Ojai, Calif

As I write the check, I say to self, "I really can't afford this." A the words are utterly meaningl in the face of the bitter truths these people's lives. The fact of matter is that what is done for th with my money is done for me well.
LAUREL S. ROLLIN
New York, N.Y

▶ Because donations of food a clothing for the Da Silvas or o er families in the *favela* would subject to Brazilian duty char which the slum families could pay, no packages should be s until some distribution plan set up. Cash contributions m be sent by check or money or to The Flavio Fund, care of L Magazine, TIME and LIFE Bu ing, New York 20, N.Y. Th will be used to move the Da vas into modest quarters, set Flavio's father in a regular and bring Flavio himself t hospital for treatment.—ED.

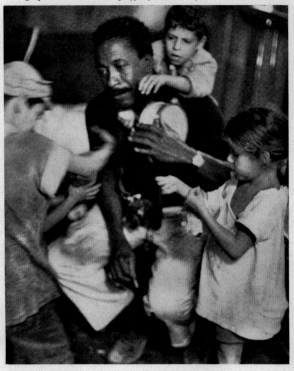

Photographer Gordon Parks is playfully assaulted by three Da Silva children

16

242

What this country needs is a good 25¢ Martini!

It's here!

oy Heublein Cocktails at home. They cost less than plain liquor. *(Taste better, too!)*

ouldn't spare a quarter for a perfect Dry Martini, mixed with choice liquors pertly proportioned? What eye won't twinkle at a Whiskey Sour or Manthat's as easy to pour as plain whiskey—yet tastes much more delicious, sts *less?* Besides adding to domestic bliss, these Heublein Cocktails are a asset! Keep several different kinds on hand—and offer friends a *choice*

when they drop in! Just pour them on-the-rocks—right from the Heublein bottle. **10 favorite kinds—all full strength.** Extra Dry Martinis, 67.5 proof. Manhattans, 55 proof. Vodka Martinis, 60 proof. Daiquiris, 52.5 proof. Whiskey Sours, Gin Sours, Vodka Sours, 52.5 proof. Old Fashioneds, 62 proof. Side Cars, 52.5 proof. Stingers, 50 proof. Quality products of Heublein Inc., Hartford, Conn.©1961.

Ready-to-serve . . . just pour on-the-rocks

HEUBLEIN COCKTAILS
(pronounced Hugh-Bline)

Also enjoy
Heublein Cordials
20 delicious flavors

LIFE

"THE COMPASSION OF AMERICANS BRINGS A NEW LIFE FOR FLAVIO"

The following pages reproduce the original *Life* follow-up story
as it was published on July 21, 1961.

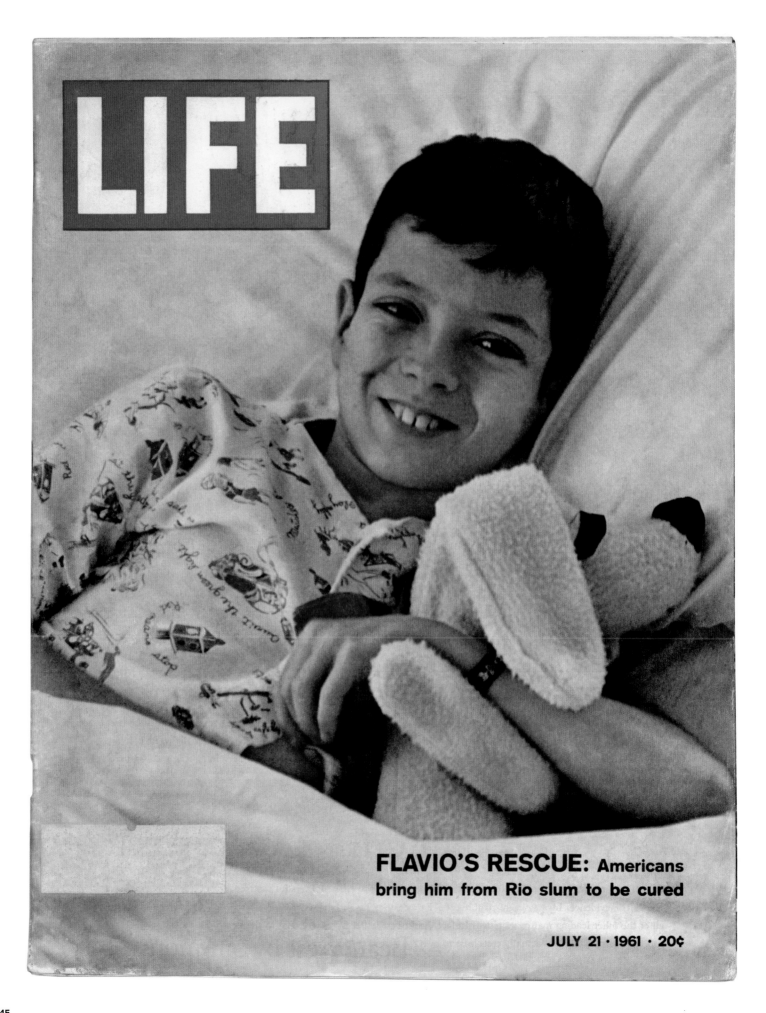

LIFE

FLAVIO'S RESCUE: Americans
bring him from Rio slum to be cured

JULY 21 · 1961 · 20¢

A Brave Boy,
Symbol
of Impoverished
Millions,
Is Rescued
from a Rio Slum

THE COMPASSION OF AMERICAN

It is the same boy—lying then on a slum bed, skin tight on delicate bones, eyes old with anguish; and now, swinging skyward, shouting, "*Está Bom!*" a grin blooming on his face.

Three weeks ago Flavio da Silva, 12, lived in a Rio de Janeiro hovel (*above*), wasted by malnutrition and bronchial asthma, with only a few years to live. Today he is in Colorado, and his smile, his new clothes, his Hopalong

Cassidy watch flopping down his skinny wr and his chance to live—all are the work hundreds of generous, compassionate Am icans. They saw and read of Flavio in LIF photographic essay, "Freedom's Fearful F Poverty" (June 16), where he symbolized enormous problems of Latin America's i poverished millions. Touched by Flavi plight and bravery, Americans took up

24

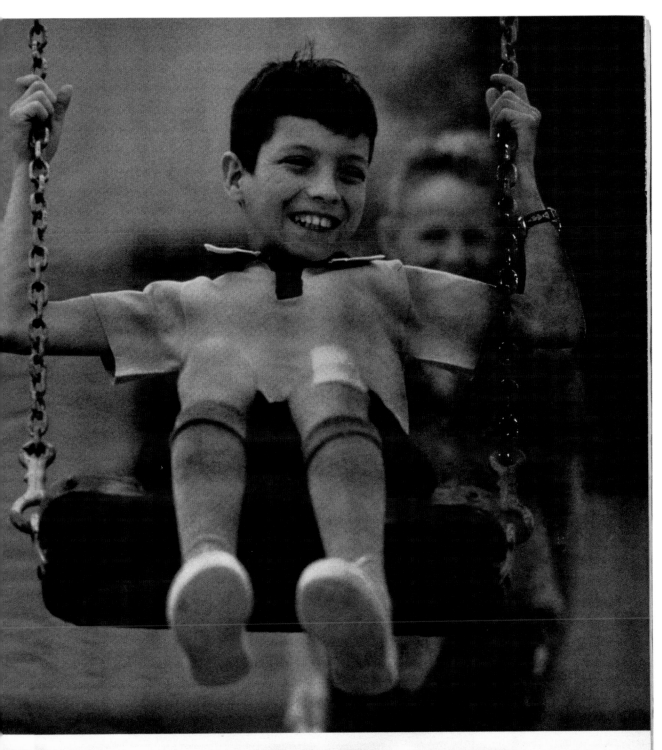

RINGS A NEW LIFE FOR FLAVIO

cause. Letters and money poured in. The Children's Asthma Research Institute and Hospital in Denver offered to take Flavio as a free emergency case and try to cure him. Photographer Gordon Parks, who did the original story, went to Rio to bring Flavio back.

The money has done much for the family who had lived in a shanty-town slum, a *favela*, on $25 a month, sleeping eight to a bed, cooking meager beans and rice over an open fire. Only Flavio sustained them. He cooked, kept house, acted as referee and comforter to his seven brothers and sisters. Now the family has moved and, like Flavio, has a new chance.

But in molding human lives, money cannot finish what it begins. The Da Silvas will have to build on their miracle, not lapse into dependency. And a well, happy Flavio does not solve the problems he dramatizes. LIFE's readers—who insist that they want to send money as long as it is needed—all recognize that Flavio is just one in a numberless multitude. But his story can be a catalyst, can make people understand how desperate the need is—and bring on the massive help and change required to give some measure of well-being and dignity to the many who so desperately need it.

25

247

OUT OF THE SHANTY-TOWN SLUM
TO A PLACE FIT TO LIVE IN

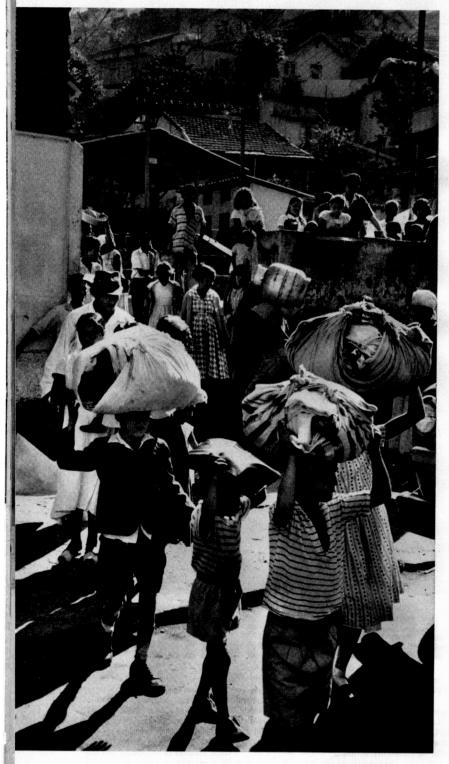

DAZED WITH WONDER. In their modern house
José da Silva and his wife Nair, carrying
Zacarias, 1½, look out at the shady front yard
of the new home. At left is José's sister-in-law,
who will live in backyard cottage and help nurse
Nair when she has her ninth child next month.

LEAVING THE FAVELA. Solemnly the Da Silvas,
led by 8-year-old Mario, with Flavio
third in line, wind their way down from old home.
On their heads the children carry the last
remnants of slum life—old clothing, little more
than rags, which their mother had washed.

WELCOME TO NEW HOME. Their neighb
who generously painted and replastered the ho
greet the Da Silva family. Flavio's mo
who no longer has to work as laun
and to tote water and wood up the hill,
have time and strength to keep house in o

26

CONTI

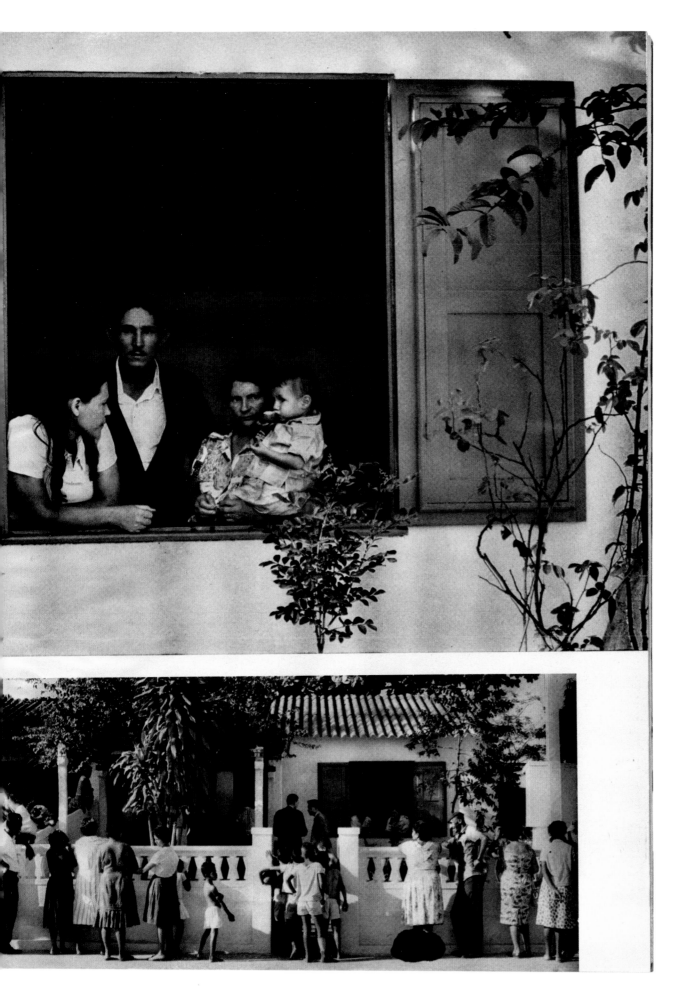

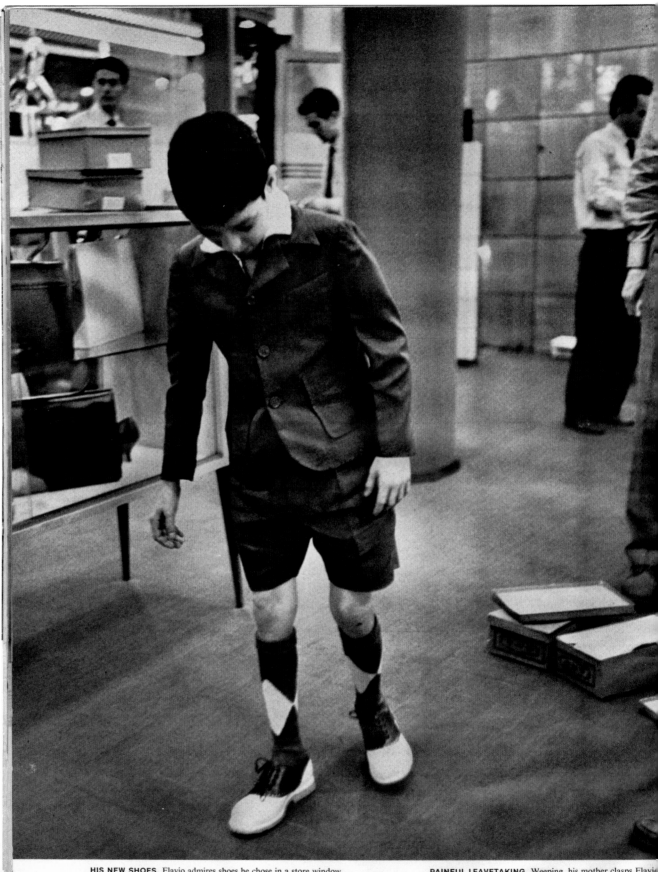

HIS NEW SHOES. Flavio admires shoes he chose in a store window. They were the first new shoes he ever had, and in Denver doctors found angry blisters on his feet. He had uttered no word of complaint.

PAINFUL LEAVETAKING. Weeping, his mother clasps Flavio one strong arm. To console her as they said goodby, he her to take the small amount of money which was given him for h

PARTING—WITH TEARS AND NEW SHOES

...me day," Flavio told Photographer Gordon Parks ...n he was still in the *favela*, "I want to live in a real ...se on a real street with pots and pans and a bed with ...ts." Suddenly it was all at hand for the whole family. ...ir new home (*previous page*) has five rooms, costs ...00 completely furnished. It is part of a worker hous- ...project where most residents come from *favelas*, and ...irector is an old hand at adjustment problems. Behind ...house is a three-room bungalow which Flavio's father ...rented to his brother. By selling their *favela* shacks ...kerosene stall, the two hope to make a down payment ...an old truck and go into the hauling business.

...he Da Silvas, resplendent in new clothes, explored ...ir home. Flavio tried the water taps, gently touched ...plastic flowers in a plastic vase, repeatedly flushed the ...et. Then it was time to go, to fly to Denver. ...lavio came up behind his mother and touched her ...a. "I've come to say goodby, Momma," he said. She ...not move. "I'm going now, Momma, goodby." She ...rled and enclosed him in her arms, sobbing. "Go, go ...son! God protect you." Then Flavio kissed each sleep- ...brother and sister and pulled Parks from the house.

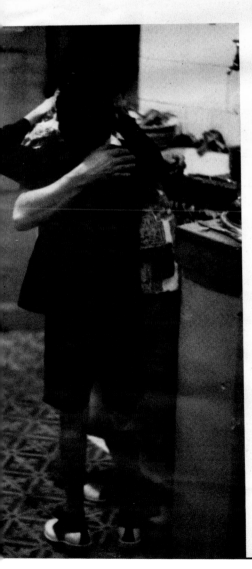

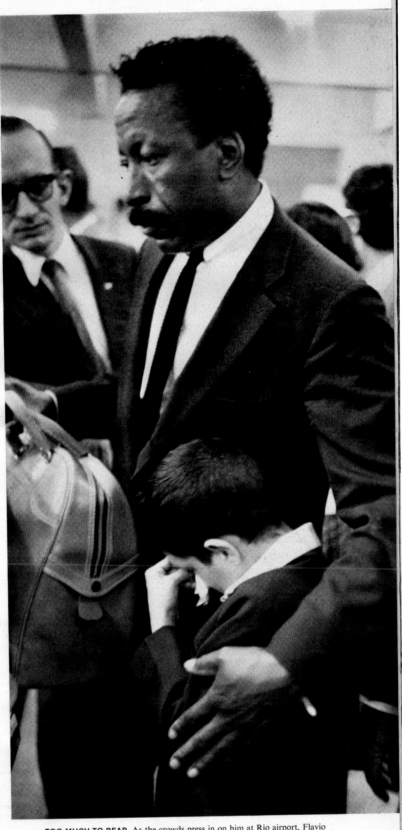

TOO MUCH TO BEAR. As the crowds press in on him at Rio airport, Flavio breaks down, huddles behind the protective arm of Photographer Parks. When the two good friends finally parted later in Denver, Parks wept.

CONTINUED 29

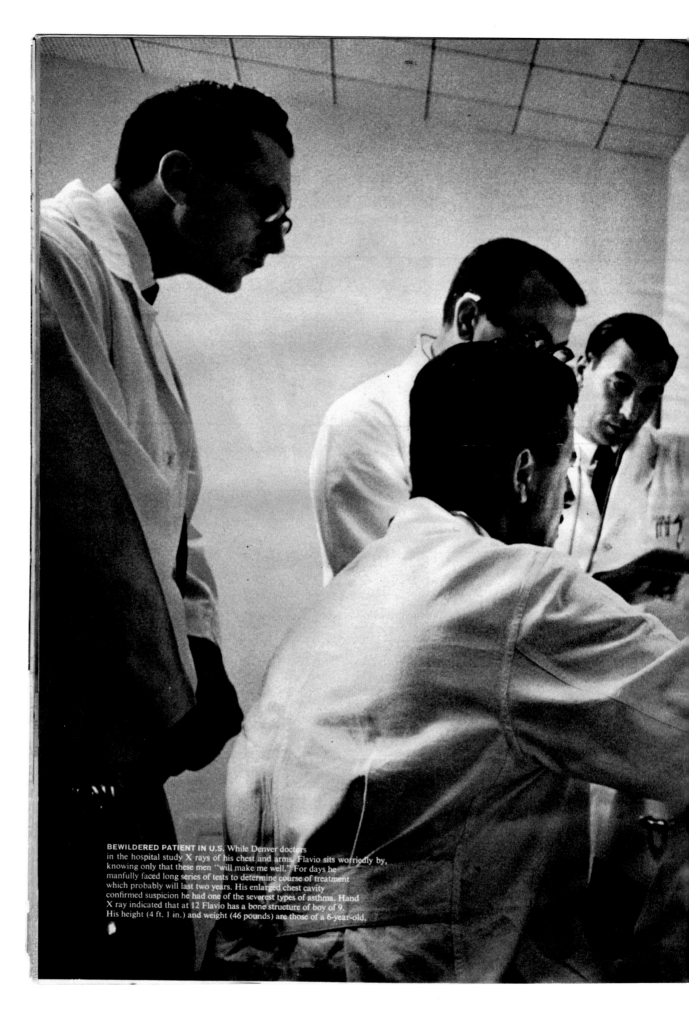

BEWILDERED PATIENT IN U.S. While Denver doctors
in the hospital study X rays of his chest and arms, Flavio sits worriedly by,
knowing only that these men "will make me well." For days he
manfully faced long series of tests to determine course of treatment
which probably will last two years. His enlarged chest cavity
confirmed suspicion he had one of the severest types of asthma. Hand
X ray indicated that at 12 Flavio has a bone structure of boy of 9.
His height (4 ft. 1 in.) and weight (46 pounds) are those of a 6-year-old.

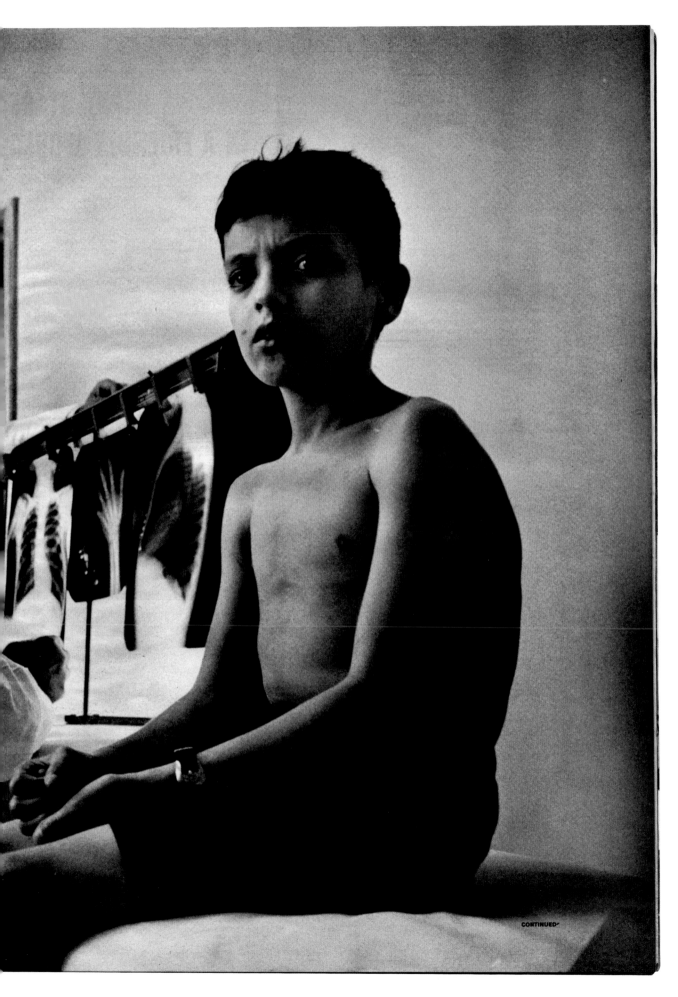

CONTINUED

A HAPPY START
IN A FRIENDLY WORLD

A carefree little boy for the first time, Flavio eagerly joi[ns]
the play at the children's asthma hospital. To help him ma[ke]
the enormous leap into this new life, his friend and int[er-]
preter, Brazilian Reporter José Gallo, would be with h[im]
ten days. He met a local Portuguese-speaking family a[nd]
spent a happy afternoon with them. His doctor is an Arg[en-]
tine whose Spanish Flavio partially understands, think[ing]
it bad Portuguese. To ease the change to American fo[od]
("People eat too much here—three times a day"), he w[as]
allowed to cook himself some beans and rice.

There have also been the frequent medical tests, som[e-]
times painful or offensive to Flavio's innate modesty. A[nd]
once the rain poured down as in Brazil, and he sat by a w[in-]
dow weeping. The doctors are concerned about him b[ut,]
free of attacks so far, he is dreaming ahead. When he gr[ows]
up he wants to be an aviator and "fly free like a balloo[n."]

LEARNING A NEW LANGUAGE. Flavio's tutor, Virginia Hansen, teaches him English by showing objects he knows—here an onion. He found it amusing but soon wearied and was eager to join playmates.

ING A GAME. Flavio and hospital boys play "keep away" under eye
~~ed~~ Cross volunteer. He also played marbles. "Boy, can he shoot,"
~~a~~ patient as Flavio accurately knocked marbles from circle.

REFUSING A BAT. Suspicious, Flavio shrinks from baseball bat offered
him by roommate James Gaddy, 14, and refuses to play. Gaddy was so eager
to help Flavio he bought a phrase book hoping he could talk with him.

CONTINUED 33

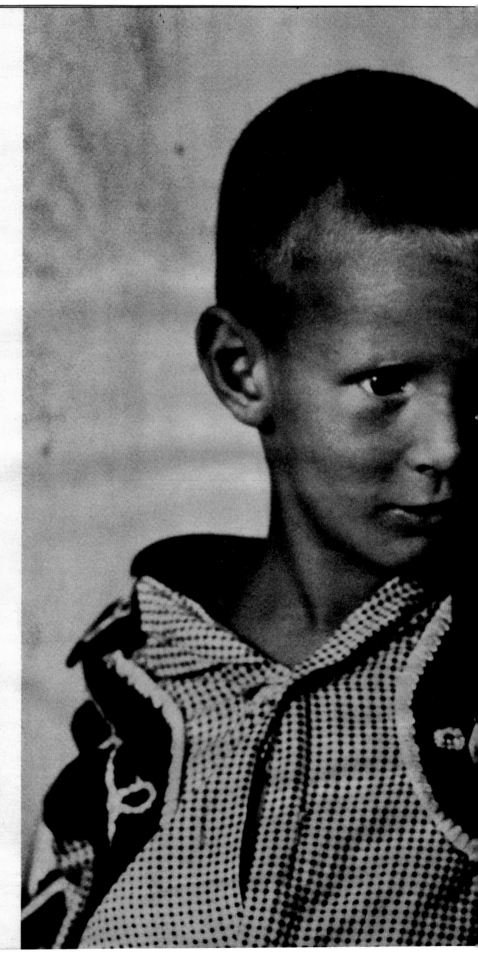

A GENTLE MOMENT.
Unable to break the language
barrier, Tommy Ebbe, 7,
pleads: "Will you be my friend?
Say yes!" Though the words
meant nothing, Flavio
could understand the hand
on his shoulder. The boys
simply take Flavio by
the arm and lead him through
the day's routine. But
he has now learned
such basic American
words as "baseball,"
"television," "food"—
also "hello" and "friend."

34

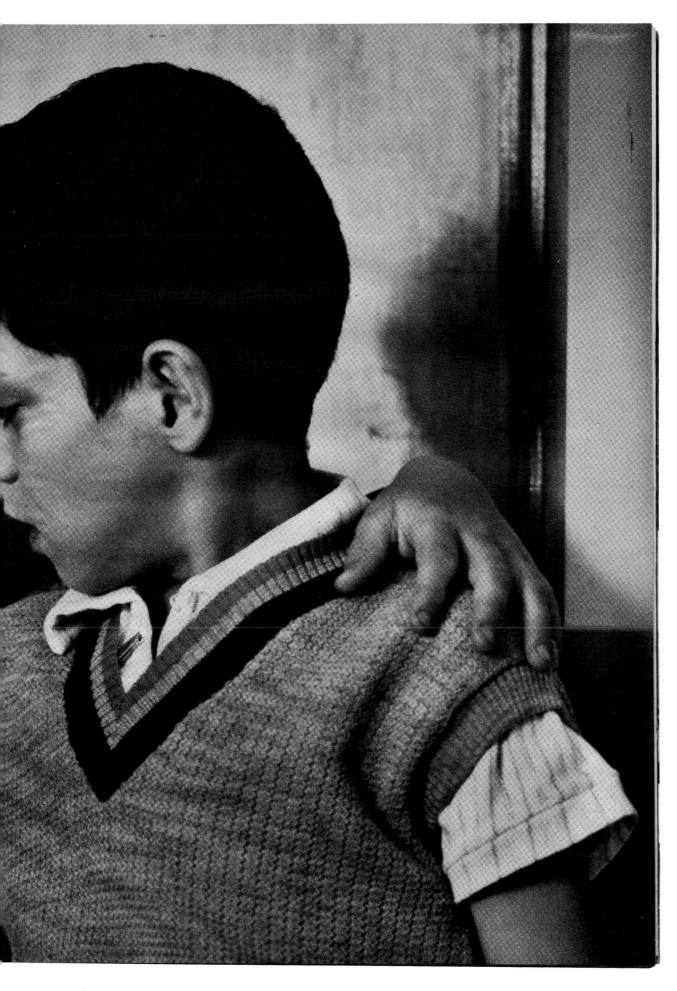

O CRUZEIRO

"NÔVO RECORDE AMERICANO: MISÉRIA"

The following pages reproduce the original *O Cruzeiro* story
as it was published on October 7, 1961.

O CRUZEIRO

CR$ 40,00 — 7 DE OUTUBRO DE 1961

O Repórter Henri Ballot
descobre em N. York um
novo recorde americano:
MISÉRIA

NÔVO RECORDE AMERICANO:

MISÉRIA

A revista "Life", em suas três edições (Doméstica, Internacional e Espanhola), publicou, nos meses de junho e julho, uma reportagem focalizando a miséria na América Latina. Como ambiente, foi escolhida uma favela do Rio de Janeiro e, desta favela, uma família nordestina.

Não podemos negar aqui a existência das favelas cariocas. Conhecemos o seu drama e o seu problema. Mas a miséria não é exclusividade nossa. A revista "O Cruzeiro" enviou o repórter Henri Ballot a Nova York. Como ambiente, êle escolheu um "slum" (favela) de Manhattan e, dêste "slum", uma família pôrto-riquenha.

Para os leitores que não chegaram a ver a reportagem de "Life", queremos esclarecer que seguimos, propositalmente, o mesmo roteiro e a mesma paginação daquela revista. Para melhor compreensão, reproduzimos em "fac-simile", ao lado das várias fotografias de Henri Ballot sôbre os "slums", as páginas daquela publicação americana sôbre as favelas cariocas.

A Direç

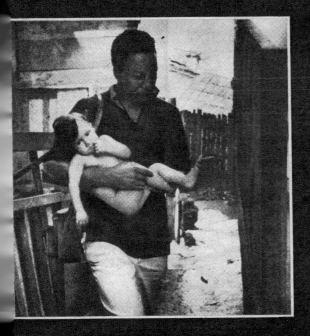

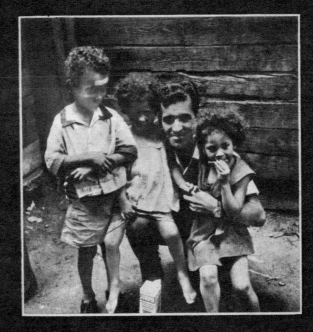

GORDON PARKS
no Rio de Janeiro

HENRI BALLOT
em Nova York

O FOTÓGRAFO norte-americano Gordon Parks passou várias semanas no Rio de Janeiro, onde, a serviço da revista "Life", reuniu elementos e fotografias em tôrno da vida humana em uma favela carioca. A reportagem de Gordon Parks teve grande repercussão, principalmente nos Estados Unidos, onde se manifestou grande escândalo público, acompanhado, muito à moda americana, de uma campanha para arrecadação de fundos para ajudar a família Silva, posta em foco pelo repórter Parks. Em sua reportagem para "Life", Gordon Parks escolheu um dos casos de miséria mais aguda encontrados em nossas favelas: uma família de nordestinos vindos para o Rio, com oito filhos menores, cujo chefe se encontrava em estado de invalidez, em conseqüência de acidente de trabalho. Parks, além de tudo, pegou um dos membros dessa família e levou-o para exibição nos Estados Unidos. Como se a miséria fôsse exclusivamente nossa. Não é. Em Nova York, em Chicago, e em outras cidades dos EE.UU. e de outros países, existem casos iguais — ou piores — do que os relatados por Gordon Parks. Vejam como, na América do Norte, também a miséria bate recordes.

O REPÓRTER Henri Ballot, que, apesar do nome, é brasileiro, do Rio Grande do Sul, foi enviado pelo "O Cruzeiro" aos Estados Unidos, a fim de fotografar e recolher elementos sôbre as favelas ("slums") de lá. Demorando-se um mês e meio em Nova York e passando a maior parte dêsse tempo hospedado em plena área dos "slums" nova-iorquinos, Henri Ballot regressou com um acervo de fatos e fotografias realmente impressionante. Sua vida e sua missão de repórter o têm levado aos pontos mais distantes do Universo. Desde o Pólo Sul ao Oriente Médio, até às selvas do Brasil Central e América do Sul, Ballot e sua câmara têm feito para "O Cruzeiro" coberturas audaciosas, algumas com risco de vida (revolução no Líbano, revolução e terremotos no Chile etc.). Mas, apesar de tôda a sua tarimba profissional, o contato direto com a miséria humana, em seus aspectos mais degradantes, a visão de crianças dormindo com baratas passeando pelo corpo, as noites passadas em claro, porque os percevejos e as pulgas não o deixavam dormir — tudo isso o deixou mais impressionado do que o silvar das balas no Líbano, do que o perigo das selvas brasileiras, e mesmo do que o próprio aspecto da terra se abrindo em crateras no Chile.

CONTINUA

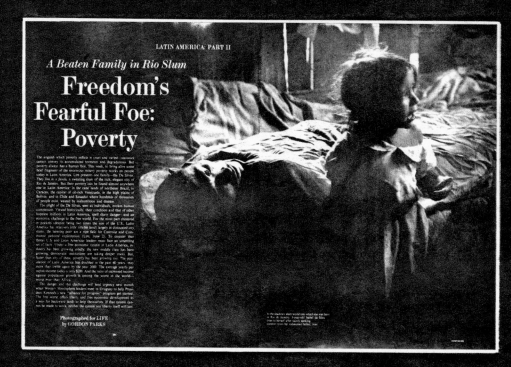

ESTA é a página
de abertura da reportagem
publicada no número de
16 de junho dêste ano da
revista "Life". Ao lado da
foto que mostra a vida num
barraco, está o
título: "Terrível
Inimigo da Liberdade:
a Pobreza".

História da miséria
nas favelas
de Nova York

A ANGÚSTIA da fome e do desamparo é universal. Ela se torna mais dramática e incompreensível q
se encontra a dois passos de Wall Street — eixo econômico do Mundo —, em Manhattan, coração de
York. À sombra do Chase Manhattan e do First National City Bank, se estendem ruas e mais ruas
e escuras, onde vegeta uma população de milhares de sêres nas piores condições de habitação e higiene. Esta
mação não é exagêro nosso, mas uma declaração de Charles Abrams, chefe da Comissão Anti-Racista do
de Nova York:

"— Nos últimos doze meses eu viajei 75 000 milhas em missão da ONU, para estudar as condições da h
ção humana. Com alguma vergonha, sou obrigado a concluir que os "slums" do Harlem, onde a maioria dos
to-riquenhos procura abrigo, estão entre os piores do mundo".

Em Nova York não há favelas como nós as conhecemos no Rio. O clima, muito rigoroso no inverno, não
mite viver em barracos improvisados. Os "slums", ou favelas americanas, são quarteirões de velhos prédi
palhados em tóda a cidade, mais agrupados no leste do Harlem e em tôrno da Rua Bowery. As construçõ
tam, geralmente, do fim do século passado. Há muitos anos não são reformados. As janelas de vidros q
dos hoje são fechadas com tábuas. O rebôco das paredes e dos tetos cai aos pedaços. O chão é esburacad
escadas, inclinadas e quase a cair. As instalações sanitárias e as canalizações de água vazam. O lixo e a s
cobrem o chão dos quintais, gerando uma infinidade de ratos, baratas e percevejos.

Para explorar maior número de inquilinos, os proprietários subdividiram os apartamentos. O bloco escu
Rua 100, entre a Primeira e a Segunda avenidas, hospeda 4 000 habitantes. Cada "apartamento", em geral
sala e uma cozinha, alguns sem nenhuma janela — os centrais —, abriga entre 10 e 15 pessoas. Naturalm
as leis sanitárias da cidade impedem uma tal promiscuidade — o máximo permitido são três moradores por
to —, porém o proprietário, ao fechar os olhos para tal irregularidade, cobra aluguéis caros, de 50 a 100 d
mensais, que os inquilinos pagam para não serem despejados.

Não há dúvida de que a administração da cidade de N. Y., preocupada com êste problema, está derru
alguns velhos prédios para edificar novos conjuntos residenciais populares. Infelizmente poucas famílias p
podem gozar deste privilégio. Para acomodar, nos têrmos da lei, os seus numerosos filhos, precisariam de ap
mentos de 5 a 6 quartos, o que não só não existe como ultrapassaria o seu orçamento.

Mas imaginemos que conseguissem um lugar. O acesso a um "project" é regulamentado pela renda a
mínima, aumentando em função do número de pessoas. No caso de um aumento de salário, êles serão aut
ticamente despejados, uma vez que a renda anual mínima será ultrapassada. Onde irão morar? A fero
criminação racial existente os impedirá de alugar um apartamento melhor, num bairro melhor. Como so
única, resta a volta ao "slum".

Para não ser injusto é bom reconhecer que a cidade ajuda os desempregados, mas podemos citar a dec
ção do "State Interdepartment Comitee of Low Incomes": "Para uma pessoa recebendo assistência da cidad
Nova York, há pelo menos três que não recebem nada".

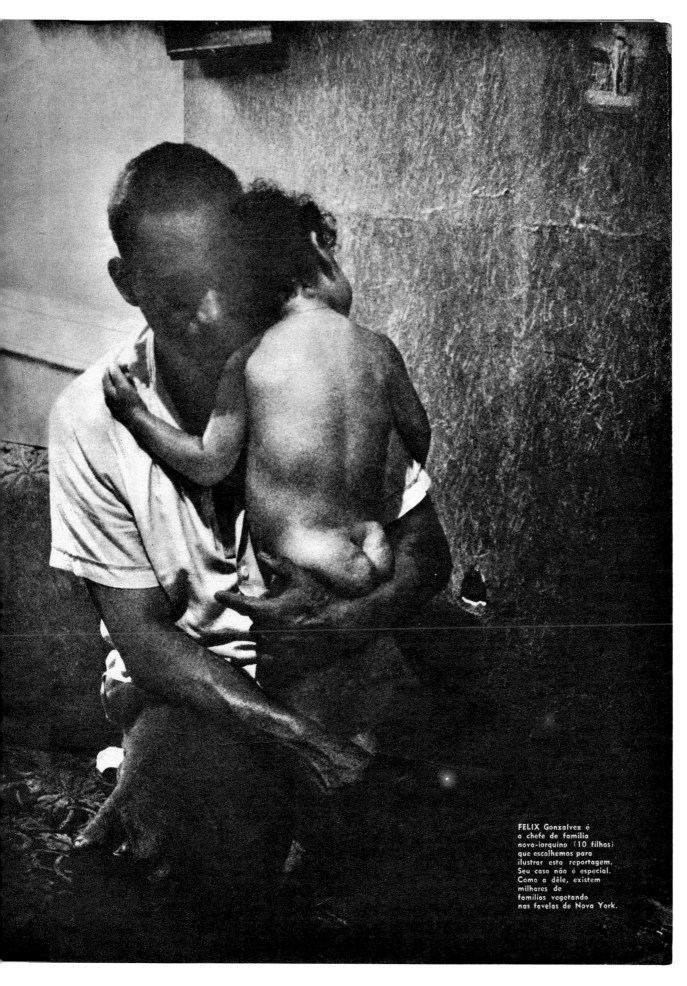

FELIX Gonzalvez é
o chefe de família
nova-iorquino (10 filhos)
que escolhemos para
ilustrar esta reportagem.
Seu caso não é especial.
Como a dêle, existem
milhares de
famílias vegetando
nas favelas de Nova York.

PÁGINA DE "LIFE": O CRISTO ABENÇOA AS FAVELAS.

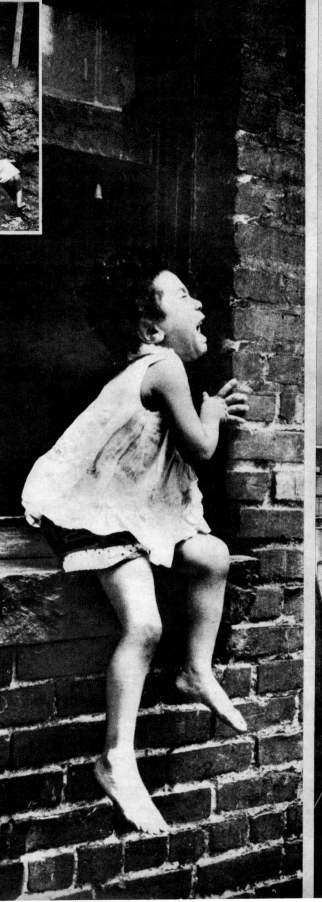

Favela
sem samba
e sem sol

A CINCO minutos de automóvel de Wall Street, a poucos passos da Broadway, no n.º 40 da Rua Revington, mora o casal Felix e Esther Gonzalvez, com os seus dez filhos. Como muitos pôrto-riquenhos, Felix fugiu, anos atrás, das plantações de cana, onde vivia apenas com o salário de quatro meses por ano: "Era morrer de fome, meu senhor".

Êle já tem 53 anos, é considerado velho, e, num país onde existem atualmente 10 milhões de desempregados, não acha trabalho fixo. Quando não chove, vai lavar carros, no bairro distante de Long Island, a hora e meia de trem, ganhando 1 dólar por hora de serviço. Quem sustenta a família é a filha mais velha, Ana Cecilia, de 19 anos. Ela trabalha numa oficina de costura e recebe 30 dólares por semana.

Pagam 75 dólares mensais para viver amontoados numa sala-cozinha de um prédio velho da Rua Rivington. Tudo que êles têm, até a humilde mobília, é donativo dos "Catholic Workers". Os filhos, para brincar, só têm o corredor escuro e o pequeno pátio interno onde se acumula o lixo de todos os vizinhos. O pai não os deixa mais ir à rua: "A rua é terrível, já basta ter perdido Maria Esther. Não se pode deixar uma criança sair sòzinha em N. Y., porque ela corre o risco de ser abordada por um estranho, que lhe propõe uma "sensação fantástica" por um preço mínimo: é uma dose de heroína. Este estranho voltará regularmente até certificar-se de que a criança já está viciada. A partir de então o preço da droga sobe de tal forma que sòmente no roubo e até no crime a vítima encontrará o meio de saciar-se". Assim aconteceu com Maria Esther que, tendo feito parte da "gang" dos Dragões, acha-se, atualmente, num reformatório, a pedido do seu pai.

EM NOVA York, o pano de fundo de uma das favelas são os edifícios de Wall Street, para onde converge, pràticamente, todo o dinheiro do Mundo.

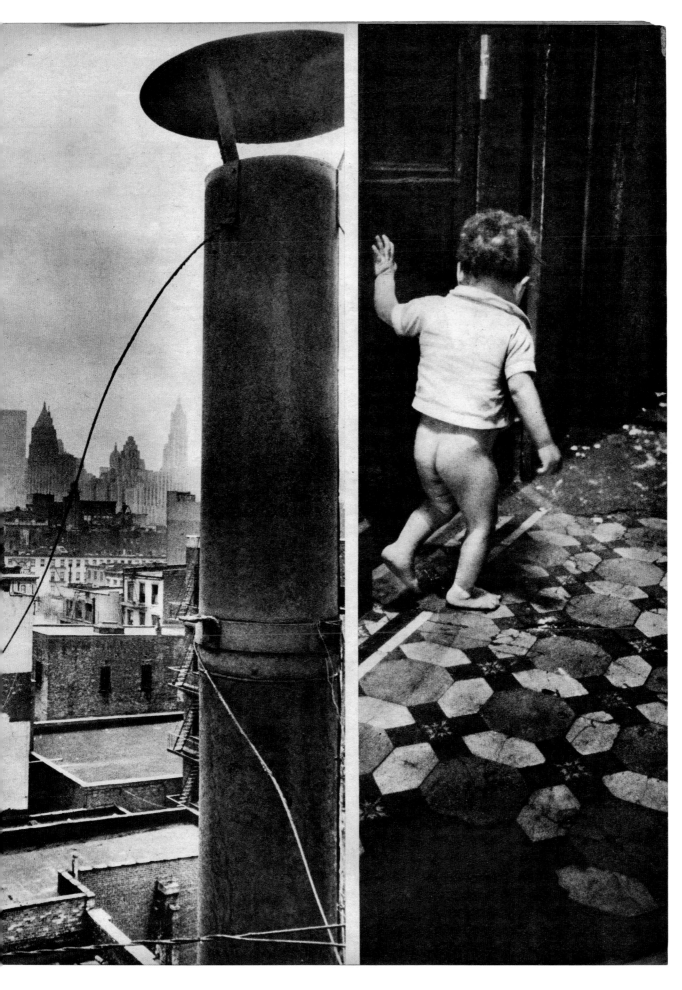

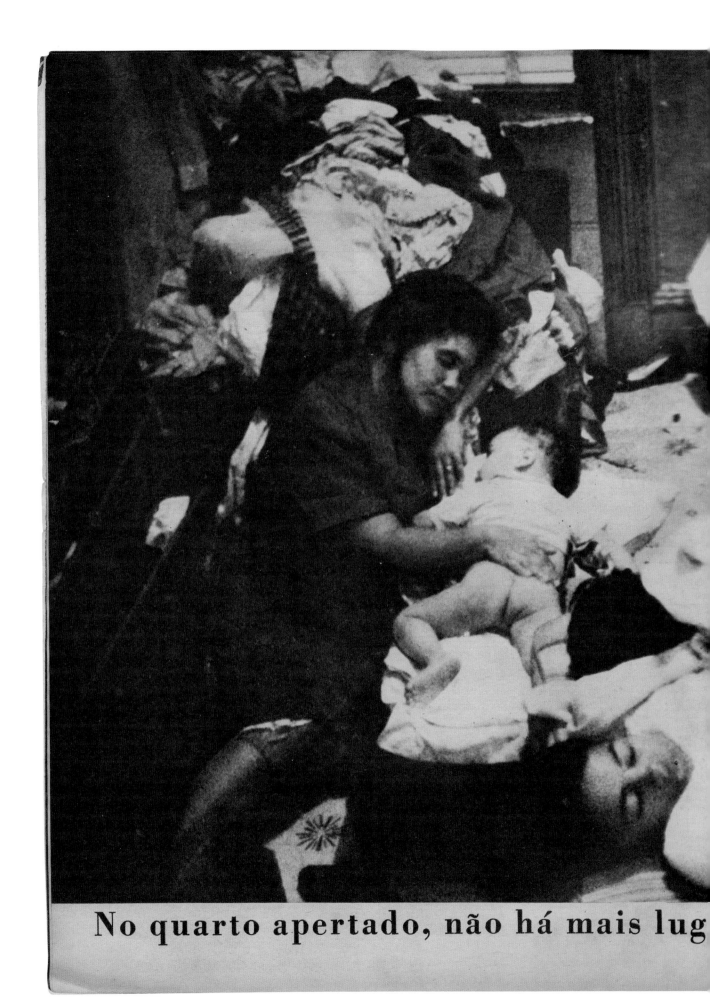

No quarto apertado, não há mais lug

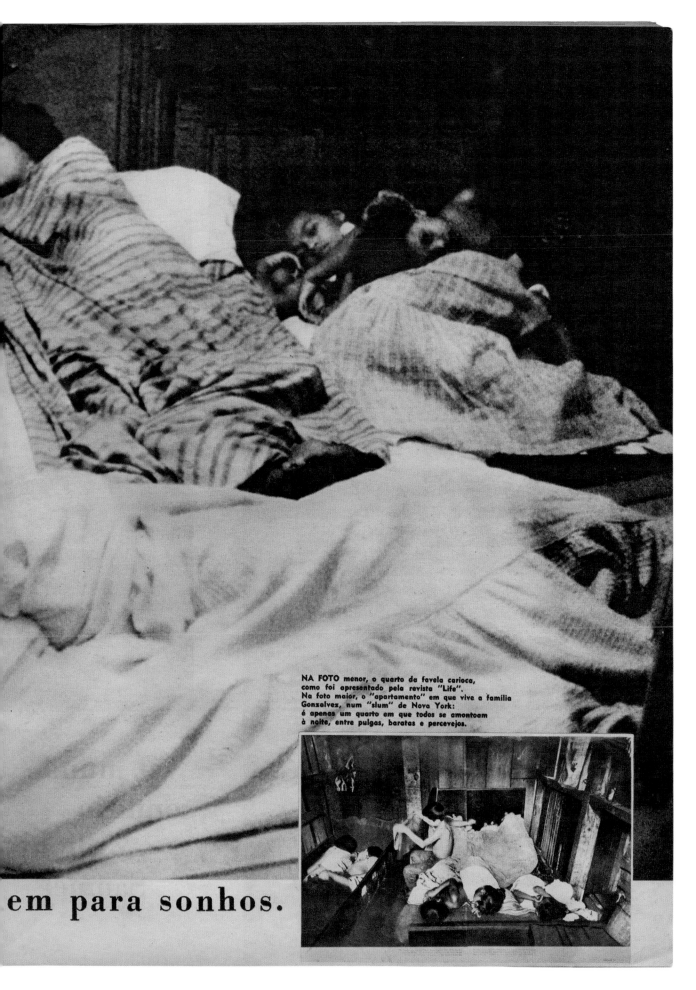

NA FOTO menor, o quarto da favela carioca,
como foi apresentado pela revista "Life".
Na foto maior, o "apartamento" em que vive a família
Gonzalvex, num "slum" de Nova York:
é apenas um quarto em que todos se amontoam
à noite, entre pulgas, baratas e percevejos.

em para sonhos.

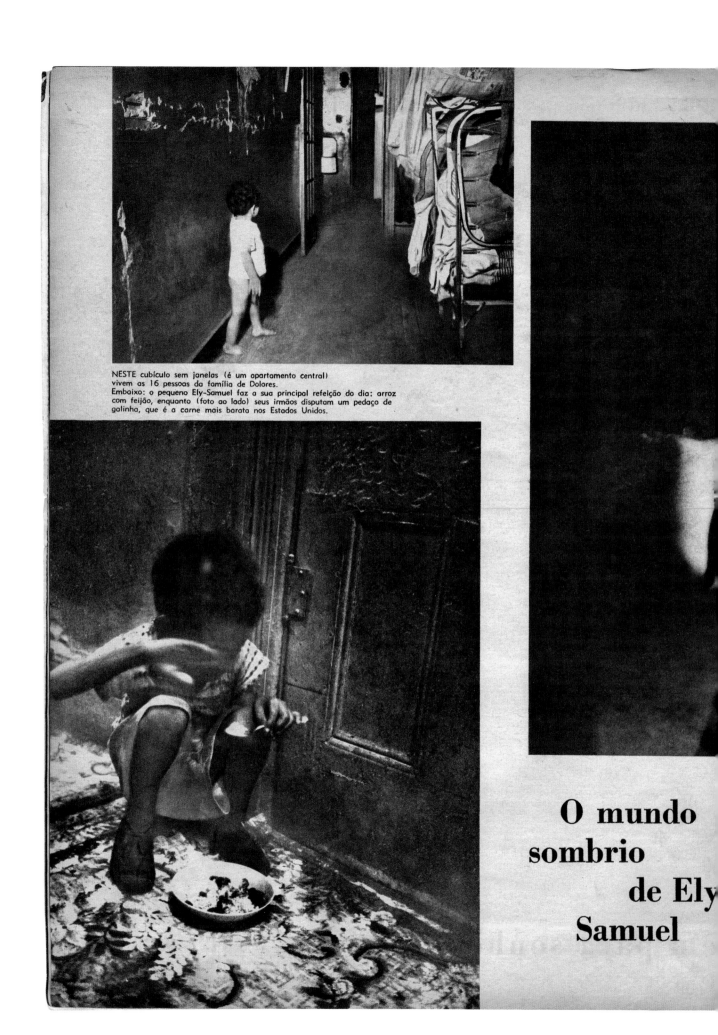

NESTE cubículo sem janelas (é um apartamento central)
vivem as 16 pessoas da família de Dolores.
Embaixo: o pequeno Ely-Samuel faz a sua principal refeição do dia: arroz
com feijão, enquanto (foto ao lado) seus irmãos disputam um pedaço de
galinha, que é a carne mais barata nos Estados Unidos.

O mundo
sombrio
de Ely
Samuel

MÃE, cansada da luta diária contra a miséria, a invasão de ratos e insetos, a queixa contínua dos filhos com fome, já foi vencida o desespêro. O pai, esmagado por uma civilização impiedosa, só tem última esperança de receber um dia a ajuda que a cidade dá aos cessitados. Para êstes dois sêres vencidos, os filhos seriam uma ão de viver. A Providência até hoje parece abandoná-los neste imo sonho. Maria Esther está internada na "Wassic State School". a Cecília já se acha prêsa pela mesma engrenagem que abateu o pai, e ganha um salário irrisório. Restam os menores.

Ely-Samuel tem nove anos mas a aparência de quatro. O seu po magro de subnutrido é recoberto de feridas, roído das baratas e invadem a sua cama cada noite. Na sua testa, um esparadrapo conde uma mordida de rato. Quase não sabe sorrir. Quando se diver-é jogando bola ao lado das latas de lixo, num pequeno quintal sem . Sua magreza e sua apatia deixam crer que êle sofre de uma pro-nda anemia. O "handicap" de ser pôrto-riquenho já pesa bastante s seus ombros fracos. Se, porventura, êle conseguir vencer a doen-não vencerá a sociedade. Sua triste condição de "lousy puerto-an" (pôrto-riquenho piolhento) o relegará a um plano secundário.

FOI ASSIM QUE A REVISTA "LIFE" APRESENTOU O PEQUENO FLÁVIO.

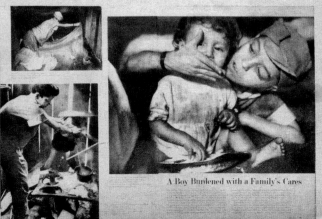

A Boy Burdened with a Family's Cares

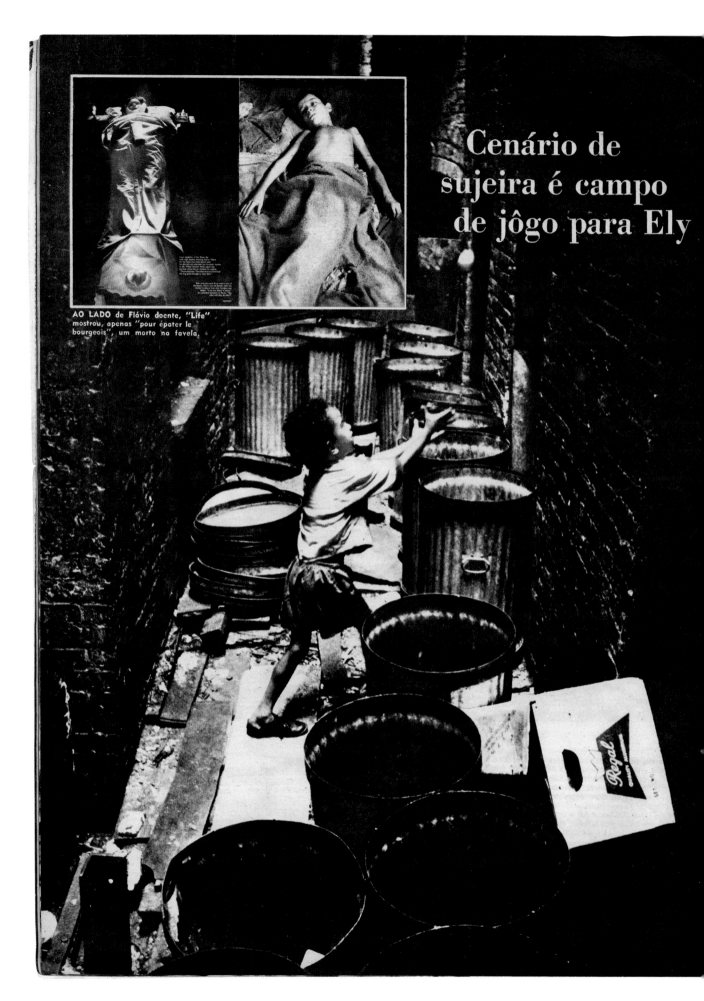

Cenário de sujeira é campo de jôgo para Ely

AO LADO de Flávio doente, "Life" mostrou, apenas "pour épater le bourgeois", um morto na favela.

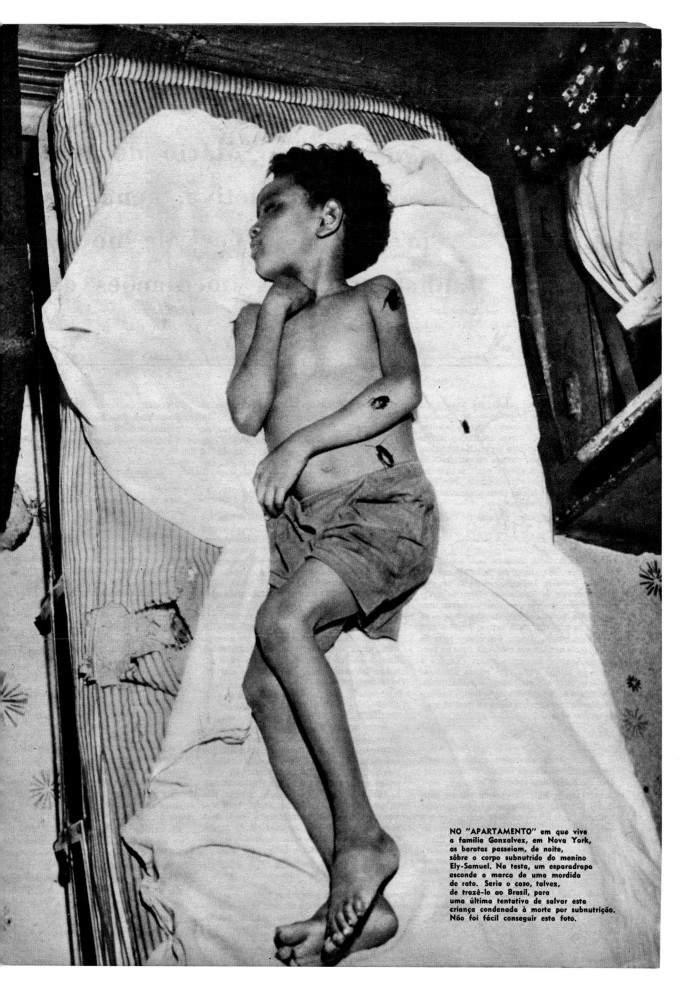

NO "APARTAMENTO" em que vive
a família Gonzalvez, em Nova York,
as baratas passeiam, de noite,
sôbre o corpo subnutrido do menino
Ely-Samuel. Na testa, um esparadrapo
esconde a marca de uma mordida
de rato. Seria o caso, talvez,
de trazê-lo ao Brasil, para
uma última tentativa de salvar esta
criança condenada à morte por subnutrição.
Não foi fácil conseguir esta foto.

Fragmentos do diário do Repórte

relatando, de maneira objetiva, cenas e fat

presenciados por êle no Harle

de Manhattan e nas imediações da Ru

URANTE a sua estada em Nova York, Henri Ballot hospedou-se no Spanish-Harlem. Êle conheceu diversas famílias.

Os Gonzalvez foram escolhidos porque não representam um caso especial, apenas um casal com dez filhos, vivendo na miséria mais profunda. Nenhuma doença, nenhum vício dos pais poderia desculpar o seu estado. Pelo contrário, Felix Gonzalvez, profundamente religioso, não fuma e não bebe.

Aqui estão algumas páginas do diário de nosso repórter:

Agôsto 3.

Na altura das Ruas 110 até 100, entre a Avenida Lexington e Park, um dos piores lugares de Manhattan. Diversos quarteirões demolidos para construções novas, usados agora como depósito de lixo. Entro no n.º 120 da Rua 106. Casa antiga, corredor com placas de rebôco caindo. Um cheiro forte de amoníaco e de cachorro molhado. Bato na porta 10. Aparece um môço magro. Explico a razão da minha visita. Êle recusa absolutamente e bate a porta. Mêdo e desconfiança. No mesmo edifício, o zelador pretende não conhecer um inquilino que mora no local há mais de quinze anos.

Agôsto 4.

O meu nôvo amigo Armando Beniamino, corretor de imóveis e pôrto-riquenho, me indica dois endereços.

N.º 165 da Rua 107: prédio velho e sujo, cheiro habitual. Apartamento 5, um corredor comprido com uma sala de 2 metros por 3 a cada extremidade. Aqui vivem 12 pessoas: Gaspar, doente, a mulher grávida, e 10 filhos, o último, num berço e com a "doença azul". Os serviços médicos da cidade até agora se negaram a visitar o doente. Os cinco mais jovens não têm roupa e não podem sair à rua nem ir à escola. O aluguel é de 110 dólares mensais. Nêle vai quase todo o auxílio da Prefeitura. "Es vivir muriendo" — me diz Gaspar.

Vi preparar o almôço — uns pedacinhos de toucinho fritos e feijão.

Dali vou até o n.º 175 da mesma rua, no ap. 7. Lá, vive uma mulher envelhecida, com oito filhos. A sala é escura e poeirenta. A mulher me olha com mêdo e, a tôdas as minhas perguntas, responde: "Yes, yes, yes".

Agôsto 5.

Nas Ruas 100 a 101. A Rua 100 é famosa por ser o lugar onde cresceu Lucky Luciano, o famoso "gangster". Nela também, dizem, nasceu Burt Lancaster. Umas crianças brincam na calçada. Homens nas escadarias jogam cartas. Eu sou olhado da cabeça aos pés, com desconfiança. Começo a fotografar e imediatamente a rua se esvazia. Uma garrafa de cerveja cai aos meus pés, lançada de um telhado; em seguida, um tijolo e uma lata de água. Vou para a direita e me escondo num terreno baldio, entre dois prédios. No meio do lixo, umas crianças brincam de beisebol. Quando elas me vêem, param e vêm pedir esmola. Um grito sai de uma janela e a criançada foge correndo.

Agôsto 6.

Vou até o "El Diario de Nueva York", editado em espanhol para quase um milhão de pôrto-riquenhos que moram ali. Sou apresentado ao Sr. Stanley Ross, secretário-gerente. Êle já conhece "O Cruzeiro", e foi amigo, anos atrás, do Dr. Assis Chateaubriand, no Uruguai. Recebe-me dizendo: "Então, veio buscar um "Flávio" em Nova York? Você teve uma boa idéia. Aqui encontrará coisas bem piores do que no Rio, em matéria de favela. É bom que êstes fatos sejam conhecidos. Talvez ajude a resolvê-los".

Agôsto 7.

Estou na Park Avenue, na altura da Rua 105. Já fui abordado umas seis vêzes por gente môça e velha pedindo esmola.

Ubiratan de Lemos, em sua passagem Nova York, me dizia que sempre dava níqueis com a satisfação de um bras a ajudar um amigo subdesenvolvido do N

Agôsto 8.

Eileen Fantino Díaz, filh uma família da classe média, junto com amigas Mary Ann McCoy e Helen Ru sendo membros dos "Catholic Workers", atrás mudaram-se, voluntàriamente, pa n.º 321 da Rua 100, no Harlem espanhol. elas cozinhavam para as famílias pobr distribuíam brinquedos para as crianças. suma, com o seu próprio dinheiro e o da organização, ajudavam o mais possível os vizinhos de miséria. Hoje, eu visitei E Díaz. Casou-se com um rapaz pôrto-riqu e já tem dois filhos. Mora num apartam nôvo, de um projeto popular. Ela conf e repete o que os meus olhos já viram, a tuando que, no Brooklyn, recentemente, criança morreu, roída pelos ratos, no berço, durante a noite.

Agôsto 9.

Ainda na Park Avenue, num lho prédio que estremece cada vez que o t elevado passa. Apartamento 6: uma sal 4 metros por 3, um colchão num canto. mulher magra com uma criança no colo. volta dela, mais três. Um homem segu porta meio aberta e me pergunta o qu quero. Novamente faço uso da minha f chave, dizendo que eu sou latino como êl eu queria conversar e tirar algumas foto sua família e da sua casa. Porém, com misto de orgulho e de dignidade, me asse que vive muito bem e não precisa de r Eileen Díaz me dissera que êste, porém tava à beira do suicídio pela precariedad sua situação financeira.

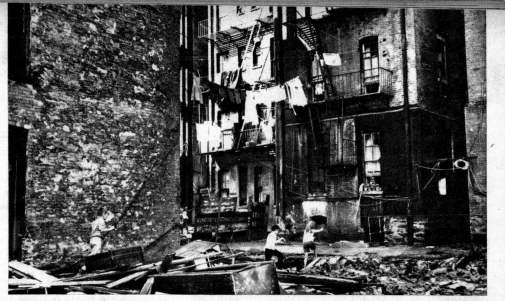

"PLAYGROUND" DE CRIANÇA FAVELADA DE NOVA YORK É TERRENO BALDIO, ONDE SE USA DEPOSITAR LIXO.

Agôsto 10.

Vou pesquisar o Bowery. Da ...nal Street, atravesso o pitoresco Bairro Chi-...s. Desço a Bowery; ao longo da calçada, ...zenas de bêbedos estão dormindo. Isto deve ...r tão comum que os transeuntes seguem os ...us caminhos sem olhar.

Agôsto 15.

Vou ver Pedro Canino, o lí-...r dos pôrto-riquenhos em NY, que é co-...ecido como sendo o segundo prefeito. Êle ...e recebe, com desconfiança. Surpreendo-o ...rrendo o seu escritório. Fala muito do seu ...vo, do seu sofrimento. Parece ser um misto ... samaritano e de demagogo. Fala muito da ...lores. Vou lá imediatamente. N.º 159 da ...ua 109. Uma mulher de uns quarenta anos ...e recebe. Na entrada, uma cozinha com um ...ão a gás quebrado, uma pia suja vazando, ...chão feito de pedaços de linóleo, onde pas-...iam mil baratas. Depois, um corredor sem ...nela. Contra a parede, já meio na escuridão, ...m beliche duplo, onde dorme uma criança ...ua. Outra meia parede e, já na escuridão ...mpleta, uma cama. Uma filha casada de ...lores está deitada, com febre. No canto, ...m altar com imagens de santos e uma vela ...esa. Na última parte do corredor, fechada ...r uma parede de tábuas, uma sala de 3 me-...os por 4, onde vive Dolores com 8 filhos. ... todo, 16 pessoas moram ali. O marido, ...vangelista, trabalhava numa fábrica. Ficou ...berculoso e voltou para Pôrto Rico, no ano ...assado. Quem sustenta a família é o filho ...illiams. Ganha 49 dólares por semana, o alu-...el é de 71 por mês. As duas filhas maiores ...abalhavam no hospital "Mount Sinai", mas, ...mo participaram de uma greve, foram des-...edidas. Por causa disso, não acham mais tra-...alho. Desde então êles tentam voltar para ...ôrto Rico. O dinheiro que Williams traz para ...asa mal dá para comer. Dolores se queixa ...s ratos "do tamanho de um gato" que, à ...oite, invadem o apartamento.

Agôsto 17.

No Bowery, na Rua Christie, um parque abandonado, as calçadas recobertas de lixo. Um homem branco, jovem ainda, mexe num montão de lixo. Acha um pedaço de pão, que cheira e, em seguida, come.

Agôsto 20.

Ainda na Rua Christie, no restaurante popular dos "Catholic Workers". Stewart, universitário, cozinha para os necessitados, por idealismo. Êle está picando cebolas para fazer os "hamburgers" do jantar. Sua freguesia são os bêbedos de Bowery e também algumas crianças do "slum" vizinho. Na hora do jantar, êles vêm chegando, um por um, sentam nos bancos de madeira e comem em silêncio. Stewart me fala da família de Felix Gonzalvez, que mora na Rua Rivington.

Agôsto 21.

Chego cedo a casa dos Gonzalvez. O pai está em Long Island, trabalhando. Encontro a mãe chorando. Ontem à noite a polícia veio buscar a filha Maria Esther, para a internar. Hoje de madrugada, um emissário da "gang" dos Dragões, de que Maria Esther fazia parte, ameaçou a família de represálias. A minha chegada é vista com muita desconfiança. Até provar que eu não sou membro da "gang".

Agôsto 22.

Receberam hoje uma carta do "Waissic State School", para onde foi Maria Esther. Pedindo dinheiro para os pequenos gastos e roupa. "Êles não sabem que a única roupa que ela possui é aquela que tem no corpo."

De noite, chegou Felix. Cansado de um dia inteiro de trabalho. O seu almôço consiste de um sanduíche, que êle come com a mão esquerda, enquanto continua trabalhando.

"Estamos na época das chuvas. Quando o dia amanhece bom, é preciso aproveitar. A semana passada eu só consegui trabalhar dois dias."

Agôsto 23.

Reparei que as crianças não tinham nenhum brinquedo. Nem uma boneca de pano. Hoje, feito Papai Noel, cheguei com um presente para cada uma. Fiquei comovido. As meninas abraçavam as suas novas bonecas, chorando. Os meninos davam pulos. Num canto, Ely-Samuel abraça o carrinho de matéria plástica, sem uma palavra, alheio à alegria dos seus irmãos. Como se, prematuramente maduro, êle não se deixasse enganar por um prazer tão breve.

Agôsto 24.

Grande agitação no apartamento. Hoje cedo, enquanto a menina Maria estava tomando um banho de bacia, um rato escorregou de uma prateleira e caiu dentro da água. Um corre-corre épico seguiu-se até encurralar o animal.

Agôsto 25.

Encontro Esther chorando, o cobrador veio ameaçar de cortar a luz e o gás, caso não sejam pagos ainda hoje. Em nome de "O Cruzeiro" eu resolvo êste pequeno problema.

Ao ir-me embora, já bem tarde, o pequeno Ely-Samuel me acompanha até o fim do corredor:

"— Eu gostaria tanto de morar lá em cima!"

E como eu não entendesse bem, êle continuou:

"— Me disseram que lá em cima, na casa dos anjos, tudo é bonito e a gente pode beber leite à vontade..."

273

O CRUZEIRO

"HENRI BALLOT DESMASCARA REPORTAGEM AMERICANA"

The following pages reproduce the original *O Cruzeiro* follow-up story
as it was published on November 18, 1961.

O CRUZEIRO

18 DE NOVEMBRO DE 1961

JOÃO AGRIPINO
REPLICA
CLEMENTE MARIANI

PEDROSO HORTA
RESPONDE 26 PERGUNTAS
DE CARLOS CASTELLO BRANCO
SÔBRE A RENÚNCIA DE JÂNIO

David Nasser
COMO EVITAR A REVOLUÇÃO

Henri Ballot
DESMASCARA
REPORTAGEM AMERICANA
SÔBRE FAVELA CARIOCA

HENRI BALLOT
DESMASCARA

JOSÉ e o armário, cujos puxadores das gavetas foram feitos com alças de um caixão.

NESTAS 2 páginas do "Life", de sua reportagem sôbre as favelas cariocas, são apresentados uma mulher morta e o pequeno Flávio, tendo um ataque de asma no barraco dos Da Silva.

PARA nós, de "O Cruzeiro", o tempo corre depressa. A reportagem, quando é publicada, já nos encontra na feitura de outra. Raramente achamos conveniente repisar o assunto. E era isso que eu ia fazer com o meu trabalho sôbre as favelas de New York. Foi publicado, teve grande repercussão, e estaria colocado ponto final no problema, se não viessem me provocar. Como foi o caso da crônica de autoria de um certo Sr. Paul Vanorden Shaw, que saiu no "Brazil Herald". Por pouco êle torna realidade a predição do nosso Stanislaw Ponte Preta e me acusa de haver importado, do Kremlin, as baratas que passeavam no corpo do desnutrido Ely Samuel. Para êle, a mostra da miséria nova-iorquina era lenha para a fogueira comunista. É questão de opinião, e a opinião dêsse tal Shaw, para mim, não tem nenhum valor. Felizmente, existiram outros, que entenderam melhor o meu intento, como foi o caso do "New York Times". Êste famoso diário americano publicou dois editoriais (um dos quais reproduzido na edição de "O Cruzeiro" de 28-10-961), levando, o segundo, o título de "Operação plástica nas favelas". Nêle, o "New York Times" reconhece que será preciso esperar pelo menos por uma geração para que possam ser extinguidos os "slums" de New York. E, acredito, a palavra de tão conceituado órgão, vale muito mais do que a do tal Shaw.

O "Time", da mesma organização jornalística do "Life" (revista que publicou a reportagem sôbre as favelas do Rio), num artigo intitulado "Vingança carioca", depois de felicitar o meu trabalho e concordar inteiramente com tudo o que "O Cruzeiro"

TEOTÔNIO ROSA FEZ O PAPEL DE CADÁVER PARA GO

ORTAGEM AMERICANA

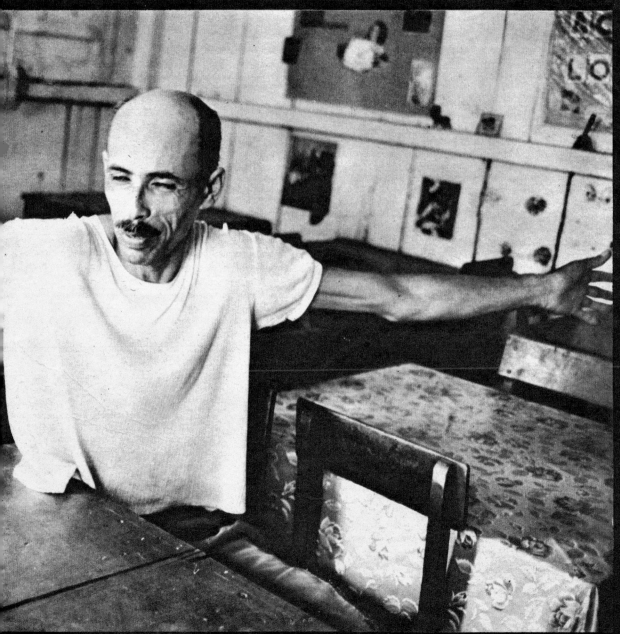

EGUNDO ESTA TESTEMUNHA, A FOTO DE FLÁVIO, AO LADO, FOI FEITA NA "BIROSCA" E O MENINO (EMBORA ASMÁTICO) POSAVA NAQUELA HORA.

CONTINUA

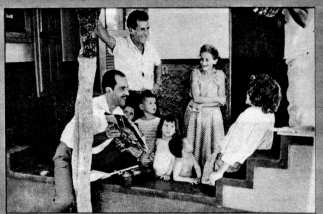

O REPÓRTER Mário de Moraes, na foto, em companhia de Henri Ballot, gravou todos os depoimentos. Na hora do flagrante, êle mostrava à menina Maria da Penha a fotografia de seu irmão chorando, depois de "ser mordido por um cachorro".

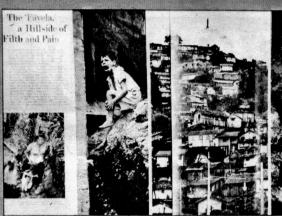

NESTAS duas páginas da revista americana aparece a foto de Mário choro Nos depoimentos da avó do menino e de sua irmã Maria, que assistiram à ce garôto levara uma surra de sua mãe. A criança nunca foi mordida por cach

havia publicado, fêz algumas restrições à minha idoneidade profissional. Dizia êle que as baratas que apareciam no corpo de Ely Samuel, ali haviam sido colocadas por mim. E insistia que tôdas as fotos tinham sido posadas e que os "modelos" haviam sido pagos para serem fotografados. Não tenho necessidade de vir a público defender-me de falta não cometida.

A crítica do "Time", porém, fêz com que eu fôsse olhar mais uma vez a reportagem sôbre a miséria brasileira, tão divulgada pelo "Life". E, para meu espanto de profissional, nela encontrei duas falhas. Uma de ordem técnica; outra de ordem social. Na foto onde aparecem várias crianças dormindo num mesmo quarto, em companhia dos pais, notei os raios de luz que passavam pelas frestas das parêdes. A foto parecia ter sido feita de dia e não à noite, nem de madrugada. A outra, de sentido mais humano, referia-se a certos trechos do "diário" publicado pelo Repórter Gordon Parks. Nêle as crianças da favela, filhos de humildes nordestinos, são apresentadas como autênticos monstros, que sacam armas e agridem os visitantes. Gordon Parks "sofre" tôda sorte de agressão. É atacado a faca, leva agulhadas e mordidas de pequenos satãs moradores da favela. Seria esta realmente a verdade? Era o que me propunha averiguar.

ATRAVÉS DO "LIFE" O REPÓRTER DESCOBRE A MANEIRA MAIS DIFÍCIL DE FAZER UMA REPORTAGEM FÁCIL

E foi com a ida a Deodoro e ao morro da Catacumba, que eu averigüei tôda a verdade. Bem pior do que imaginava.

Com a revista americana debaixo do braço, dirigi-me para a Rua 8, no bairro carioca de Guadalupe. Ali estava a casa doada pela emprêsa estadunidense à família Da Silva. Casa modesta, mas confortável, pintada e mobiliada de nôvo, dando-se até ao luxo de ter geladeira. Não encontrei José da Silva nem sua mulher, pais do menino Flávio, que foi levado para os Estados Unidos. Informaram-me que estão trabalhando no morro da Catacumba. Na residência, apenas D. Maria, sogra de José, e 5 filhos dêste. Apresento-me. Noto, de início, certa desconfiança por parte dos moradores. Aos poucos, porém, vou ganhando-lhes a confiança. Mostro, então, a reportagem do "Life", com a foto de abertura, em duas

páginas. E leio a legenda: "O pai, prostrado de exaustão, nem se preo com o desespêro da filha". Pergunto a Izabel, menina que aparece na a razão do seu chôro. Mas é Maria da Penha, das filhas a mais velha, responde: — "Imagina o senhor, era de tarde, esta gente queria que ficássemos deitados uns contra os outros. Izabel não quis, de jeite nhum, deitar ao lado da mãe. Começou a chorar depois que o pa deu um cascudo. Ficamos a tarde tôda deitando e levantando, cada mudando de lugar, para que êles pudessem tirar as suas fotografias"

Viro a página da revista e mostro a Mário, um menino esperto olhos vivos que está a meu lado, a sua foto chorando. Leio a leg explicativa: "Mário da Silva, de 8 anos, berra depois de ter sido mo por um cão".

— Como foi isso, Mário? — pergunto.

Desta vez é a avó das crianças quem responde: — "Mordid cachorro coisa nenhuma. Êles haviam inventado de botar uma lat água na cabeça do coitado do Flávio, e mandaram que êle subis morro para tirar fotografia. O meu Flávio, o senhor sabe, é doen asma, não teve mais fôlego, caiu no chão com lata e tudo, não quis carregar nada e começou a chorar. Então êles foram ao Mário que êle carregasse a lata e Mário não quis. Tratou de fugir, desc o morro. Nair, a mãe dêle, chamou o Mário e êle mandou uma nela. Ela pegou êle e deu uma sova de cinto. Foi quando o Mário ç ou a chorar. Mordido de cachorro nada, "seu" môço".

Pilheriei: — Doeu muito, Mário?

E é ainda a velha quem responde: — "Que nada, "seu" môç de galinha não mata pinto".

Leio, então, algumas passagens do diário, criado pela imagi fértil de Gordon Parks. Nêle a pequena Izabel, na intimidade cha "Bia", é apresentada quase como um cão hidrófobo que vive morc gente. E, por coincidência, durante a leitura, é ela quem está no colo, mexendo nos meus cabelos. Sem nenhum perigo de mordida. da Penha, segundo ainda o internacional Parks, é uma agressiva mo que ataca todo mundo a faca. Depois de tentar esfaquear o irmão F avança para o repórter americano que, numa luta tipo "far west", gue subjugá-la. Maria da Penha, na verdade, é uma menina dócil certo modo, até acanhada. Não posso imaginá-la empunhando uma

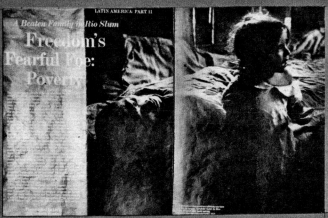

MENINA assinalada na foto é chamada familiarmente de Bia, uma pequena ...sa, humilde e acanhada. Segundo Gordon Parks, a garôta não permitia a ...a leve aproximação do repórter, ameaçando mordê-la a todo instante.

O HOMEM estava tão exausto, afirma o texto do "Life", que não tinha mais fôr-ças para acudir a filha. A verdade, porém, era bem outra: a menina Bia chorava porque levara um cascudo do pai, depois de ter recusado deitar-se ao seu lado.

No diário ainda existem passagens de crianças que cravam agulhas ... pele delicada do repórter. Pobres meninos nordestinos, que perma-...em pelos cantos, olhar assustado, sem saberem ao certo as minhas ...nções. E que, momentos depois, me cercam amigàvelmente, tentando ...cer na máquina que trago a tiracolo. Bons e mansos meninos nor-...inos.

Mostro, finalmente, a foto de duas páginas do "Life", em que apa-...em, num só quarto, o casal Da Silva e seus 8 filhos. Maria da Penha ...nda a rir quando lhe pergunto se êles dormiam normalmente daquela ...eira. E explica:

— "Não. Eu não dormia com o Mário no berço, como está na ...grafia. Nós dormíamos, os maiores, lá embaixo. No berço dormiam ...arias e a Bia. "Seu" Zé é quem mandou nós fazer isso para a ...grafia".

Minha tarefa em Guadalupe estava finda. Todos haviam sido devi-...ente fotografados e seus depoimentos iam escritos no meu caderno. ... fui para o morro da Catacumba, onde pretendia obter o depoimento ...osé da Silva e sua mulher. Ao mesmo tempo tiraria minhas dúvidas ...espeito da foto batida "de madrugada" no barraco, embora as decla-...es de Maria da Penha já tivessem colocado um pouco de luz no ...nto.

Foi na "birosca", mantida pelo casal Da Silva no sopé do morro, ...eu colhi o material que me faltava. De início sou recebido com a ...ma desconfiança encontrada em Guadalupe. Mas quebro o frio aco-...ento, mostrando ao casal uma carta que Flávio havia mandado dos ...dos Unidos. Fôra recebida pela avó do menino e eu servira de ...sageiro. Leio a carta para os Da Silva, que a esta altura mostram-se ...s cordatos. E vão soltando a língua. Começo devagar, falando na ...antesca aranha preta" que, segundo o "diário" de Gordon Parks, ...a andado pela perna de José. Dá gostosa gargalhada:

— "Aranhas, tinham sim, mas pequeninas e no telhado. Não na ...ha perna".

O dono da "birosca" já me olha como velho amigo. E é com os ...s brilhantes que fala nos dólares distribuídos pelos americanos: "Meu senhor, como esta gente sabe gastar o dinheiro. Empregaram muita gente para ajudar a fazer a reportagem. Havia o José, o Rex, o Paulo e os meus dois irmãos. Trabalhamos muito. Deita, levanta, faça isso e aquilo. Mas sempre recebendo dinheiro. Dez contos uma vez, mais quinze, mais dez. E mais ainda quando a Nair deu à luz. Como gastavam...".

Fala num entêrro que houve no morro, onde o caixão, que subiu e desceu a encosta, estava cheio de pedras. Fôra comprado pelos ame-ricanos, que desejavam mostrar como "se enterra" gente na favela. Depois, para dar mais autenticidade às suas palavras, leva-me até os fundos da tenda, onde mostra duas gavetas de um armário, cujos puxa-dores foram feitos com as alças do caixão. E completa:

— "Eu ganhei o caixão. Desmontei êle, fiz as prateleiras e botei as alças aqui".

Mais tarde eu havia de colhêr o depoimento do Sr. Teotônio Rosa, encarregado da direção da "Escola do Lions Club" da Catacumba, em que êle me contaria que fizera o papel de um cadáver, entrando no caixão ofertado ao José da Silva. O caixão fôra carregado morro acima, por quatro rapazes do lugar, entre êles seu amigo Jair. O próprio Teotônio falou-me na compra de várias caixas de gêlo sêco pelos americanos:

— "Êles queriam fazer uma neblina, como se fôsse de madrugada. Eu e outros rapazes quebramos vários pedaços de gêlo sêco para sair fumaça. O Flávio andava por dentro dela carregando uma lata de água, para dar a impressão que adquirira asma no frio e umidade do ambiente. Bateram muitas chapas do menino, mandando que êle tossisse enquanto caminhava. Aliás, eu trabalhei muito para os americanos. Fui eu quem comprou o caixão, lá numa funerária da Rua General Polidoro, perto do Cemitério São João Batista. Paguei 3 000 cruzeiros por êle".

Pergunto em nome de quem comprou o caixão. Responde Teotônio:
— "Em nome de ninguém. Disse que era para fazer cinema".

Contam-me alguns moradores da favela que a turma do "Life" obrigou o menino Flávio a carregar tanta lata de água que êle terminou tendo mesmo um ataque violento de asma. Uma mulata gorducha comenta:
— "Os homens ficaram com mêdo quando o menino começou a tossir de verdade. Saíram correndo para a farmácia e deram injeção nêle".

CONTINUA

Foto de madrugada foi feita ao meio-dia

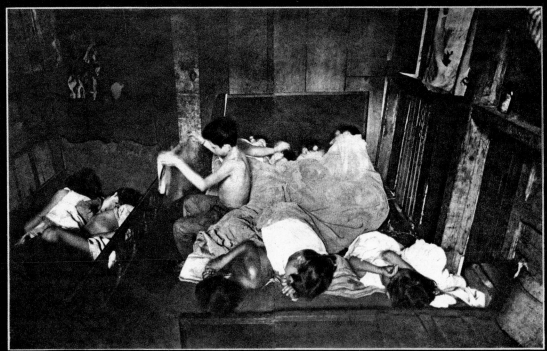

NUM MESMO QUARTO, O CASAL DA SILVA E SEUS OITO FILHOS. É MADRUGADA E FLÁVIO LEVANTA-SE PARA O TRABALHO (DO "LIFE").

Resolvo subir até o barraco dos Da Silva. Lá encontro o casal José Tavares Filho e Francisca Iara, que estão vivendo no local, na ausência dos seus antigos donos. Também aparece a vizinha parede-meia Aracy Pereira. E é ela quem me mostra o quarto do barraco onde foi forjada a fotografia do casal Da Silva "dormindo" com seus 8 filhos. Aponta para o teto: — "Olha lá, môço. Êles tiraram as telhas do barraco para entrar mais luz. A fotografia foi feita de dia, mas aqui é muito escuro".

Minha missão estava terminada. No dia seguinte voltei ao bairro de Guadalupe e ao morro da Catacumba, desta vez em companhia de meu colega de "O Cruzeiro", Mário de Moraes, e do cinegrafista da Televisão Tupi, Raimundo Genito do Carmo. Êles me ajudaram a gravar todos os depoimentos prestados pelos Da Silva e outros moradores da favela, bem como a fazer as filmagens que se fizeram necessárias. Serviriam para um programa de televisão, onde seria mostrado como se fabrica realmente uma reportagem. Demonstrando como um trabalho, fácil de ser executado, pode transformar-se numa tarefa das mais difíceis quando entram em ação famosos repórteres internacionais, que têm que lançar mão de quilos de gêlo sêco, cadáveres inexistentes, caixões "para cinema", muita imaginação e outros ingredientes para mostrar nos Estados Unidos uma "autêntica favela carioca".

O CINEGRAFISTA da Televisão Tupi, Raimundo Genito, filma o teto destelhado que permitiu o "flagrante".

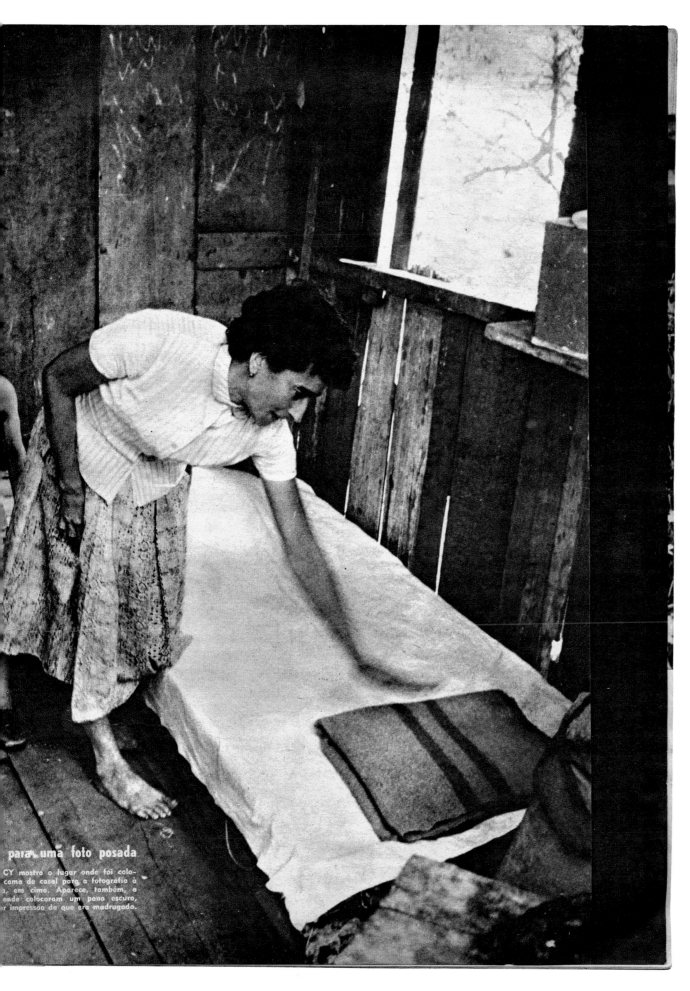

para uma foto posada

CY mostra o lugar onde foi colo-
cama de casal para a fotografia à
a, em cima. Aparece, também, a
onde colocaram um pano escuro,
r impressão de que era madrugada.

Interview with Flávio da Silva

The following is taken from conversations between
Flávio da Silva and Michael Astor, Amanda Maddox,
and Paul Roth, at various locations in Rio de Janeiro,
December 10–12, 2016. The exchanges were filmed
and recorded by Douglas Engle.

Interviewer: *Flávio, thanks for agreeing to talk with us about your experience with Gordon Parks.*

Flávio: You know what? Yesterday I sit in the bed and I start to feel some smell. Like in those times. This smell is the same. Do you believe in that?

Interviewer: *I don't understand.*

Flávio: After Gordon left the first time, between that and the report that the magazine goes to publish, every week, especially on Sundays, I was feeling him coming. And I don't know that he will, but he said to me, "I will come back."

Interviewer: *Wait, who? Gordon?*

Flávio: Gordon Parks. Every week. On Sundays, I feel, I smell, I feel that he was coming back.

Interviewer: *When was this?*

Flávio: Those early times. Before the first *Life* magazine.

Interviewer: *Oh, that's really interesting.*

Flávio: In 1999, I was having the smelling again.

Interviewer: *So do you think Gordon is with us now?*

Flávio: No, I don't think about that, that we'll feel his presence. No. When you die, the spirit don't come to bother nobody.

Interviewer: *Okay.*

Flávio: After we die—we just die.

Interviewer: *What do you think the smell is?*

Flávio: I don't know how He's able to leave the materials with me. But it can go through the air.

Interviewer: *Do you go to church regularly?*

Flávio: I don't have a regular church. . . . You can't find God in a church. I believe in and have a fear in God. And those that don't believe don't make sense to me.

Interviewer: *Didn't you used to go to church in the favela nearby? Wasn't that your church community?*

Flávio: I was going there. But the situation is not good now. It changed.

Interviewer: *What happened?*

Flávio: The priest died and then there was confusion there. And I don't much like to go there to the favela anyway. But it's their problems why I don't go.

Interviewer: *How much do you remember about Catacumba, where you used to live?*

Flávio: I lived there for . . . since about two years, one years old.

Interviewer: *So you weren't born there?*

Flávio: No.

Interviewer: *I didn't know that. Where were you born?*

Flávio: I guess in some hospital around Copacabana.

Interviewer: *But your family did live in Catacumba then? Your mother and stepfather, Nair and José?*

Flávio: Yeah.

Interviewer: *So you lived in Catacumba from the time you were a baby until when you left? Were you always in the same home there?*

Flávio: We lived in different places there.

Interviewer: *And how long has it been since you've been back to Catacumba?*

Flávio: Well, not for many years. Except just recently for the journalists from *O Globo*.

Interviewer: *Oh, when was that? And why were you there?*

Flávio: Just a few weeks ago. They were doing a story on me, on the past situation. They make a film with me. It's not much to see now, just a park, full of trees—high trees. But it's wonderful. The color is very strong.

Interviewer: *Did it feel familiar to you to be there?*

Flávio: I tried to find out the position where we lived, but . . .

Interviewer: *It's changed a lot.*

Flávio: It's very difficult. I wished I could see the Cristo Redentor. It's higher. It gives you a direction, a line. A reference point.

Interviewer: *When you lived in Catacumba, could you see any other favelas?*

Flávio: I can't remember that. I don't have time, I'm always busy, and I simply don't see nothing about that.

Interviewer: *Your world was your world.*

Flávio: Yeah. My world was my world. But there was a big rock up there, I could always see. So many times I looked there. And see people there, close to those rocks. Another world.

Interviewer: *Do you remember the first time you saw Gordon in Catacumba?*

Flávio: Well, I was crossing the street. That I remember.

Interviewer: *And what did you think of him before you knew who he was? A guy with a camera, probably well dressed, walking in the favela. What was your first impression before you met him?*

Flávio: I don't know. Just like somebody passing.

Interviewer: *But he was different from the people you were used to seeing, right? He was an outsider.*

Flávio: Well, after the conversations I could understand that he was different. His language was not my language.

Interviewer: *In his book, he wrote that you smiled at him with a big smile.*

Flávio: Well, if you see somebody different, what is your reaction? So much things is different. It's tough to imagine. You laugh, or you get serious. And I think that day, I paid attention. And that's it.

Interviewer: *Gordon said that he thought you were different. That there was something about your optimism. He said that despite your illness and the terrible environment, he saw you as surprisingly alive and energetic and happy.*

Flávio: If he say so, I'll believe it. I do remember I was very sick, full of pain, and I believe that I had something I was doing, something walking up. Maybe carrying the water. I don't remember.

Interviewer: *Do you remember Gordon and José Gallo coming with you, and going into your house? How did that happen? Did you just invite him in?*

Flávio: That was being recorded in my eyes, but now is not something so fixed in my memory.

Interviewer: *You just have vague images in your mind?*

Flávio: Yeah, but not so clear. I might have had a lack of trust. Like—"Who are these guys?" They came with two, about two or three cameras. Gordon would do this [lifts hands to face], go—click—and then another one—click—and then the roll of film was put in the can just to keep it safe. And change, and keep going. How many days, I don't remember. At first I was afraid of my stepfather.

Interviewer: *Afraid? Why?*

Flávio: Of the situation. He wasn't home, and I was alone with them.

Interviewer: *Was José Gallo with Gordon every time he came, were they always together?*

Flávio: José was with him all of the time. But I believe that one day Gordon came alone. I don't remember very well. I think he come one day by himself.

Interviewer: *Do you remember if either one of them was keeping notes?*

Flávio: I believe they were keeping all the situations in their mind. I didn't see them writing anything.

Interviewer: *Do you remember the way that Gordon photographed you? Would he just tell you to do what you normally did, and then just take pictures?*

Flávio: I remember that I would be doing something, and he took pictures. I don't remember he give me directions, the only word that he said is one time about my brothers, to get on the bed.

Interviewer: *What do you remember about that? When you look at the whole roll of film, it looks like Gordon took that picture over and over again.*

Flávio: He repeat it, yeah.

Interviewer: *Flávio, can I ask you to look at these pictures right here? These are Gordon's pictures of you having an asthma attack. Do you remember what that was like, when you would have an attack?*

Flávio: How can I describe that? It's terrible, it's something that you can't touch, can't find, and that you need. Your breath.

Interviewer: *Did you feel like you could die from that? Was it scary for you?*

Flávio: I never was scared, because I didn't know what to be afraid of.

Interviewer: *You didn't know what fear was?*

Flávio: I was just afraid of spanking.

Interviewer: *Did any of your brothers or sisters have the same condition? Or are you the only one with asthma?*

Flávio: Yeah, the rest of them, they're okay. There's no problem with them.

Interviewer: *When you were a child, did you ever work in your stepfather's store?*

Flávio: I remember something. There was a police post in the neighborhood. They had conflict with my father, and he with them, because somebody there fights to get his store out of there because there was no permission to build. Something like that. His stand was made of wood. Sells fruits, tomato, kerosene, bleach, salt. And we had a police post there, and the medical house was there that could treat about my situation, my asthma problem. But because they don't understand each other, there was a problem. That's what I heard. So he won't take me there. I never know what is happening until I got this information. And the whole thing just passed and nobody remember, and those that remember never say about.

Interviewer: *Did Gordon know about the conflict?*

Flávio: I think he knows it.

Interviewer: *It makes sense. Because he and José took you to the clinic to get treated.*

Flávio: You're right. Now I remember. You see, the same time you said to me, it comes. Like a flash, now I remember.

Interviewer: *Do you recall being at the clinic with them?*

Flávio: Yes.

Interviewer: *Did they tell you anything about how bad your condition was? Gordon later wrote that they told you everything would be fine.*

Flávio: I never did discuss those things with them.

Interviewer: *Can you think back to when Gordon returned to Rio, the time he arrived to take you to the United States? Do you remember that he filmed a movie about you the second time he came?*

Flávio: Not exactly . . . It's passed so many years. About the movie, I don't remember.

Interviewer: *Did you ever see it?*

Flávio: I saw it, later. I saw it on TV, but I don't see it by myself, somebody showed me. But I didn't remember seeing anybody filming me back then.

Interviewer: *Do you have memories of when Gordon and José took you and your family shopping? Do you remember all the journalists and cameramen?*

Flávio: Ahhh. So many people. When we were leaving the favela, with some clothes on the head. And at the new house: so many cars stop in the front of the house, that's all I remember, and the neighbors. Everybody want to see the family come.

Interviewer: *Had you ever imagined that you would be able to leave the favela?*

Flávio: No. We didn't know anything else, we didn't even have radio at that time. The poor people have more facility now.

Interviewer: *Flávio, what are your memories of Denver—are they very positive?*

Flávio: Yes.

Interviewer: *Did you like staying in the hospital?*

Flávio: It was far away from the city, but I like it. It's different.

Interviewer: *Was it hard to adjust to living in the United States, or was it easy?*

Flávio: It was hard. Yes. They teach me how to play baseball, basketball, American football. I don't like American football much. You get something broken. Baseball, I like. In school we practiced. . . . We used the softball 'cause it's doesn't hurt nobody. You can't get hurt. Competition by the boys, the girls, who's the winner, who's the first, second, third—we had that. I guess it gives more incentive for the child. One thing that I liked when I was there, they took us to a company to show how it works. That was good.

Interviewer: *Which company?*

Flávio: Coca-Cola. They showed how to prepare the syrup, how they make the bottle.

Interviewer: *When you were in Denver, did your family stay in touch with you? Did you get correspondence from your mother, from your sisters and brothers?*

Flávio: I had to write a letter every week. Sometimes I don't have nothing to say, to write; and you have to anyway, or else you're not going to vacation with the Gonçalves family, or else you're not going camping.

Interviewer: *Who said you had to do that? Was it Kathy Gonçalves who made you write the letters?*

Flávio: Not her. The director at the hospital, of the building that I was with the other children. They say: "It's time to write the letter." "But I don't have nothing to say!" "No. You have to write!" "Why I have to do again, I do it last week, why do you want me to?" "You have to make twenty lines at least." "Oh no, how can I make?" They think that was easy for me. I had to walk a line. Or else I was going to be in trouble. If I fight with somebody once, they say, "Okay, you done this, if you do it again, you don't stop, you're going to be punished. We are not your mother, not your father, but you are our responsibility. You have to do the best you can, with the others!" So that's my education.

Interviewer: *How did you feel about your house parents at the hospital, were they like your mother and father?*

Flávio: No, somebody else was responsible about me. Kathy Gonçalves and José, with Mark, Rick, and Neil. I never forgot those times. I have pictures of them in my mind, just passing in front of my eyes, in the moment.

Interviewer: *At the Gonçalveses' country house?*

Flávio: Yeah. Mark, Ricky, we fishing in the lake. I still remember. It's coming now, because it's not all the time, but I can say we were very tight. The Americans got likes, and those times, they like to go to the mountains, weekends, Thanksgiving, Christmas. Like summer each week.

Interviewer: *Who told you that you would be leaving Colorado to go back to Brazil? Do you remember?*

Flávio: Kathy Gonçalves told me. She was trying to prepare me. But I could feel that something was happening. She comes one day, using a little bit of Portuguese. I was thinking, Why Portuguese? Then she said, "You're going back home." And I think, Okay. . . . "Back home, I think you will like it." Now I'm going, "This can't be right. Why back home? All right, yes, I have my parents, I have my brother, sister, but I made so many friends here and I care about the other children." You don't give everybody, most the time, happiness. Just once you have this. But what can I do? I don't have no authority about myself. I say, "No, I'm not going." But Kathy says "Yes, you have to go. Your mother has signed some papers saying that you're supposed to stay just two years." So that was it.

Interviewer: *Did you keep in touch with Kathy after you left? Did she write to you?*

Flávio: She did. Yes. All these letters, and from others too, help me keep my English for a while. I don't know if my English is the same now. In Denver there's Kathy, and there's some other Brazilian girl in the hospital that's learning English. She has good pronunciation. We have conversation when we get contact with each other.

Interviewer: *Your English is very good, actually.*

Flávio: I don't practice. I don't speak much anymore. It was happiness to know another language, and appreciate the situation and all of it. To learn, and to have so many times communication with Kathy, and Gordon Parks, and others. Like Irene Tatem. She was a lady who saw me in *Life*, and she every letter send me ten cents, five cents, from United States in the mail, for years.

Interviewer: *Gordon wrote that when you were leaving the United States he wanted to adopt you, and that your stepfather didn't want to let him. Would you have been happy with that?*

Flávio: Yes. He told me he wanted to. Not just him, several people wanted to do it. But they don't. Phil Vandervoort, one of the *Life* readers who stay in touch, he took a plane to visit me. That's showing something in his mind about that.

Interviewer: *Would you have liked to stay in the United States? Did you want to stay there?*

Flávio: Yes, I wished to stay. If I could have run away, I would have. I imagined that. I was in the car alone when we were leaving the hospital. Impala, that was a big car. The school principal, she says, "Oh, you stay in the car. I'm going inside to have some conversation, and I'll be back." Okay. I could drive a car. You go in the front, it's very easy. One of the people that took care of us, he was nice and he said, "Ah, let's go take a drive. Let's go around." And part of the ride, he said, "Now you're going to drive." I say, "What? Me drive? What I going to do?" And he said, "You're going to drive. Did you listen what I was doing? Okay, you're going to do the same."

Interviewer: *Have you ever imagined what it might have been like to stay? Did you think, "If I hadn't come back to Brazil, I would have done other things, and my life would be different"?*

Flávio: Please, I . . . [trails off]. I think so many times about the situation. I just can't say much because . . . I passed most of the time thinking, after I know that the people weren't for my staying and . . . I start to think, Why they not do it, why not give the permission for it?

Interviewer: *What would you have done if you had stayed in the United States? What kind of job would you have liked to have?*

Flávio: You have to pass through each situation to see what you want.

Interviewer: *When you went to the United States, did everyone say, "Oh, he's the Brazilian boy?" Did they treat you differently?*

Flávio: Oh, everyone treated me well.

Interviewer: *When you went back to Brazil and attended school in São Paulo, did they see you as a Brazilian boy, like them? Or did they see you as someone from a lower class, someone from the favela?*

Flávio: Yes, they did. There's some difference of treatment, from one country to other country.

Interviewer: *And what was that like?*

Flávio: Well, because I didn't know how to speak Portuguese anymore, there's those situations that they make jokes about you. . . . I also had a lot of problem about punching.

Interviewer: *In São Paulo?*

Flávio: Yeah.

Interviewer: *Did you like the school?*

Flávio: I will not say yes. I really liked that it was very different, though.

Interviewer: *Did you like José Gallo? Was he kind to you, was he somebody that you enjoyed being around?*

Flávio: Yes. He was happy all the time. Laughing, playing. I remember him, he was a good interpreter. I had to go to his office, the Time-Life bureau. I went there to get some money for the month . . . no, for the week.

Interviewer: *Every week?*

Flávio: Every week he give me something. From the trust that I had, I'd say I got twenty-five cents for every week to spend on what I want. That's why I learned something that teach me about spending, because this was so little, twenty-five cents, but I could buy six bottles of Coke that comes in the box, and buy some model pieces. You put the pieces together and glue them. I would feel, Oh, I want this, I need this, but how I can get? I just have twenty-five cents for a week, and I really want some of those things, but there was no possibility. The other boys that have their situation better would buy anything, and that teach me once more the responsibility to try to save.

Interviewer: *Did José give you any advice when you would see him?*

Flávio: About the papers of the house, the house *Life* bought us with the money from the readers. There was a situation, my stepfather says he wants to sell the house. José says, "Oh, he said that? Okay." He went there in the office, finds some paper, and says: "I'm going to read for you. You see, you cannot sell because of this, this, and this. Okay. You can take it, show it to him." I go home and say, "Here . . . José Gallo sent for me to give this to you about the selling the house. I say the situation, and those lines that he marks with red, I read for him. But then my stepfather says, "No, I'm going to wait for one of my brothers. I'm going to wait for him to come to read for me." "Why?" I say. "Don't you believe that I'm saying what's right in there? I'm not lying for you. I'm saying what's right in there, but it's up to you." Then the brother reads, and then he start to believe, okay. And stop saying that he was going to sell. That's it. I don't know what was passing in his head.

Interviewer: *Your stepfather?*

Flávio: Yes, him. I didn't understand. Would we go to another favela? Why? You have two schools here from the government, one more school where you pay. Stores, medicine post, and private clinics. Where do you want to go with yourself, I'm thinking. If you have something better, then you never dream to have. Maybe my mother has her prayers, him, maybe wants a better life, and you go forward. It depends on the person. Of you, of me, of anybody. But why would we sell? There's nowhere to live, not back to the favela. That's my thinking.

Interviewer: *When you finally came back home from school in São Paulo, you had been away for many years, right?*

Flávio: Two years in Denver, and then since three years in São Paulo.

Interviewer: *And when you returned home, what did the house look like, and how did you feel about it?*

Flávio: Very, very different.

Interviewer: *Why was it different?*

Flávio: Because, so many new childs. But just two rooms and four bunk beds.

Interviewer: *How many brothers and sisters do you have, total?*

Flávio: Thirteen. One died, so, it was fourteen.

Interviewer: *Did you still feel like part of your family? Were you welcomed by everybody?*

Flávio: Oh, by that time, yes. Some other times are different. It depends of each one. You bring happiness for one, two, three maybe, and others don't feel like. But I don't feel no bothering about that. At first the neighbors say, "Oh, Flávio is home, he don't speak Portuguese, he speak just English." And for me, I went from Denver to New York, and New York to Brazil. I stay at home only one day. And the next I went to São Paulo. But when I came back from São Paulo, I already speak Portuguese normally.

Interviewer: *When you came back to Rio, did you go to visit Catacumba, just to see how things looked?*

Flávio: Yes. One day I was in Rio and went to visit there, and then come back.

Interviewer: *Did you still know some of the people who lived in the favela, or was it very different?*

Flávio: Already was different. Everything was changed.

Interviewer: *Because of the money that came in from the readers of* Life?

Flávio: Well, they divide the money. To make a better condition for the people there, and better condition for my family. And the other part was for my treatment.

Interviewer: *And when you went back to the favela, did you go alone?*

Flávio: No. I don't remember that. I believe I went with my mother.

Interviewer: *Had she been back in the meantime, or was that also her first time back?*

Flávio: Yes. Sometimes she went there. She still knew people.

Interviewer: *How was it different when you went back there that first time?*

Flávio: I remembered the other day, because you can still see the cement box of water, for the plumbing. *Life* buy the material, everything, and build with the help of the people. I think they went up the hill.

Interviewer: *So this was to pump the water up the hill?*

Flávio: Yeah. So the people would have water. They had a motor down there maybe, I don't know.

Interviewer: *When you went back to Catacumba, did the people there appreciate the improvements that were made?*

Flávio: They appreciate it. What I think when I was there visiting, that they was happy with the situation. They don't have to go down to get water to make the food, to take bath. That was something that made life a lot easier. We all go to get water, every day. More than once a day. Just one pipe for everybody.

Interviewer: *But did they see that you were the reason that had happened, or did they feel angry you had left?*

Flávio: No, I don't see that in them. If it has, I don't know. But they don't lose nothing. They win something.

Interviewer: *When you came back that first time, did people recognize you?*

Flávio: Yes. I hadn't changed much. Only two years about. They first said that I was healthy.

Interviewer: *Do you know whether people were upset about being relocated from Catacumba in 1970, when the favela was destroyed?*

Flávio: Yes, they were. Well, but I believe that they are happy too. When they said it was better for them. I guess they don't have a . . .

Interviewer: *Choice?*

Flávio: Yes, choice. So maybe they get angry about that, I don't know. I believe it is good for them.

Interviewer: *You said that your mother still knew some people in the favela. Did she ever talk about how those people felt about your family getting out, about your good fortune?*

Flávio: The situation is different for each group. Some persons say some things that aren't true, you know?

Interviewer: *Like what?*

Flávio: She said to me that some people said that she sold me. Sold me for large amount. They said, "They got money. He went away."

Interviewer: *Really?*

Flávio: They decided this is what happened. I believe that for a reason. So she wants to show to the people the contract where it says, You get better, then they'll bring you back. That's the contract.

Interviewer: *Did you have any lung problems after you returned from Colorado, or did your asthma go away completely?*

Flávio: Oh, I still had some problems. I don't say I don't have. I have.

Interviewer: *So you still experience it sometimes?*

Flávio: I pass the treatment for one year since now.

Interviewer: *Here? You had to get treatment recently? Were these like the big asthma attacks you used to have?*

Flávio: Asthma, yes, but not that bad.

Interviewer: *Flávio, what did you do when you left school? What jobs did you have?*

Flávio: My first job was helping on building houses.

Interviewer: *Construction?*

Flávio: I helped a bricklayer. First job. I would come home with blisters on my hands because I wasn't used to it.

Interviewer: *How old were you at that time?*

Flávio: I was about eighteen, nineteen. The first job was in . . . start a building from the ground. I learned helping

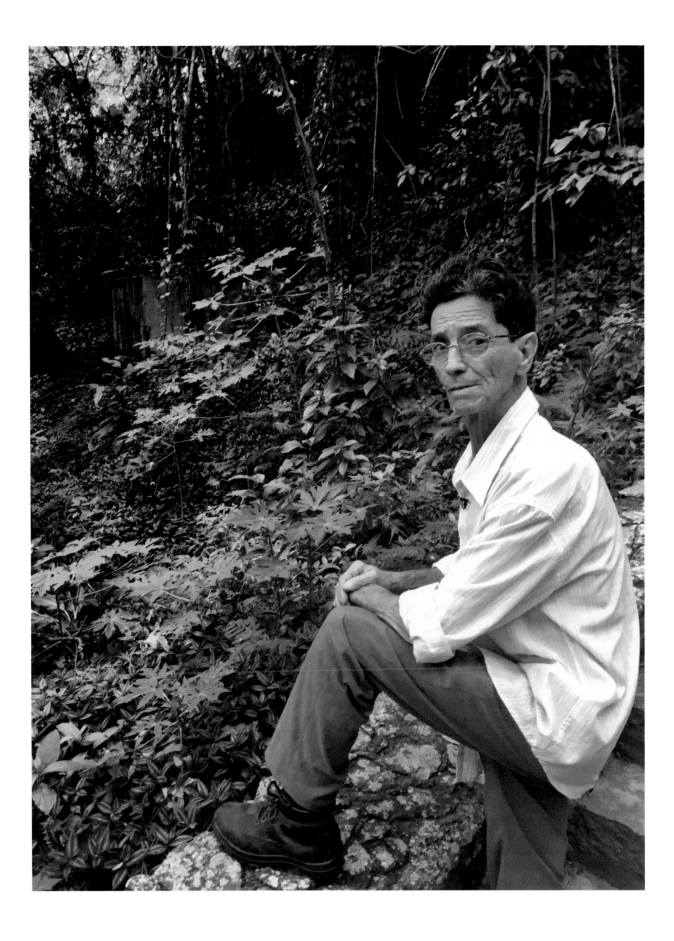

there. Then after, I went to work in restaurant. I work in restaurant four years.

Interviewer: *What did you do there?*

Flávio: Help all the parts. Kitchen, all situation.

Interviewer: *What kind of place was it?*

Flávio: Good restaurant with server seating. But I worked in many . . . three years in one, and one year in another. There was one restaurant where I only stayed one day, because it had very steep stairs. There are some you can go up and down without getting tired, but a really steep staircase you get tired really quickly. So I went there one day, and, "You have to put the refrigerant and all this material upstairs." "Oh, yeah?" I said. "Okay. Where? Upstairs?" I never go back again.

Interviewer: *What is the longest job you ever had?*

Flávio: The company I worked for eighteen years. Security guard. But now finished, I'm not working anymore.

Interviewer: *How do you pay for food and other things?*

Flávio: Well, I earn a pension. It's more than ten years now I have.

Interviewer: *How does that work, do you get money once a month?*

Flávio: Yeah, once a month.

Interviewer: *The same amount every month? Is it a retirement benefit?*

Flávio: Not so much money. You can do only so many things. I buy my necessities in the supermarket, I look forward to see what I can do—pay first, and pay second for the phone. . . .

Interviewer: *So you make choices?*

Flávio: Yeah. So I'm in the front of the situation.

Interviewer: *When you met Gordon, did he talk to you about growing up as a poor person? Did he explain his background?*

Flávio: No, after, when he came here later, he told me.

Interviewer: *When he came back to write his book about you? In 1976?*

Flávio: Yes, when he come back.

Interviewer: *When did you first see the book?*

Flávio: He send me by mail. I went to post office to pick up.

Interviewer: *Do you remember what you thought when you first saw the book?*

Flávio: Yeah. I read it, but then I stop. I read it, then I stop.

Interviewer: *Why did you stop?*

Flávio: The feelings. It hurts so much. Because, so many situations that pass, and . . . how can I say? So many

situations that is not very glad in one part, and in the others very glad. I'm going to tell you the simple way. It touch my feelings and I just couldn't get to the end of the book.

Interviewer: *You couldn't finish it?*

Flávio: So I just keep it. When I want something, I'll go there and read, read, read something . . . jump some page, then I get the information. Like a dictionary.

Interviewer: *Were there things in the book that you had never heard before?*

Flávio: I don't think so. What do you mean?

Interviewer: *Well, was this the first time, reading the book, that you heard the background of everything that had happened when you were a child? For example, about all the readers from* Life *magazine, how much money they sent in? And what the doctors were saying to Gordon about your condition? All of that was in the book.*

Flávio: No, I don't have no information about everything the doctors were saying. They keep the information between them. I think these are the more important things.

Interviewer: *Was that hard to read? Was it difficult emotionally?*

Flávio: Yeah, that's what I'm saying. Difficulties to get at the end of the pages.

Interviewer: *Gordon starts to address this at the beginning of the book, when he says that as a journalist, he probably shouldn't have tried to help somebody he's photographing. That he's supposed to be dispassionate and apart, right? But he tried to help you.*

Flávio: I think the same thing.

Interviewer: *Did you feel mistreated by what happened? By how it all ended?*

Flávio: No, because some people thinks that *Life* magazine done everything. It's not true. *Life* magazine was not the one giving the money. The people, the boys that give ten cents, five cents, what they have of their allowance. They give, and some older people give some money too. And the help come most from the people. But I feel what you're saying.

Interviewer: *Did you ever tell Gordon this?*

Flávio: No. I don't remember telling him. But he was just one part of it. He was not the doctor. The doctor made their part. Each one made their part. This one responsible to teach me English, this other one the responsible of the building. Taking care of you and was there all the time. Each made their parts.

Interviewer: *Flávio, if you could go back to that day in Catacumba when Gordon first came up to you, do you ever wish that it never had happened?*

Flávio: I no have no choice! I was a boy.

Interviewer: *If you could change your future, what would you do?*

Flávio: Everybody always trying to change the future. Everybody tries. But you don't do it alone. I don't regret

anything. There were several situations that worked, and some situations that didn't.

Interviewer: *Were your brothers and sisters upset that you got to leave and they did not? Was that the same feeling for them?*

Flávio: Need you open that? I don't feel like it . . . [chokes up].

Interviewer: *Okay.*

Flávio: It's so many years of this situation. Because back there, I started to know what was happened. Born from the same mother. The father's different, but the mother's the same. Why the difference? My brother's O-positive. Him, them, all is the same. I discovered that after thinking, thinking, thinking. Then one day, I discovered by myself, nobody say nothing. I know what has happened. I told them, all, I speak it out. Because I was so mad all the time. So many confusion, so many things.

Interviewer: *When did you realize this? How old?*

Flávio: Before my mother died, I told them. About seven years back. Seven, eight years back. Why this situation? If you use your eyes, and look for some union of man and woman: "That baby looks like someone else, another person. . . ." I believe that maybe because of the possibility, that José said, "Oh, Flávio's not my son." That's how I knew. The face. The blood. It's my way of seeing—not from my thinking, but observations. I look for detail in everything. But now I am suffering through this.

Interviewer: *Were you always looking for a father figure after that? Was Gordon a person you thought of as a father figure?*

Flávio: Oh . . . what am I trying to say with that? Because I personally, I feel this way. Which one has the paper of father, you know? Take care, assume the responsibilities, be the teacher. So the others—they all done what supposed to do. And also I have my responsibility, with them too.

Interviewer: *You mean you have to obey them too, for them to be a parent?*

Flávio: Yes. I thought this.

Interviewer: *You mean that many people have been a parent to you? What about Gordon, was it different with him? Gordon wasn't like that for you?*

Flávio: Well, Gordon was just a little there, and got back to his job.

Interviewer: *Not the same?*

Flávio: It's different. Others was present all day, all night, on most of the time.

Interviewer: *Did you ever write Gordon, in his later years? Did you stay in touch?*

Flávio: I wrote there. I think, let me see if he's there, or somebody can give him the letter. And we start to contact again.

Interviewer: *When was this? After Gordon came to visit you the last time?*

Flávio: Yeah, about that time, 1999.

Interviewer: *How did you find out about Gordon's death?*

Flávio: By the computer of a friend of mine. He asked me, "Let's go see about that friend"—he tried to say the name. "Gordon?" I asked. "Yes, Gordon. Let's try to see it again." Then I find out that he was died. And when I discovered that, I just came out and said, "Well, what happened?" Nobody had communication, send letters, to tell me.

Interviewer: *How did that make you feel?*

Flávio: I came back and start think about it. I don't feel so very good. I feel really bad, because of the situation. So many people in contact with him, so many people that works with him, and nobody . . .

Interviewer: *You think somebody should have called you and told you?*

Flávio: Yes. Well, why not? When Phil Vandervoort died, I just had to send him one letter; there is no answer. I was feeling that something was happening, because we always write one to each other, all that time, almost regular. And then I feel that something was wrong, and I asked in another letter, "What's happening?" I got answer that he died. Somebody answered me.

Interviewer: *How do you think about Gordon now that he's gone?*

Flávio: I miss him. Yeah. In truth, if you lose a parent, you're going to . . . you're not going to forget it. But you know that situation pass, and brings you peace, and you're going to . . . tears.

Interviewer: *Cry?*

Flávio: Tears, cry every day, every night. Then one moment you stop.

Interviewer: *Flávio, have you ever gone back to the magazines to try to remember what it was like when you were a boy?*

Flávio: No. No, no, no, no.

Interviewer: *Because you look so carefully at the pictures that we've shown you, and when you look at them you talk about things you remember.*

Flávio: I always look at things closely, and I look at a lot of details because all of a sudden there's something I never saw before.

Interviewer: *You said that when you read about your life in the book, it makes you emotional. When you look at the photographs from your past, does that make you emotional too?*

Flávio: Well, photographs, you see it and it's gone. But when you read, it stays more in the mind. Because the expression of the words, the situation is going through your head, like a recorder.

Interviewer: *So, Flávio, can you tell us about your children?*

Flávio: Sure, I just have two.

Interviewer: *I thought you had three. . . .*

Flávio: No more. Flávio Jr., I don't know what he's doing now.

Interviewer: *Okay. You're not in touch?*

Flávio: We don't have no contact. A lot of years.

Interviewer: *Did you have a fight? An argument?*

Flávio: I don't have no contact with him. Even his mother don't haves.

Interviewer: *What about your other children? Do they live near you?*

Flávio: Yes. They live with their mother, very nearby. Felipe fixes sofas, chairs. Reupholsters. "Phil" is his nickname.

Interviewer: *Did you name your son after Phil Vandervoort?*

Flávio: Yeah.

Interviewer: *Wow . . . And what about your daughter? What is your daughter's name?*

Flávio: Shayla.

Interviewer: *Do you see—*

Flávio: In the moment I don't know exactly what she's doing. It's about two weeks that I didn't go there.

Interviewer: *So you normally go by to see her and her mother?*

Flávio: Almost every day I was going there. But . . . when you feel that you, there are situations that you can't see because . . . you stop . . .

Interviewer: *You step away?*

Flávio: Yeah.

Interviewer: *Do you have to help support your children, or do they have jobs?*

Flávio: No. They have their own jobs.

Interviewer: *Do they help you?*

Flávio: No, no, no.

Interviewer: *Even when you get sick?*

Flávio: Then, maybe they help a bit.

Interviewer: *Flávio, where are we right now? Can you describe it?*

Flávio: This is where I live.

Interviewer: *How many rooms is it? How big is it?*

Flávio: It's not too big. Two rooms and kitchen.

Interviewer: *How many square meters, do you think?*

Flávio: About two hundred forty, something like. This is a bedroom, and there's the living room, where I keep some necessities, and the kitchen is over there.

Interviewer: *Did you build all of this?*

Flávio: Yes, I did my home by myself. The simple things I know how to do. Those complicated things I don't.

Interviewer: *Did you hire somebody to help? Do you know how to do all of the electricity, the plumbing?*

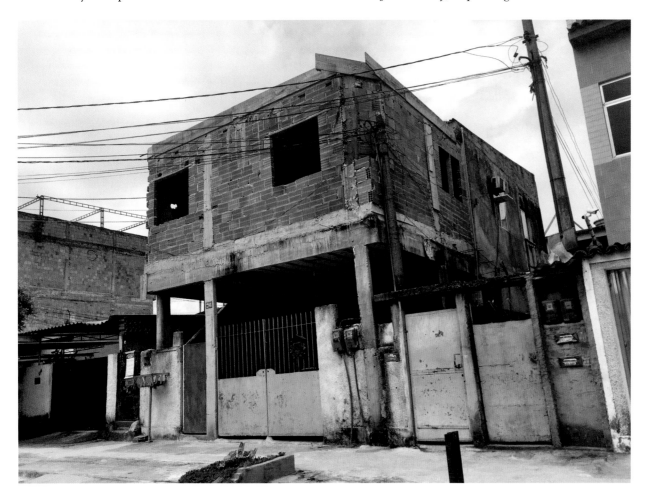

Home of Flávio da Silva and the da Silva family, Guadalupe, Rio de Janeiro, Brazil, December 2016. Courtesy Paul Roth

Flávio: I did most myself.

Interviewer: *When did you come back to the property to live?*

Flávio: After my wife and I separated, I come back to live. With my mother there in the house, it was full, so then we decided I could come back to the apartment back here. This upstairs part come later. I put everything down, the old one down, and start again.

Interviewer: *Was this a result of some sort of fighting with the family? Or did you move up here because you needed more space?*

Flávio: Everyone want to have your own space, get time to rest, get time to do what lives need to do.

Interviewer: *So what's your next project here? Obviously you aren't finished. What are you doing now to your house?*

Flávio: It's to finish what it needs.

Interviewer: *What does it need?*

Flávio: Cement first. What I can afford. Higher and higher, the price of everything. But recently was a low price for a moment, just one day. So I bought twelve at a time sack of cement. It's not enough, but it's a lot of cement to do the pavement. And for the sink, to give more protection.

Interviewer: *Is that everything?*

Flávio: Oh, each day needs some kind of job. I need tile for the kitchen, for the room. Also, I put this porch here, but I'm going to fix it right again because there's a little curve there. I have to get it in line like this, for the door to close well. And I still have to make a roof.

Interviewer: *Why, what's wrong with it?*

Flávio: The rooftop is leaking. Already I don't have any more of my things from the past, because there's water came in, pressing the roof over the house, and destroyed everything. My books from Gordon, the magazines, the letters, except for a few. I still have the dog from the cover of *Life.*

Interviewer: *The stuffed animal you got on the way to Denver?*

Flávio: I still have the dog. It's not very good anymore. Bugs and rot. When I got to finally see the leak, it's already done. I can't have these little things that matters, I think.

Interviewer: *You think you aren't meant to have them?*

Flávio: No, this time is still in my mind. . . . Years, no bugs can eat, nobody can touch it. It's the only place that nobody can take from you. Your thinking, your dreams, situations . . .

Interviewer: *What happened with your hand?*

Flávio: The finger's not here. Machine. Cutting wood.

Interviewer: *When did that happen?*

Flávio: Two years already.

Interviewer: *Oh, not so long ago.*

Flávio: I'm trying to . . . do my best.

Interviewer: *Do you think you'll finish the house?*

Flávio: Yeah, I do. That's to keep it more safer, I need to. But it's expensive. You spend so much because everything's more expensive.

Interviewer: *The cement, the tiles, I know, everything's going up.*

Flávio: Yeah. But I'm not without money, I have some money saved. So I will finish. You have to move forward. I not stop. I never stop, thinking to finish what I started to live. It's all in my mind almost every time.

List of Plates

Unless otherwise noted, all works are by Gordon Parks (1912–2006). Plates are indicated by page numbers.

4. Verso of *Untitled* (Flávio da Silva), Rio de Janeiro, Brazil, 1961
Gelatin silver print
13 x 8 9/16 in. (sheet)
International Center for Photography, The LIFE Magazine Collection, 2005
1596.2005

11. Catacumba Favela, Rio de Janeiro, Brazil, 1961
Gelatin silver print
13 3/8 x 7 11/16 in. (image/sheet)
International Center of Photography, The LIFE Magazine Collection, 2005
1602.2005

12. Untitled (Flávio and Zacarias da Silva), Rio de Janeiro, Brazil, 1961
Gelatin silver print
13 7/8 x 8 13/16 in. (image/sheet)
International Center of Photography, The LIFE Magazine Collection, 2005
1620.2005

13. The da Silva Shack in the Favela of Catacumba (Fire in the Alley), Rio de Janeiro, Brazil, 1961
Gelatin silver print
8 1/8 x 11 7/8 in. (image); 11 x 14 in. (sheet)
The Gordon Parks Foundation
GP01200

14. Zacarias Plays Beneath the da Silva Shack, Rio de Janeiro, Brazil, 1961
Gelatin silver print
14 1/8 x 9 3/4 in. (image/sheet)
International Center of Photography, The LIFE Magazine Collection, 2005
1599.2005

15. Untitled (Nair, Luzia, and Abia da Silva), Rio de Janeiro, Brazil, 1961
Gelatin silver print
13 1/4 x 8 13/16 in. (image/sheet)
International Center of Photography, The LIFE Magazine Collection, 2005
1601.2005

16. Untitled (The da Silva Children), Rio de Janeiro, Brazil, 1961

Gelatin silver print
13 1/4 x 9 1/8 in. (image/sheet)
The J. Paul Getty Museum, Los Angeles, purchased in part with funds provided by the Photographs Council, Trish and Jan de Bont, Daniel Greenberg and Susan Steinhauser, Manfred Heiting, Lyle and Lisi Poncher, and Devon Susholtz and Stephen Purvis
2015.26.3

17. Untitled (Flávio da Silva), Rio de Janeiro, Brazil, 1961
Gelatin silver print
13 3/8 x 8 3/4 in. (image/sheet)
International Center of Photography, The LIFE Magazine Collection, 2005
1616.2005

19. Flávio da Silva, Rio de Janeiro, Brazil, 1961
Gelatin silver print
13 1/8 x 9 in. (image/sheet)
International Center of Photography, The LIFE Magazine Collection, 2005
1618.2005

20. Luzia, the Favela, Rio de Janeiro, Brazil, 1961
Gelatin silver print
13 1/2 x 9 1/8 in. (image/sheet)
The J. Paul Getty Museum, Los Angeles, purchased in part with funds provided by the Photographs Council, Trish and Jan de Bont, Daniel Greenberg and Susan Steinhauser, Manfred Heiting, Lyle and Lisi Poncher, and Devon Susholtz and Stephen Purvis
2015.26.4

21. Untitled (Mário da Silva), Rio de Janeiro, Brazil, 1961
Gelatin silver print
13 x 8 1/2 in. (image/sheet)
The Gordon Parks Foundation
GP04628

23. Mário, Crying After Being Bitten by Dog, Rio de Janeiro, Brazil, 1961
Gelatin silver print
7 7/8 x 5 1/4 in. (image/sheet)
The J. Paul Getty Museum, Los Angeles, purchased with funds provided by the Photographs Council
2015.18.6

25. Abia and Isabel, Rio de Janeiro, Brazil, 1961
Gelatin silver print

9 1/16 x 11 3/4 in. (image); 11 x 13 7/8 in. (sheet)
The J. Paul Getty Museum, Los Angeles, purchased with funds provided by the Photographs Council
2015.18.11

26. Untitled (Nair da Silva), Rio de Janeiro, Brazil, 1961
Gelatin silver print
11 7/8 x 7 3/4 (image); 14 x 11 in. (sheet)
The Gordon Parks Foundation
GP01157

27. José da Silva, Rio de Janeiro, Brazil, 1961
Gelatin silver print
13 7/8 x 11 in. (image/sheet)
The J. Paul Getty Museum, Los Angeles, purchased with funds provided by the Photographs Council
2015.18.10

28. Flávio Feeds Zacarias, Rio de Janeiro, Brazil, 1961
Gelatin silver print
9 x 13 1/4 in. (image/sheet)
International Center of Photography, The LIFE Magazine Collection, 2005
1595.2005

29. Nair da Silva and Zacarias, Rio de Janeiro, Brazil, 1961
Gelatin silver print
12 x 9 in. (image); 14 x 11 in. (sheet)
The J. Paul Getty Museum, Los Angeles, purchased with funds provided by the Photographs Council
2015.18.12

30. The da Silva Family at Dawn, Rio de Janeiro, Brazil, 1961
Gelatin silver print
8 x 11 7/8 (image); 11 x 14 in. (sheet)
The Gordon Parks Foundation
GP00300

31. Family's Day Begins, Rio de Janeiro, Brazil, 1961
Gelatin silver print
10 3/4 x 14 in. (image); 11 x 14 in. (sheet)
The J. Paul Getty Museum, Los Angeles, purchased with funds provided by the Photographs Council
2015.18.3

33. Untitled (Flávio da Silva), Rio de Janeiro, Brazil, 1961

Gelatin silver print
9 x 13 3/8 in. (image/sheet)
International Center of Photography, The LIFE Magazine Collection, 2005
1597.2005

34. Untitled (Flávio da Silva), Rio de Janeiro, Brazil, 1961
Gelatin silver print
13 1/4 x 9 in. (image/sheet)
The J. Paul Getty Museum, Los Angeles, purchased in part with funds provided by the Photographs Council, Trish and Jan de Bont, Daniel Greenberg and Susan Steinhauser, Manfred Heiting, Lyle and Lisi Poncher, and Devon Susholtz and Stephen Purvis
2015.26.1

35. Untitled (Maria Penha da Silva), Rio de Janeiro, Brazil, 1961
Gelatin silver print
14 x 11 in. (image/sheet)
The Gordon Parks Foundation
GP01184

36. Untitled (Luzia da Silva), Rio de Janeiro, Brazil, 1961
Gelatin silver print
4 1/2 x 3 1/4 (image); 4 7/8 x 3 3/4 in. (sheet)
The Gordon Parks Foundation
GP05947

37. Isabel, Rio de Janeiro, Brazil, 1961
Gelatin silver print
12 7/8 x 8 3/4 in. (image); 14 x 11 1/16 in. (sheet)
The J. Paul Getty Museum, Los Angeles, purchased with funds provided by the Photographs Council
2015.18.8

39. Flávio After Asthma Attack (Under the Covers), Rio de Janeiro, Brazil, 1961
Gelatin silver print, mounted on masonite
45 3/4 x 29 5/8 (image/sheet/board)
The Gordon Parks Foundation
GP06209

40 (top). Untitled (Flávio and Mário da Silva), Rio de Janeiro, Brazil, 1961
Gelatin silver print
3 1/4 x 4 1/2 (image); 3 3/4 x 4 7/8 (sheet)
The Gordon Parks Foundation
GP05958

40 (bottom). Untitled (Maria and Mário da Silva), Rio de Janeiro, Brazil, 1961
Gelatin silver print
3 1/4 x 4 1/2 (image); 3 3/4 x 4 7/8 (sheet)
The Gordon Parks Foundation
GP05959

41. Untitled (Flávio da Silva), Rio de Janeiro, Brazil, 1961
Gelatin silver print
4 1/2 x 3 1/4 (image); 5 x 3 3/4 (sheet)
The Gordon Parks Foundation
GP05737

43. Isabel Beside Sick Father (Two Figures: Girl Crying), Rio de Janeiro, Brazil, 1961
Gelatin silver print, mounted on masonite
29 x 40 1/8 in. (image/sheet/board)
The Gordon Parks Foundation
GP06218

44–45. Flávio Amuses Smaller Brothers and Sisters, Rio de Janeiro, Brazil, 1961
Gelatin silver print
14 1/4 x 18 3/4 in. (image); 14 3/4 x 19 1/4 in. (sheet)
Collection of Lyle and Lisi Poncher

47. Flávio's Neighbor's Corpse (Cruciform Figure with Candles), Rio de Janeiro, Brazil, 1961
Gelatin silver print, mounted on masonite
30 3/8 x 21 in. (image/sheet/board)
The Gordon Parks Foundation
GP06162

48. Untitled (Mário and Flávio da Silva), Rio de Janeiro, Brazil, 1961
Gelatin silver print
3 1/2 x 3 1/2 in. (image); 4 7/8 x 4 in. (sheet)
The Gordon Parks Foundation
GP05952

49. Untitled (Flávio and Mário da Silva), Rio de Janeiro, Brazil, 1961
Gelatin silver print
10 5/8 x 10 7/16 in. (image/sheet)
International Center of Photography, The LIFE Magazine Collection, 2005
1617.2005

51. Untitled (Mário and Flávio da Silva), Rio de Janeiro, Brazil, 1961
Gelatin silver print
7 1/4 x 7 1/2 in. (image); 10 x 8 in. (sheet)
International Center of Photography, Museum Purchase, International Fund for Concerned Photography, 1974
343.1974

55. Untitled (The da Silvas' New Home in the Guadalupe District), Rio de Janeiro, Brazil, 1961
Gelatin silver print
9 1/8 x 13 1/2 in. (image); 11 x 14 in. (sheet)
The J. Paul Getty Museum, Los Angeles, purchased with funds provided by the Photographs Council
2015.18.13

56. Untitled (José, Nair, and Zacarias da Silva and José's Sister-in-Law Stand at the Window of Their New Home), Rio de Janeiro, Brazil, 1961
Gelatin silver print
9 1/4 x 13 1/2 (image); 11 x 14 in. (sheet)
The Gordon Parks Foundation
GP01119

57. Paulo Muniz
(Brazilian, 20th century)
Untitled (His New Shoes), 1961
Gelatin silver print
13 3/8 x 9 1/4 (image); 14 x 11 in. (sheet)
The Gordon Parks Foundation
GP01169

59. Paulo Muniz
(Brazilian, 20th century)
Untitled (Too Much to Bear), 1961
Gelatin silver print
19 1/2 x 14 in. (image/sheet)
The Gordon Parks Foundation
GP01194

60–61. Proof sheet, Set No. 63020, Take No. 2, C-1, 1961
Gelatin silver print
8 x 10 in. (sheet)
The Gordon Parks Foundation
63020_2C-1

62. Untitled (Flávio da Silva), 1961
Original 35mm negative (Set No. 63020, Take No. 3, C-2)
The Gordon Parks Foundation
42.216

63. Carl Iwasaki
(American, 1923–2016)
LIFE photographer Gordon Parks arriving in U.S. with Flávio da Silva, boy from slums of Rio de Janeiro, 1961
Gelatin silver print
Dimensions unknown
The LIFE Images Collection

64–65. Carl Iwasaki
(American, 1923–2016)
Untitled (Bewildered Patient in the U.S.), Denver, Colorado, 1961
Gelatin silver print
9 1/4 x 13 1/2 (image); 11 x 14 in. (sheet)
The Gordon Parks Foundation
GP01100

66. Carl Iwasaki
(American, 1923–2016)
Flávio da Silva, boy from slums of Brazil, being examined by American doctors for asthma, 1961
Gelatin silver print
Dimensions unknown
The LIFE Images Collection

67. Carl Iwasaki
(American, 1923–2016)
Doctors testing Flávio da Silva for allergies, 1961
Gelatin silver print
Dimensions unknown
The LIFE Images Collection

69. Carl Iwasaki
(American, 1923–2016)
Untitled (Joining a Game), Denver, Colorado, 1961
Gelatin silver print
9 1/4 x 13 1/2 (image); 11 x 14 in. (sheet)
The Gordon Parks Foundation
GP01134

70. Carl Iwasaki
(American, 1923–2016)
Untitled (Refusing to Bat), Denver, Colorado, 1961
Gelatin silver print
13 3/8 x 9 1/4 (image); 14 x 11 in. (sheet)
The Gordon Parks Foundation
GP01139

71. Carl Iwasaki
(American, 1923–2016)
Untitled (Flávio da Silva), Denver, Colorado, 1961
Gelatin silver print
13 1/2 x 9 1/4 (image); 14 x 11 in. (sheet)
The Gordon Parks Foundation
GP01141

72. Carl Iwasaki
(American, 1923–2016)
Flávio da Silva, boy from slums of Brazil, enjoying an American amusement park, 1961
Gelatin silver print
Dimensions unknown
The LIFE Images Collection

73. Carl Iwasaki
(American, 1923–2016)
Untitled (A Gentle Moment), Denver, Colorado, 1961
Gelatin silver print
9 1/4 x 13 3/8 (image); 11 x 14 in. (sheet)
The Gordon Parks Foundation
GP01140

74. Carl Iwasaki
(American, 1923–2016)
Untitled (Learning a New Language), Denver, Colorado, 1961
Gelatin silver print
9 1/4 x 13 3/8 (image); 11 x 14 in. (sheet)
The Gordon Parks Foundation
GP01159

75. Carl Iwasaki
(American, 1923–2016)
A Brazilian boy, Flávio da Silva, showing off his art work at school, 1962
Gelatin silver print
Dimensions unknown
The LIFE Images Collection

76. Carl Iwasaki
(American, 1923–2016)
A Brazilian boy, Flávio da Silva, attending school, 1962
Gelatin silver print
Dimensions unknown
The LIFE Images Collection

77. Carl Iwasaki
(American, 1923–2016)
Rescued slum child Flávio da Silva of Brazil participating in American classroom, 1962
Gelatin silver print
Dimensions unknown
The LIFE Images Collection

79. Carl Iwasaki
(American, 1923–2016)
A Brazilian boy, Flávio da Silva, fixing his hair, 1962
Gelatin silver print
Dimensions unknown
The LIFE Images Collection

80. José Gonçalves
(American, born 1927)
Christmas at the Gonçalves Home, Denver, Colorado, 1963
Chromogenic print
4 5/8 x 3 1/8 in. (image); 5 x 3 1/2 in. (sheet)
The Gordon Parks Foundation
GP01173

81 (top). José Gonçalves
(American, born 1927)
Thanksgiving at the Gonçalves Home. Flávio's Very First Turkey Dinner, Denver, Colorado, ca. 1961
Chromogenic print
3 1/2 x 4 7/8 in. (image/sheet)
The Gordon Parks Foundation
GP01174

81 (center). José Gonçalves
(American, born 1927)
Flávio's Birthday Cake, Denver, Colorado, April 14, 1963
Chromogenic print
3 1/2 x 4 7/8 in. (image/sheet)
The Gordon Parks Foundation
GP01171

81 (bottom). José Gonçalves
(American, born 1927)
Christmas, Flávio Presents Kathy Sweet Rolls for a Present, Denver, Colorado, 1961
Chromogenic print
3 1/8 x 4 5/8 in. (image); 3 1/2 x 5 in. (sheet)
The Gordon Parks Foundation
GP01172

82 (top). José Gonçalves
(American, born 1927)
Untitled (Gonçalves Boys and Flávio da Silva, Easter), Denver, Colorado, 1962
Chromogenic print
3 1/8 x 4 5/8 in. (image); 3 1/2 x 5 in. (sheet)
The Gordon Parks Foundation
GP13282

82 (bottom). José Gonçalves
(American, born 1927)
Untitled (Mark Gonçalves and Flávio da Silva, Easter), Denver, Colorado, 1962
Chromogenic print
3 1/8 x 4 5/8 in. (image); 3 1/2 x 5 in. (sheet)
The Gordon Parks Foundation
GP13406

83 (top). José Gonçalves
(American, born 1927)
Untitled (Flávio da Silva), Denver, Colorado, ca. 1963
Chromogenic print
3 1/2 x 4 7/8 in. (image/sheet)
The Gordon Parks Foundation
GP13408

83 (bottom). José Gonçalves
(American, born 1927)
Untitled (Flávio da Silva), Denver,
Colorado, ca. 1962–1963
Chromogenic print
3 1/8 x 4 5/8 in. (image); 3 1/2 x 5
in. (sheet)
The Gordon Parks Foundation
GP13408

84 (top). José Gonçalves
(American, born 1927)
Kathy Gonçalves and Flávio in
the Denver Hills, Colorado, 1961
Gelatin silver print
6 5/8 x 9 5/8 in. (image); 8 x 10
in. (sheet)
The Gordon Parks Foundation
GP01176

84 (bottom). José Gonçalves
(American, born 1927)
Flávio with the Three Gonçalves
Boys (Neil, Mark, and Rick),
Denver, Colorado, 1961
Gelatin silver print
6 5/8 x 9 5/8 in. (image); 8 x 10
in. (sheet)
The Gordon Parks Foundation
GP01180

85. José Gonçalves
(American, born 1927)
Flávio Catches His First Fish,
Denver, Colorado, 1961
Gelatin silver print
9 5/8 x 6 5/8 in. (image); 10 x 8
in. (sheet)
The Gordon Parks Foundation
GP01582

86. José Gonçalves
(American, born 1927)
Untitled (Flávio da Silva and
Others at Train Station), Denver,
Colorado, July 27, 1963
Chromogenic print
3 1/8 x 4 5/8 in. (image); 3 1/2 x 5
in. (sheet)
The Gordon Parks Foundation
GP13401

87. José Gonçalves
(American, born 1927)
Flávio Waves Goodbye to the
Gonçalves Family from the Train
That Will Take Him to New York,
Denver, Colorado, July 27, 1963
Gelatin silver print
6 5/8 x 9 5/8 in. (image); 8 x 10
in. (sheet)
The Gordon Parks Foundation
GP01179

141. Henri Ballot
(Brazilian, 1921–1997)
Maria, Flávio's Grandmother,
and Her Other Grandchildren,
Reading *Life* Magazine,
Guadalupe, Rio de Janeiro,
Brazil, 1961
(Maria, avó de Flávio, e seus
outros netos lendo a revista *Life*,
Guadalupe, Rio de Janeiro, Brasil,
1961)
Gelatin silver print
6 1/4 x 9 3/8 in. (image/sheet)
Instituto Moreira Salles
023Nova Iorque123

142. Henri Ballot
(Brazilian, 1921–1997)
Henri Ballot, Standing, and

Reporter Mário de Moraes,
Showing Gordon Parks' Report in
Life Magazine to Flávio's Family,
Guadalupe, Rio de Janeiro,
Brazil, 1961
(O fotógrafo Henri Ballot, de pé,
e o repórter Mário de Moraes,
mostrando a reportagem de
Gordon Parks na revista *Life* para
a família de Flávio, Guadalupe,
Rio de Janeiro, Brasil, 1961)
Gelatin silver print
6 1/4 x 9 3/8 in. (image/sheet)
Instituto Moreira Salles
023Nova Iorque116

143. Henri Ballot
(Brazilian, 1921–1997)
Maria da Penha, Flávio's Sister,
with Her Dog on Her Lap,
Guadalupe, Rio de Janeiro,
Brazil, 1961
(Maria da Penha, irmã de Flávio,
com seu cachorro no colo,
Guadalupe, Rio de Janeiro, Brasil,
1961)
Gelatin silver print
6 3/4 x 9 1/4 in. (image/sheet)
Instituto Moreira Salles
023Nova Iorque119
The white arrow indicates Abia.

144. Henri Ballot
(Brazilian, 1921–1997)
José da Silva, Catacumba Hill,
Rio de Janeiro, Brazil, 1961
(José da Silva, Morro da
Catacumba, Rio de Janeiro,
Brasil, 1961)
Gelatin silver print
6 3/8 x 9 1/2 in. (image/sheet)
Instituto Moreira Salles
023Nova Iorque129

145. Henri Ballot
(Brazilian, 1921–1997)
José da Silva Leaning on a
Cabinet, with Drawer Handles
Made from Coffin Handles,
Catacumba Hill, Rio de Janeiro,
Brazil, 1961
(José da Silva apoiado no
armário, cujos puxadores das
gavetas foram feitos com alças de
caixão, Morro da Catacumba,
Rio de Janeiro, Brasil, 1961)
Gelatin silver print
9 7/8 x 6 1/8 in. (image/sheet)
Instituto Moreira Salles
023Nova Iorque089
The white arrows indicate the
handles.

146. Henri Ballot
(Brazilian, 1921–1997)
Iracy, a Neighbor of the da Silva
Family, Pointing Out Where the
Photographs for Gordon Parks'
Report Were Taken, Catacumba
Hill, Rio de Janeiro, Brazil, 1961
(Iracy, vizinha do casal da Silva,
mostrando onde foram tiradas as
fotografias da reportagem
de Gordon Parks, Morro da
Catacumba, Rio de Janeiro,
Brasil, 1961)
Gelatin silver print
9 1/8 x 6 in. (image/sheet)
Instituto Moreira Salles
023Nova Iorque122

147. Henri Ballot
(Brazilian, 1921–1997)

Raimundo Genito, a Cameraman
for TV Tupi, Filming the Broken-
Tiled Roof, Catacumba Hill, Rio
de Janeiro, Brazil, 1961
(Cinegrafista da TV Tupi,
Raimundo Genito, filmando
o teto destelhado, Morro da
Catacumba, Rio de Janeiro,
Brasil, 1961)
Gelatin silver print
9 1/4 x 6 3/8 in. (image/sheet)
Instituto Moreira Salles
023Nova Iorque083

148–149. Henri Ballot
(Brazilian, 1921–1997)
Apartment Building Where
the Gonzalez Family Lived,
Manhattan, New York, 1961
(Edifício onde morava a família
Gonzalez, Manhattan, Nova
Iorque, 1961)
Gelatin silver print
7 1/8 x 9 1/2 in. (image/sheet)
Instituto Moreira Salles
023Nova Iorque109

150. Henri Ballot
(Brazilian, 1921–1997)
Neighborhood of the Gonzalez
Family, Manhattan, New York,
1961
(Arredores da residência da
família Gonzalez, Manhattan,
Nova Iorque, 1961)
Gelatin silver print
9 1/8 x 6 5/8 in. (image/sheet)
Instituto Moreira Salles
023Nova Iorque041

151. Henri Ballot
(Brazilian, 1921–1997)
Neighborhood of the Gonzalez
Family, Manhattan, New York,
1961
(Arredores da residência da
família Gonzalez, Manhattan,
Nova Iorque, 1961)
Gelatin silver print
6 5/8 x 9 1/8 in. (image/sheet)
Instituto Moreira Salles
023Nova Iorque054

153. Henri Ballot
(Brazilian, 1921–1997)
Neighborhood of the Gonzalez
Family, Manhattan, New York,
1961
(Arredores da residência da
família Gonzalez, Manhattan,
Nova Iorque, 1961)
Gelatin silver print
9 1/2 x 7 1/8 in. (image/sheet)
Instituto Moreira Salles
023Nova Iorque042

154. Henri Ballot
(Brazilian, 1921–1997)
Child Playing on Wasteland Used
as a Trash Dump, Manhattan,
New York, 1961
(Criança brincando em um ter-
reno baldio usado para depositar
lixo, Manhattan, Nova Iorque,
1961)
Gelatin silver print
9 1/2 x 6 1/4 in. (image/sheet)
Instituto Moreira Salles
023Nova Iorque111

155. Henri Ballot
(Brazilian, 1921–1997)
Child Playing Surrounded by

Trash, Manhattan, New York,
1961
(Criança brincando em meio ao
lixo, Manhattan, Nova Iorque,
1961)
Gelatin silver print
7 1/8 x 9 1/2 in. (image/sheet)
Instituto Moreira Salles
023Nova Iorque107

157. Henri Ballot
(Brazilian, 1921–1997)
Neighborhood of the Gonzalez
Family, Manhattan, New York,
1961
(Arredores da residência da
família Gonzalez, Manhattan,
Nova Iorque, 1961)
Gelatin silver print
9 1/2 x 7 1/8 in. (image/sheet)
Instituto Moreira Salles
023Nova Iorque032

159. Henri Ballot
(Brazilian, 1921–1997)
Child Crying at the Window,
Manhattan, New York, 1961
(Criança chorando na janela,
Manhattan, Nova Iorque, 1961)
Gelatin silver print
9 1/2 x 7 1/8 in. (image/sheet)
Instituto Moreira Salles
023Nova Iorque074

160. Henri Ballot
(Brazilian, 1921–1997)
One of the Gonzalez Boys in the
Hallway, Manhattan, New York,
1961
(Filho do casal Gonzalez no
corredor do edifício, Manhattan,
Nova Iorque, 1961)
Gelatin silver print
9 1/8 x 6 3/8 in. (image/sheet)
Instituto Moreira Salles
023Nova Iorque017

161. Henri Ballot
(Brazilian, 1921–1997)
Family, Manhattan, New York,
1961
(Família, Manhattan, Nova
Iorque, 1961)
Gelatin silver print
9 1/8 x 6 1/8 in. (image/sheet)
Instituto Moreira Salles
023Nova Iorque038

162. Henri Ballot
(Brazilian, 1921–1997)
The Gonzalez Family,
Manhattan, New York, 1961
(Família Gonzalez, Manhattan,
Nova Iorque, 1961)
Gelatin silver print
6 5/8 x 9 1/2 in. (image/sheet)
Instituto Moreira Salles
023Nova Iorque060

163. Henri Ballot
(Brazilian, 1921–1997)
Ely-Samuel Gonzalez, Manhattan,
New York, 1961
(Ely-Samuel Gonzalez,
Manhattan, Nova Iorque, 1961)
Gelatin silver print
7 1/8 x 9 1/2 in. (image/sheet)
Instituto Moreira Salles
023Nova Iorque069

164. Henri Ballot
(Brazilian, 1921–1997)
Ely-Samuel Gonzalez and His

Mother, Esther Gonzalez, Manhattan, New York, 1961 (Ely-Samuel Gonzalez e sua mãe, Esther Gonzalez, Manhattan, Nova Iorque, 1961)
Gelatin silver print
9 1/2 x 6 3/8 in. (image/sheet)
Instituto Moreira Salles
023Nova Iorque004

165. Henri Ballot
(Brazilian, 1921–1997)
Ely-Samuel Gonzalez on His Bed, Manhattan, New York, 1961 (Ely-Samuel Gonzalez em seu leito, Manhattan, Nova Iorque, 1961)
Gelatin silver print
9 1/8 x 6 1/8 in. (image/sheet)
Instituto Moreira Salles
023Nova Iorque036

167. Henri Ballot
(Brazilian, 1921–1997)
Bedroom in the Gonzalez Family Apartment, Manhattan, New York, 1961 (Quarto na casa da família Gonzalez, Manhattan, Nova Iorque, 1961)
Gelatin silver print
7 1/8 x 9 1/2 in. (image/sheet)
Instituto Moreira Salles
023Nova Iorque037

179. Flávio During Author's Second Visit to Brazil, Rio de Janeiro, Brazil, 1976
Gelatin silver print
12 x 8 1/2 in. (image); 14 x 11 in. (sheet)
The J. Paul Getty Museum, Los Angeles, purchased with funds provided by the Photographs Council
2015.18.16

181. Photographer unknown
Untitled (Flávio and Cleuza Take Their Wedding Vows), Rio de Janeiro, Brazil, ca. 1970–1971
Gelatin silver print (copy photograph)
9 1/4 x 13 3/8 in. (image); 11 x 14 in. (sheet)
The Gordon Parks Foundation
GP03707

182. Photographer unknown
Untitled (Flávio and Cleuza on Their Wedding Day), Rio de Janeiro, Brazil, ca. 1970–1971
Gelatin silver print (copy photograph)
13 3/8 x 9 1/8 in. (image); 11 x 14 in. (sheet)
The Gordon Parks Foundation
GP01161

183. Photographer unknown
Untitled (Flávio and Cleuza on Their Wedding Day), Rio de Janeiro, Brazil, ca. 1970–1971
Gelatin silver print (copy photograph)
9 1/8 x 13 3/8 in. (image); 11 x 14 in. (sheet)
The Gordon Parks Foundation
GP01160

185. Untitled (Flávio da Silva), Rio de Janeiro, Brazil, 1976
Gelatin silver print

13 1/2 x 9 1/4 in. (image); 13 7/8 x 11 in. (sheet)
The J. Paul Getty Museum, Los Angeles, purchased with funds provided by the Photographs Council
2015.18.14

186. Untitled (Flávio da Silva), Rio de Janeiro, Brazil, 1976
Gelatin silver print
13 1/2 x 9 1/4 in. (image); 14 x 11 in. (sheet)
The Gordon Parks Foundation
GP01137

187. Flávio Looking at Gordon Parks' Book *Moments Without Proper Names*, Rio de Janeiro, Brazil, 1976
Gelatin silver print
13 1/2 x 9 3/8 in. (image); 14 x 11 in. (sheet)
The Gordon Parks Foundation
GP01136

188. Untitled (Flávio da Silva and José Gallo), Rio de Janeiro, Brazil, 1976
Gelatin silver print
9 1/4 x 13 1/2 in. (image); 11 x 14 in. (sheet)
The Gordon Parks Foundation
GP01087

189. Untitled (Flávio and Flávio Jr., Cleuza, Isabel, and Felipe Luiz, Guadalupe District), Rio de Janeiro, Brazil, 1976
Gelatin silver print
9 1/8 x 13 3/8 in. (image); 11 x 14 in. (sheet)
The Gordon Parks Foundation
GP03702

190. Untitled (Cleuza and Felipe Luiz da Silva), Rio de Janeiro, Brazil, 1976
Gelatin silver print
9 1/4 x 13 1/2 in. (image); 11 x 14 in. (sheet)
The Gordon Parks Foundation
GP01130

191. Untitled (Abia and Isabel), Rio de Janeiro, Brazil, 1976
Gelatin silver print
13 3/8 x 9 3/8 in. (image); 14 x 11 in. (sheet)
The Gordon Parks Foundation
GP03712

192. Untitled (Luzia and Her Daughter), Rio de Janeiro, Brazil, 1976
Gelatin silver print
13 1/2 x 9 1/4 in. (image); 14 x 11 in. (sheet)
The Gordon Parks Foundation
GP03711

193. Untitled (Nair da Silva), Rio de Janeiro, Brazil, 1976
Gelatin silver print
13 1/2 x 9 1/4 in. (image); 14 x 11 in. (sheet)
The Gordon Parks Foundation
GP03706

195. Untitled (Flávio, His Mother and Brothers and Sisters), Rio de Janeiro, Brazil, 1976
Gelatin silver print

9 x 13 3/8 in. (image); 11 x 14 in. (sheet)
The J. Paul Getty Museum, Los Angeles, purchased with funds provided by the Photographs Council
2015.18.15

196. Untitled (Flávio Jr. in Tree and Felipe Luiz), Rio de Janeiro, Brazil, 1976
Gelatin silver print
13 1/2 x 9 1/4 in. (image); 14 x 11 in. (sheet)
The Gordon Parks Foundation
GP03710

197. Untitled (Flávio da Silva in His Chicken Coop), Rio de Janeiro, Brazil, 1976
Gelatin silver print
13 1/2 x 9 3/8 in. (image); 14 x 11 in. (sheet)
The Gordon Parks Foundation
GP03708

199. Untitled (Flávio and Cleuza da Silva), Rio de Janeiro, Brazil, 1976
Gelatin silver print
13 1/2 x 9 1/4 in. (image); 14 x 11 in. (sheet)
The Gordon Parks Foundation
GP01162

200–201. Envelope (left) and Letter (right) from Flávio da Silva to Gordon Parks, December 19, 1977
The Gordon Parks Foundation

205. Untitled (Flávio da Silva), Rio de Janeiro, Brazil, 1999
Gelatin silver print
9 3/8 x 6 1/2 in. (image); 8 x 10 in. (sheet)
The Gordon Parks Foundation
GP00681

206–207. Proof sheet, Set No. 93350-401, C-2, 1999
Gelatin silver print
8 1/2 x 11 in. (sheet)
The Gordon Parks Foundation
93350_401_C-2

208. Untitled (Flávio da Silva), Rio de Janeiro, Brazil, 1999
Gelatin silver print
6 1/2 x 9 3/8 in. (image); 8 x 10 in. (sheet)
The Gordon Parks Foundation
GP00651

209. Untitled (Flávio da Silva), Rio de Janeiro, Brazil, 1999
Gelatin silver print
6 1/2 x 9 3/8 in. (image); 8 x 10 in. (paper)
The Gordon Parks Foundation
GP00741

304. Verso of *Flávio After Asthma Attack*, Rio de Janeiro, Brazil, 1961
Gelatin silver print
8 5/8 x 7 in. (sheet)
International Center for Photography, The LIFE Magazine Collection, 2005
1593.2005

Biographies

GORDON PARKS was born into poverty and segregation in Fort Scott, Kansas, in 1912. An itinerant laborer, he worked as a brothel pianist and railcar porter, among other jobs, before buying a camera at a pawnshop, training himself, and becoming a photographer. During his storied tenures photographing for the Farm Security Administration (1941–1945) and *Life* magazine (1948–c. 1971), Parks evolved into a modern-day Renaissance man; he found success as a film director, writer, and composer. The first African American director to helm a major motion picture, he helped launch the blaxploitation genre with his film *Shaft* (1971). He wrote numerous memoirs, novels, and books of poetry, and received countless awards, including the National Medal of Arts, and more than fifty honorary degrees. Parks died in 2006.

HENRI BALLOT was born in 1921 in Pelotas in southern Brazil and moved to France during his childhood. He was a member of the French Resistance in World War II and flew as a pilot for the Free French Air Forces. After returning to Brazil in 1949, he freelanced for the tabloid *Radar* and the *Revista do Globo* until 1951, when he started at the weekly *O Cruzeiro*. He continued working for the magazine until 1968. Among his many reports, two stand out: one on the situation of indigenous peoples of Brazil and one on poverty in New York City, which challenged Gordon Parks' photo essay on Flávio da Silva and poverty in a favela of Rio de Janeiro, published in *Life*. Ballot died in 1997. His photographic works are now in the collection of the Instituto Moreira Salles in Brazil.

SÉRGIO BURGI holds an undergraduate degree in social sciences from the University of São Paulo and an MFA in photography and an associate degree in photographic science from the Rochester Institute of Technology School of Photographic Arts and Sciences. He was coordinator of the Brazilian National Arts Foundation's (FUNARTE) Center for the Conservation and Preservation of Photography between 1984 and 1991. A member of the Photography Conservation Group of the Committee for Conservation of the International Council of Museums (ICOM), he has since 1999 directed the photography department of the Instituto Moreira Salles, Brazil's principal institution for the safekeeping and preservation of photographic collections.

BEATRIZ JAGUARIBE is a professor in the School of Communication of the Federal University of Rio de Janeiro. She has been a visiting professor at Dartmouth College, Stanford University, the New School, Princeton University, New York University, and the University of Cergy-Pontoise in France. She has written books and essays on urban culture, media culture, and Latin American literature and culture. Among her books are *Fins de século: Cidade e cultura no Rio de Janeiro* (1998), *O choque do real* (2007), and *Rio de Janeiro: Urban Life Through the Eyes of the City* (2014).

PETER W. KUNHARDT, JR., is executive director of the Meserve-Kunhardt Foundation and the Gordon Parks Foundation. Recent museum exhibitions in which he has been involved include *Gordon Parks: I Am You, Selected Works 1942–1978* (C/O Berlin, 2016), *Invisible Man: Gordon Parks and Ralph Ellison in Harlem* (Art Institute of Chicago, 2016), and *Gordon Parks: Back to Fort Scott* (Museum of Fine Arts, Boston, 2015). He coedited the multivolume *Gordon Parks: Collected Works* (2012), and edited *The Photographs of Abraham Lincoln* (2015). He is responsible for the Meserve-Kunhardt Foundation's acquisition of the archive of *Life* photographer Ed Clark. Kunhardt has established a scholarship program and a fellowship program awarding grants to young artists.

AMANDA MADDOX is associate curator in the Department of Photographs at the J. Paul Getty Museum. Her most recent publications include *Ishiuchi Miyako: Postwar Shadows* (2015) and *Thomas Annan: Photographer of Glasgow* (2017).

MARIA ALICE REZENDE DE CARVALHO is a professor in the Center for Social Sciences at the Pontifical Catholic University of Rio de Janeiro, and is the coordinator of CENTRAL-Urban Research Nucleus. Her research focuses on the relationship between intellectual life and urban experiences. Her publications include *Quatro vezes cidade* (1994), *O quinto século* (1998), and *Irineu Marinho: Imprensa e cidade* (2012).

PAUL ROTH is director of the Ryerson Image Centre in Toronto, Canada. He previously served as senior curator of Photography and Media Arts at the Corcoran Gallery of Art in Washington, D.C., and as executive director of The Richard Avedon Foundation in New York City. He is author and coeditor of *Gordon Parks: Collected Works*.

NATALIE SPAGNOL is a curatorial assistant at the Ryerson Image Centre and previously served as director of operations at Stephen Bulger Gallery, also in Toronto. She holds a graduate degree in art history and curatorial studies from York University, Toronto. She is coeditor of *Pete Doherty: World's Greatest* (2013).

Acknowledgments

Gordon Parks: The Flávio Story is the result of a transnational, multiyear collaboration supported by diverse institutions. Working in concert with the Gordon Parks Foundation in the United States, three museums have contributed to this book and will present accompanying exhibitions across the Americas: the Ryerson Image Centre in Toronto, Canada; the J. Paul Getty Museum in Los Angeles, United States; and Instituto Moreira Salles in Rio de Janeiro and São Paulo, Brazil.

The editors would like to thank the Gordon Parks Foundation for its co-presentation and unflagging support of this project, and for working so diligently to preserve and promote the work and legacy of Gordon Parks. Without the Foundation's commitment, this book would not exist. We are grateful to Peter W. Kunhardt, Jr., its executive director, for helping to initiate and sustain this project over many years, and for granting the opportunity to delve deeply into this subject. We are profoundly indebted to our project manager, the Foundation's assistant director, Amanda Smith, who served as associate editor for the book—working tirelessly and patiently to gather the elements and coordinate the many moving parts. Copy editor Anna Jardine brought her skills to bear on the texts in this volume; we truly appreciate her precision and tenacity. It has been a distinct pleasure to work with the rest of the Foundation's dedicated team as well, including Marisa Cardinale, James L. Jordan, Brigid Slattery, Sara Krugman, Tom Conway, and Logan Adler. The Foundation's Board of Directors has also championed the project; in particular, founding chair Peter W. Kunhardt encouraged us throughout the gestation of *The Flávio Story*, and we are very grateful for his backing. Board member Genevieve (Gene) Young, Parks' third wife and his frequent editor during her distinguished career at J. B. Lippincott and other publishers, offered remarkable insight into Parks and his writing methods.

At the Ryerson Image Centre, we express our utmost gratitude to curatorial assistant Natalie Spagnol, the book's assistant editor, for her research support, project management, and crystalline introductions to each plate section. Natalie's organizational and administrative skills have been invaluable. In addition, Alexandra Gooding contributed important research. We thank curators Gaëlle Morel and Denise Birkhofer, and head of research Thierry Gervais, for their generous cooperation. We also appreciate the contributions of the RIC's outstanding exhibitions team, including Valérie Matteau, senior exhibitions officer; Chantal Wilson, registrar and collections officer; Eric Glavin, art installer and facility technician; and Jennifer Park, art preparator. We thank Erin Warner, marketing and communications coordinator; Heather Kelly, marketing specialist; Laura Margaret Ramsey, digital imaging assistant; Sophia Costomiris, financial and administrative assistant; and the rest of the RIC team for their tireless assistance with the show. For fundraising support, thanks are due to Aleksandar Zakonovic and Ashley Raghubir. Finally, we are grateful to the leadership team of Ryerson University for their unwavering confidence: Mohamed Lachemi, president and vice chancellor; Michael Benarroch, provost and vice president, academic; Chris Evans, interim provost and vice president, academic; and Amy Casey, Marsha McEachrane Mikhail, Ian Mishkel, Rivi Frankle, Julia Shin Doi, and Michael Forbes.

At the J. Paul Getty Museum, the editors would like to thank director Timothy Potts and associate director of collections Richard Rand for their consistent advocacy of the Department of Photographs' exhibition program, and their encouragement of *The Flávio Story* in particular. Virginia Heckert, curator and department head, stood behind this project, from the acquisition of a significant cache of Parks' photographs for the Museum's collection, through realization of this book, to organization of the exhibition: we appreciate her investment in our efforts. Also in the Department of Photographs, we thank Arpad Kovacs, assistant curator; Miriam Katz, research associate; and Adam Monohon, former graduate intern. The Getty Museum Photographs Council fervently supported this endeavor: special thanks to Council members Trish and Jan de Bont, Daniel Greenberg and Susan Steinhauser, Manfred Heiting, Lisi Rona and Lyle Poncher, and Devon Susholtz and Stephen Purvis. We are especially indebted to the Ponchers, who graciously loaned work from their collection for the exhibitions. Also at the Getty, we thank Carolyn Marsden-Smith, associate director of exhibitions, and the Exhibitions Department; Marc Harnly, senior conservator, and the Department of Paper Conservation; Merritt Price and the Design Department; Lisa Clements, assistant director, and the Department of Education, Public Programs and Interpretive Content; Betsy Severance, chief registrar, and the Registrar's Office; Kevin Marshall, head of preparations, and the Preparations Department; and Michael Smith and the Imaging Services Department.

At Instituto Moreira Salles, we thank Flávio Pinheiro, executive superintendent, for his steadfast belief in the project. Our colleague and friend Sérgio Burgi, curator and photography coordinator at IMS Rio, readily agreed when we asked him to share his knowledge

of Henri Ballot and *O Cruzeiro*'s campaign against Parks and *Life* magazine, a story little known outside Brazil. We are grateful to him for answering our call, and for the fascinating essay he has contributed to this book. We also greatly appreciate the assistance of Joanna Barbosa Balabram and Andrea Wanderley, and the encouragement of Thyago Nogueira, curator and head of contemporary photography at IMS Paulista.

A significant number of institutions supported our research for *The Flávio Story*. The collection of the International Center of Photography in New York City holds important prints associated with Parks' photo essay, including many that were reproduced in the story's first appearance in *Life*, and we are grateful to be able to publish and borrow a selection of these for this book and the accompanying exhibition. At ICP, we thank Mark Lubell, the museum's executive director, as well as Claartje van Dijk, Erin Barnett, Cynthia Young, Christopher George, and Pauline Vermare. Records and ephemera from Gordon Parks' life and career are preserved in archives at three institutions besides the Gordon Parks Foundation; all proved indispensable. At the Library of Congress in Washington, D.C., we thank the librarians in the Manuscript Reading Room and Motion Picture and Television Reading Room. At the Ablah Library Special Collections at Wichita State University, Wichita, Kansas, we thank Mary Nelson. And at the Gordon Parks Museum for Culture and Diversity in Fort Scott, Kansas, our appreciation goes to Jill Warford, the dedicated founder and director. Additional critical research was conducted in the Time Inc. Archives, housed at the New-York Historical Society in New York City; we are grateful to Bill Hooper, Time Inc. archivist, and to Tammy Kiter and her colleagues in the Patricia D. Klingenstein Library at the Historical Society. The archive of the Children's Asthma Research Institute and Hospital, where Flávio recuperated from chronic asthma, is housed in the Beck Archives, University Libraries Special Collections and Archives, at the University of Denver in Colorado. We thank Jeanne Abrams, Thyria Wilson, and Aaron Davis for their assistance. Joshua Chuang and Johnny Gore at the New York Public Library provided essential help with our research on the film *Flavio*. We express our gratitude to Bob Workman at the Ulrich Museum of Art, Wichita State University, and to Linda Duke and Sarah Price at the Marianna Beach Kistler Museum of Art at Kansas State University, Manhattan, Kansas.

Many other people contributed to *The Flávio Story*, in myriad ways. We are immensely indebted to Beatriz Jaguaribe and Maria Alice Rezende de Carvalho for their excellent essay, which places the favela in the cultural and historical context of 1950s–1960s Rio de Janeiro. Photographer and curator Leo Rubinfein recommended and introduced us to Beatriz. José and Rick Gonçalves, members of Flávio da Silva's surrogate family in Denver from 1961 to 1963, generously authorized reproduction of their family photographs and agreed to be interviewed for this book; we greatly appreciate their help. Jeanne Moutoussamy-Ashe, Parks' photography assistant during his 1976 return visit to Rio de Janeiro, went above and beyond to share her memories and insight. Parks dedicated the book resulting from that trip, *Flavio*, to Leslie Parks Bailey, his youngest daughter; we thank her for inspiring us, and for expressing enthusiasm for this project early on. Brazilian scholar Fernando de Tacca's research into the Flávio story and *O Cruzeiro*'s reaction, which appears in the online publication *Studium*, was crucial during the initial stages of our research, and we thank him for his earlier work on the subject. Curator Philip Brookman, who organized Parks' 1997 retrospective at the Corcoran Gallery of Art, offered wise counsel during joint research visits to Kansas collections and archives with Paul Roth. Howard Greenberg and Karen Marks of Howard Greenberg Gallery, which represents Parks, supported the project from the outset in numerous capacities. Photojournalist Susan Meiselas provided her New York apartment as a location for us to finalize our plate sequence. JoAnn Magdoff facilitated research requests concerning the film *Flavio*. And Instituto Sacatar in Itaparica, Bahia, hosted Paul Roth for a residency to research and write his essay for this book. We thank Taylor Van Horne, Mitch Loch, Augusto Albuquerque, and Marcelo Thomaz for their generous support of this project, as well as the staff and other fellows at Instituto Sacatar.

Talks based on our ongoing research helped us refine our arguments and share our findings with colleagues. We thank Andrés Mario Zervigón, Rutgers University, and Maria Antonella Pelizzari, Hunter College, CUNY, for inviting Paul Roth to participate in "Print Matters: Histories of Photography in Illustrated Magazines," at the New York Public Library, April 8–9, 2016. We also thank Katherine Bussard, Princeton University Art Museum, and Kristen Gresh, Museum of Fine Arts, Boston, for inviting our participation in "*Life* Scholars Day" at the Princeton Club, New York, March 28, 2017.

Working with support from the Gordon Parks Foundation, the editors visited Flávio da Silva and his family in Rio de Janeiro in December 2016. Our sincere gratitude to the team we worked with to locate and interview Flávio: journalist Michael Astor, cameraman Douglas Engle, and our intrepid driver, Alan Lima. While in Rio, we visited Sascha Bercovitch, a young scholar studying life and culture in the city's favelas, and we extend our thanks to him for sharing his experiences and thoughts with us. In Pleasantville, New York, editor George Kunhardt of Kunhardt Films offered valuable assistance with many hours of footage and sound.

At Steidl Verlag in Göttingen, Germany, our amazing publisher, we thank Gerhard Steidl, Duncan Whyte, Nadine Reese, and Monte Packham.

Finally, we want to express immeasurable thanks to Flávio da Silva, for inspiring our efforts; providing vital information and context; and for enduring one more inquiry into the details of his experience with Gordon Parks, and everything that followed.

Paul Roth and Amanda Maddox
Coeditors

This publication accompanies an exhibition of the same name:

Instituto Moreira Salles, São Paulo, Brazil, 2 December 2017–28 January 2018
Instituto Moreira Salles, Rio de Janeiro, Brazil, 6 February–29 April 2018
Ryerson Image Centre, Toronto, Canada, 12 September–2 December 2018
The J. Paul Getty Museum, Los Angeles, United States, 9 July–10 November 2019

First edition published in 2018

Book design by Duncan Whyte
Scans and tritone separations by Steidl image department

Production and printing by Steidl, Göttingen

Steidl
Düstere Str. 4 / 37073 Göttingen, Germany
Phone +49 551 49 60 60 / Fax +49 551 49 60 649
mail@steidl.de
steidl.de

The Gordon Parks Foundation
48 Wheeler Avenue
Pleasantville, New York 10570
gordonparksfoundation.org

ISBN 978-3-95829-344-1
Printed in Germany by Steidl

photo # 1376185

6-16-6

Used in Life
June 16, 1961
p. 95

62170

A

USED IN TIME

C-2

OCT 20 1961 19

62170-A CR 6

USED IN LIFE
50th Anniversary
Issue
PAGE 154

G. PARKS

FAMOUS PICTURE
DO NOT CIRCULATE

X

USED IN LIFE
50th Anniversary
Issue
PAGE 154

CX Brazil - P + C

Underprivileged child DD

CX Housing - Brazil - Slums - Rio de Janeiro

Flavio (da) Silva (Rio Slumboy)

(In his Family's Shack

119.5

in Rio de Janeiro "Favela"
or Slum)

62170

USED IN TIME-LIFE BOOK

Best of Life

PAGE 199 0793165

N PARKS 1/16/61

1593.2005